A Year in Art
A Treasure A Day

In cooperation with

ARTOTHEK

Prestel
Munich · Berlin · London · New York

Art is eternal.

Egon Schiele

To appreciate the beauty of a snowflake,
it is necessary to stand out in the cold.

ANON.

Kanbara, from "Fifty-three Stations of the Tokaido," *c.* 1833–34
Utagawa Hiroshige

1 2 3 4 5 6 7 8 9 10 11 12 13 14 15 16 17 18 19 20 21 22 23 24 25 26 27 28 29 30 31

JANUARY

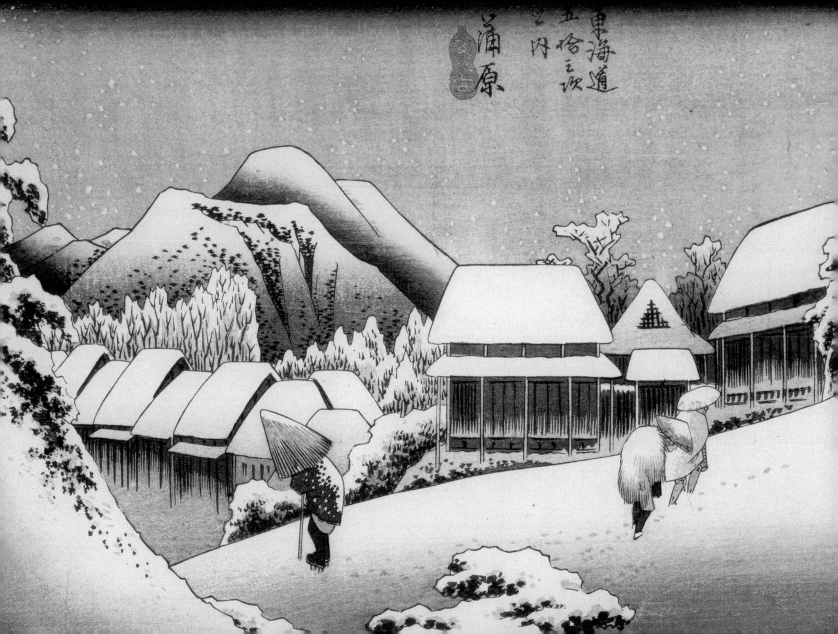

Fortune is like glass—the brighter the glitter,
the more easily broken.

PUBLILIUS SYRUS

Still Life with a Basket of Glasses, 1644
Sebastian Stoskopff
Musée de l'Œuvre Notre-Dame, Strasbourg

1 **2** 3 4 5 6 7 8 9 10 11 12 13 14 15 16 17 18 19 20 21 22 23 24 25 26 27 28 29 30 31

JANUARY

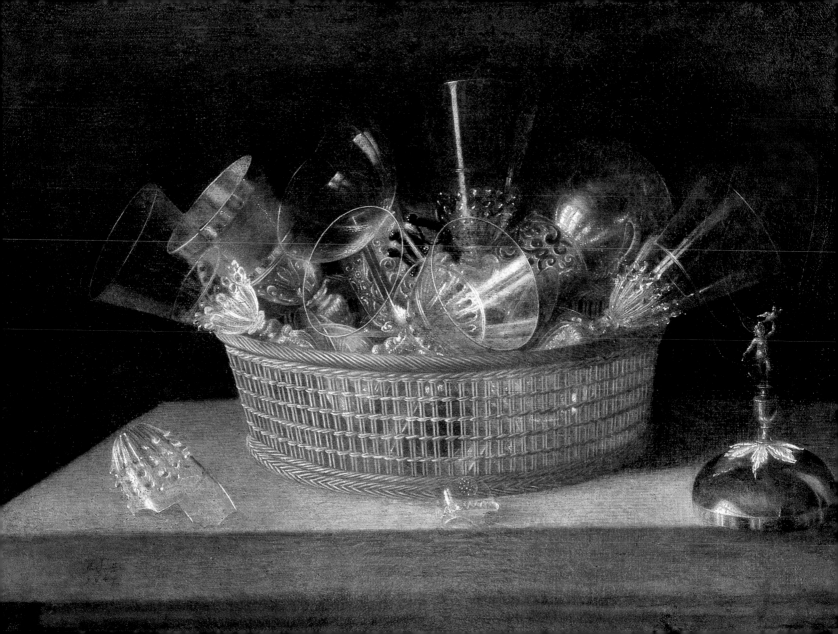

Be embraced, millions!
This kiss to the entire world!

FRIEDRICH SCHILLER

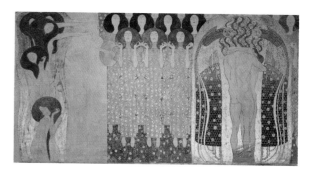

**The Arts, Choir of Angels, and Embracing Couple
(Beethoven Frieze),** 1902
Gustav Klimt
Belvedere, Vienna

1 2 **3** 4 5 6 7 8 9 10 11 12 13 14 15 16 17 18 19 20 21 22 23 24 25 26 27 28 29 30 31

JANUARY

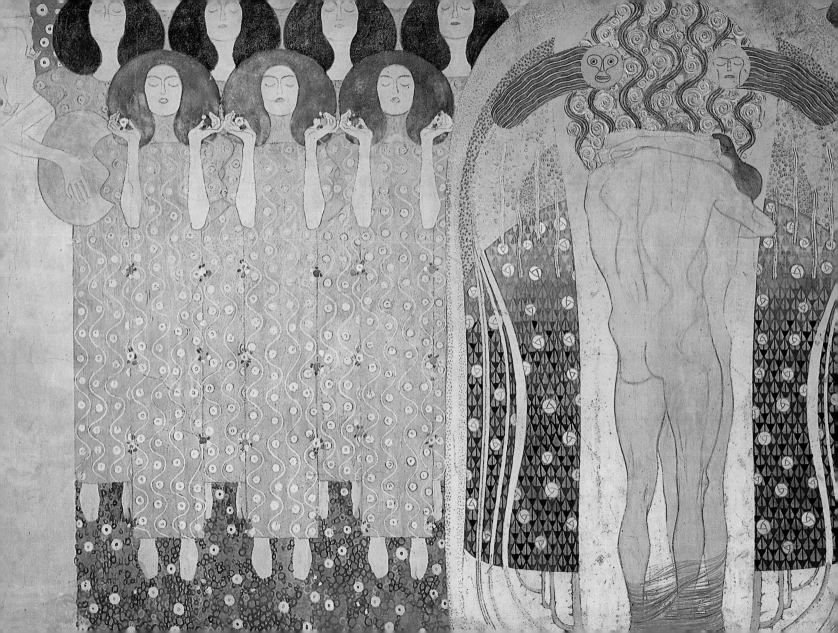

A truthful page is childhood's lovely face,
Whereon sweet Innocence has record made—
an outward semblance of the young heart's grace,
Where truth, and love, and trust are all portrayed.

BENJAMIN PENHALLOW SHILLABER

Infant Christ with John the Baptist and Two Angels, 1615–20
Peter Paul Rubens
Kunsthistorisches Museum, Vienna

1 2 3 **4** 5 6 7 8 9 10 11 12 13 14 15 16 17 18 19 20 21 22 23 24 25 26 27 28 29 30 31

JANUARY

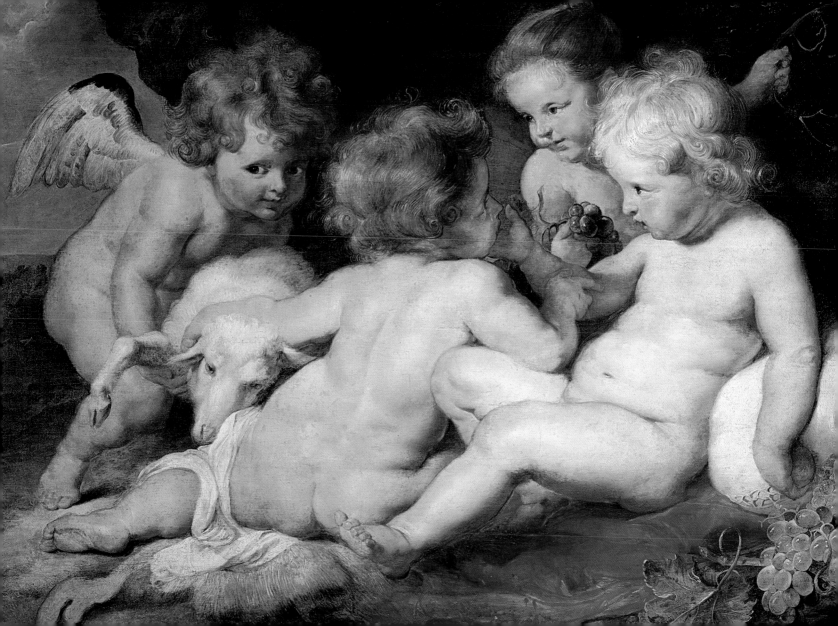

The presence of a young girl is like the presence of a flower; the one gives its perfume to all that approach it, the other her grace to all that surround her.

LOUIS CLAUDE JOSEPH DESNOYERS

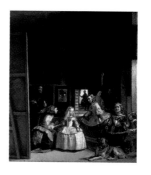

Las Meninas (The Maids of Honor), 1656
Diego Rodríguez de Velázquez
Museo Nacional del Prado, Madrid

1 2 3 4 **5** 6 7 8 9 10 11 12 13 14 15 16 17 18 19 20 21 22 23 24 25 26 27 28 29 30 31

JANUARY

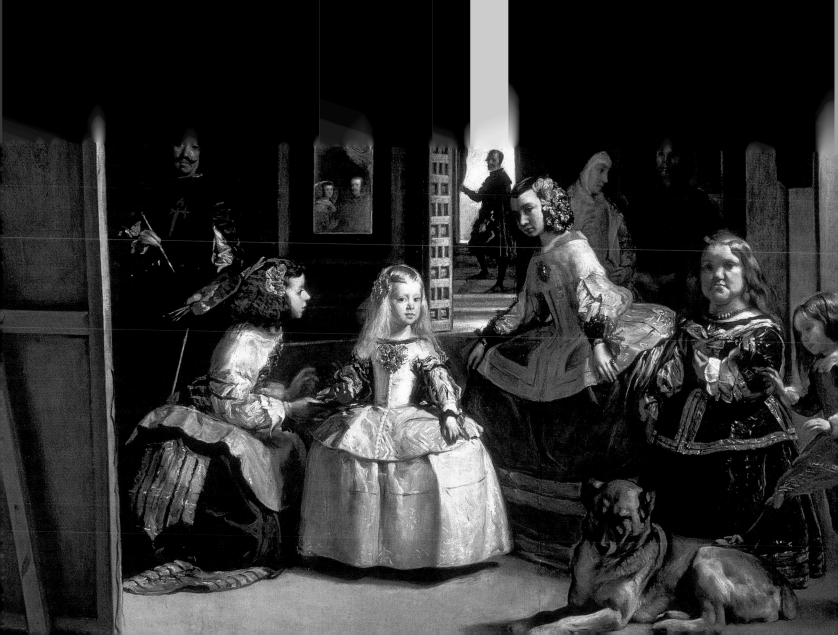

All kings shall fall down before him:
all nations shall do him service.

PSALM 72:8

Worship of the Three Holy Kings, 15th century
Dutch
Residenzgalerie, Salzburg

1 2 3 4 5 **6** 7 8 9 10 11 12 13 14 15 16 17 18 19 20 21 22 23 24 25 26 27 28 29 30 31

JANUARY

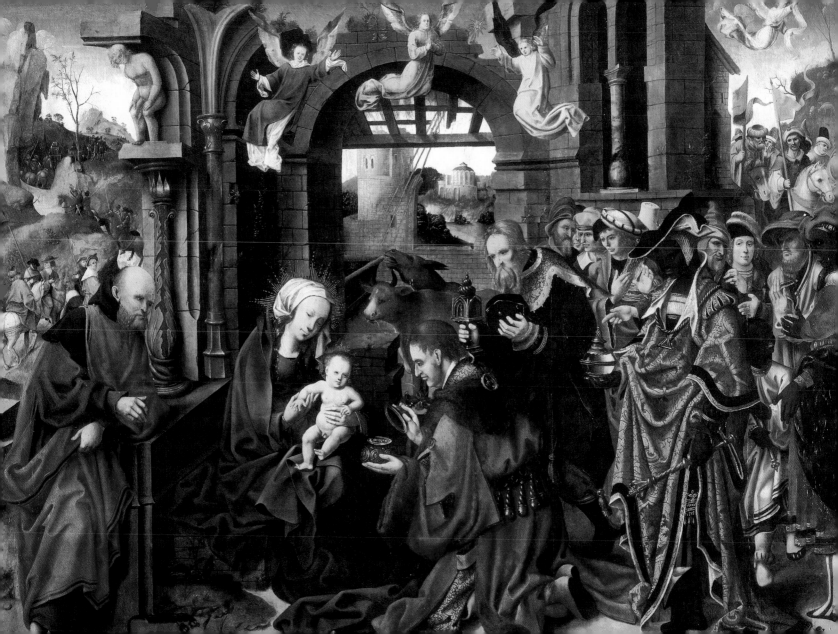

Advice is like snow; the softer it falls,
the longer it dwells upon, and the deeper it
sinks into, the mind.

SAMUEL TAYLOR COLERIDGE

Winter Scene with Ice Skaters, 1630–40
Jan van Goyen
The Pushkin Museum of Fine Arts, Moscow

1 2 3 4 5 6 **7** 8 9 10 11 12 13 14 15 16 17 18 19 20 21 22 23 24 25 26 27 28 29 30 31

JANUARY

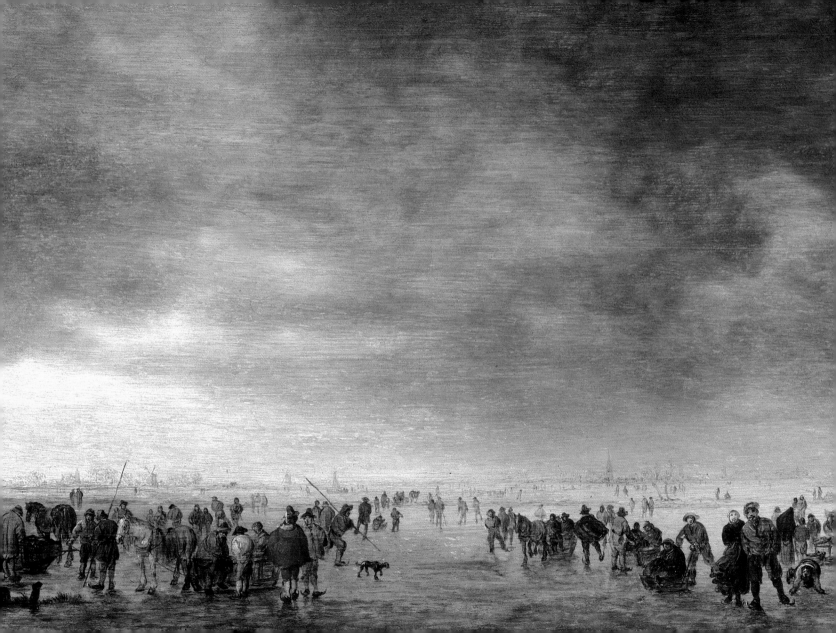

*Do you love me because I'm beautiful,
or am I beautiful because you love me?*

<small>OSCAR HAMMERSTEIN</small>

La Grande Odalisque, 1814
Jean-Auguste-Dominique Ingres
Musée du Louvre, Paris

1 2 3 4 5 6 7 **8** 9 10 11 12 13 14 15 16 17 18 19 20 21 22 23 24 25 26 27 28 29 30 31

JANUARY

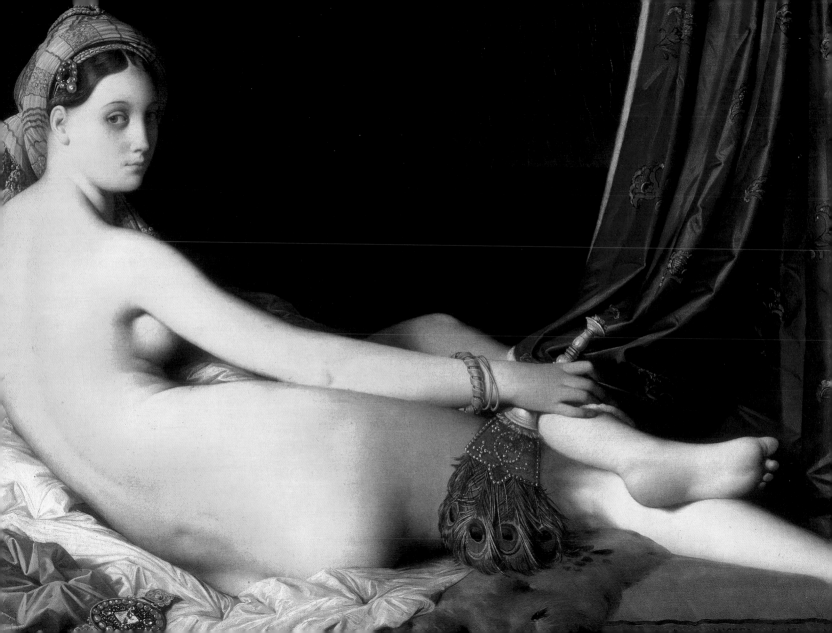

I often think that the night is more alive and more richly colored than the day.

Vincent van Gogh

Berlin Street Scene at Night, late 19th or early 20th century
Lesser Ury
Christie's, New York

1 2 3 4 5 6 7 8 **9** 10 11 12 13 14 15 16 17 18 19 20 21 22 23 24 25 26 27 28 29 30 31

JANUARY

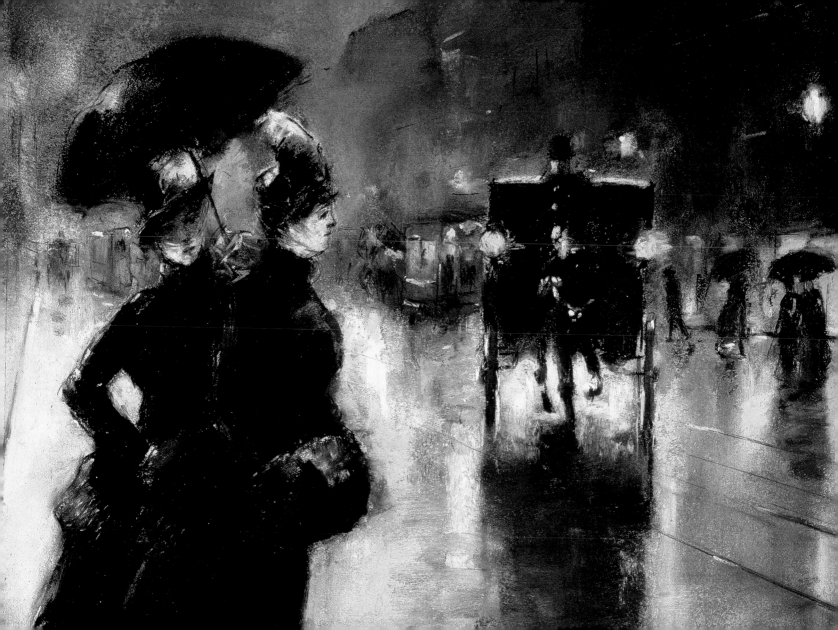

Myth is an attempt to narrate the whole of human experience, of which the purpose is too deep, going too deep in the blood and soul, for mental explanation or description.

D.H. LAWRENCE

Playing in the Waves, 1883
Arnold Böcklin
Neue Pinakothek, Munich

1 2 3 4 5 6 7 8 9 **10** 11 12 13 14 15 16 17 18 19 20 21 22 23 24 25 26 27 28 29 30 31

JANUARY

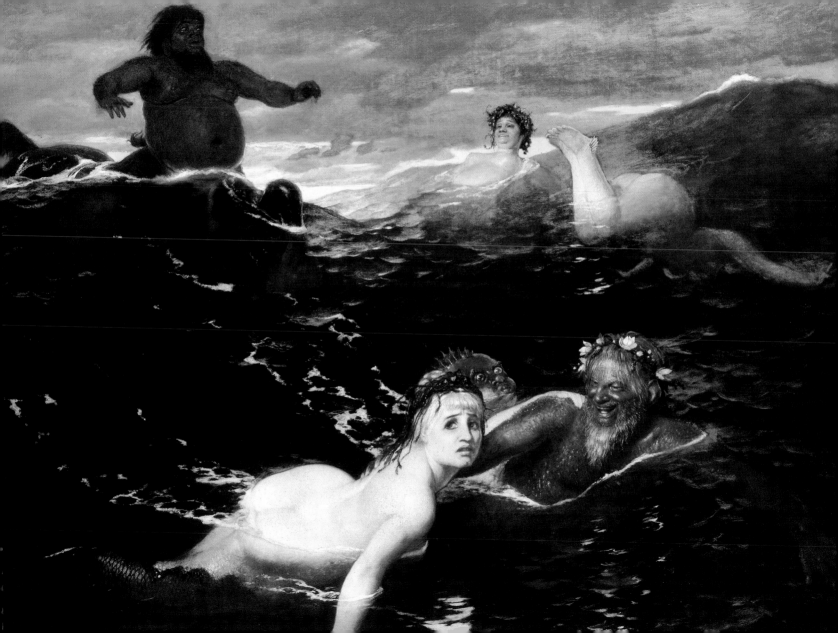

Out in the dark over the snow
The fallow fawns invisible go
With the fallow doe;
And the winds blow
Fast as the stars are slow.

Deer in the Snow II, 1911
Franz Marc
Lenbachhaus, Munich

1 2 3 4 5 6 7 8 9 10 **11** 12 13 14 15 16 17 18 19 20 21 22 23 24 25 26 27 28 29 30 31

JANUARY

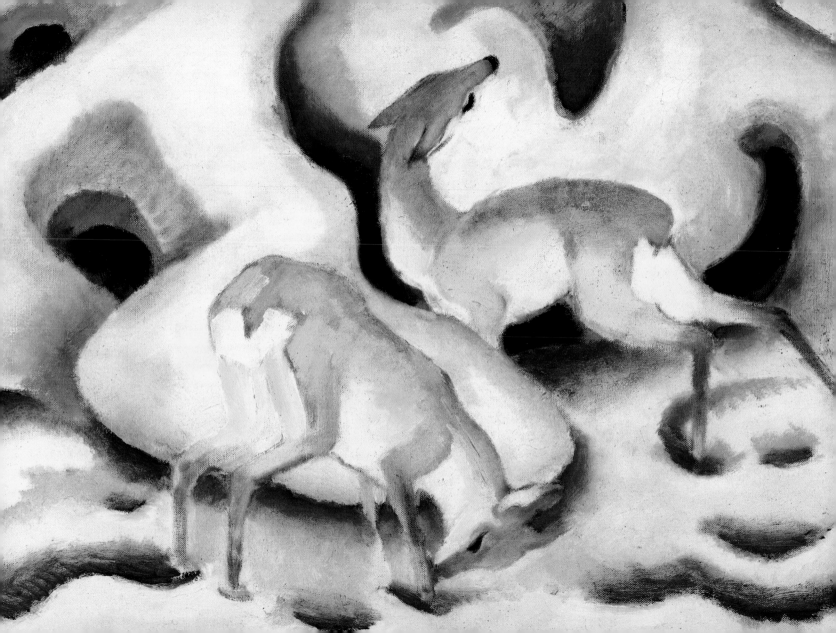

He who is unable to live in society,
or who has no need because he is sufficient
for himself, must be either a beast or a god.

<small>ARISTOTLE</small>

Elegant Society, 1628
Dirck Hals
Frans Hals Museum, Haarlem

1 2 3 4 5 6 7 8 9 10 11 **12** 13 14 15 16 17 18 19 20 21 22 23 24 25 26 27 28 29 30 31

JANUARY

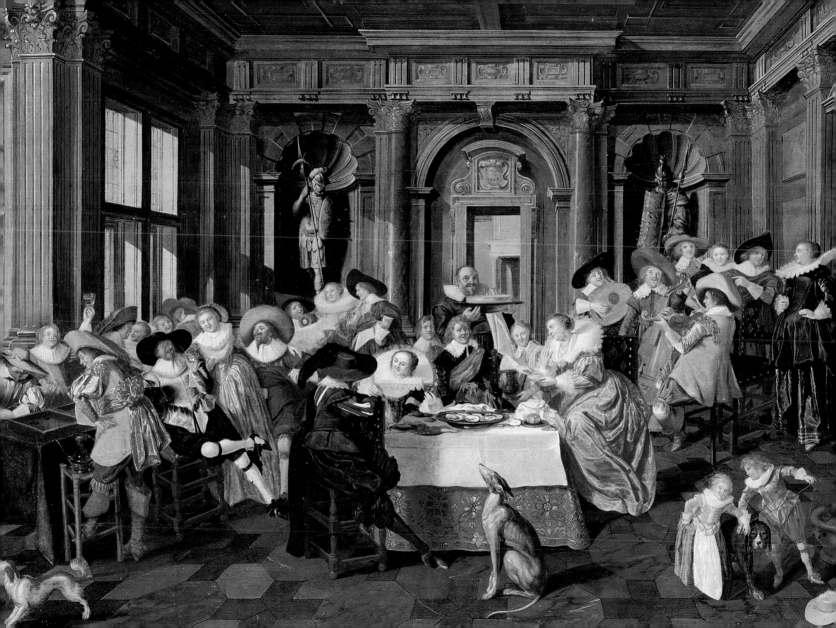

This world, after all our science and sciences,
is still a miracle;
wonderful, inscrutable, magical and more,
to whosoever will think of it.

THOMAS CARLYLE

St. Jerome in his Study, 1480
Domenico Ghirlandaio
Church of Ognissanti, Florence

1 2 3 4 5 6 7 8 9 10 11 12 **13** 14 15 16 17 18 19 20 21 22 23 24 25 26 27 28 29 30 31

JANUARY

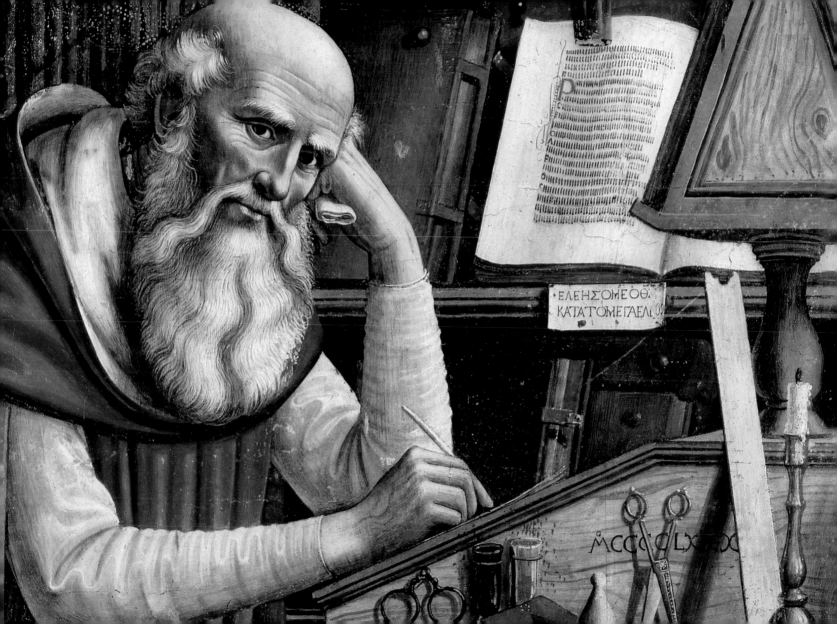

ΕΛΕΗCΟΜΕΘ
ΚΑΤΑΤΟΜΕΓΑΕΛΕ

MCCCCLXXXIII

Our imagination loves to be filled with an object or to grasp at anything that is too big for its capacity. We ... feel a delightful stillness and amazement in the soul at the apprehension of them.

JOHN ADDISON

Simultaneous Vision, c. 1912
Umberto Boccioni
Von der Heydt-Museum, Wuppertal

1 2 3 4 5 6 7 8 9 10 11 12 13 **14** 15 16 17 18 19 20 21 22 23 24 25 26 27 28 29 30 31

JANUARY

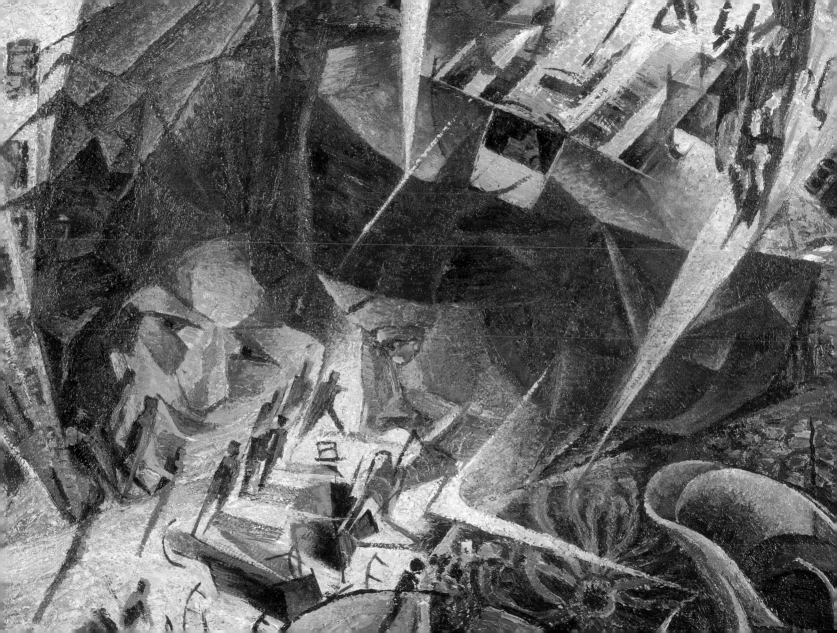

Music is the harmonious voice of creation, an echo of the invisible world, one note of the divine concord which the entire universe is destined one day to sound.

<small>GIUSEPPE MAZZINI</small>

Music Lesson, 17th century
Gerard ter Borch
The Pushkin Museum of Fine Arts, Moscow

1 2 3 4 5 6 7 8 9 10 11 12 13 14 **15** 16 17 18 19 20 21 22 23 24 25 26 27 28 29 30 31

JANUARY

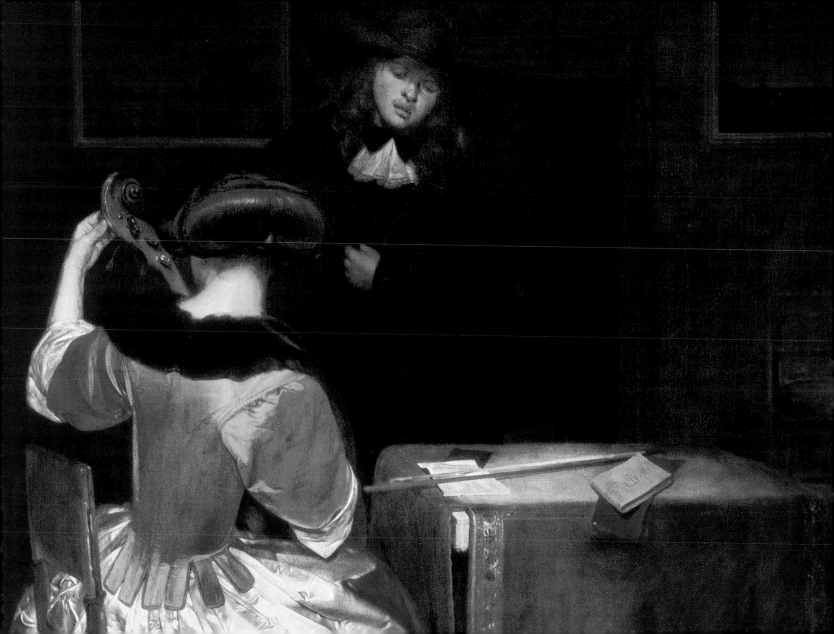

Peace is not the absence of war.
It is a virtue, a state of mind,
a disposition for benevolence,
confidence, and justice.

BENEDICTUS DE SPINOZA

Allegory of Peace and Justice, c. 1759–60
Corrado Giaquinto
Museo Nacional del Prado, Madrid

1 2 3 4 5 6 7 8 9 10 11 12 13 14 15 **16** 17 18 19 20 21 22 23 24 25 26 27 28 29 30 31

JANUARY

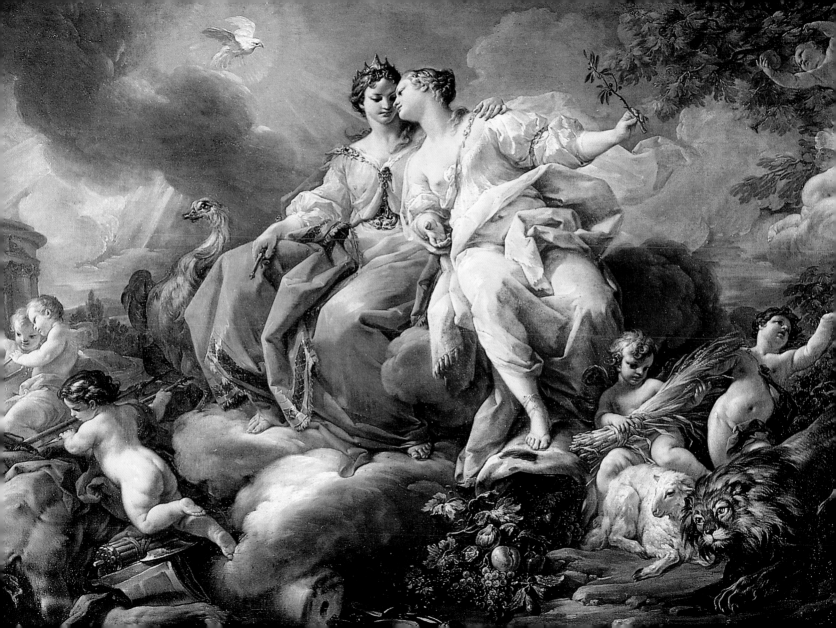

*Far away there in the sunshine
are my highest aspirations.
I may not reach them but I can look up
and see their beauty, believe in them,
and try to follow them.*

Louis May Alcott

Woman with a Pearl Necklace, 1662
Johannes Vermeer
Gemäldegalerie, Berlin

1 2 3 4 5 6 7 8 9 10 11 12 13 14 15 16 **17** 18 19 20 21 22 23 24 25 26 27 28 29 30 31

JANUARY

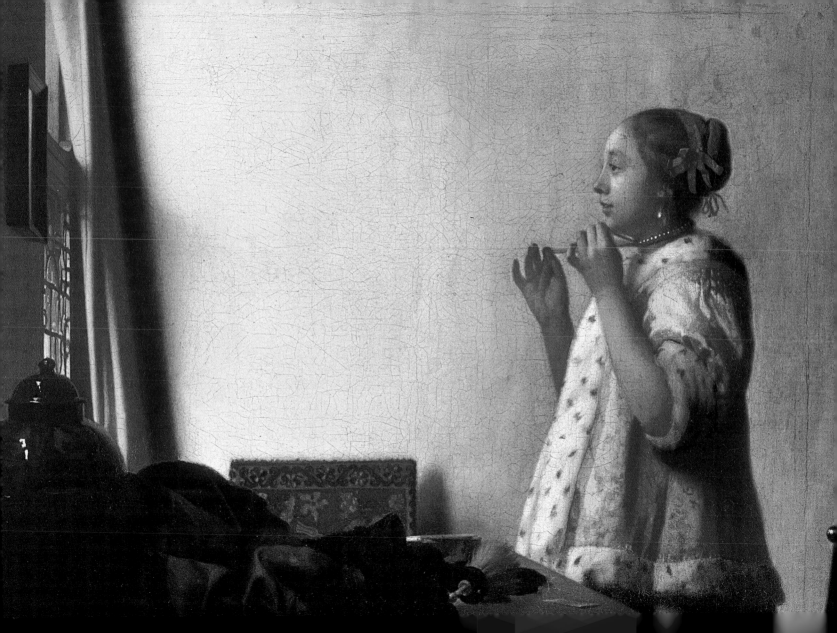

The city is an epitome of the social world. All the belts of civilization intersect along its avenues. It contains the products of every moral zone. It is cosmopolitan, not only in a national, but in a spiritual sense.

EDWIN HUBBELL CHAPIN

The Manhattan Club (The Stewart Mansion), *c.* 1891
Childe Hassam
Santa Barbara Museum of Art

1 2 3 4 5 6 7 8 9 10 11 12 13 14 15 16 17 **18** 19 20 21 22 23 24 25 26 27 28 29 30 31

JANUARY

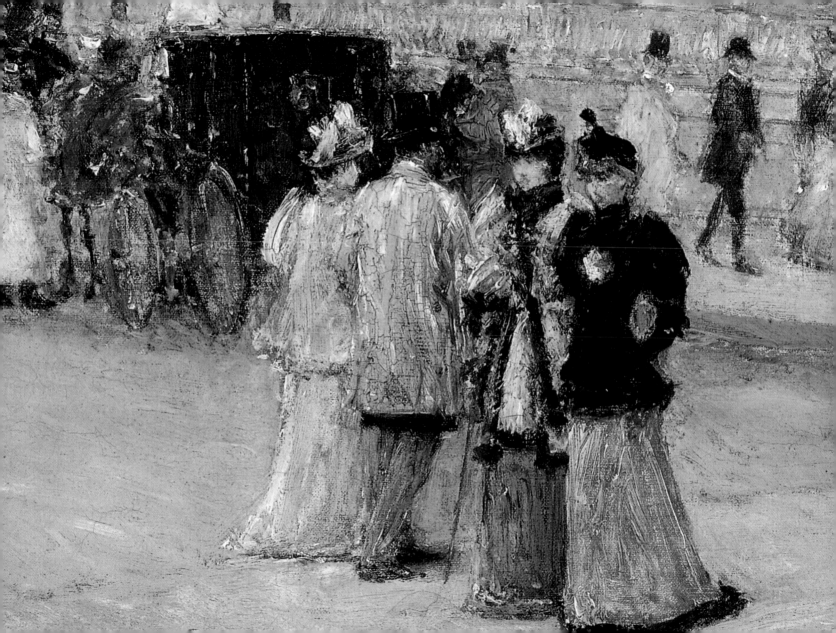

Wintry boughs against a wintry sky;
Yet the sky is partly blue
And the clouds are partly bright.
Who can tell but sap is mounting high,
Out of sight,
Ready to burst through?

CHRISTINA GEORGINA ROSSETTI

Winter Scene, early 17th century
Gysbrecht Lytens
The State Hermitage Museum, St. Petersburg

1 2 3 4 5 6 7 8 9 10 11 12 13 14 15 16 17 18 **19** 20 21 22 23 24 25 26 27 28 29 30 31

JANUARY

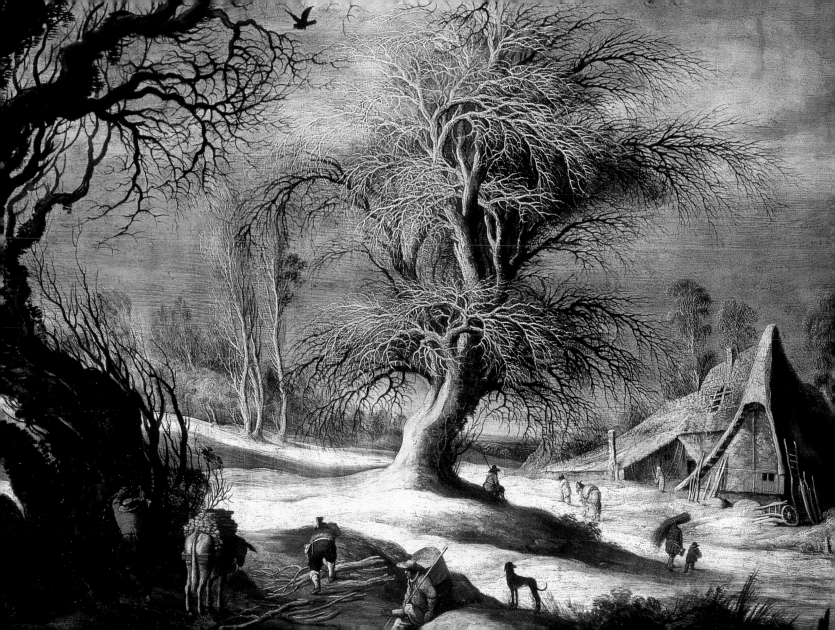

Art cannot be modern; art is eternal.

Egon Schiele

Windows, 1914
Egon Schiele
Belvedere, Vienna

1 2 3 4 5 6 7 8 9 10 11 12 13 14 15 16 17 18 19 **20** 21 22 23 24 25 26 27 28 29 30 31

JANUARY

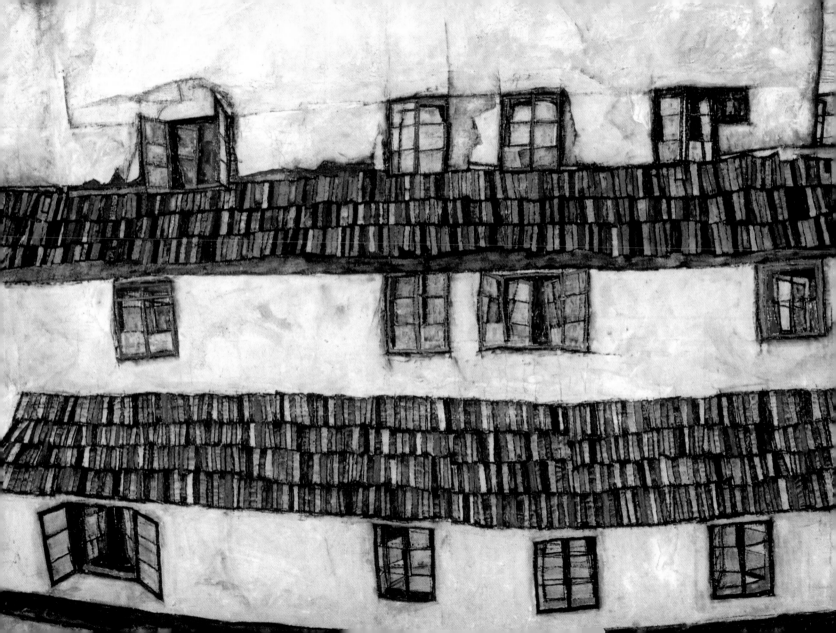

Of course you will say that I have to be practical and ought to try and paint the way they want me to paint...
I have tried, and I have tried very hard, but I can't do it. I just can't do it! And that is why I am just a little crazy.

REMBRANDT VAN RIJN

Nightwatch, 1642
Rembrandt van Rijn
Rijksmuseum, Amsterdam

1 2 3 4 5 6 7 8 9 10 11 12 13 14 15 16 17 18 19 20 **21** 22 23 24 25 26 27 28 29 30 31

JANUARY

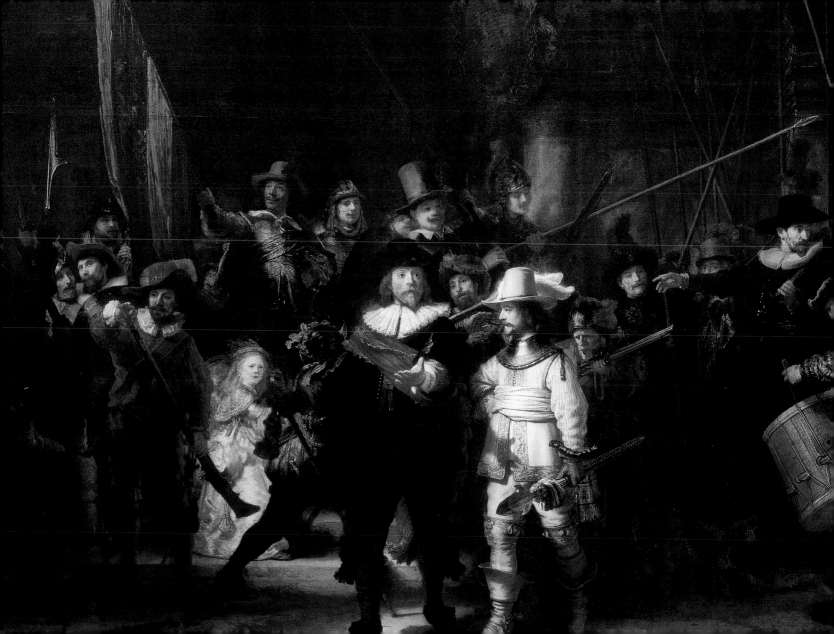

Children are the keys of paradise,
They alone are good and wise,
Because their thoughts, their very lives,
are prayer.

RICHARD HENRY STODDARD

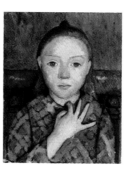

Portrait of a Girl, 1905
Paula Modersohn-Becker
Von der Heydt-Museum, Wuppertal

1 2 3 4 5 6 7 8 9 10 11 12 13 14 15 16 17 18 19 20 21 **22** 23 24 25 26 27 28 29 30 31

JANUARY

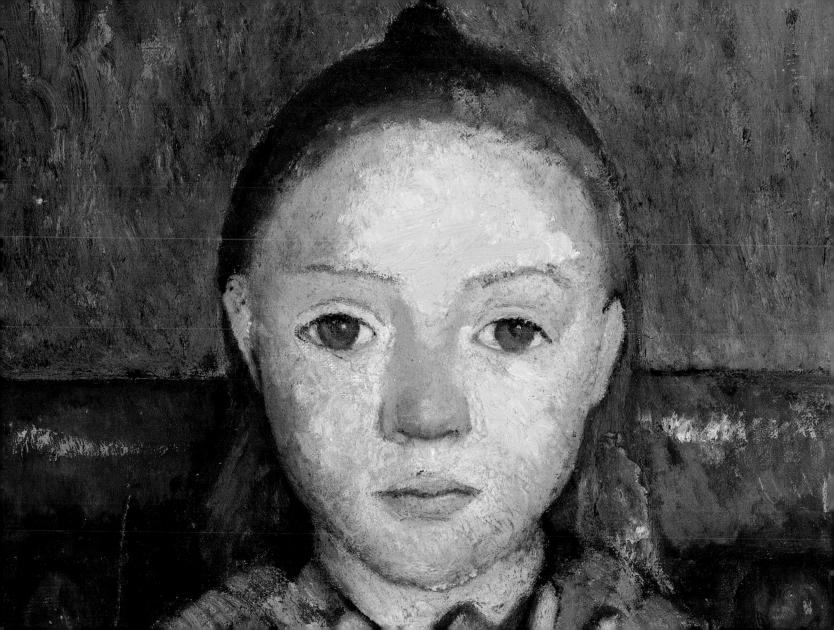

It is our own vanity that makes
the vanity in others intolerable to us.

FRANÇOIS DUC DE LA ROCHEFOUCAULD

Allegory of Vanity, 1646
Simon Luttichuys
Private Collection

1 2 3 4 5 6 7 8 9 10 11 12 13 14 15 16 17 18 19 20 21 22 **23** 24 25 26 27 28 29 30 31

JANUARY

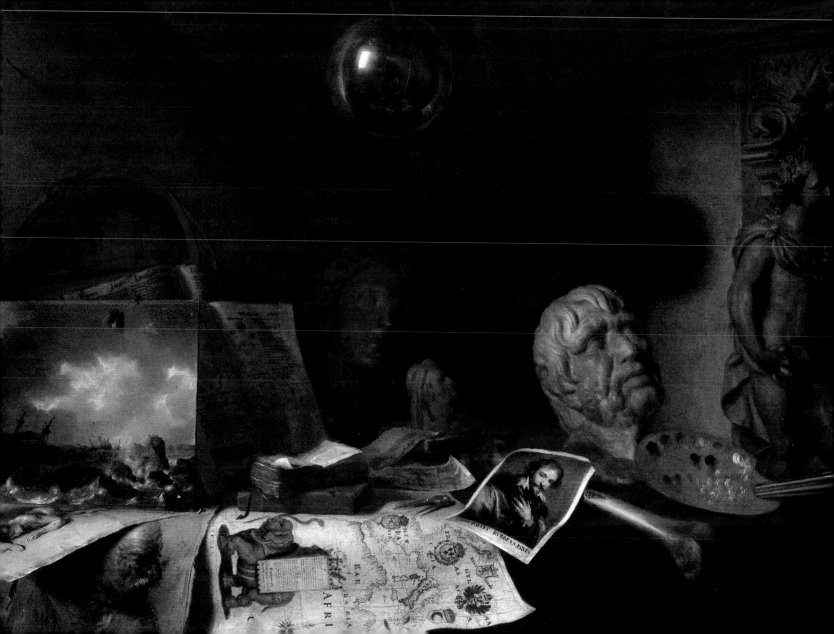

People don't notice whether it's winter or summer when they're happy.

ANTON CHEKHOV

Winter Landscape, 1601
Pieter Brueghel the Younger
Kunsthistorisches Museum, Vienna

1 2 3 4 5 6 7 8 9 10 11 12 13 14 15 16 17 18 19 20 21 22 23 **24** 25 26 27 28 29 30 31

JANUARY

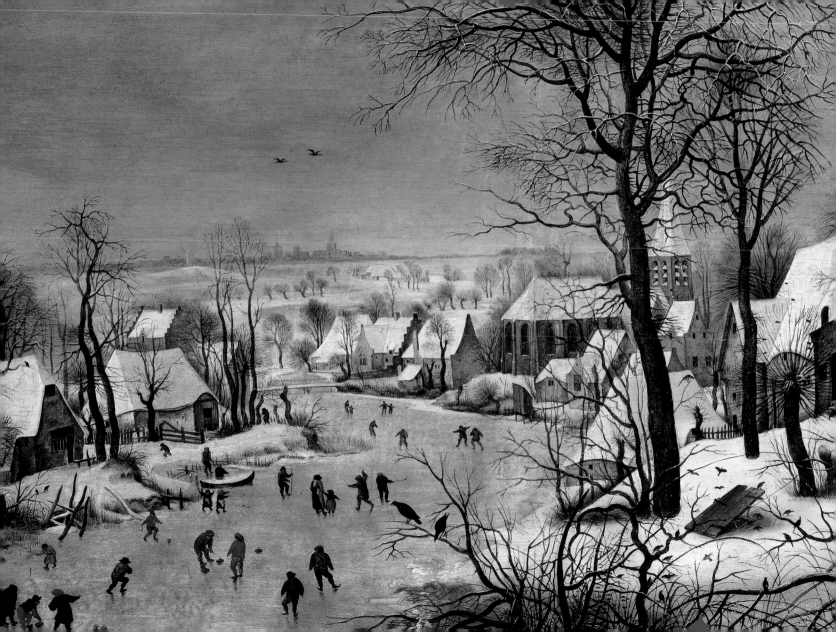

When you work you are a flute through whose heart the whispering of the hours turns to music. Which of you would be a reed, dumb and silent, when all else sings together in unison?

Kahlil Gibran

The Flutist, early 17th century
Sigismondo Coccapani
Uffizi Gallery, Florence

1 2 3 4 5 6 7 8 9 10 11 12 13 14 15 16 17 18 19 20 21 22 23 24 **25** 26 27 28 29 30 31

JANUARY

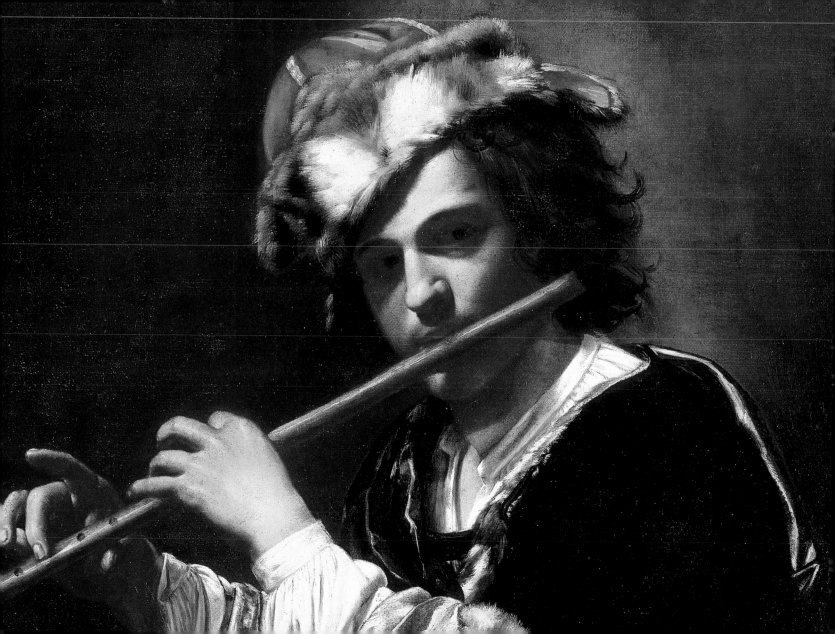

The new architecture is anti-decorative.
Color is not a decorative part of architecture,
but its organic medium of expression.

THEO VAN DOESBURG

Contra-Composite XIV, 1925
Theo van Doesburg
Private Collection

1 2 3 4 5 6 7 8 9 10 11 12 13 14 15 16 17 18 19 20 21 22 23 24 25 **26** 27 28 29 30 31

JANUARY

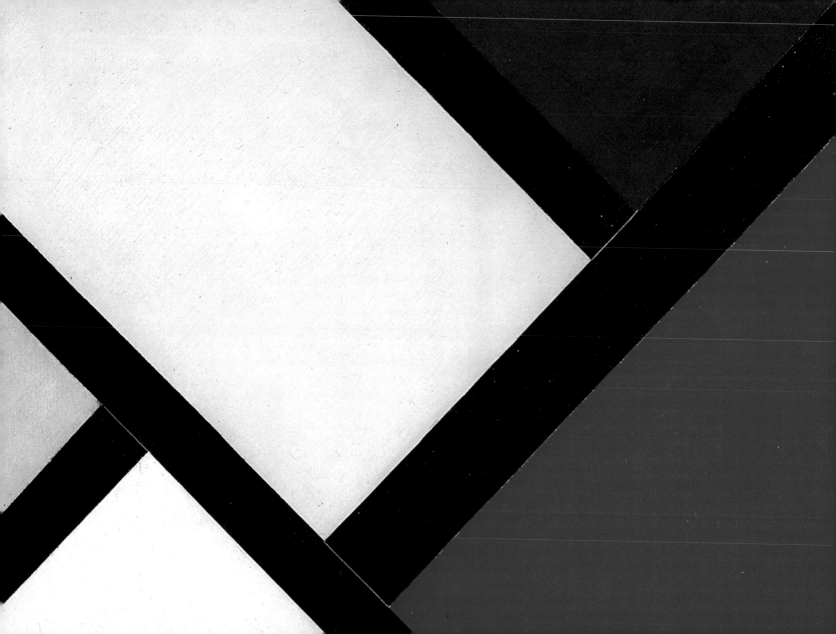

*A guest never forgets the host
who had treated him kindly.*

HOMER

Guests Attending the Wedding, before 1898
Jean-François Raffaëlli
Musée d'Orsay, Paris

1 2 3 4 5 6 7 8 9 10 11 12 13 14 15 16 17 18 19 20 21 22 23 24 25 26 **27** 28 29 30 31

JANUARY

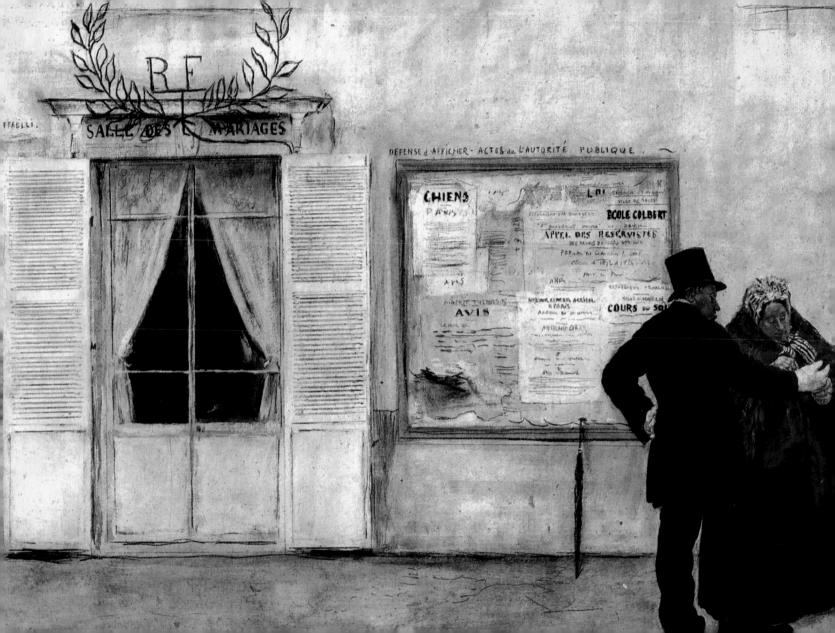

A family in harmony
will prosper in everything.

<small>Chinese Proverb</small>

The Artist with his Wife and Daughters, 1903
Franz von Lenbach
Lenbachhaus, Munich

1 2 3 4 5 6 7 8 9 10 11 12 13 14 15 16 17 18 19 20 21 22 23 24 25 26 27 **28** 29 30 31

JANUARY

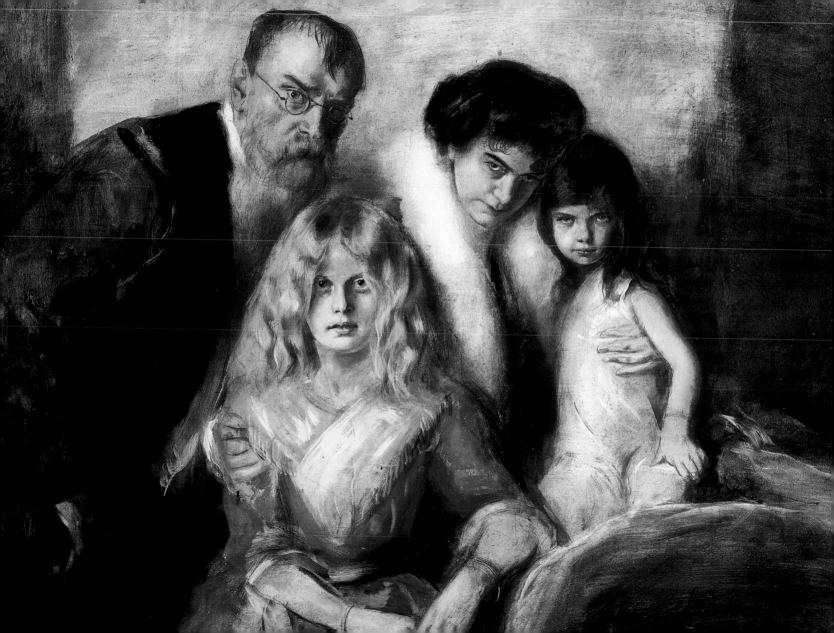

How calm, how beautiful comes on
The stilly hour, when storms are gone!
When warring winds have died away,
And clouds, beneath the glancing ray,
Melt off, and leave the land and sea
Sleeping in bright tranquillity.

Thomas Moore

Warships at Amsterdam, late 17th century
Willem van de Velde, the Younger
Mauritshuis, The Hague

1 2 3 4 5 6 7 8 9 10 11 12 13 14 15 16 17 18 19 20 21 22 23 24 25 26 27 28 **29** 30 31

JANUARY

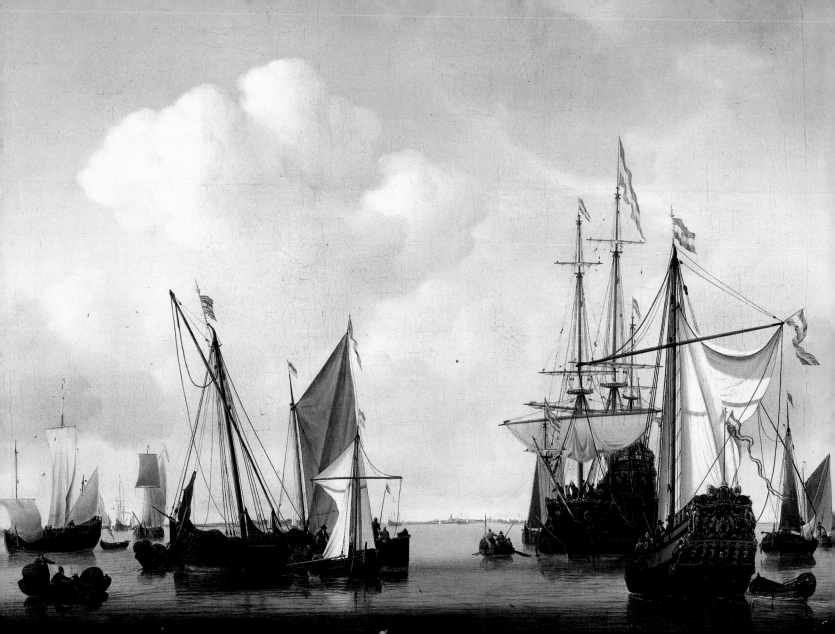

*We are shaped and fashioned
by what we love.*

JOHANN WOLFGANG VON GOETHE

Large, Bright Shop Window, 1912
August Macke
Landesmuseum, Hanover

1 2 3 4 5 6 7 8 9 10 11 12 13 14 15 16 17 18 19 20 21 22 23 24 25 26 27 28 29 **30** 31

JANUARY

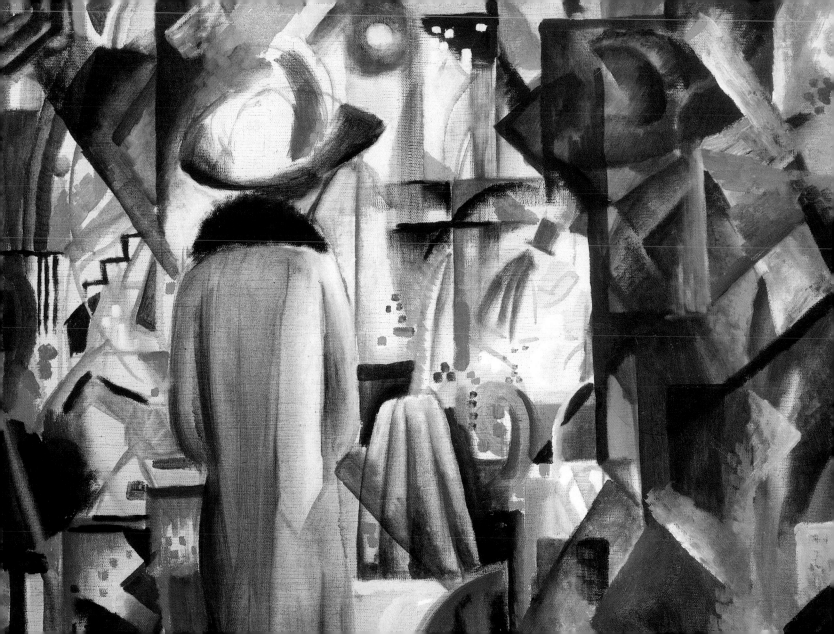

Smiling always with a never fading serenity of countenance, and flourishing in an immortal youth.

Isaac Barrow

Boy with a Basket of Fish, 18th century
Giacomo Ceruti
Palazzo Pitti, Florence

1 2 3 4 5 6 7 8 9 10 11 12 13 14 15 16 17 18 19 20 21 22 23 24 25 26 27 28 29 30 **31**

JANUARY

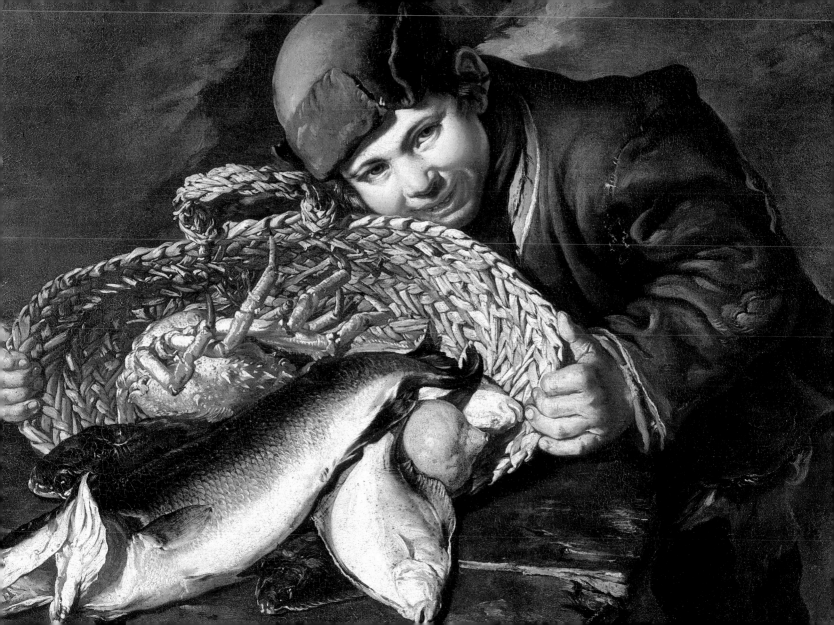

Think you, if Laura had been Petrarch's wife,
He would have written sonnets all his life?

LORD BYRON

An Embarrassing Proposal, 1716
Jean-Antoine Watteau
The State Hermitage Museum, St. Petersburg

1 2 3 4 5 6 7 8 9 10 11 12 13 14 15 16 17 18 19 20 21 22 23 24 25 26 27 28 29

FEBRUARY

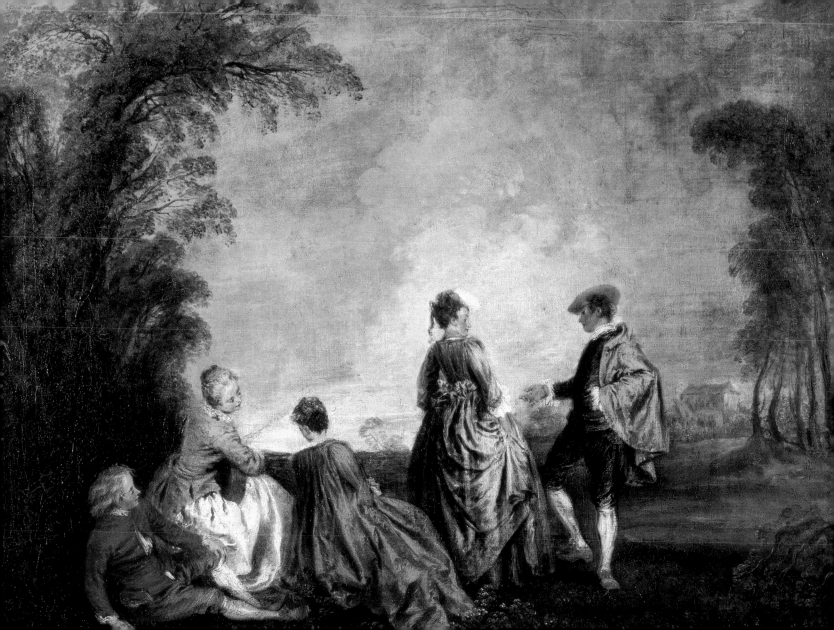

Art, to me, is the interpretation of the impression which nature makes upon the eye and brain.

CHILDE HASSAM

The Walchensee, New Snow, 1922
Lovis Corinth
Private Collection

1 **2** 3 4 5 6 7 8 9 10 11 12 13 14 15 16 17 18 19 20 21 22 23 24 25 26 27 28 29

FEBRUARY

Encourage innocent amusement.

Carnival in Florence, 19th century
Giovanni Signorini
Uffizi Gallery, Florence

1 2 **3** 4 5 6 7 8 9 10 11 12 13 14 15 16 17 18 19 20 21 22 23 24 25 26 27 28 29

FEBRUARY

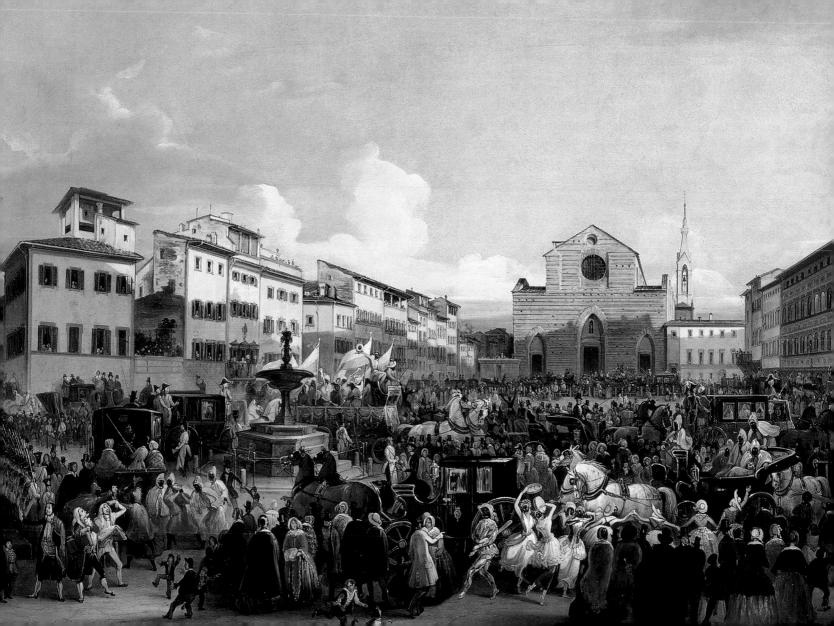

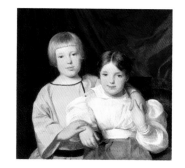

A child is an angel dependent on man.

Joseph Marie de Maistre

Two Children, 1834
Ferdinand Georg Waldmüller
The State Hermitage Museum, St. Petersburg

1 2 3 **4** 5 6 7 8 9 10 11 12 13 14 15 16 17 18 19 20 21 22 23 24 25 26 27 28 29

FEBRUARY

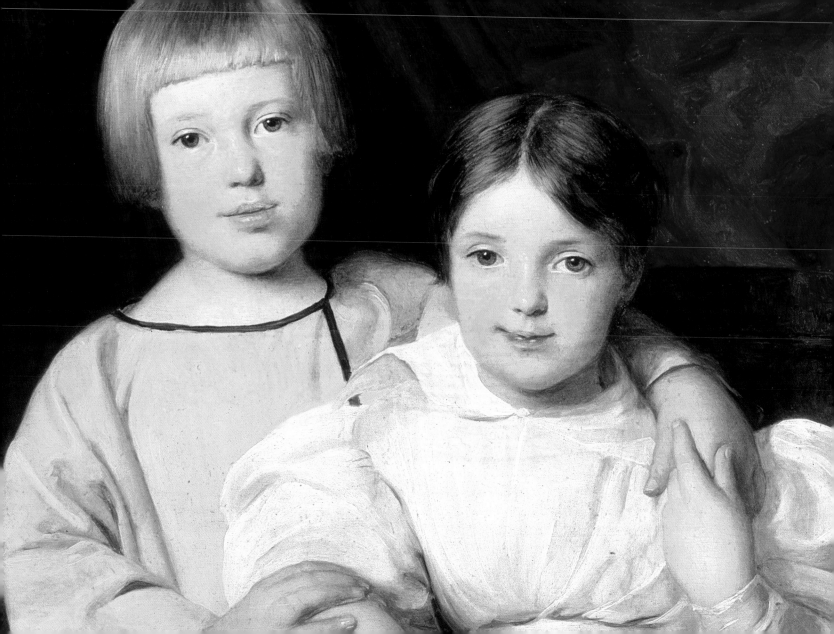

Is it the language of some other state,
born of its memory? For what can wake
the soul's strong instinct of another world,
like music?

LETITIA ELIZABETH LANDON

Concert at the Villa, 18th century
Antonio Visentini
Palazzo Contarini Fasan, Venice

5

1 2 3 4 **5** 6 7 8 9 10 11 12 13 14 15 16 17 18 19 20 21 22 23 24 25 26 27 28 29

FEBRUARY

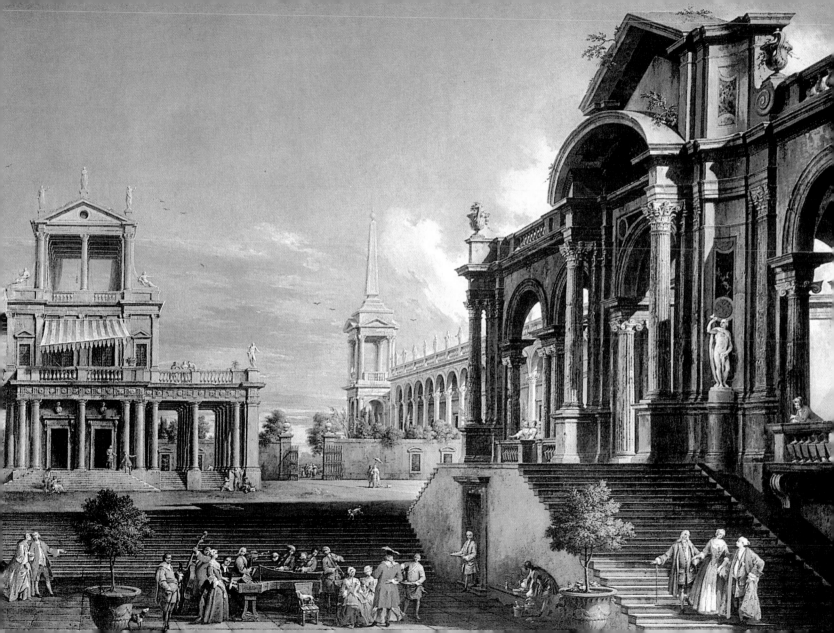

All thoughts, all passions, all delights
Whatever stirs this mortal frame
All are but ministers of Love
And feed His sacred flame.

SAMUEL TAYLOR COLERIDGE

The Fire, 1566
Giuseppe Arcimboldo
Kunsthistorisches Museum, Vienna

1 2 3 4 5 **6** 7 8 9 10 11 12 13 14 15 16 17 18 19 20 21 22 23 24 25 26 27 28 29

FEBRUARY

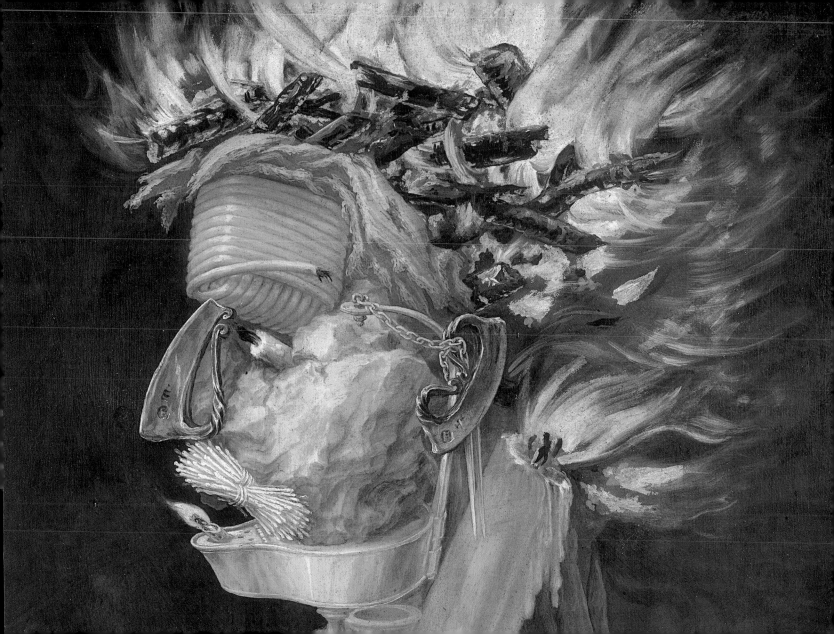

Solitude sometimes is the best society,
and short retirement urges sweet returns.

John Milton

A Polar Bear Hunting in Moonlight, 1899
Alexander Borisov
Arkhangelsk Fine Arts Museum

1 2 3 4 5 6 **7** 8 9 10 11 12 13 14 15 16 17 18 19 20 21 22 23 24 25 26 27 28 29

FEBRUARY

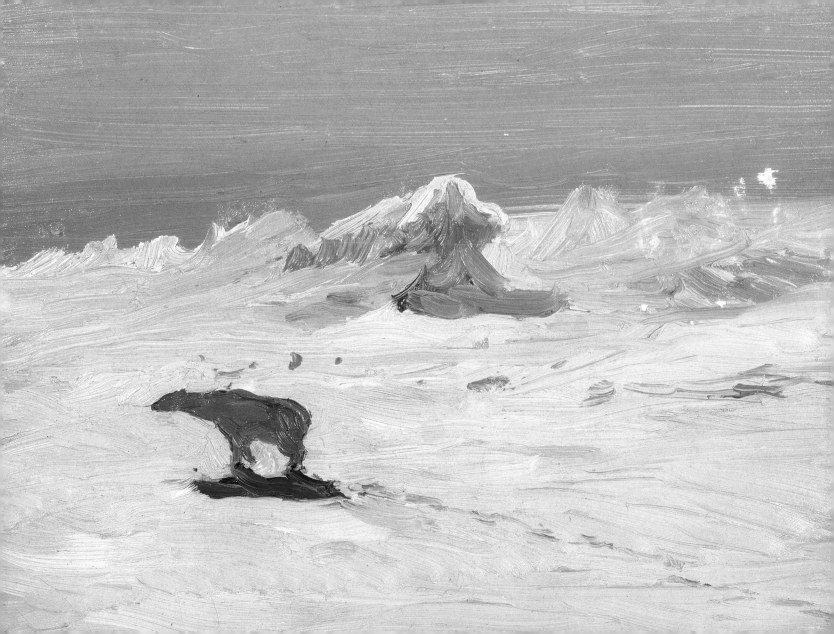

Cheerfulness is also an excellent wearing quality. It has been called the bright weather of the heart.

SAMUEL SMILES

Flea Hunt in Candlelight, c. 1620
Gerrit van Honthorst
Public Art Collection, Museum of Art, Basel

1 2 3 4 5 6 7 **8** 9 10 11 12 13 14 15 16 17 18 19 20 21 22 23 24 25 26 27 28 29

FEBRUARY

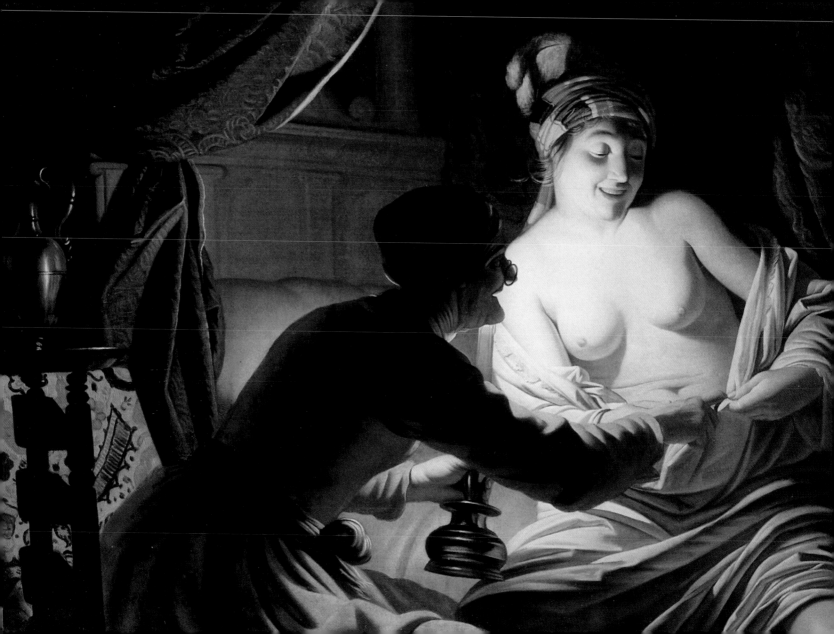

If country life be healthful to the body,
it is no less so to the mind.

Giovanni Ruffini

Amusement on Ice, 19th century
Anton Doll
Private Collection

1 2 3 4 5 6 7 8 **9** 10 11 12 13 14 15 16 17 18 19 20 21 22 23 24 25 26 27 28 29

FEBRUARY

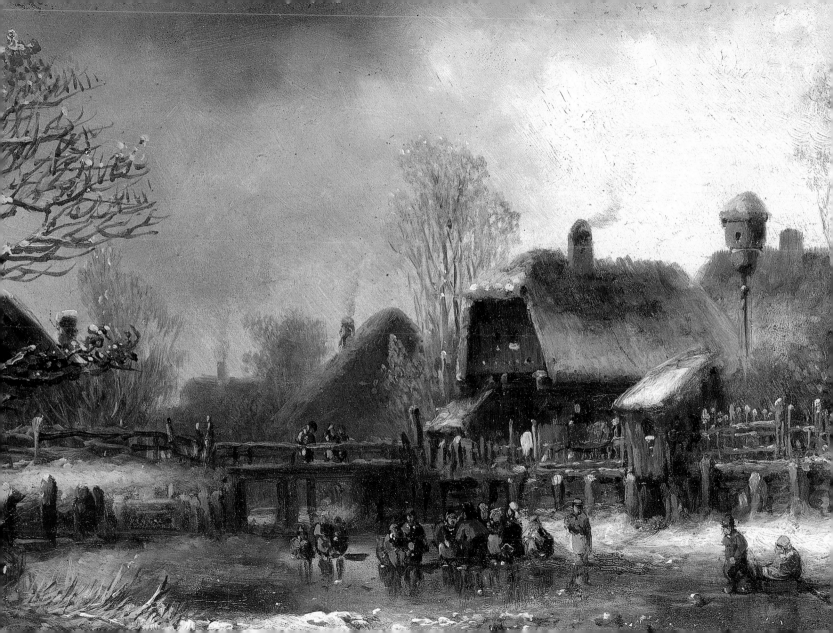

Concentration is the secret of strength.

RALPH WALDO EMERSON

Domino!, 1886
Frank Bramley
Vocational Education Committee, City of Cork (Crawford Art Gallery, Cork)

1 2 3 4 5 6 7 8 9 **10** 11 12 13 14 15 16 17 18 19 20 21 22 23 24 25 26 27 28 29

FEBRUARY

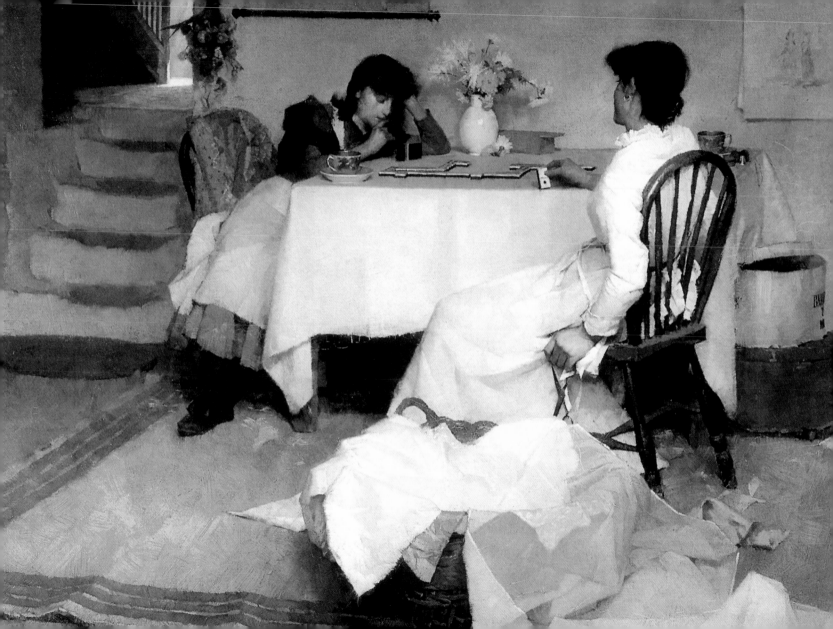

A painter paints the appearance of things, not their objective correctness. In fact, he creates new appearances of things.

Ernst Ludwig Kirchner

The Village Monstein near Davos, 1927
Ernst Ludwig Kirchner
Museum Folkwang, Essen

1 2 3 4 5 6 7 8 9 10 **11** 12 13 14 15 16 17 18 19 20 21 22 23 24 25 26 27 28 29

FEBRUARY

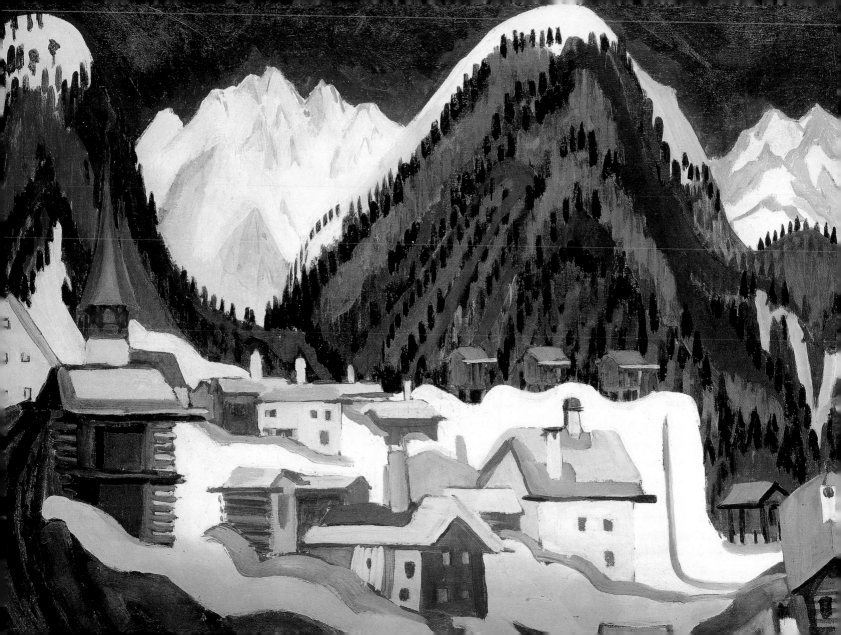

The first wealth is health.

RALPH WALDO EMERSON

Still Life with Bread and Milk, 1787
Henri Roland de la Porte
Musée du Louvre, Paris

1 2 3 4 5 6 7 8 9 10 11 **12** 13 14 15 16 17 18 19 20 21 22 23 24 25 26 27 28 29

FEBRUARY

One single grateful thought raised to heaven is the most perfect prayer.

Gotthold Ephraim Lessing

Three Women in a Church, 1878–82
Wilhelm Leibl
Fine Art Museums of San Francisco

1 2 3 4 5 6 7 8 9 10 11 12 **13** 14 15 16 17 18 19 20 21 22 23 24 25 26 27 28 29

FEBRUARY

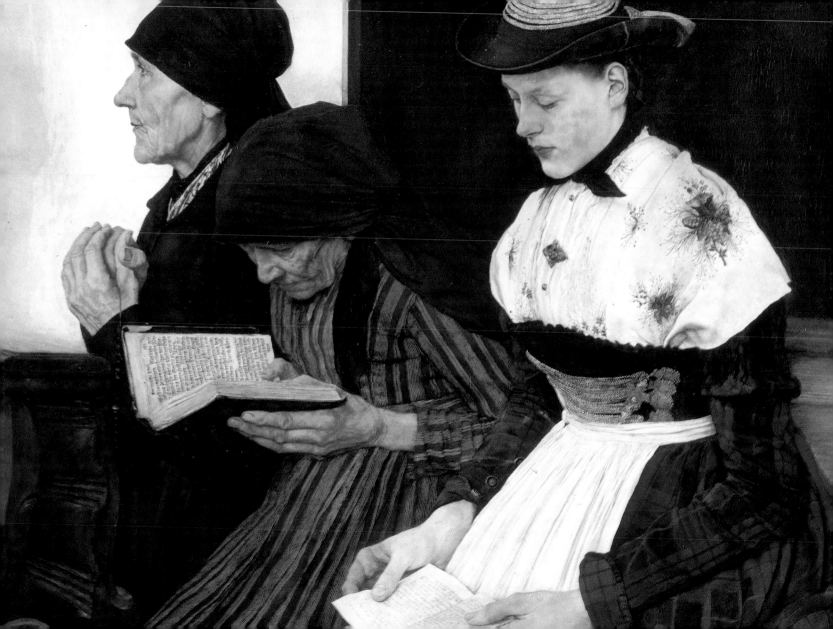

Over the winter glaciers,
I see the summer glow,
And, through the wild-piled snowdrift,
The warm rosebuds below.

<small>RALPH WALDO EMERSON</small>

Winter Landscape, 1610
Denis van Alsloot
Musée du Louvre, Paris

1 2 3 4 5 6 7 8 9 10 11 12 13 **14** 15 16 17 18 19 20 21 22 23 24 25 26 27 28 29

FEBRUARY

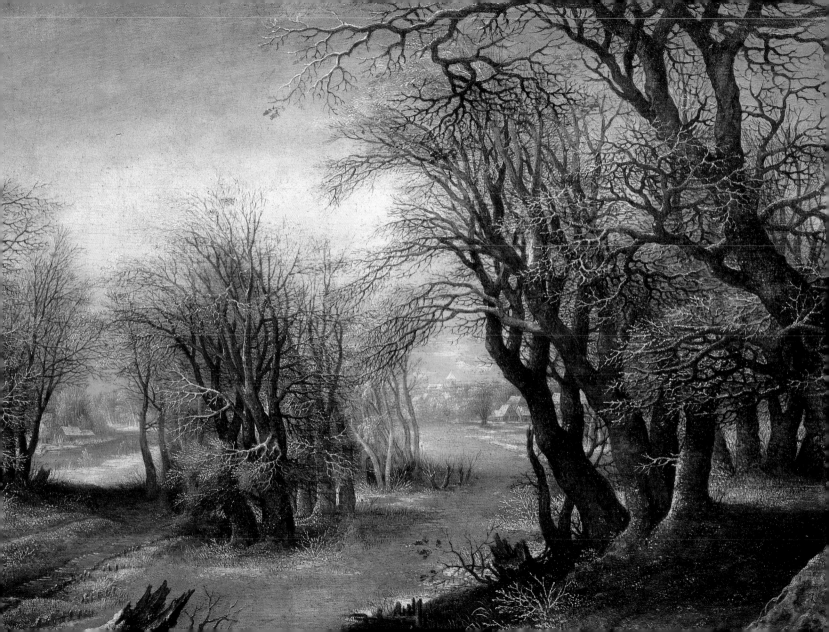

What are Raphael's Madonnas
but the shadow of a mother's love,
fixed in permanent outline forever?

THOMAS WENTWORTH

Sistine Madonna, c. 1513
Raphael
Gemäldegalerie, Dresden

1 2 3 4 5 6 7 8 9 10 11 12 13 14 **15** 16 17 18 19 20 21 22 23 24 25 26 27 28 29

FEBRUARY

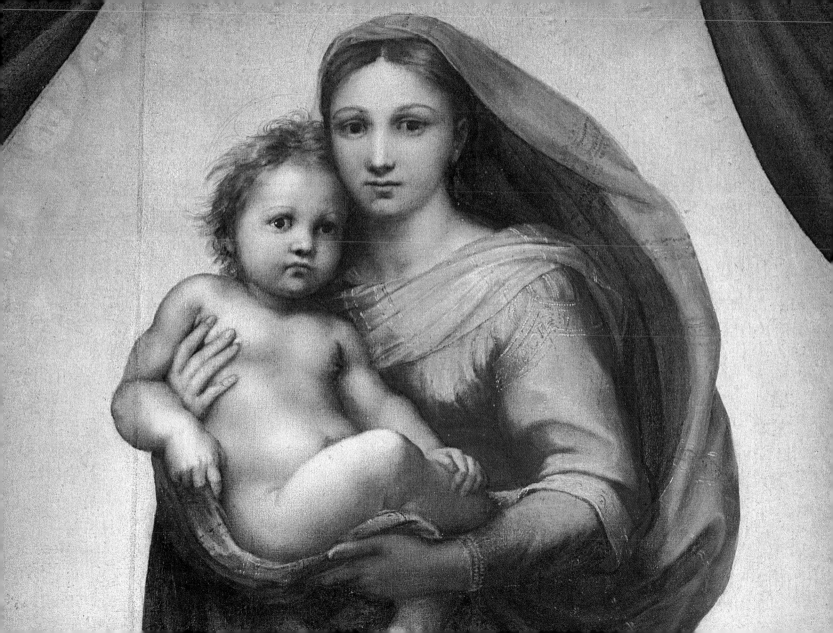

Color is the key. The eye is the hammer.
The soul is the piano with its many chords.
The artist is the hand that, by touching
this or that key, sets the soul vibrating
automatically.

WASSILY KANDINSKY

Study for Composition VII (Draft 3), 1913
Wassily Kandinsky
Lenbachhaus, Munich

1 2 3 4 5 6 7 8 9 10 11 12 13 14 15 **16** 17 18 19 20 21 22 23 24 25 26 27 28 29

FEBRUARY

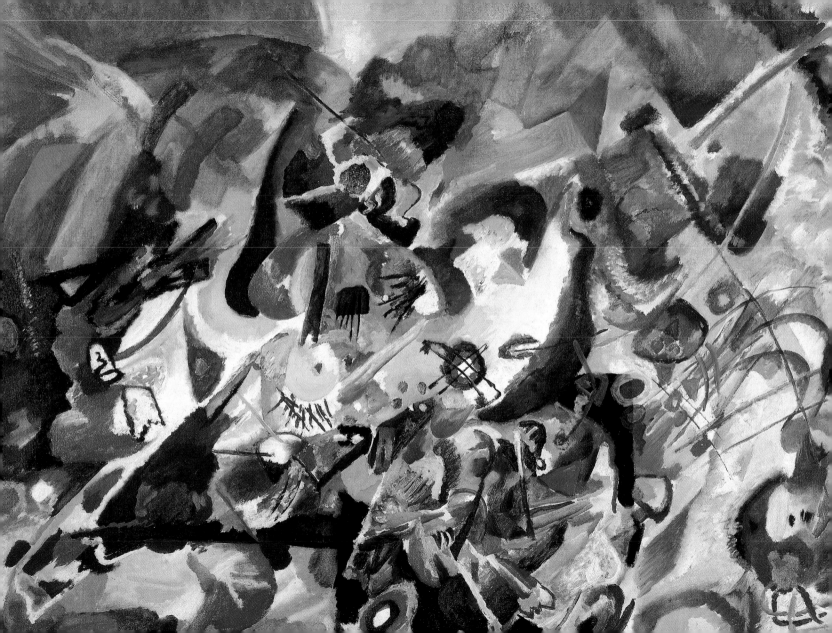

To pass their lives on fountains and on flowers,
and never know the weight of human hours.

LORD BYRON

Dance of the Elves, 1844
Moritz von Schwind
Städel Museum, Frankfurt

1 2 3 4 5 6 7 8 9 10 11 12 13 14 15 16 **17** 18 19 20 21 22 23 24 25 26 27 28 29

FEBRUARY

*The merit of originality is not novelty,
it is sincerity. The believing man is the
original man.*

Thomas Carlyle

Golconda, 1953
René Magritte
The Menil Collection, Houston

1 2 3 4 5 6 7 8 9 10 11 12 13 14 15 16 17 **18** 19 20 21 22 23 24 25 26 27 28 29

FEBRUARY

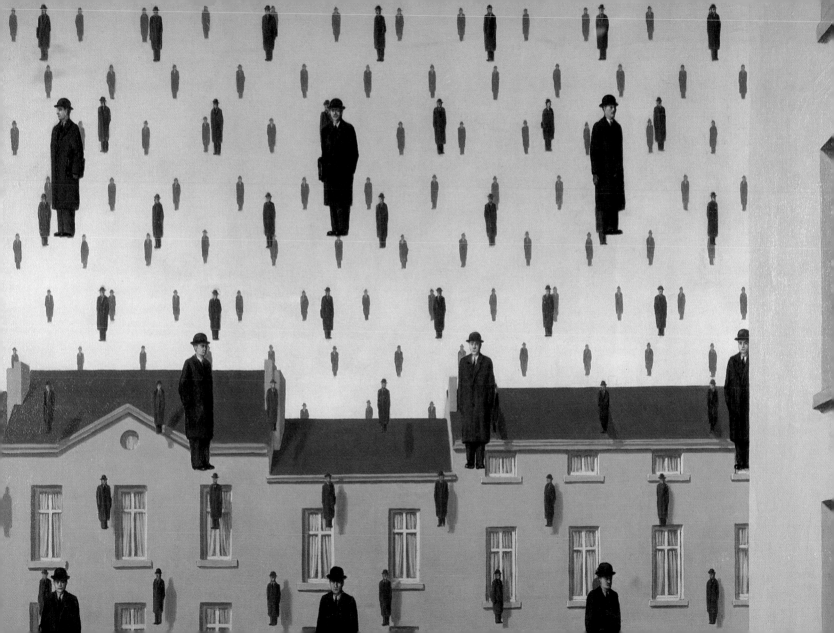

The best part of beauty is that which no picture can express.

The Judgment of Paris, 1638–39
Peter Paul Rubens
Museo Nacional del Prado, Madrid

1 2 3 4 5 6 7 8 9 10 11 12 13 14 15 16 17 18 **19** 20 21 22 23 24 25 26 27 28 29

FEBRUARY

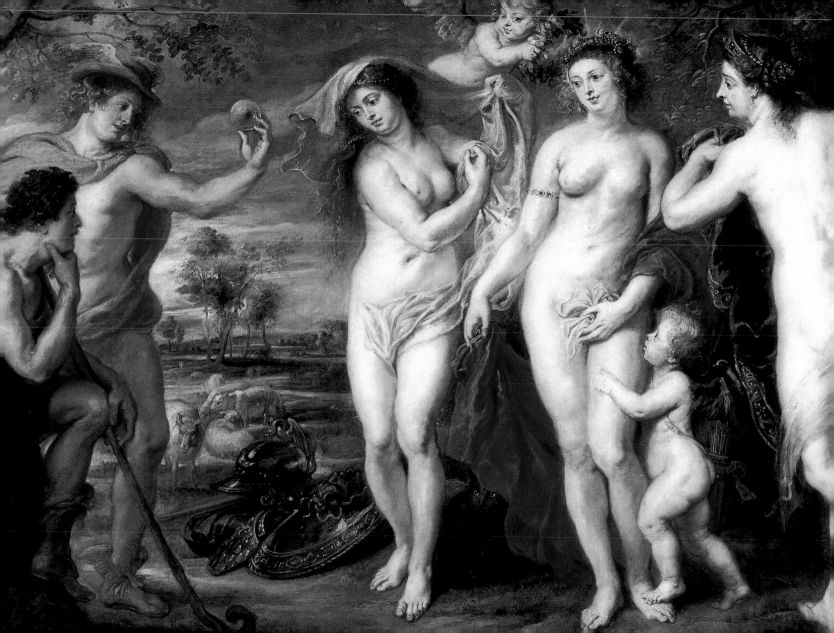

Every portrait that is painted with feeling is a portrait of the artist, not of the sitter.

Oscar Wilde

Painter and Model, 1963
Pablo Picasso
Pinakothek der Moderne, Munich

1 2 3 4 5 6 7 8 9 10 11 12 13 14 15 16 17 18 19 **20** 21 22 23 24 25 26 27 28 29

FEBRUARY

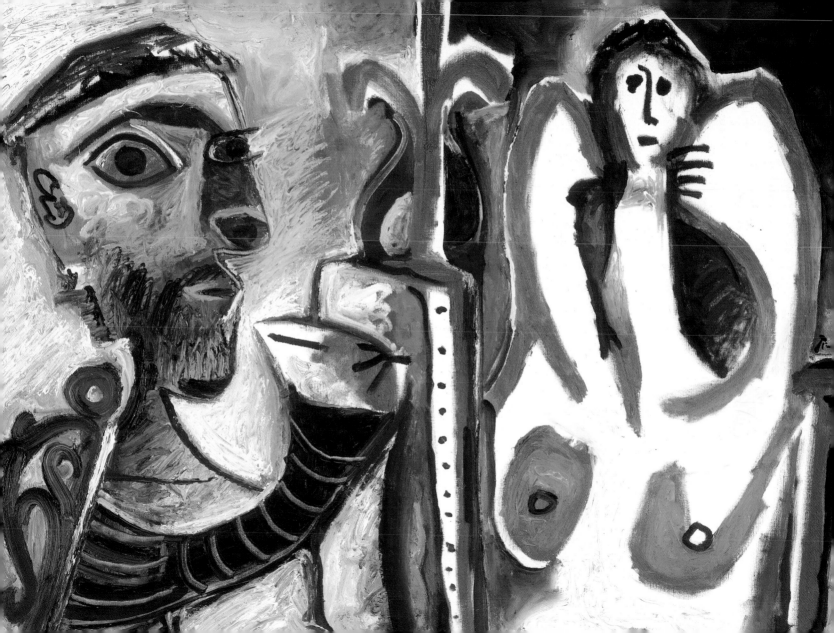

Peace hath higher tests of manhood than battle ever knew.

JOHN GREENLEAF WHITTIER

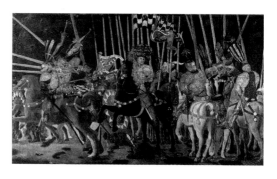

The Battle of San Romeano, 15th century
Paolo Uccello
Musée du Louvre, Paris

1 2 3 4 5 6 7 8 9 10 11 12 13 14 15 16 17 18 19 20 **21** 22 23 24 25 26 27 28 29

FEBRUARY

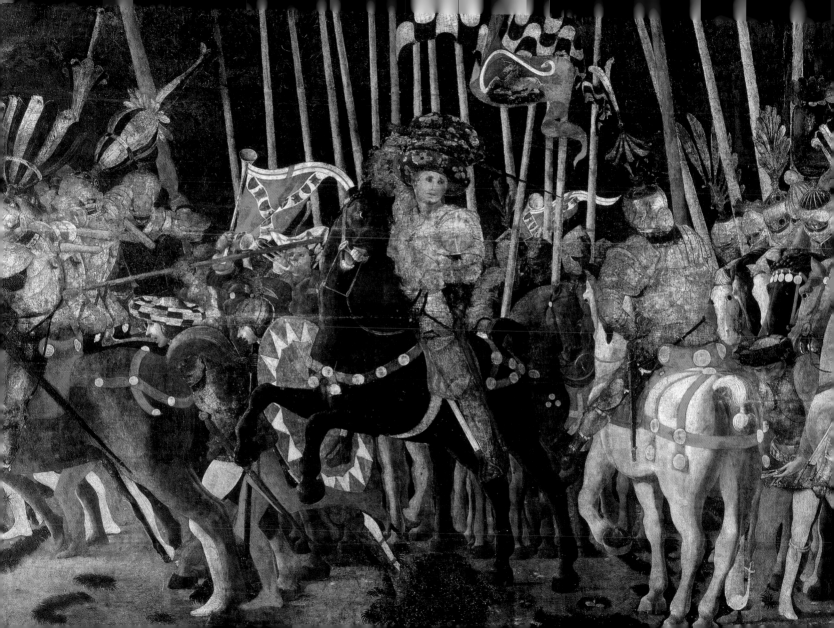

I believe that our Heavenly Father invented man because he was disappointed in the monkey.

<small>MARK TWAIN</small>

Monkeys as Judges of Art, *c.* 1889
Gabriel von Max
Neue Pinakothek, Munich

1 2 3 4 5 6 7 8 9 10 11 12 13 14 15 16 17 18 19 20 21 **22** 23 24 25 26 27 28 29

FEBRUARY

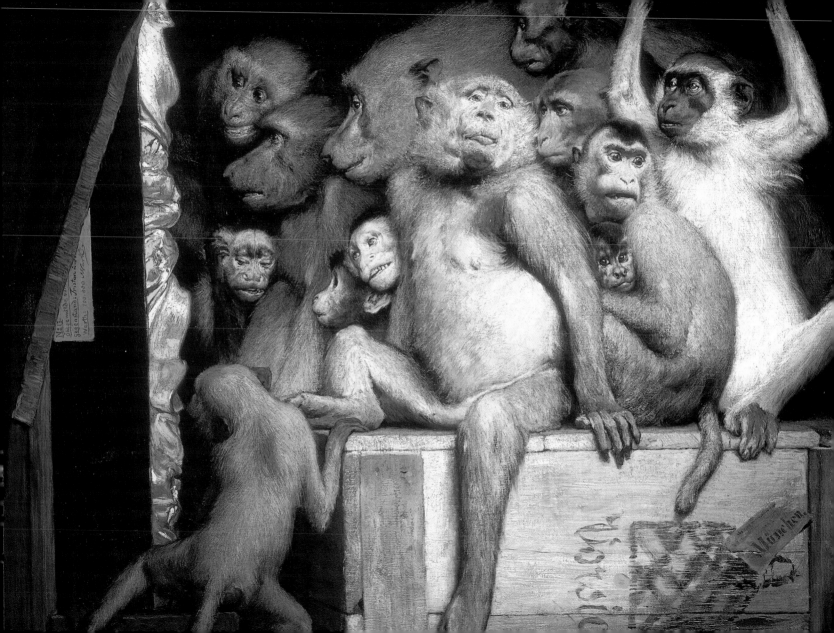

Vision is the art of seeing the invisible.

Allegory of Vision, early 17th century
Jan Brueghel the Elder, with Peter Paul Rubens
Museo Nacional del Prado, Madrid

1 2 3 4 5 6 7 8 9 10 11 12 13 14 15 16 17 18 19 20 21 22 **23** 24 25 26 27 28 29

FEBRUARY

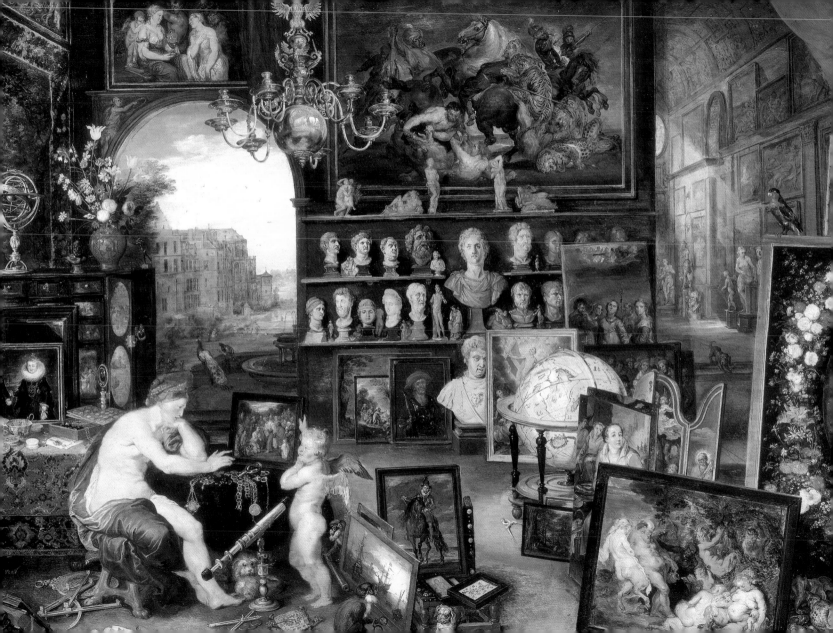

*The greatest danger for most of us
is not that our aim is too high and we miss it,
but that it is too low and we reach it.*

MICHELANGELO

**The Delphic Sybil
(Detail from the Ceiling of the Sistine Chapel),**
1508–12
Michelangelo
Vatican Museum, Vatican City

1 2 3 4 5 6 7 8 9 10 11 12 13 14 15 16 17 18 19 20 21 22 23 **24** 25 26 27 28 29

FEBRUARY

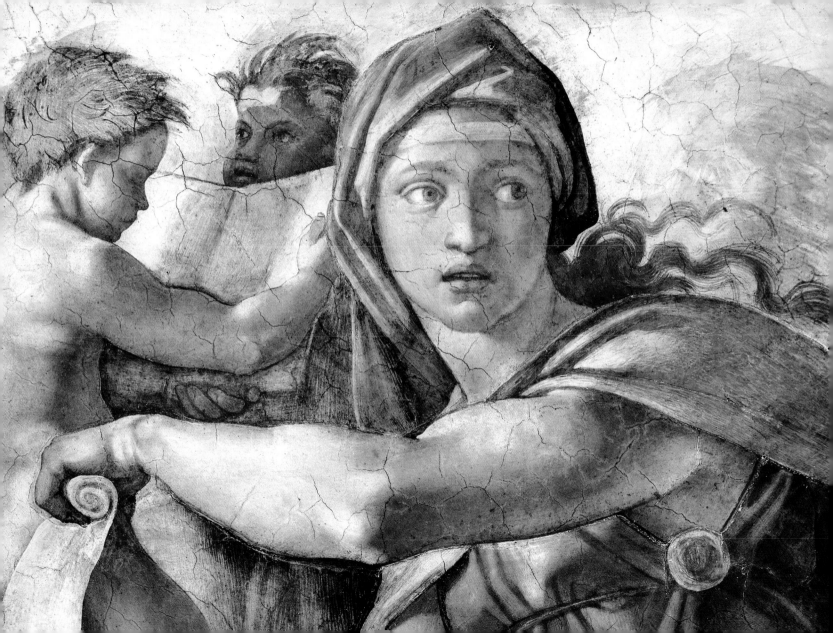

*The purest ore is produced
from the hottest furnace,
and the brightest thunderbolt
is elicited from the darkest storms.*

CHARLES CALEB COLTON

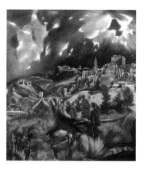

Storm over Toledo, *c.* 1595–1610
El Greco
The Metropolitan Museum of Art, New York

1 2 3 4 5 6 7 8 9 10 11 12 13 14 15 16 17 18 19 20 21 22 23 24 **25** 26 27 28 29

FEBRUARY

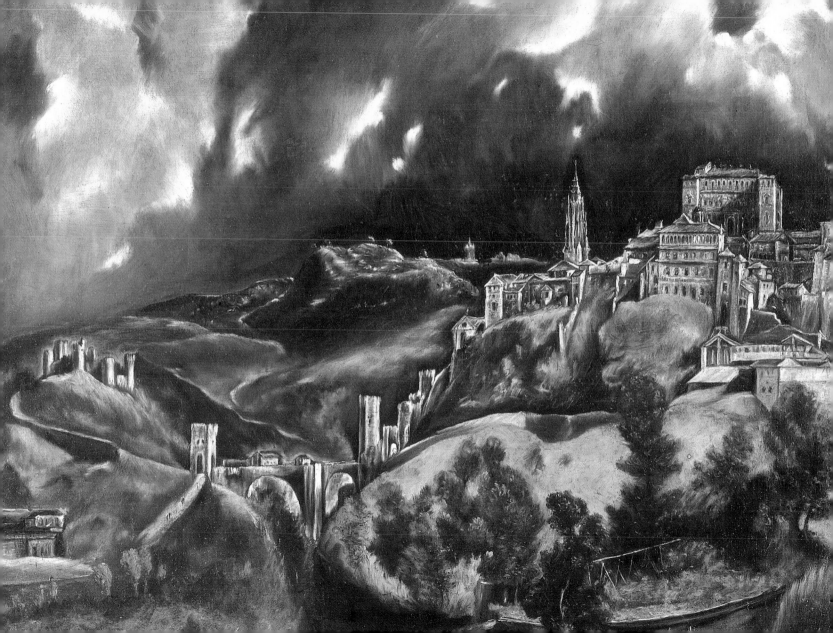

Treat people as if they were what they ought to be and you help them to become what they are capable of being.

JOHANN WOLFGANG VON GOETHE

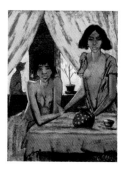

Gypsies with Cat, 1927
Otto Mueller
Museum Ludwig, Cologne

1 2 3 4 5 6 7 8 9 10 11 12 13 14 15 16 17 18 19 20 21 22 23 24 25 **26** 27 28 29

FEBRUARY

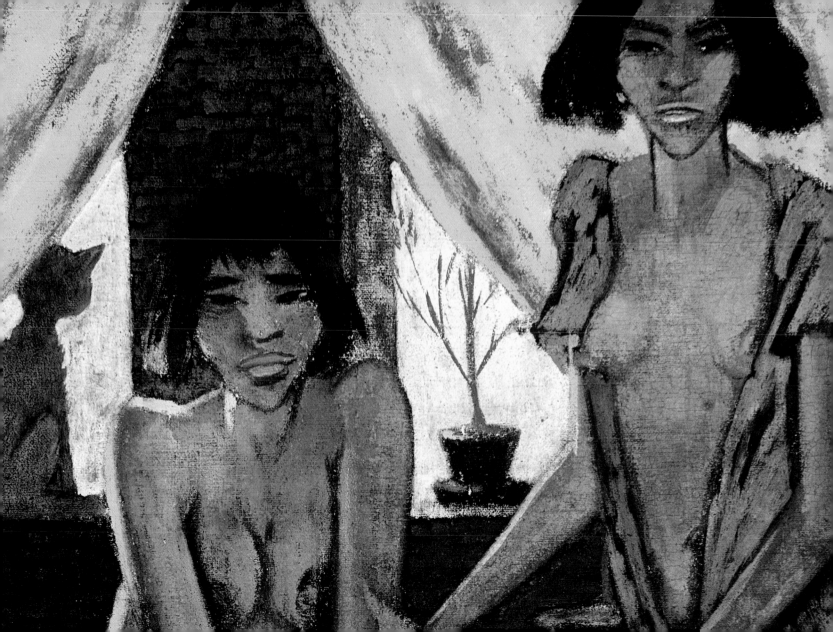

*We build too many walls
and not enough bridges.*

The Devil's Bridge, *c.* 1830
Carl Blechen
Neue Pinakothek, Munich

1 2 3 4 5 6 7 8 9 10 11 12 13 14 15 16 17 18 19 20 21 22 23 24 25 26 **27** 28 29

FEBRUARY

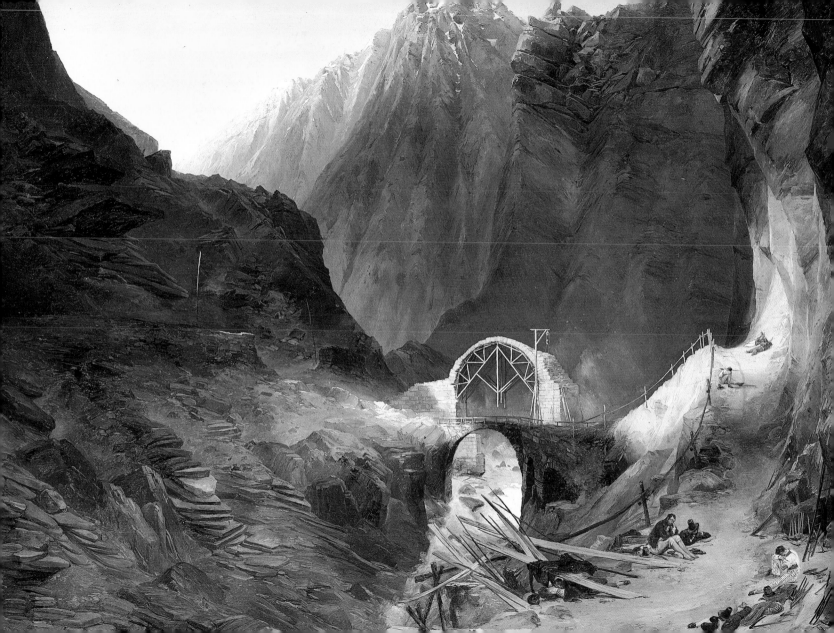

Small cheer and great welcome make a merry feast.

WILLIAM SHAKESPEARE

Supper Party, early 17th century
Gerrit van Honthorst
Uffizi Gallery, Florence

1 2 3 4 5 6 7 8 9 10 11 12 13 14 15 16 17 18 19 20 21 22 23 24 25 26 27 **28/29**

FEBRUARY

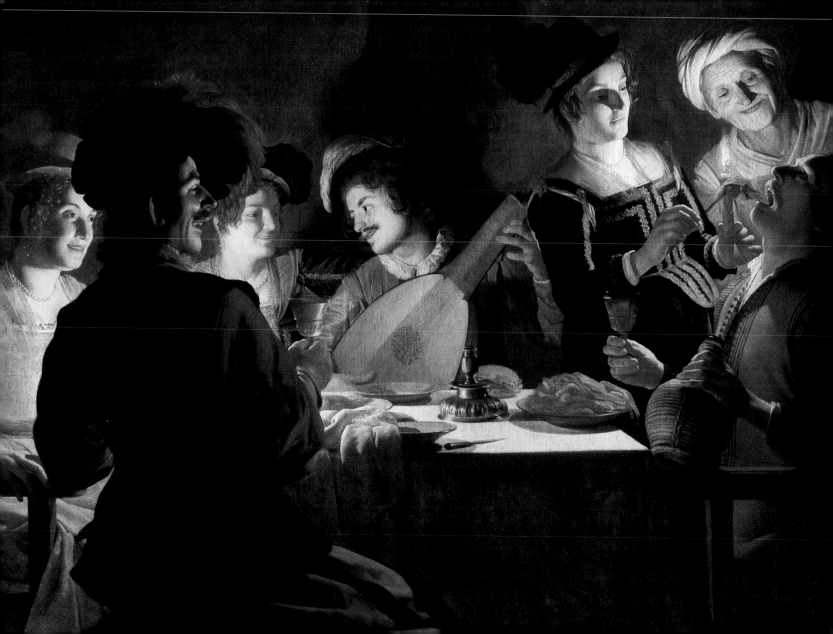

Art evokes the mystery without which the world would not exist.

RENÉ MAGRITTE

The Traveler, 1937
René Magritte
Private Collection

1 2 3 4 5 6 7 8 9 10 11 12 13 14 15 16 17 18 19 20 21 22 23 24 25 26 27 28 29 30 31

MARCH

Beauty and Grace command the world.

Park Benjamin

Triumph of Galatea, 1512
Raphael
Villa Farnesina, Rome

1 2 3 4 5 6 7 8 9 10 11 12 13 14 15 16 17 18 19 20 21 22 23 24 25 26 27 28 29 30 31

MARCH

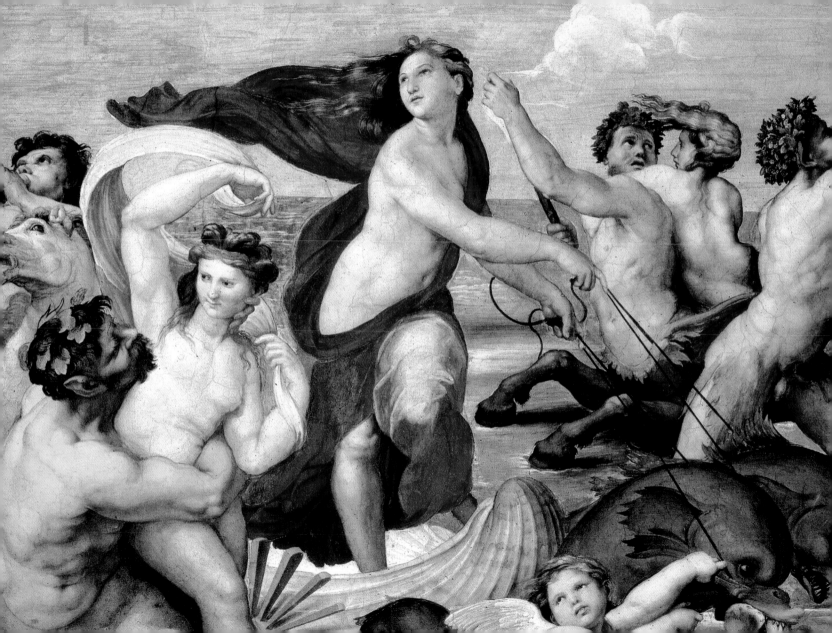

A man who has not been in Italy,
is always conscious of an inferiority,
from his not having seen what is expected
a man should see.

<small>SAMUEL JOHNSON</small>

View of the Canal Grande from Palazzo Balbi, 18th century
Canaletto
Museo del Settecento Veneziano

1 2 **3** 4 5 6 7 8 9 10 11 12 13 14 15 16 17 18 19 20 21 22 23 24 25 26 27 28 29 30 31

MARCH

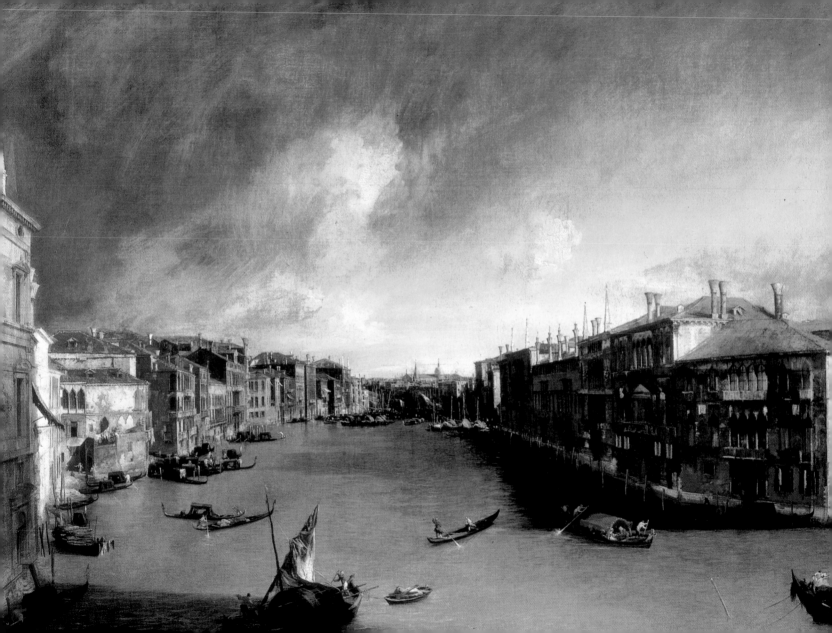

Society is a masked ball,
where everyone hides his real character,
and reveals it by hiding.

RALPH WALDO EMERSON

A Corner in the Moulin de la Galette, 1892
Henri de Toulouse-Lautrec
National Gallery of Art, Washington

1 2 3 **4** 5 6 7 8 9 10 11 12 13 14 15 16 17 18 19 20 21 22 23 24 25 26 27 28 29 30 31

MARCH

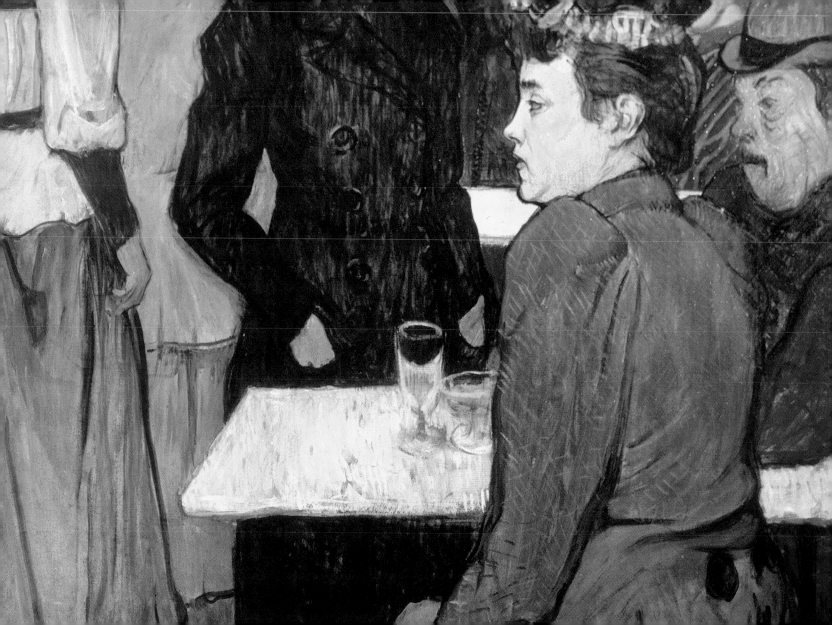

*Successful leaders have the courage
to take action where others hesitate.*

ANON.

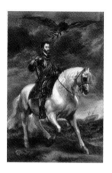

Horseback Portrait of Charles V, early 17th century
Anthonis van Dyck
Uffizi Gallery, Florence

1 2 3 4 **5** 6 7 8 9 10 11 12 13 14 15 16 17 18 19 20 21 22 23 24 25 26 27 28 29 30 31

MARCH

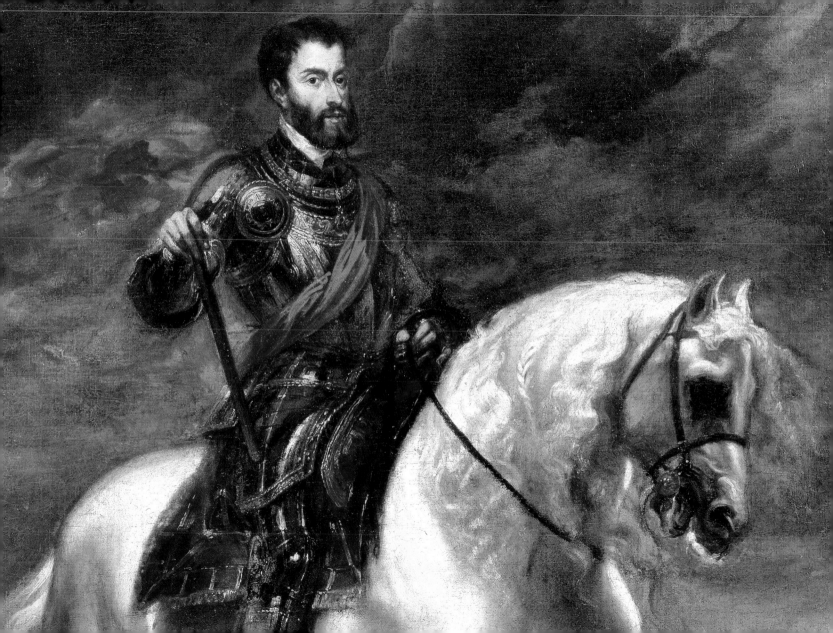

Every poet ... finds himself born in the midst of prose. He has to struggle from the littleness and obstruction of an actual world into the freedom and infinitude of an ideal.

THOMAS CARLYLE

The Poor Poet, 1839
Carl Spitzweg
Neue Pinakothek, Munich

1 2 3 4 5 **6** 7 8 9 10 11 12 13 14 15 16 17 18 19 20 21 22 23 24 25 26 27 28 29 30 31

MARCH

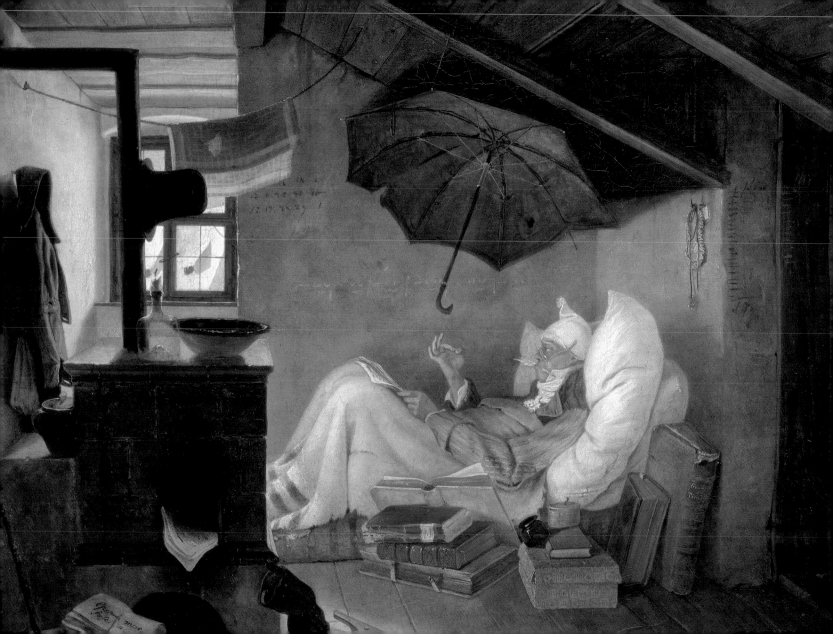

Paint the essential character of things.

<small>CAMILLE PISSARRO</small>

View of Pontoise, 1868
Camille Pissarro
Kunsthalle, Mannheim

1 2 3 4 5 6 **7** 8 9 10 11 12 13 14 15 16 17 18 19 20 21 22 23 24 25 26 27 28 29 30 31

MARCH

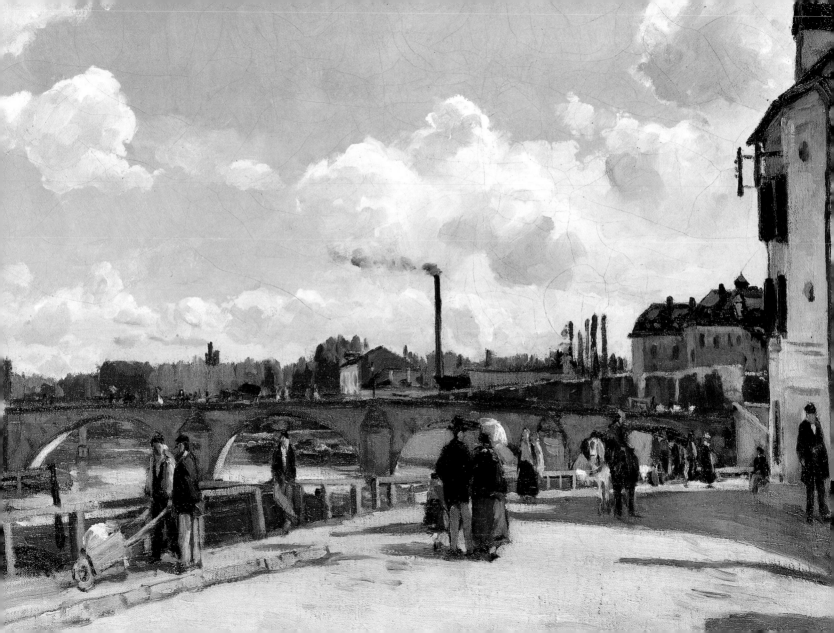

*The subtlety of nature is greater
many times over than the subtlety
of the senses and understanding.*

SIR FRANCIS BACON

Allegory of the Five Senses, 1668
Gérard de Lairesse
Kelvingrove Museum, Glasgow

8

1 2 3 4 5 6 7 **8** 9 10 11 12 13 14 15 16 17 18 19 20 21 22 23 24 25 26 27 28 29 30 31

MARCH

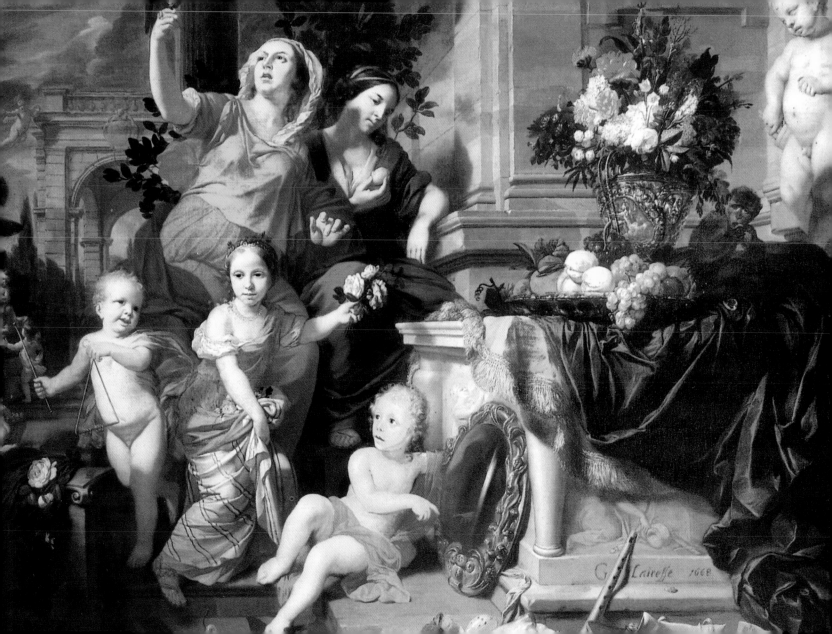

The images of men's wits and knowledge remain in books, exempted from the worry of time and capable of perpetual renovation.

SIR FRANCIS BACON

Job Lot Cheap, 1892
John Frederick Peto
Fine Art Museums of San Francisco

1 2 3 4 5 6 7 8 **9** 10 11 12 13 14 15 16 17 18 19 20 21 22 23 24 25 26 27 28 29 30 31

MARCH

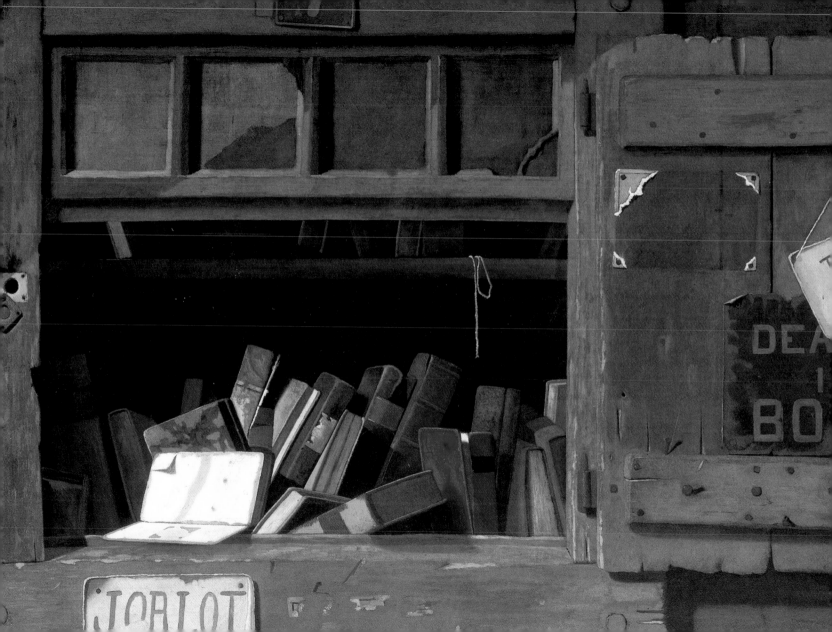

Thy birth, O Virgin Mother of God,
heralded joy to all the world.
For from thee arose the Sun of justice,
Christ our God.

FROM THE DIVINE OFFICE, MATINS

The Birth of Mary, 1520
Albrecht Altdorfer
Alte Pinakothek, Munich

1 2 3 4 5 6 7 8 9 **10** 11 12 13 14 15 16 17 18 19 20 21 22 23 24 25 26 27 28 29 30 31

MARCH

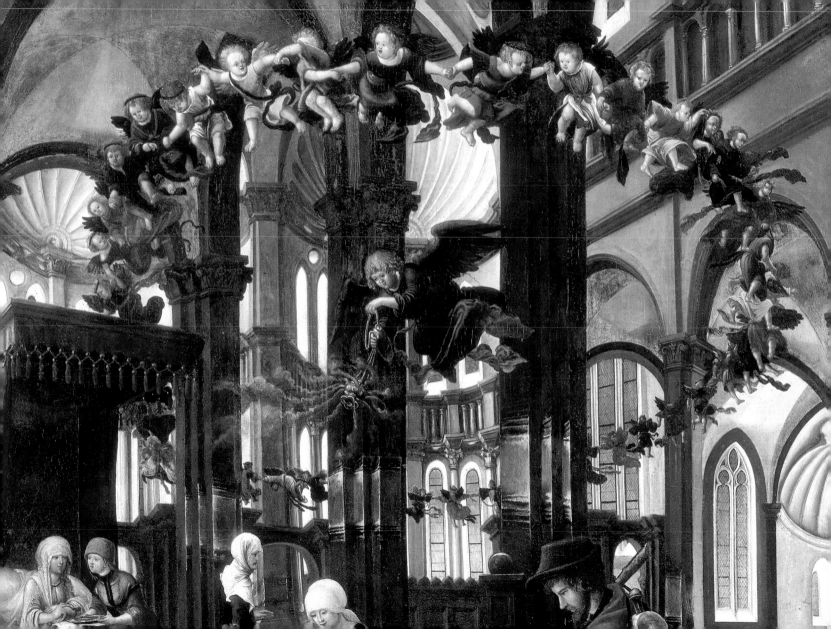

If any thing is sacred
the human body is sacred.

<small>WALT WHITMAN</small>

Woman Lying on Violet Background, 1924
Félix Vallotton
Kunsthalle, Bremen

1 2 3 4 5 6 7 8 9 10 **11** 12 13 14 15 16 17 18 19 20 21 22 23 24 25 26 27 28 29 30 31

MARCH

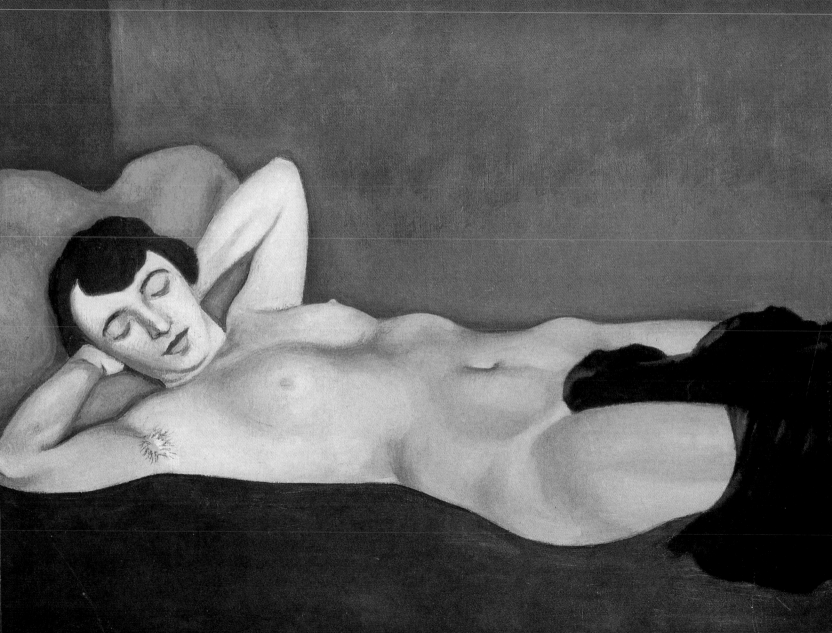

Let others praise ancient times.
I am glad I was born in these.

Exedra, Curved Bench next to a Roman House, 1871
Sir Lawrence Alma-Tadema
Christie's, New York

1 2 3 4 5 6 7 8 9 10 11 **12** 13 14 15 16 17 18 19 20 21 22 23 24 25 26 27 28 29 30 31

MARCH

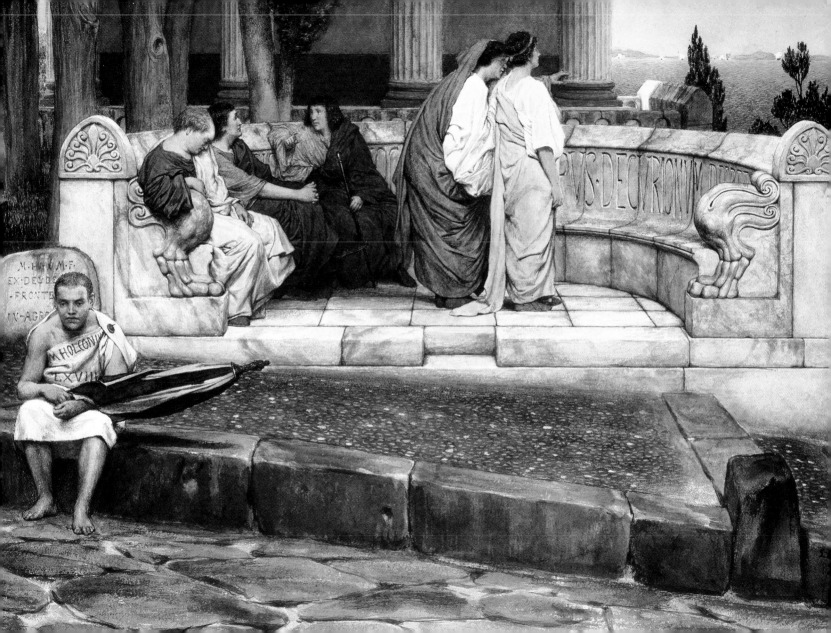

'Tis beautiful, when first the dewy light
Breaks on the earth!
While yet the scented air
Is breathing the cool freshness of the night
And the bright clouds a tint of crimson wear.

ELIZABETH MARGARET CHANDLER

Harbor with the Rising Sun, 1674
Claude Lorrain
Alte Pinakothek, Munich

1 2 3 4 5 6 7 8 9 10 11 12 **13** 14 15 16 17 18 19 20 21 22 23 24 25 26 27 28 29 30 31

MARCH

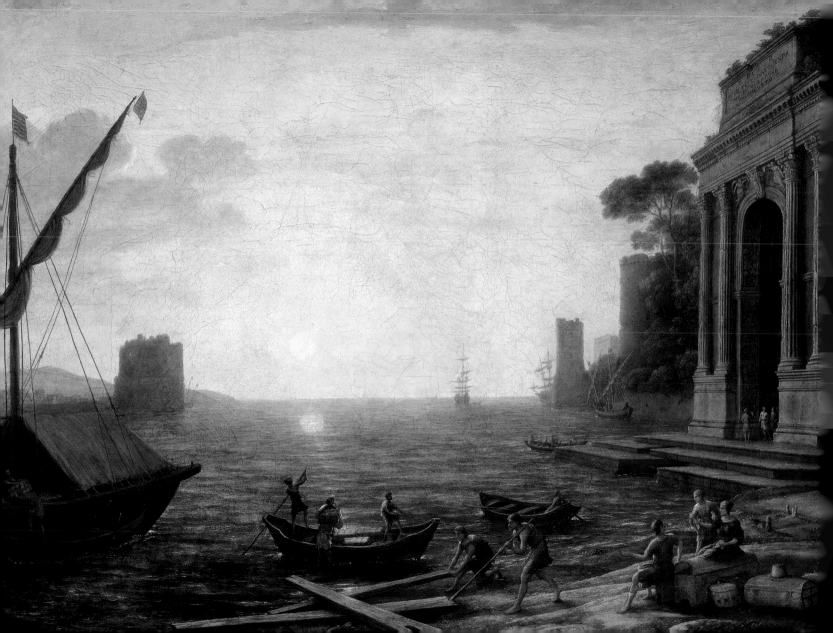

Learning is not attained by chance,
it must be sought for with ardor
and attended to with diligence.

ABIGAIL ADAMS

The Scholar (or The Old Rabbi), 1634
Rembrandt van Rijn
National Gallery, Prague

1 2 3 4 5 6 7 8 9 10 11 12 13 **14** 15 16 17 18 19 20 21 22 23 24 25 26 27 28 29 30 31

MARCH

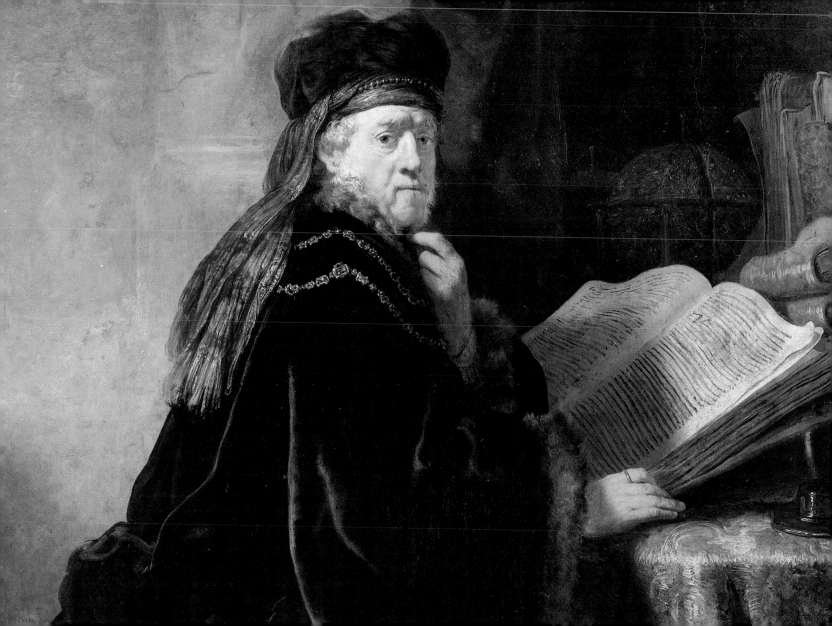

Everything you can imagine is real.

The Studio, 1928
Pablo Picasso
The Museum of Modern Art, New York

1 2 3 4 5 6 7 8 9 10 11 12 13 14 **15** 16 17 18 19 20 21 22 23 24 25 26 27 28 29 30 31

MARCH

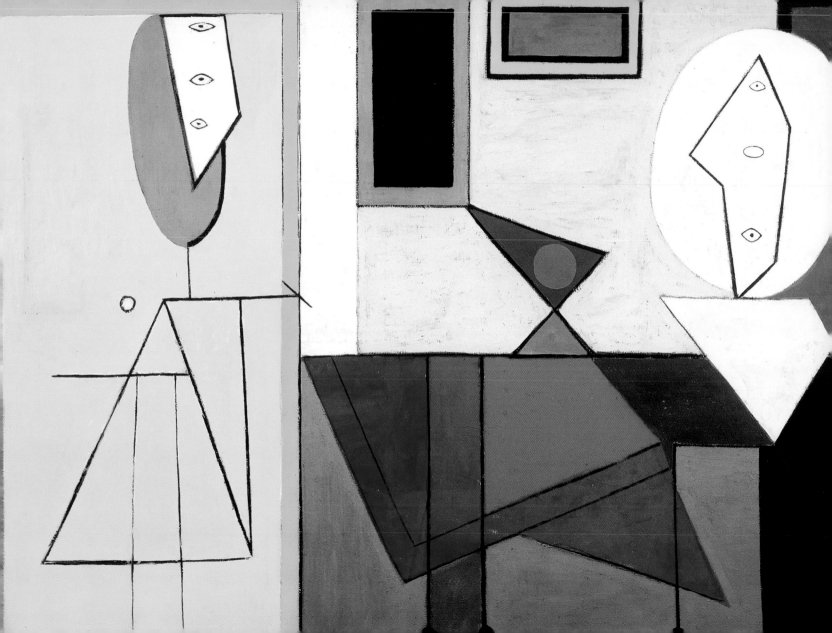

We all have our playthings.
Happy are those who are contented with
those they can obtain.

LADY MARY WORTLEY MONTAGU

The House of Cards, 19th century
Charles Hunt
Forbes Collection, New York

1 2 3 4 5 6 7 8 9 10 11 12 13 14 15 **16** 17 18 19 20 21 22 23 24 25 26 27 28 29 30 31

MARCH

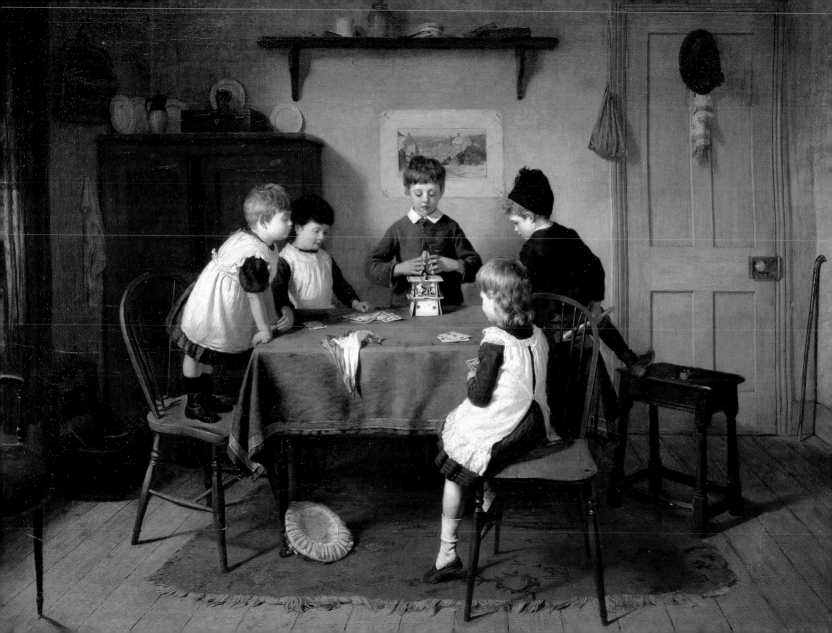

To rejoice in the prosperity of another is to partake of it.

<small>WILLIAM AUSTIN</small>

Still Life with Fruit, c. 1635
Balthasar van der Ast
Alte Pinakothek, Munich

1 2 3 4 5 6 7 8 9 10 11 12 13 14 15 16 **17** 18 19 20 21 22 23 24 25 26 27 28 29 30 31

MARCH

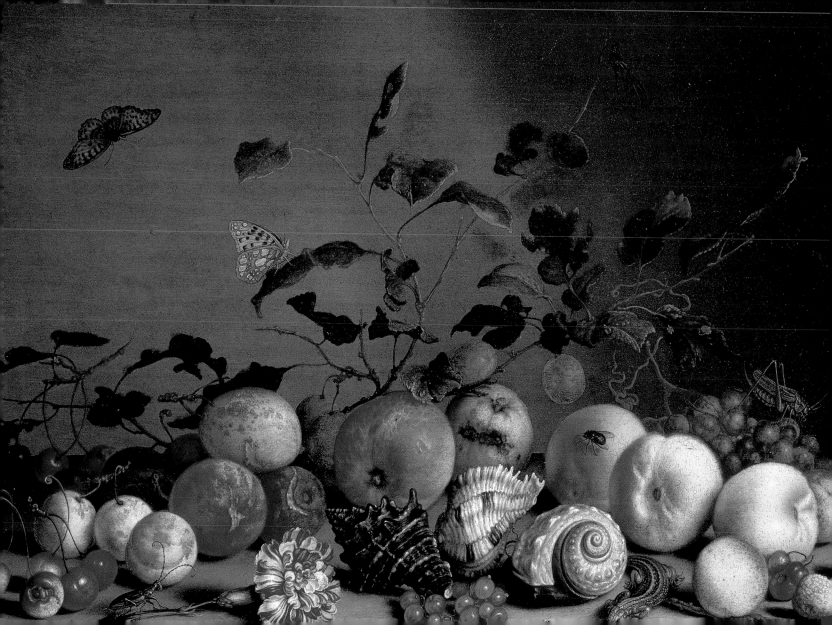

And when the daughter of the same Herodias had come in, and had danced, and pleased Herod … the king said to the damsel: ask of me what thou wilt, and I will give it thee.

THE GOSPEL OF ST. MARK, 6:22

The Feast of Herod, late 16th or early 17th century
Peter Paul Rubens
National Gallery, Edinburgh

1 2 3 4 5 6 7 8 9 10 11 12 13 14 15 16 17 **18** 19 20 21 22 23 24 25 26 27 28 29 30 31

MARCH

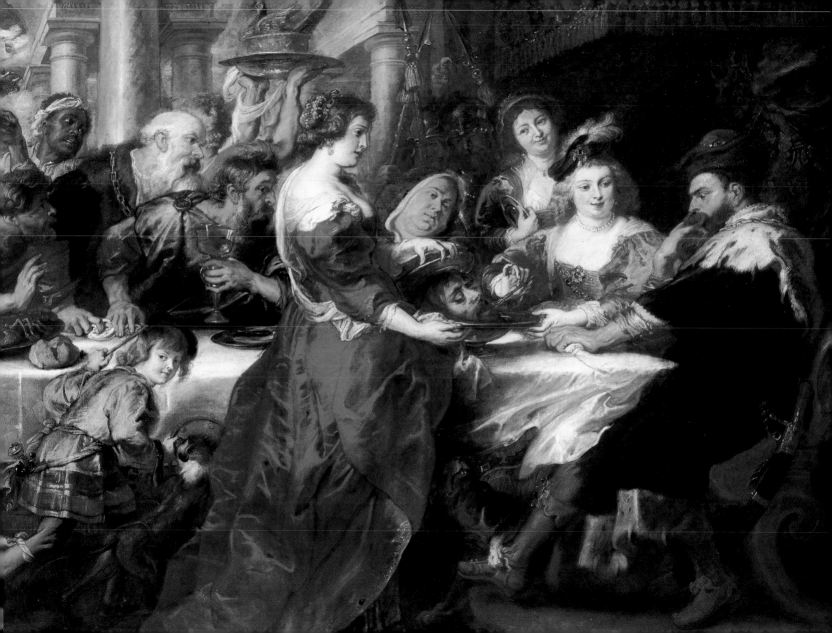

A dreamer lives for eternity.

Glimpse into Eternity, 1916
Ferdinand Hodler
Kunstmuseum, Winterthur

1 2 3 4 5 6 7 8 9 10 11 12 13 14 15 16 17 18 **19** 20 21 22 23 24 25 26 27 28 29 30 31

MARCH

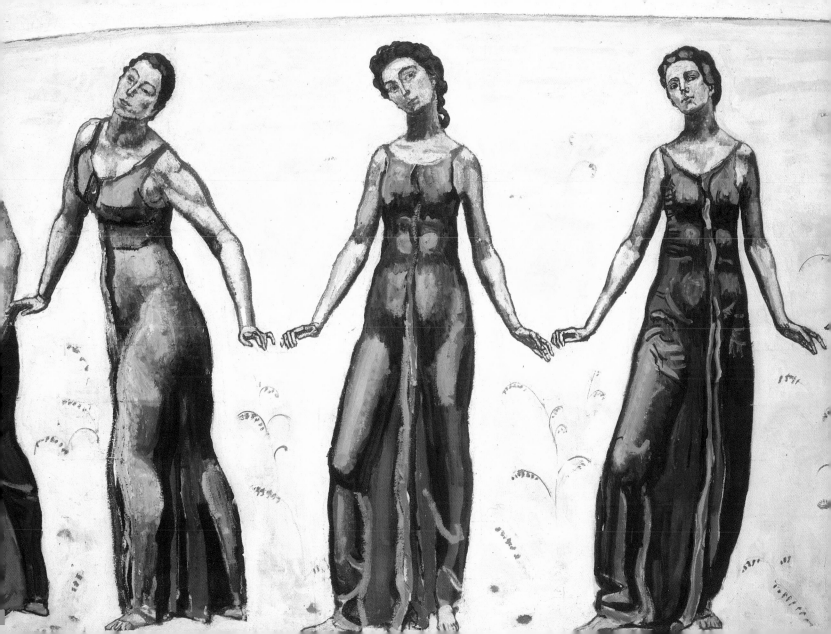

Justice extorts no reward, no kind of price.
She is sought, therefore, for her own sake.

<small>CICERO</small>

Portrait of a Warrior and a Stableboy,
late 15th or early 16th century
Giorgione
Uffizi Gallery, Florence

1 2 3 4 5 6 7 8 9 10 11 12 13 14 15 16 17 18 19 **20** 21 22 23 24 25 26 27 28 29 30 31

MARCH

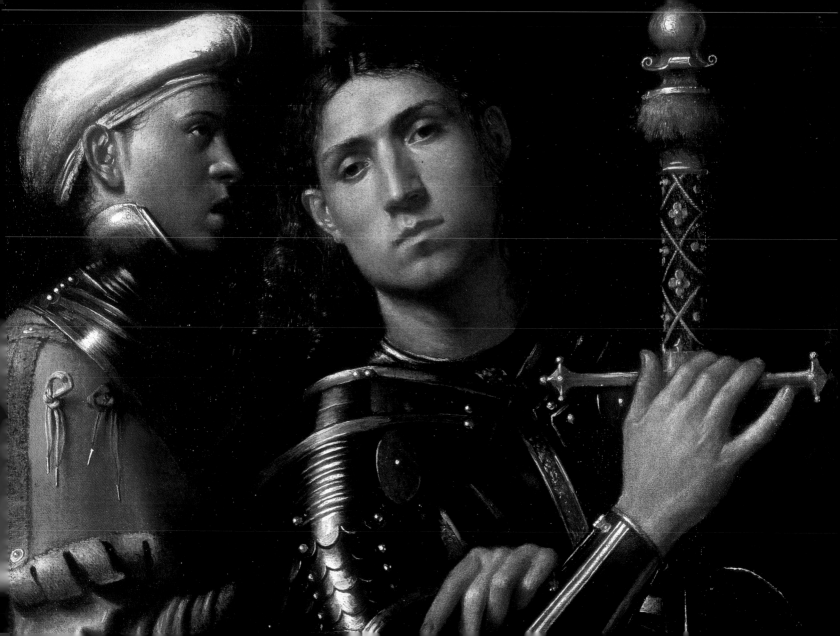

Half our life is spent trying to find something to do with the time we have rushed through life trying to save.

WILL ROGERS

The Derby in Epsom, 1821
Théodore Géricault
Musée du Louvre, Paris

1 2 3 4 5 6 7 8 9 10 11 12 13 14 15 16 17 18 19 20 **21** 22 23 24 25 26 27 28 29 30 31

MARCH

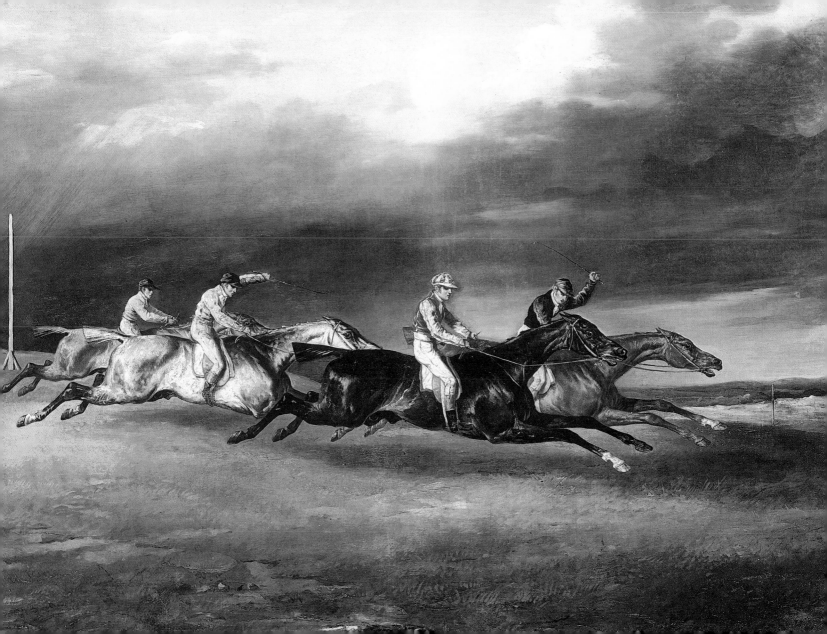

Dancing is the poetry of the foot.

JOHN DRYDEN

Farm Dance, *c.* 1568
Pieter Brueghel the Elder
Kunsthistorisches Museum, Vienna

1 2 3 4 5 6 7 8 9 10 11 12 13 14 15 16 17 18 19 20 21 **22** 23 24 25 26 27 28 29 30 31

MARCH

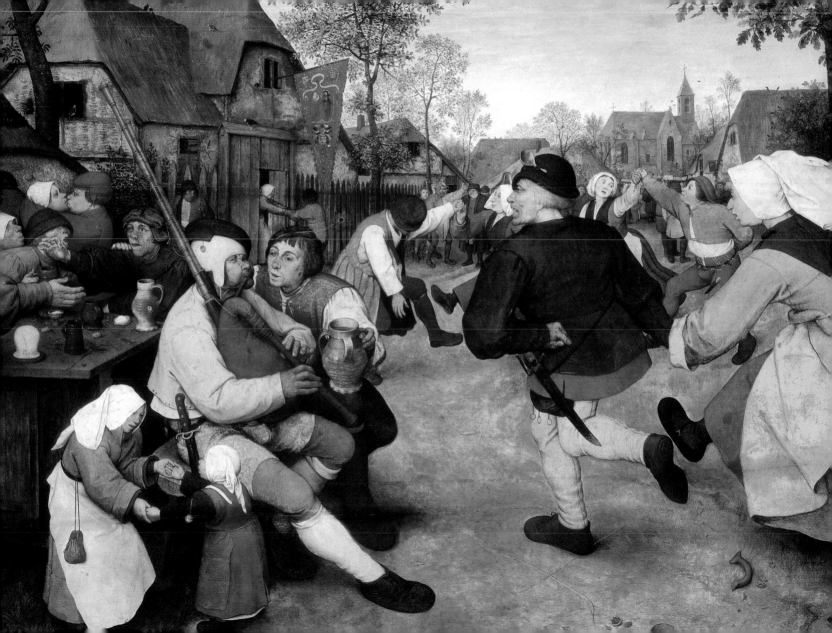

Good judgment comes from experience.
Experience comes from bad judgment.

Anon.

The Drinker, *c.* 1680
Adriaen van Ostade
Frans Hals Museum, Haarlem

1 2 3 4 5 6 7 8 9 10 11 12 13 14 15 16 17 18 19 20 21 22 **23** 24 25 26 27 28 29 30 31

MARCH

Unity, agreement, is always silent or soft-voiced. It is only discord that loudly proclaims itself.

THOMAS CARLYLE

The Concert of Birds, c. 1630
Frans Snyders
The State Hermitage Museum, St. Petersburg

1 2 3 4 5 6 7 8 9 10 11 12 13 14 15 16 17 18 19 20 21 22 23 **24** 25 26 27 28 29 30 31

MARCH

Then the angel said to her, "Do not be afraid, Mary, for you have found favor with God. Behold, you will conceive in your womb and bear a son, and you shall name him Jesus."

THE GOSPEL OF ST. LUKE, 1:30-31

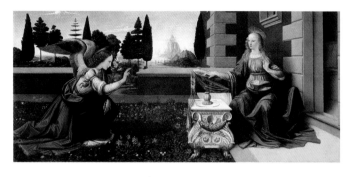

The Annunciation, 1472–75
Leonardo da Vinci
Uffizi Gallery, Florence

1 2 3 4 5 6 7 8 9 10 11 12 13 14 15 16 17 18 19 20 21 22 23 24 **25** 26 27 28 29 30 31

MARCH

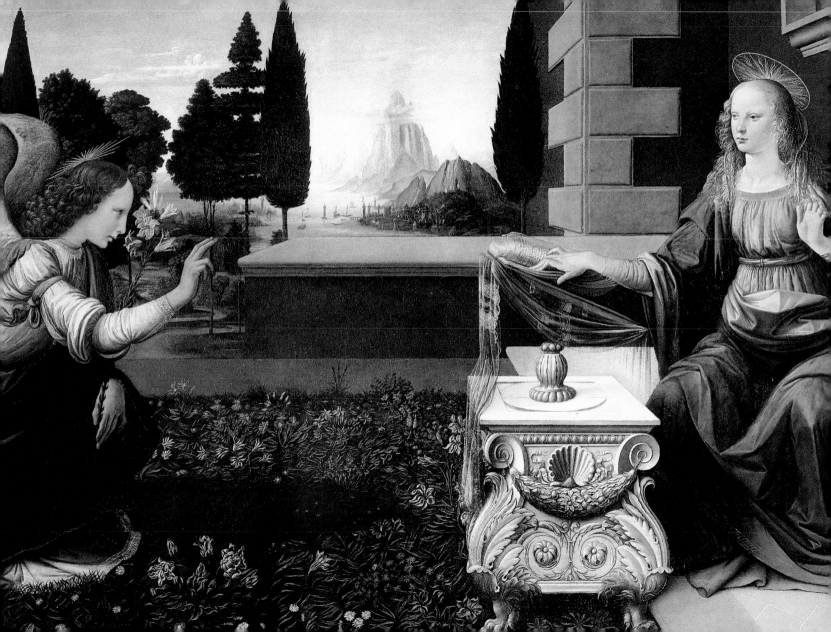

For me, it is only the surrounding atmosphere which gives subjects their true value.

The Waterloo Bridge in Haze, 1903
Claude Monet
The State Hermitage Museum, St. Petersburg

1 2 3 4 5 6 7 8 9 10 11 12 13 14 15 16 17 18 19 20 21 22 23 24 25 **26** 27 28 29 30 31

MARCH

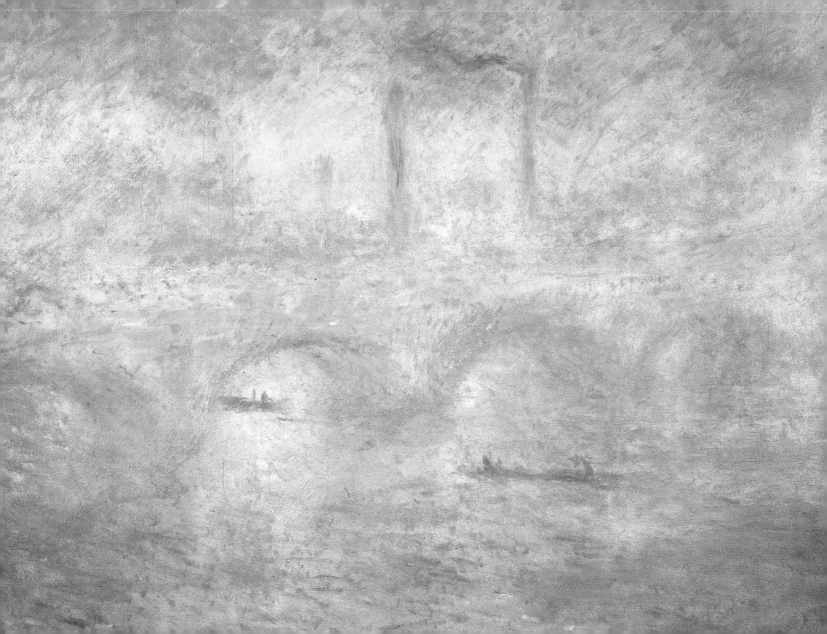

Her cheek had the pale pearly pink
Of sea shells, the world's sweetest tint, as though
She lived, one-half might deem, on roses sopp'd
In pearly dew.

PHILIP JAMES BAILEY

Françoise Renée, Marquise d'Antin, 1738
Jean Marc Nattier
Musée Jacquemart-André, Paris

1 2 3 4 5 6 7 8 9 10 11 12 13 14 15 16 17 18 19 20 21 22 23 24 25 26 **27** 28 29 30 31

MARCH

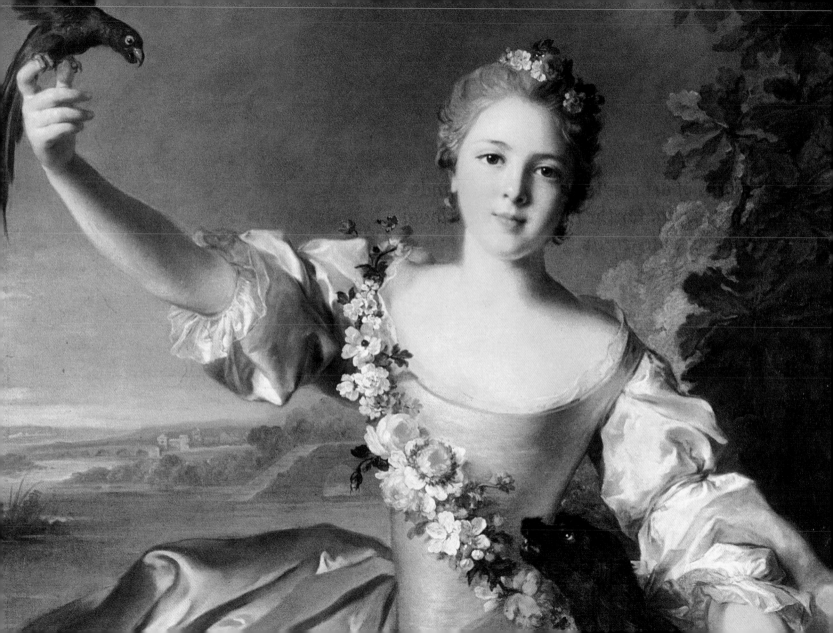

All works of art created by truthful minds
without regard for the work's conventional
exterior remain genuine for all times.

FRANZ MARC

In the Rain, 1912
Franz Marc
Lenbachhaus, Munich

1 2 3 4 5 6 7 8 9 10 11 12 13 14 15 16 17 18 19 20 21 22 23 24 25 26 27 **28** 29 30 31

MARCH

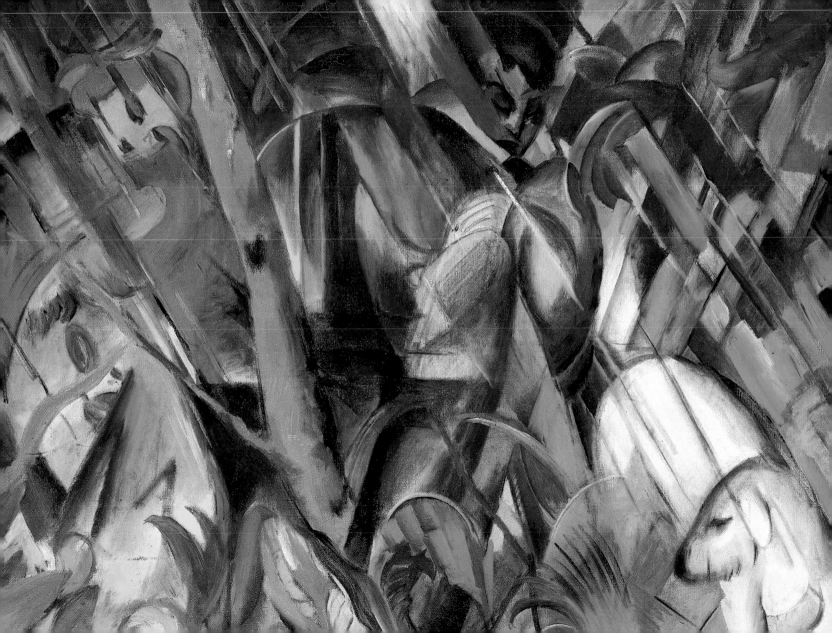

Whatever games are played with us,
we must play no games with ourselves.

RALPH WALDO EMERSON

Tric Trac Players, 1667
Jan Steen
The State Hermitage Museum, St. Petersburg

1 2 3 4 5 6 7 8 9 10 11 12 13 14 15 16 17 18 19 20 21 22 23 24 25 26 27 28 **29** 30 31

MARCH

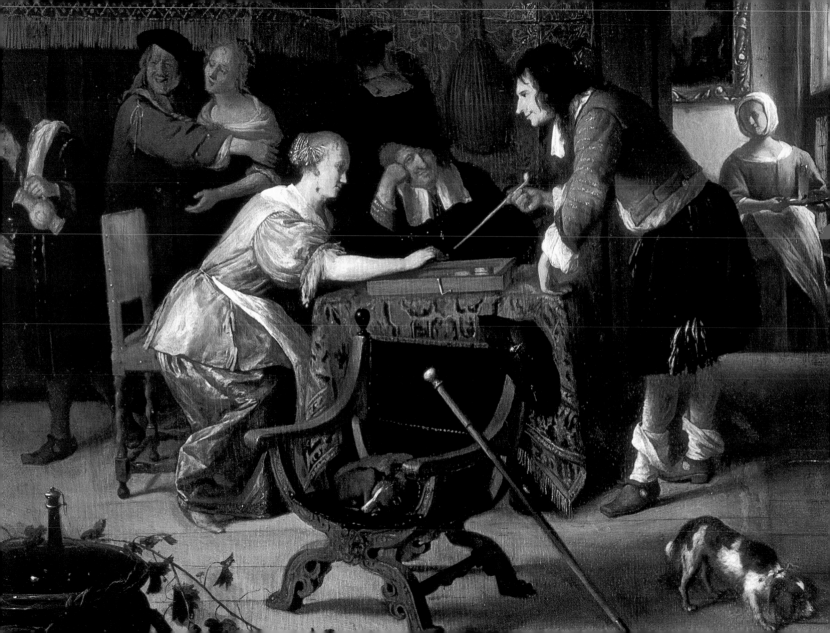

When you do the common things in life in an uncommon way, you will command the attention of the world.

GEORGE WASHINGTON CARVER

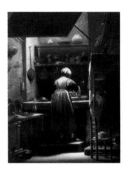

The Kitchen Maid, late 17th or early 18th century
Giuseppe Crespi
Uffizi Gallery, Florence

1 2 3 4 5 6 7 8 9 10 11 12 13 14 15 16 17 18 19 20 21 22 23 24 25 26 27 28 29 **30** 31

MARCH

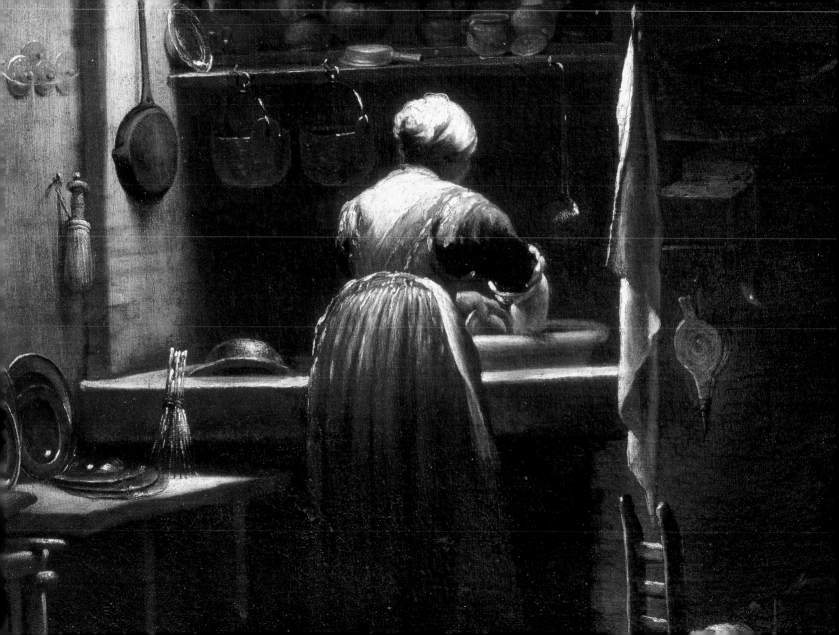

The only difference between me and a madman is that I'm not mad.

SALVADOR DALÍ

The Persistence of Memory, 1931
Salvador Dalí
The Museum of Modern Art, New York

1 2 3 4 5 6 7 8 9 10 11 12 13 14 15 16 17 18 19 20 21 22 23 24 25 26 27 28 29 30 **31**

MARCH

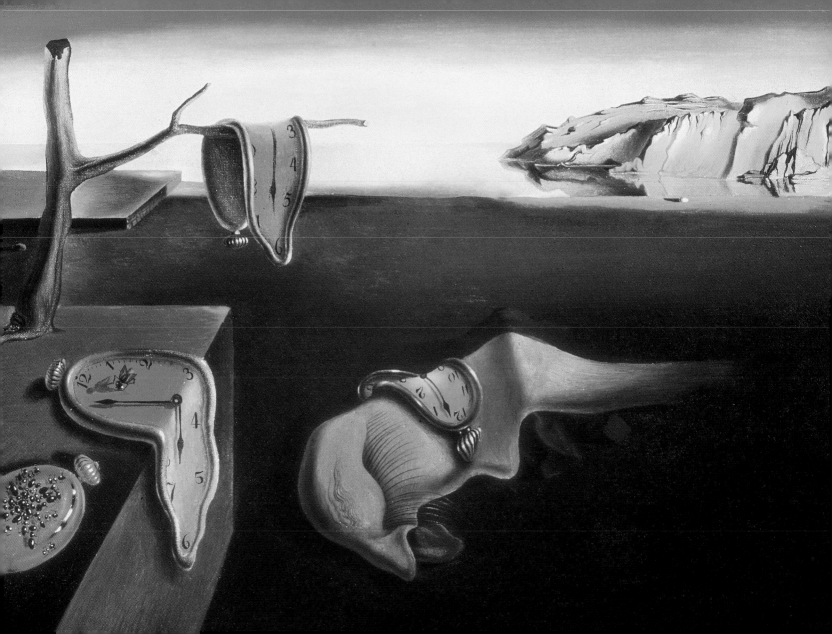

Fortune does not stand waiting at anyone's door.

The Dutch Proverbs, 1559
Pieter Brueghel the Elder
Gemäldegalerie, Berlin

1 2 3 4 5 6 7 8 9 10 11 12 13 14 15 16 17 18 19 20 21 22 23 24 25 26 27 28 29 30

APRIL

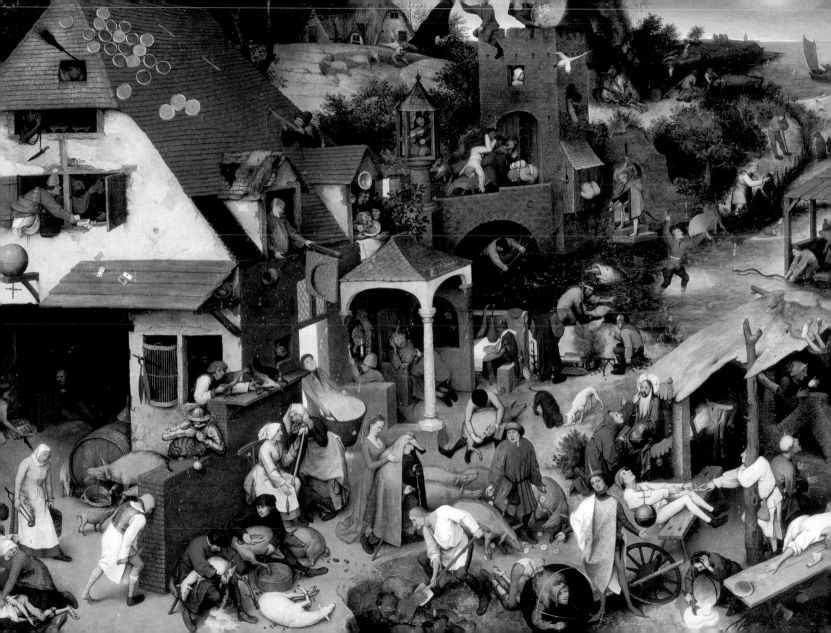

*The great hope of society
is individual character.*

WILLIAM CHANNING

Simple Woman, 1920
Gian Emilio Malerba
Private Collection

1 2 3 4 5 6 7 8 9 10 11 12 13 14 15 16 17 18 19 20 21 22 23 24 25 26 27 28 29 30

APRIL

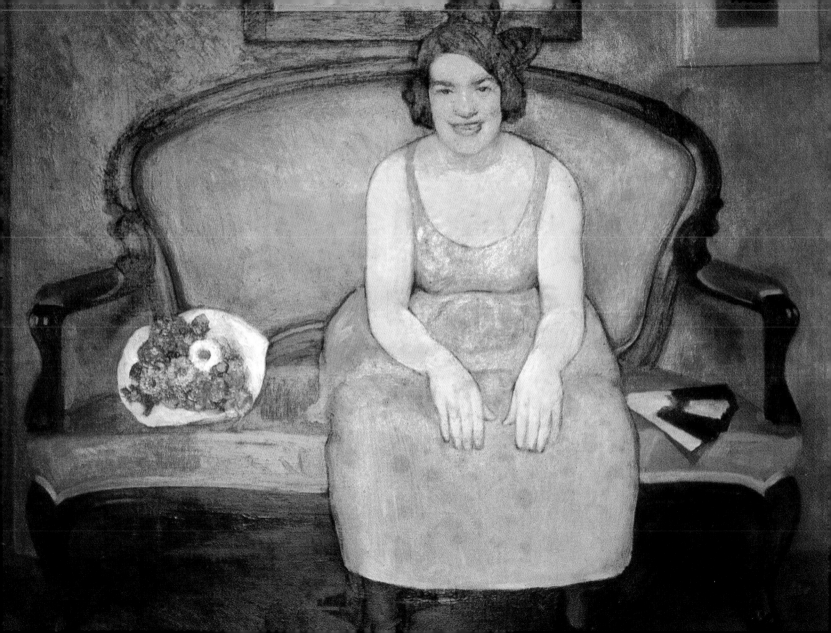

Virtue, the strength and beauty of the soul ...

<small>John Armstrong</small>

Triumph of Virtue over Vice, *c.* 1502
Andrea Mantegna
Musée du Louvre, Paris

1 2 **3** 4 5 6 7 8 9 10 11 12 13 14 15 16 17 18 19 20 21 22 23 24 25 26 27 28 29 30

April

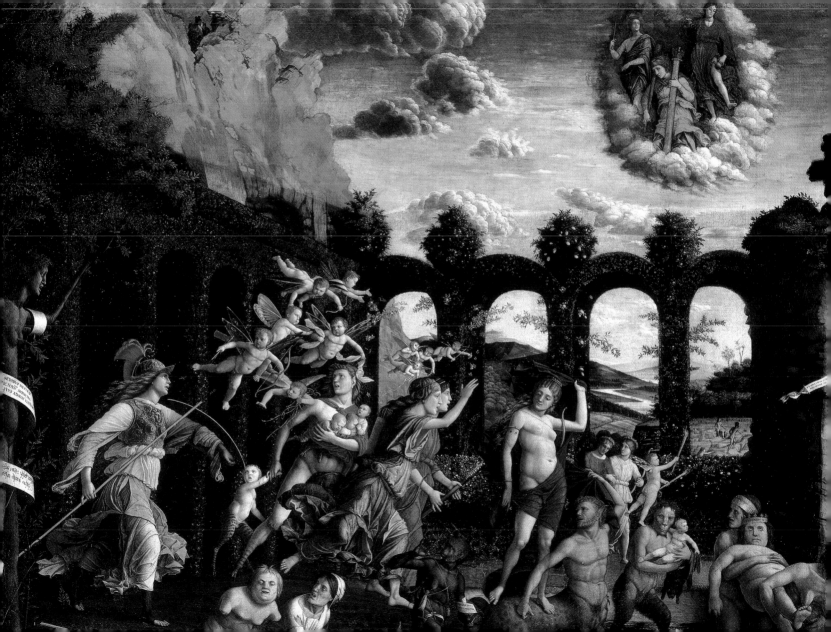

A little gale will soon disperse that cloud
And blow it to the source from whence it came.
Thy very beams will dry those vapors up,
For every cloud engenders not a storm.

WILLIAM SHAKESPEARE

The Storm, 1837
Peter Fendi
Belvedere, Vienna

1 2 3 **4** 5 6 7 8 9 10 11 12 13 14 15 16 17 18 19 20 21 22 23 24 25 26 27 28 29 30

APRIL

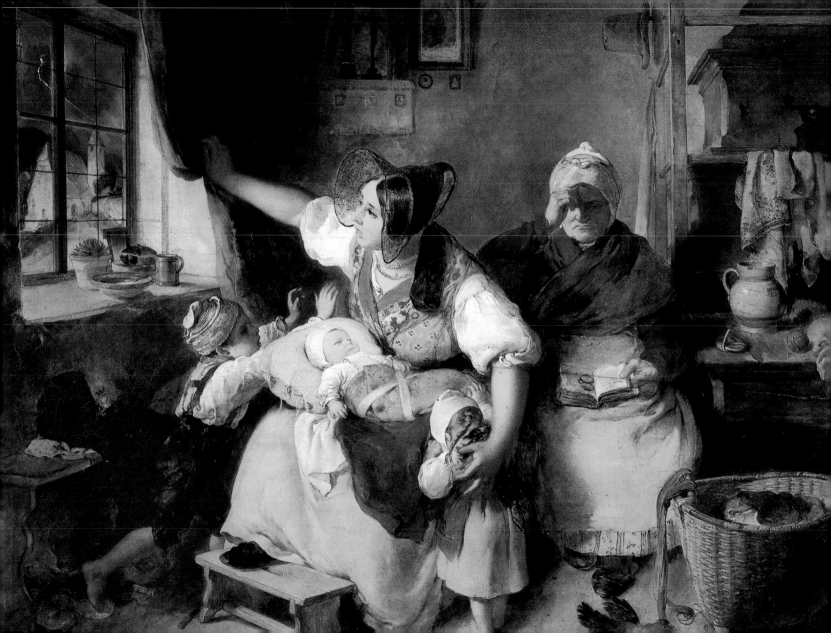

Home: the nursery of the infinite.

WILLIAM CHANNING

Still Life by a Window, 1891
Paul Serusier
Private Collection

1 2 3 4 **5** 6 7 8 9 10 11 12 13 14 15 16 17 18 19 20 21 22 23 24 25 26 27 28 29 30

APRIL

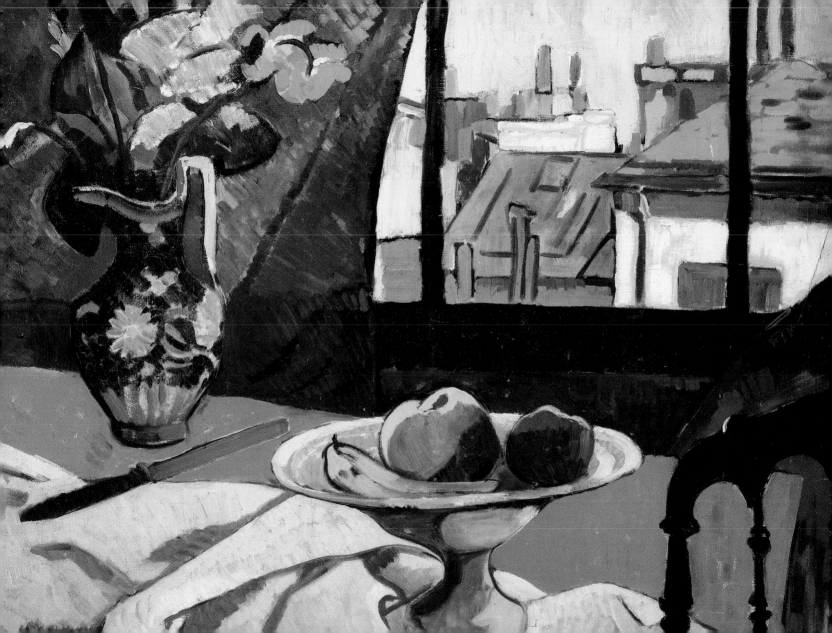

Provision for others is a fundamental responsibility of human life.

The Flight to Egypt, 17th century
Louis Licherie de Beuron
Residenzgalerie, Salzburg

1 2 3 4 5 **6** 7 8 9 10 11 12 13 14 15 16 17 18 19 20 21 22 23 24 25 26 27 28 29 30

APRIL

The Lord Jesus, on the night he was betrayed,
took bread, and when he had given thanks,
he broke it and said, "This is my body, which
is for you; do this in remembrance of me."

THE BOOK OF CORINTHIANS I, 11:23-24

The Last Supper, 1305
Giotto di Bondone
Capella degli Scrovegni, Padua

1 2 3 4 5 6 **7** 8 9 10 11 12 13 14 15 16 17 18 19 20 21 22 23 24 25 26 27 28 29 30

APRIL

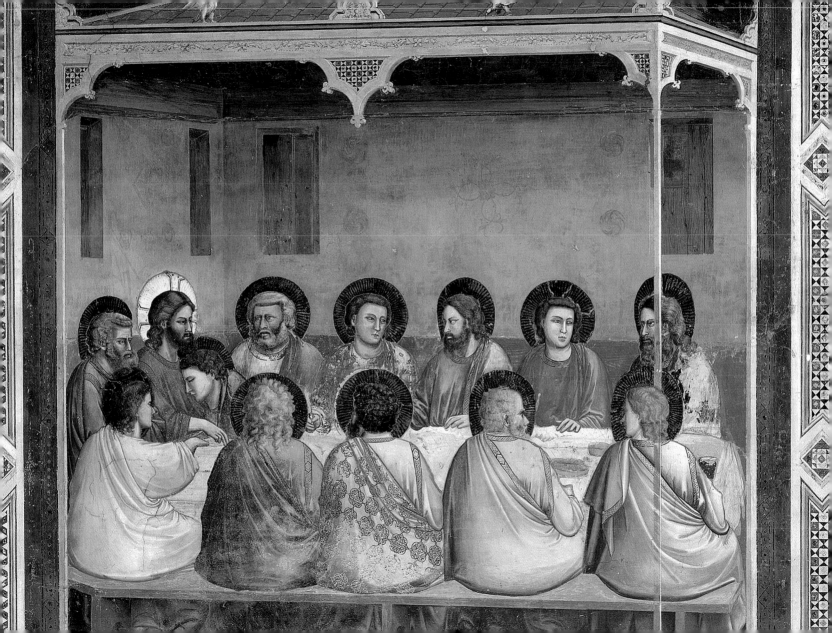

The greatest revelation is stillness.

Sundown over a River, 17th century
Aelbert Cuyp
The State Hermitage Museum, St. Petersburg

1 2 3 4 5 6 7 **8** 9 10 11 12 13 14 15 16 17 18 19 20 21 22 23 24 25 26 27 28 29 30

APRIL

For he who is honest is noble,
Whatever his fortunes or birth.

ALICE CARY

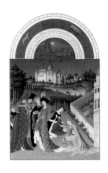

Les Très Riches Heures du Duc de Berry, April, c. 1413–16
The Limburg Brothers
Musée Condé, Chantilly

1 2 3 4 5 6 7 8 **9** 10 11 12 13 14 15 16 17 18 19 20 21 22 23 24 25 26 27 28 29 30

APRIL

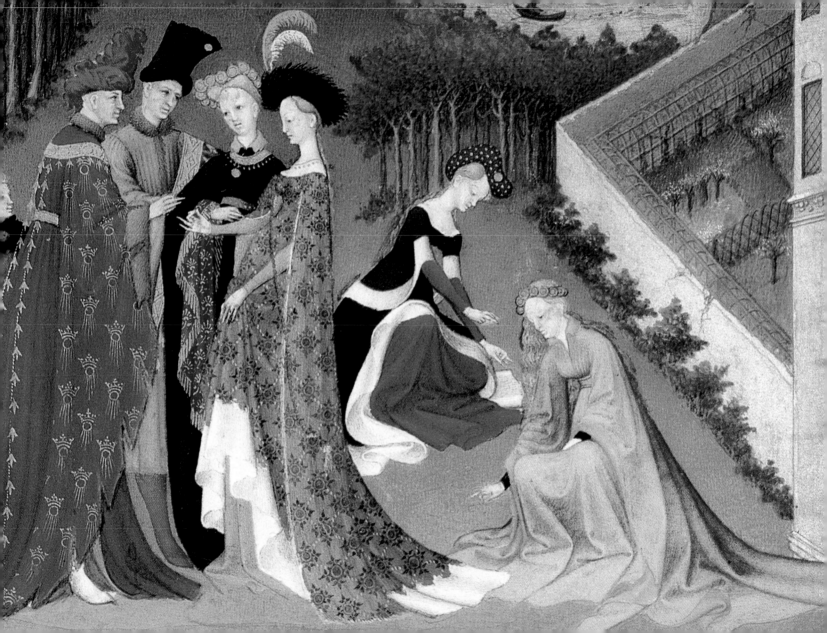

Painting is silent poetry,
and poetry is painting
with the gift of speech.

Simonides

Allegory of Painting, early 17th century
Francesco Furini
Palazzo Pitti, Florence

1 2 3 4 5 6 7 8 9 **10** 11 12 13 14 15 16 17 18 19 20 21 22 23 24 25 26 27 28 29 30

April

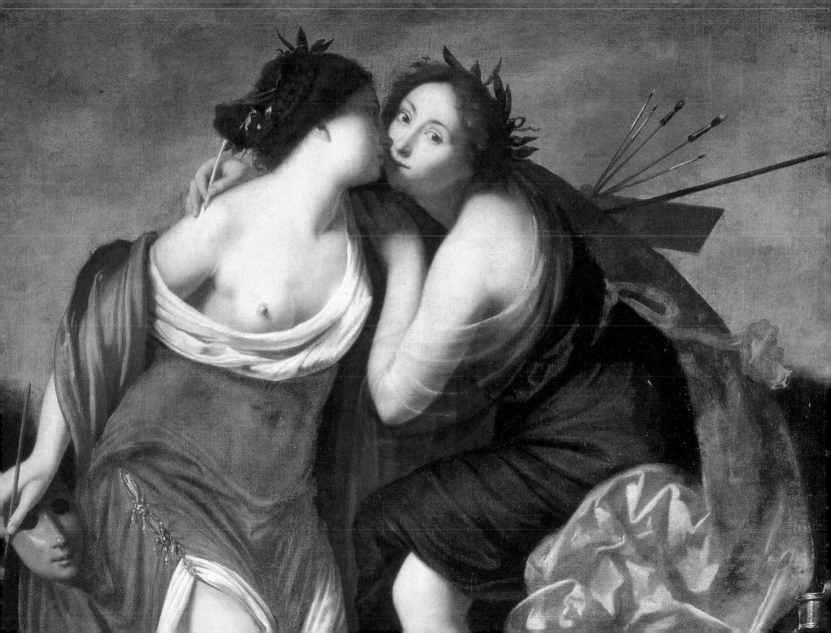

Close your bodily eye, that you may see your picture first with the eye of the spirit.

CASPAR DAVID FRIEDRICH

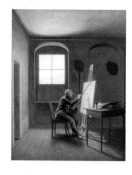

Caspar David Friedrich in his Studio, 1819
Georg Friedrich Kersting
Kunsthalle, Mannheim

1 2 3 4 5 6 7 8 9 10 **11** 12 13 14 15 16 17 18 19 20 21 22 23 24 25 26 27 28 29 30

APRIL

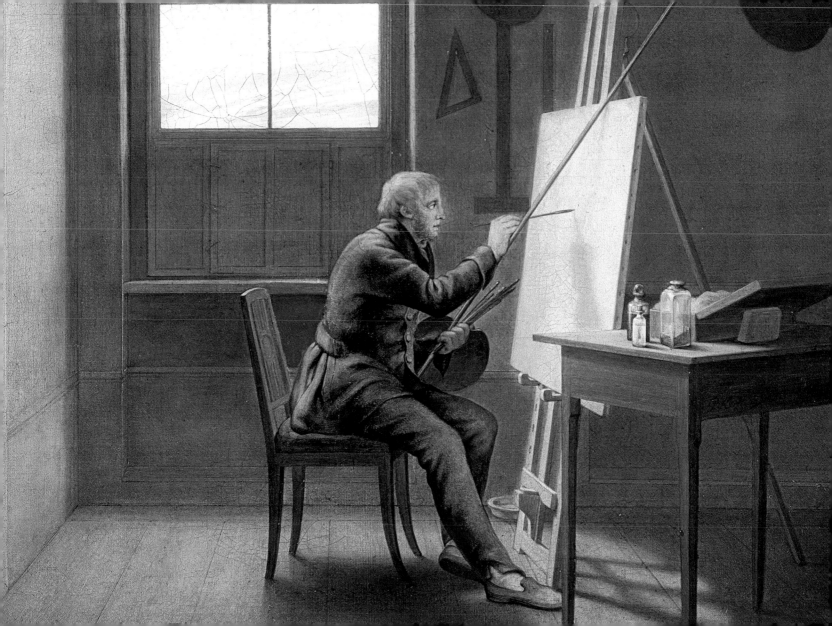

One that would have the fruit
must climb the tree.

THOMAS FULLER

Still Life with Fruit and Butterflies, 17th century
Jan Davidsz de Heem
National Gallery, Prague

1 2 3 4 5 6 7 8 9 10 11 **12** 13 14 15 16 17 18 19 20 21 22 23 24 25 26 27 28 29 30

APRIL

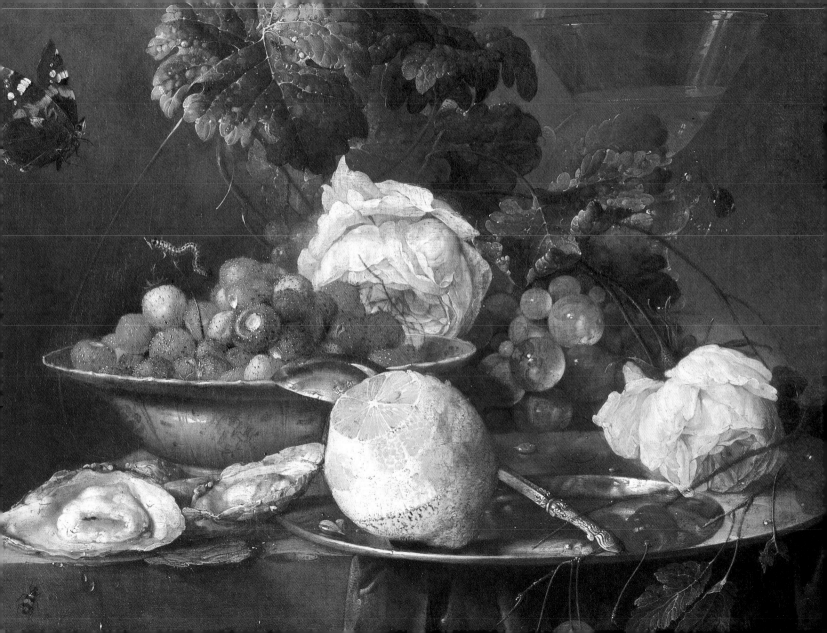

Diversity is the one true thing
we all have in common.
Celebrate it every day.

A NON.

The Canoe, Family in Tahiti, 1848–1903
Paul Gauguin
The State Hermitage Museum, St. Petersburg

1 2 3 4 5 6 7 8 9 10 11 12 **13** 14 15 16 17 18 19 20 21 22 23 24 25 26 27 28 29 30

APRIL

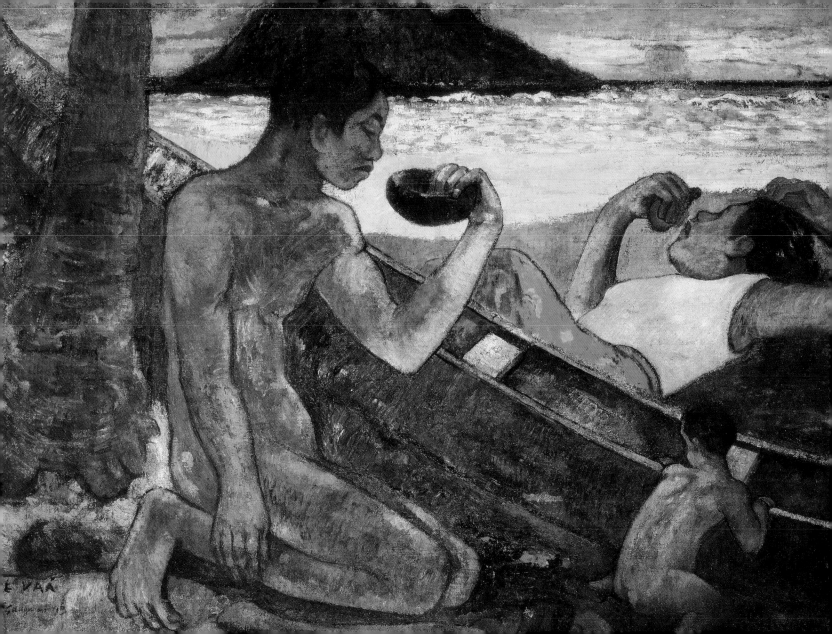

E VAÀ
Gauguin 96

It is this earth that, like a kind mother,
receives us at our birth, and sustains us
when born.
It is this alone, of all the elements around us,
that is never found an enemy of man.

PLINY THE ELDER (CAIUS PLINIUS SECUNDUS)

Landscape with Iron Mine, 16th century
Herri met de Bles
National Gallery, Prague

1 2 3 4 5 6 7 8 9 10 11 12 13 **14** 15 16 17 18 19 20 21 22 23 24 25 26 27 28 29 30

APRIL

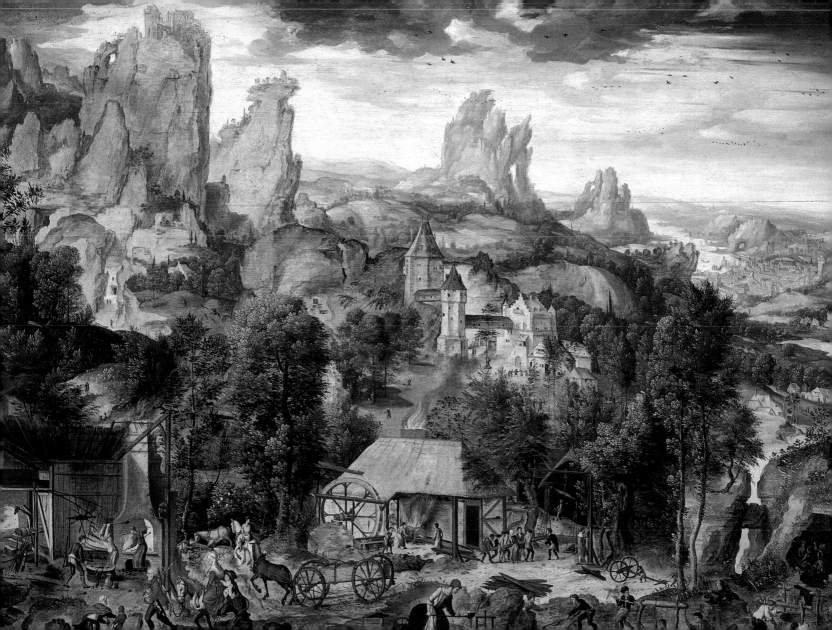

*Silence is the genius of fools
and one of the virtues of the wise.*

BERNARD DE BONNARD

The Statue of Silence, 1913
Giorgio de Chirico
Kunstsammlungen NRW, Düsseldorf

1 2 3 4 5 6 7 8 9 10 11 12 13 14 **15** 16 17 18 19 20 21 22 23 24 25 26 27 28 29 30

APRIL

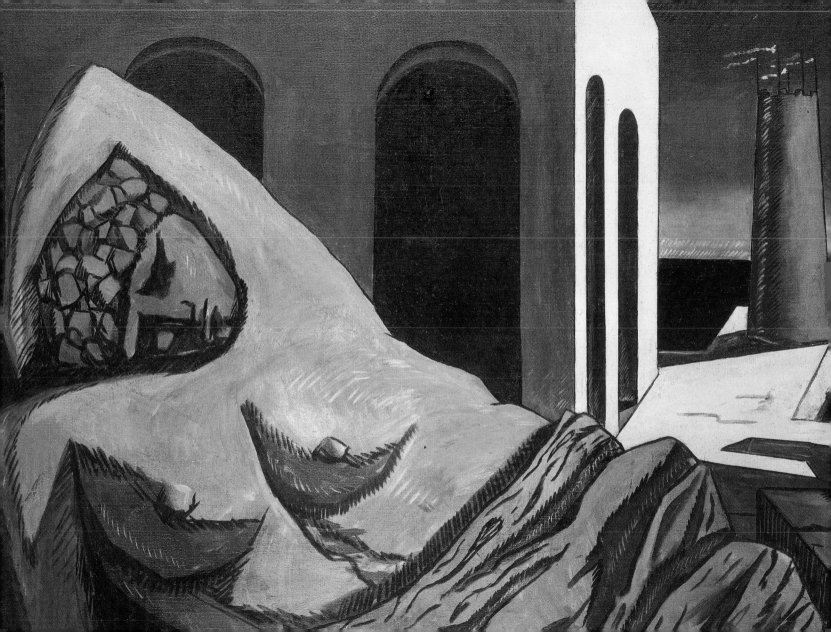

The fishermen know that the sea is dangerous and the storm terrible, but they have never found these dangers sufficient reason for remaining ashore.

<small>VINCENT VAN GOGH</small>

Stormy Sea, 17th century
Hendrick Goderis
The State Hermitage Museum, St. Petersburg

1 2 3 4 5 6 7 8 9 10 11 12 13 14 15 **16** 17 18 19 20 21 22 23 24 25 26 27 28 29 30

APRIL

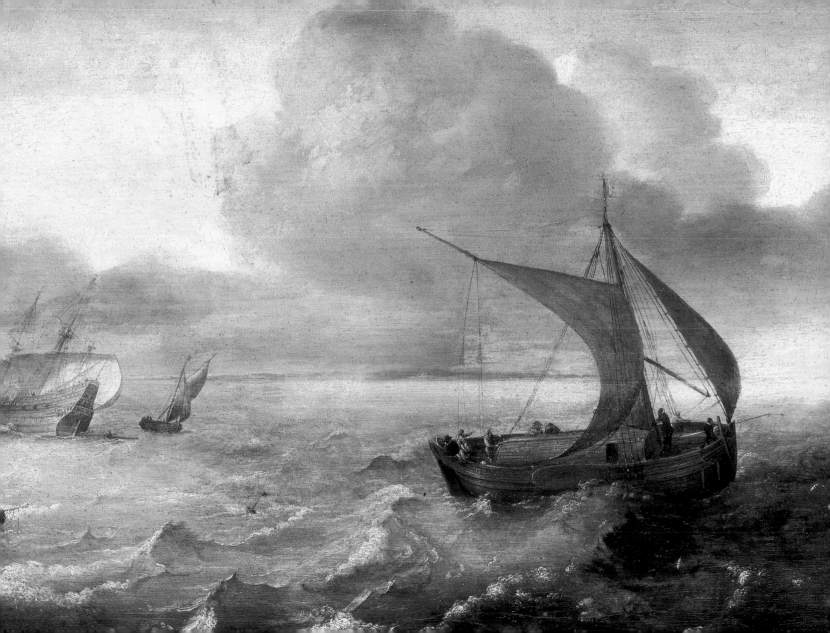

A story should, to please, at least seem true,
Be apropos, well told, concise, and new:
And whenso'er it deviates from these rules,
The wise will sleep, and leave applause to fools.

BENJAMIN STILLINGFLEET

A Tale from The Decameron, 1916
John William Waterhouse
Lady Lever Art Gallery, Port Sunlight

1 2 3 4 5 6 7 8 9 10 11 12 13 14 15 16 **17** 18 19 20 21 22 23 24 25 26 27 28 29 30

APRIL

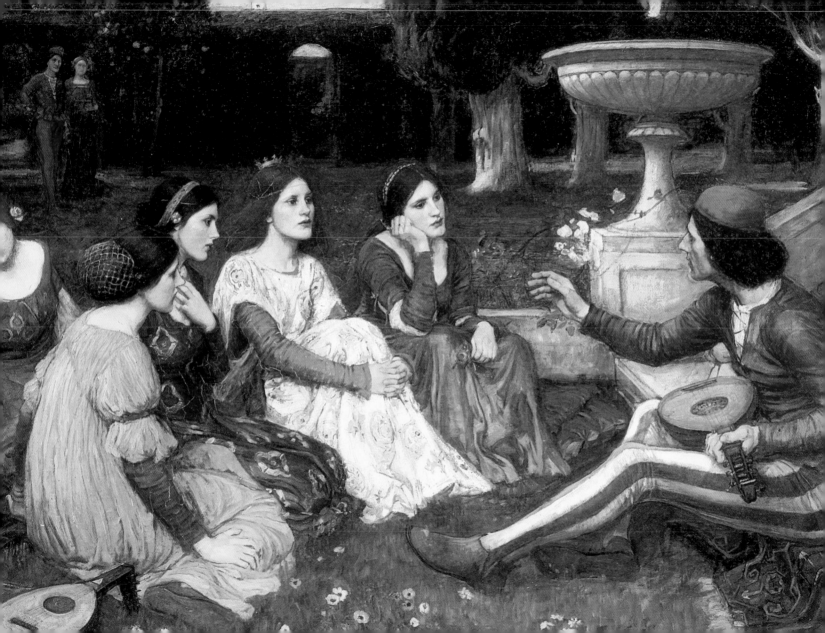

Tell me, Muse, of the man of many devices,
who wandered far and wide after he had
sacked Troy's sacred city, and saw the towns
of many men and knew their mind.

HOMER

Odysseus on the Island of the Phaeacians, early 17th century
Peter Paul Rubens
Palazzo Pitti, Florence

1 2 3 4 5 6 7 8 9 10 11 12 13 14 15 16 17 **18** 19 20 21 22 23 24 25 26 27 28 29 30

APRIL

Like the bee, we should make our industry our amusement.

The Wash Maid, 18th century
Jean-Baptiste Siméon Chardin
The State Hermitage Museum, St. Petersburg

1 2 3 4 5 6 7 8 9 10 11 12 13 14 15 16 17 18 **19** 20 21 22 23 24 25 26 27 28 29 30

APRIL

A little child with laughing look,
A lovely white unwritten book ...

JOHN MASEFIELD

The Hülsenbeckschen Children, 1805–06
Philipp Otto Runge
Hamburger Kunsthalle

1 2 3 4 5 6 7 8 9 10 11 12 13 14 15 16 17 18 19 **20** 21 22 23 24 25 26 27 28 29 30

APRIL

The way to know life is to love many things.

Vincent van Gogh

Field with Poppies, 1889
Vincent van Gogh
Kunsthalle, Bremen

1 2 3 4 5 6 7 8 9 10 11 12 13 14 15 16 17 18 19 20 **21** 22 23 24 25 26 27 28 29 30

APRIL

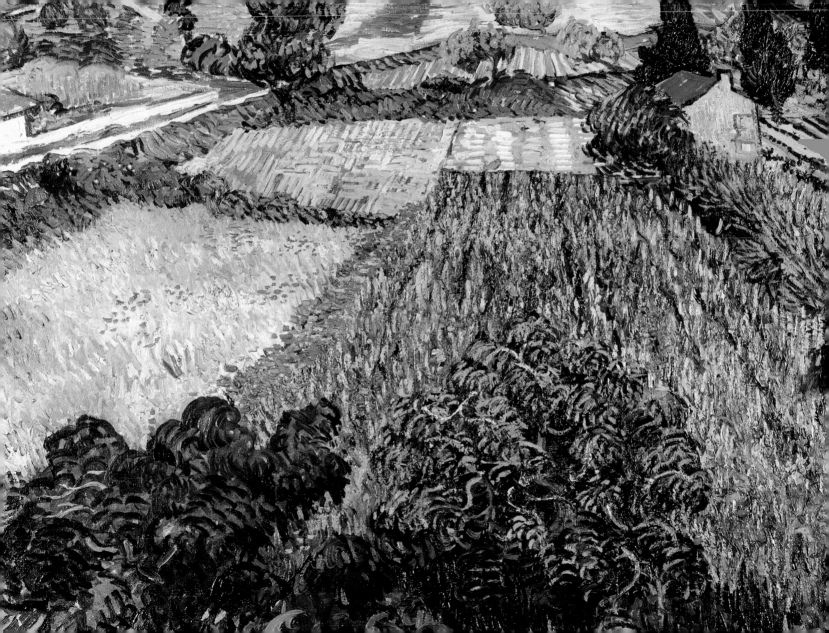

Home, in one form or another, is the great object of life.

JOSIAH GILBERT HOLLAND

The Front Yard of the Orphanage in Amsterdam, 1881–82
Max Liebermann
Städel Museum, Frankfurt

1 2 3 4 5 6 7 8 9 10 11 12 13 14 15 16 17 18 19 20 21 **22** 23 24 25 26 27 28 29 30

APRIL

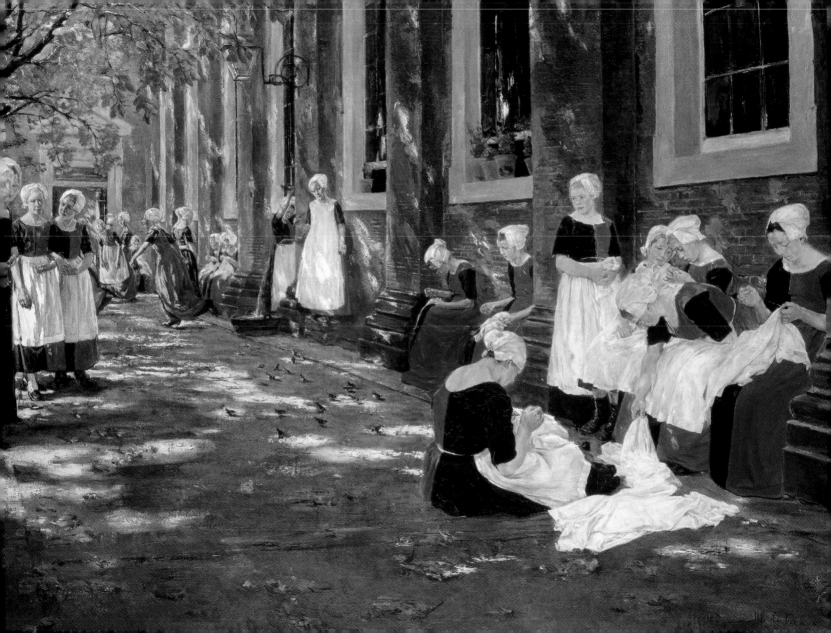

The art of taxation consists in so plucking the goose as to obtain the largest possible amount of feathers with the smallest possible amount of hissing.

Jᴏʜɴ Bᴀᴘᴛɪsᴛᴇ Cᴏʟʙᴇʀᴛ

The Tax Collectors, 16th century
Marinus van Reymerswaele
The State Hermitage Museum, St. Petersburg

1 2 3 4 5 6 7 8 9 10 11 12 13 14 15 16 17 18 19 20 21 22 **23** 24 25 26 27 28 29 30

APRIL

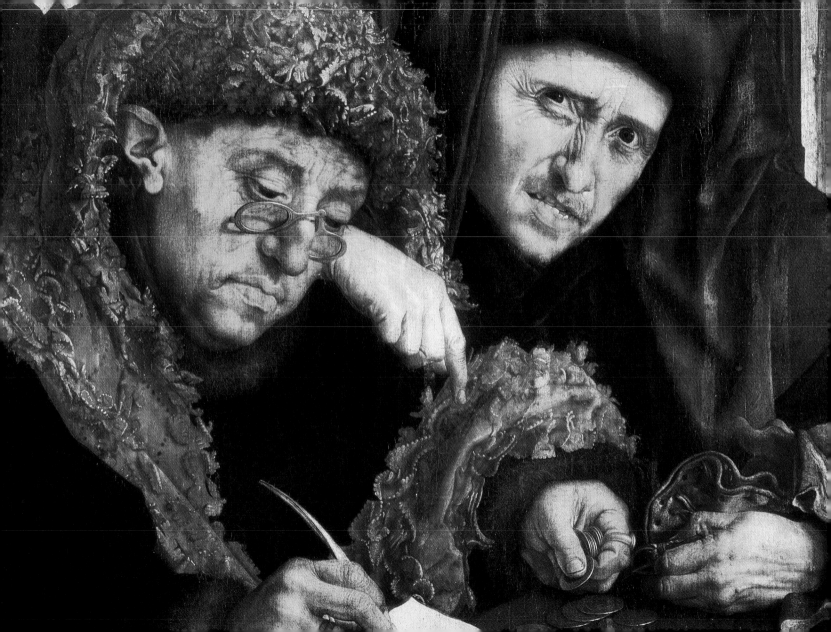

Skill'd in the globe and sphere, he gravely stands,
And, with his compass, measures seas and lands.

JOHN DRYDEN

The Geographer, 1669
Johannes Vermeer
Städel Museum, Frankfurt

1 2 3 4 5 6 7 8 9 10 11 12 13 14 15 16 17 18 19 20 21 22 23 **24** 25 26 27 28 29 30

APRIL

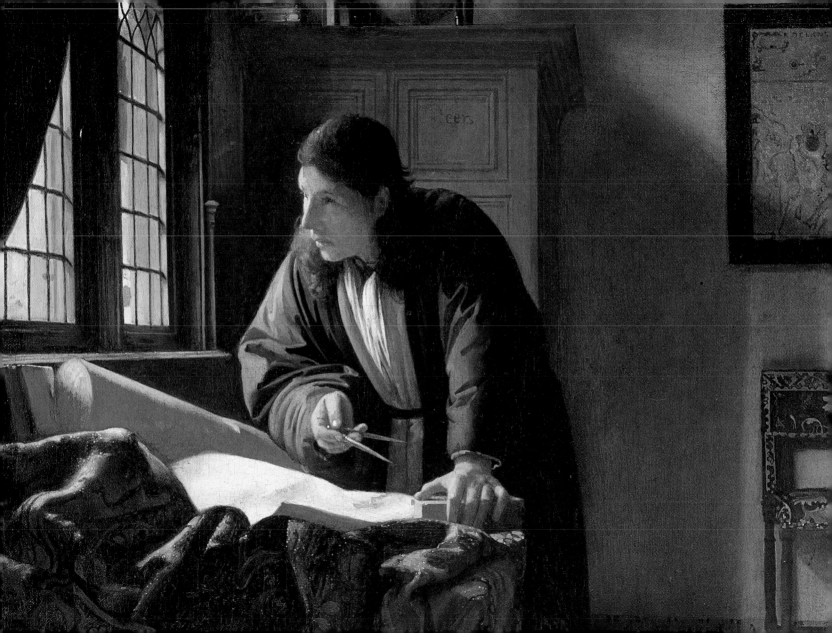

Then the king said, "Bring me a sword."
So they brought a sword for the king.
He then gave an order: "Cut the living child
in two and give half to one and half to
the other."

The Book of Kings I, 3:24-25

The Judgment of Solomon, late 15th or early 16th century
Giorgione
Uffizi Gallery, Florence

1 2 3 4 5 6 7 8 9 10 11 12 13 14 15 16 17 18 19 20 21 22 23 24 **25** 26 27 28 29 30

APRIL

It is not the ship so much as the skillful sailing that assures the prosperous voyage.

George William Curtis

Sailboats Racing on the Delaware, 1874
Thomas Eakins
Philadelphia Museum of Art

1 2 3 4 5 6 7 8 9 10 11 12 13 14 15 16 17 18 19 20 21 22 23 24 25 **26** 27 28 29 30

APRIL

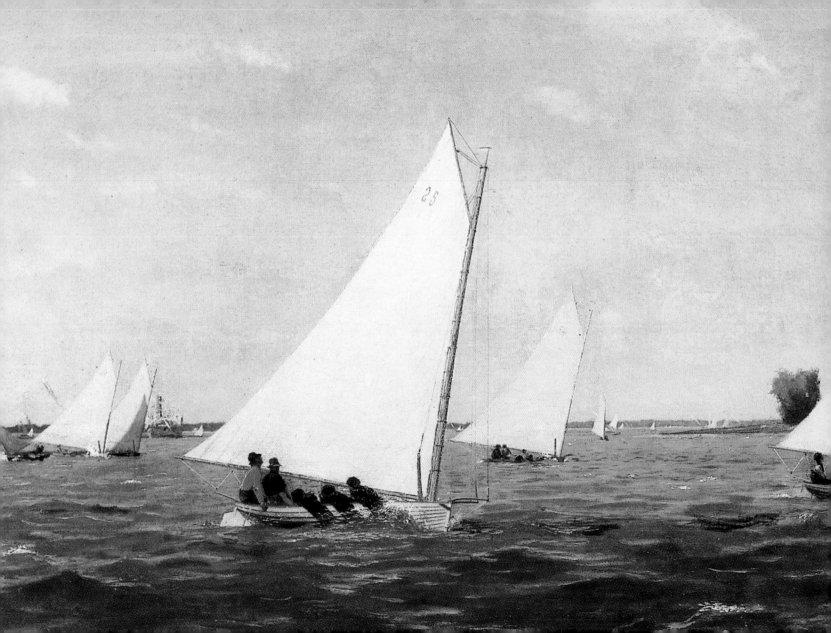

Oedipus and the Sphinx, 1864
Gustave Moreau
The Metropolitan Museum of Art, New York

Man: the glory, jest, and riddle of the world.

ALEXANDER POPE

1 2 3 4 5 6 7 8 9 10 11 12 13 14 15 16 17 18 19 20 21 22 23 24 25 26 27 28 29 30

APRIL

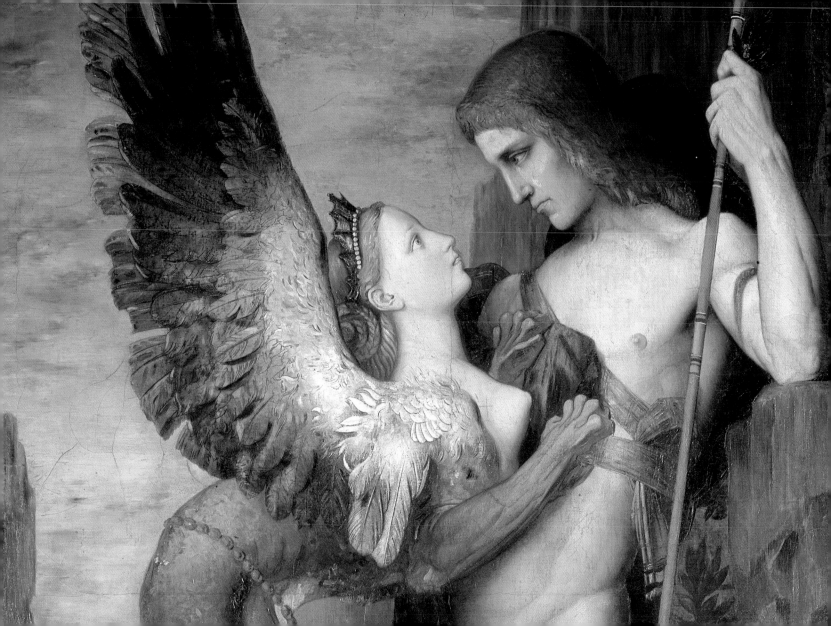

*All truly great thoughts
are conceived while walking.*

On the Europabrücke, 1876
Gustave Caillebotte
Musée du Petit Palais, Geneva

1 2 3 4 5 6 7 8 9 10 11 12 13 14 15 16 17 18 19 20 21 22 23 24 25 26 27 **28** 29 30

APRIL

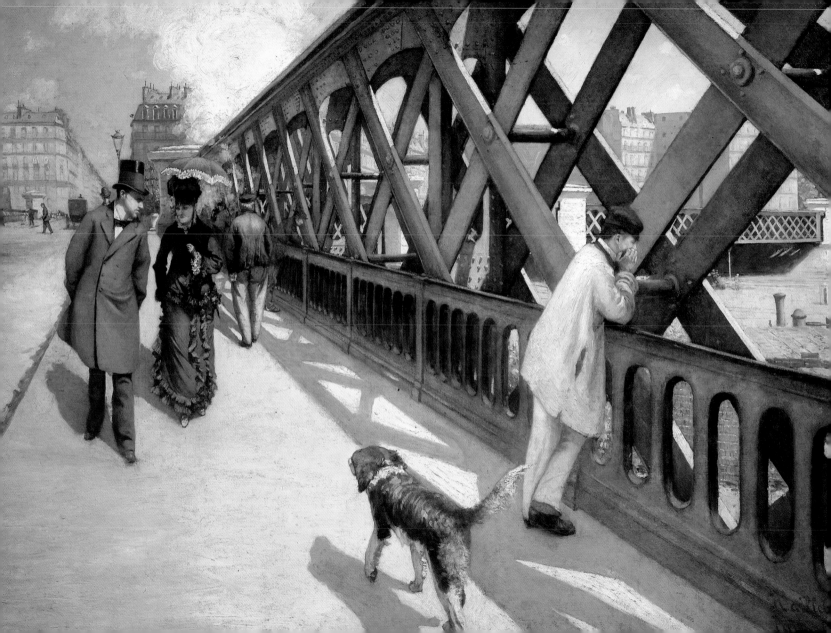

Her loveliness I never knew
Until she smiled on me;
Oh! then I saw her eye was bright,
A well of love, a spring of light.

HARTLEY COLERIDGE

Maya and the Procuress on the Balcony, c. 1808–12
Francisco José de Goya
Museo Nacional del Prado, Madrid

1 2 3 4 5 6 7 8 9 10 11 12 13 14 15 16 17 18 19 20 21 22 23 24 25 26 27 28 **29** 30

APRIL

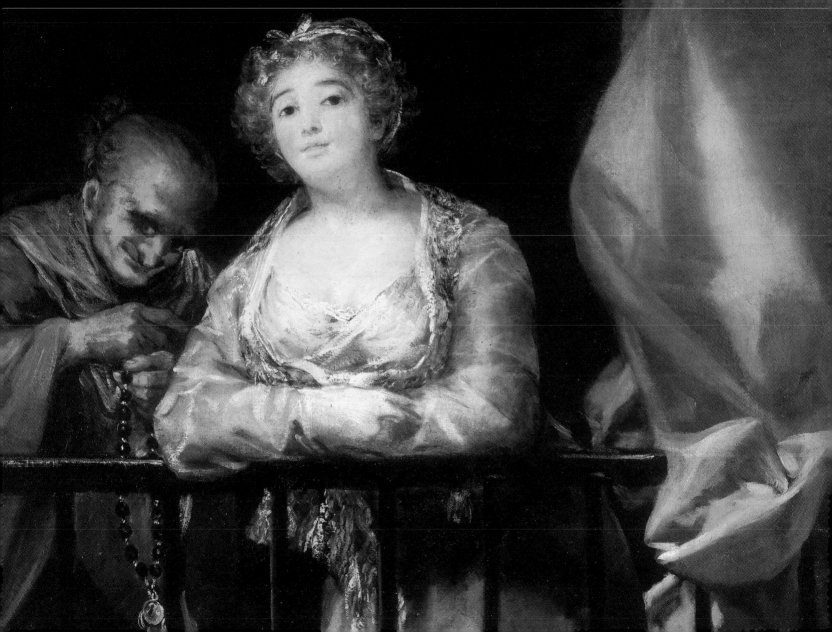

*The animation of the canvas
is one of the hardest problems of painting.*

Alfred Sisley

Marketplace in Marly, 1876
Alfred Sisley
Kunsthalle, Mannheim

1 2 3 4 5 6 7 8 9 10 11 12 13 14 15 16 17 18 19 20 21 22 23 24 25 26 27 28 29 30

APRIL

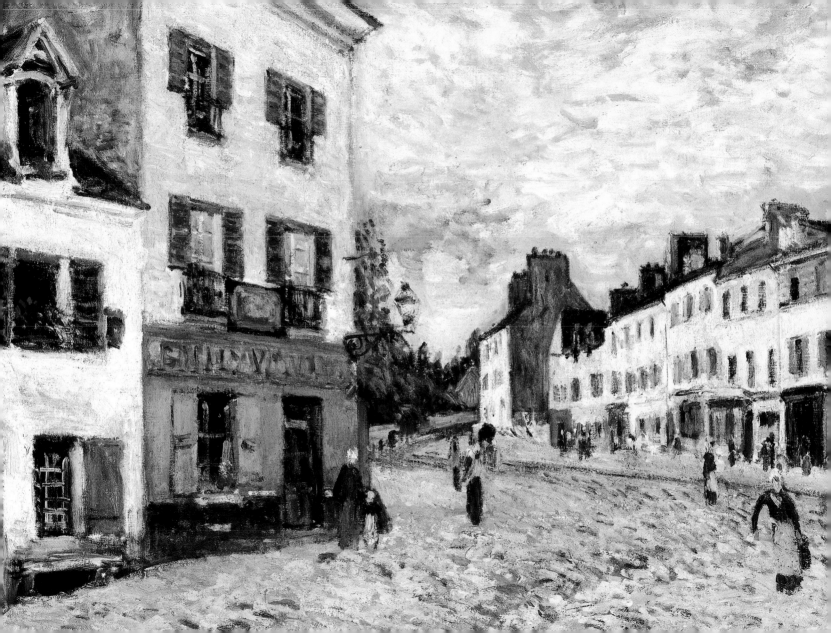

*A good artist only needs three colors:
black, white, and red.*

TITIAN

The Feast of Venus, 1518–19
Titian
Museo Nacional del Prado, Madrid

1 2 3 4 5 6 7 8 9 10 11 12 13 14 15 16 17 18 19 20 21 22 23 24 25 26 27 28 29 30 31

MAY

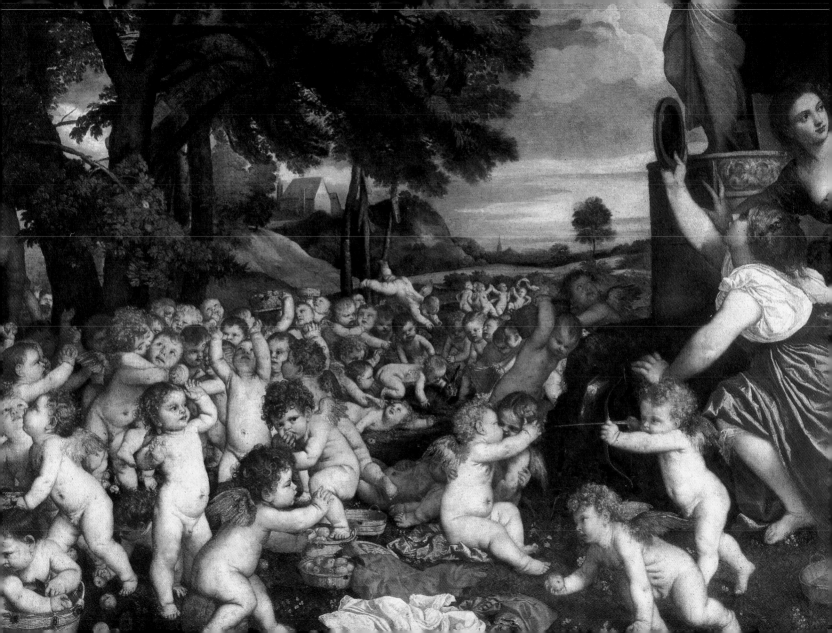

Sweet Sleep, with soft down
Weave thy brows an infant crown!
Sweet Sleep, angel mild,
Hover o'er my happy child.

WILLIAM BLAKE

Sleeping Child, early 17th century
Bernardo Strozzi (Il Capuccino)
Residenzgalerie, Salzburg

1 2 3 4 5 6 7 8 9 10 11 12 13 14 15 16 17 18 19 20 21 22 23 24 25 26 27 28 29 30 31

MAY

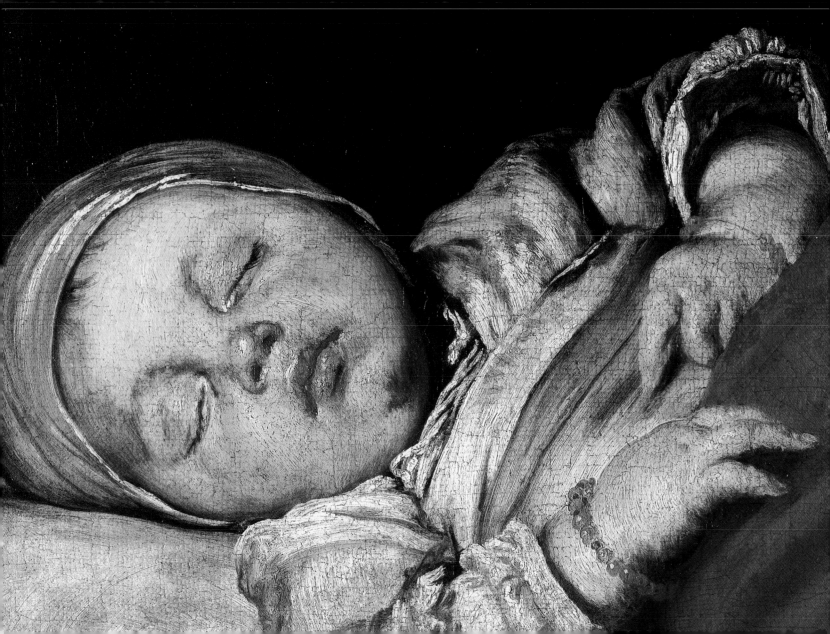

One is nearer God's heart in a garden
Than anywhere else on earth.

Dorothy Frances Bloomfield Gurney

The Daughters in the Garden, 1906
Fritz von Uhde
Kunsthalle, Mannheim

1 2 **3** 4 5 6 7 8 9 10 11 12 13 14 15 16 17 18 19 20 21 22 23 24 25 26 27 28 29 30 31

May

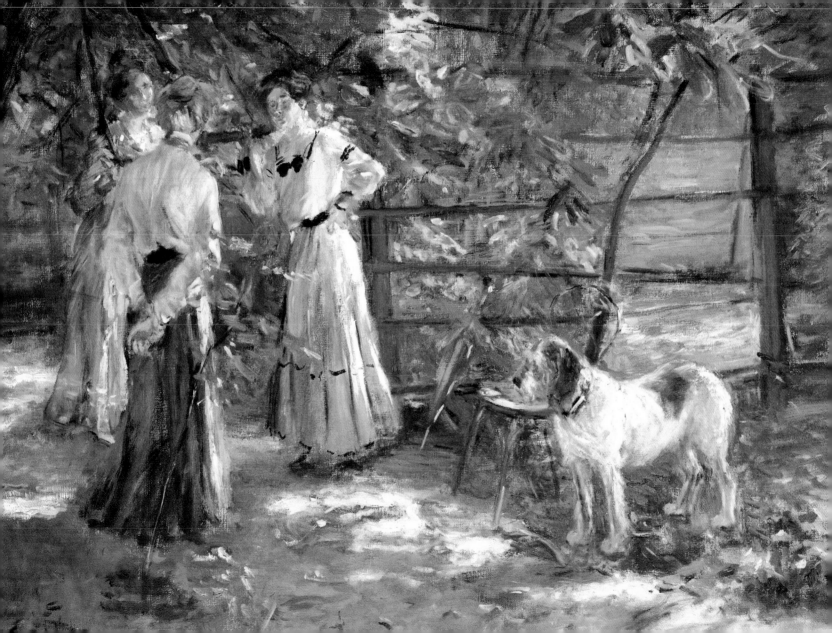

In all human affairs there are efforts and there are results, and the strength of the effort is the measure of the result.

JAMES LANE ALLEN

The Washerwomen on Etretat, 1899
Félix Vallotton
Private Collection

1 2 3 **4** 5 6 7 8 9 10 11 12 13 14 15 16 17 18 19 20 21 22 23 24 25 26 27 28 29 30 31

MAY

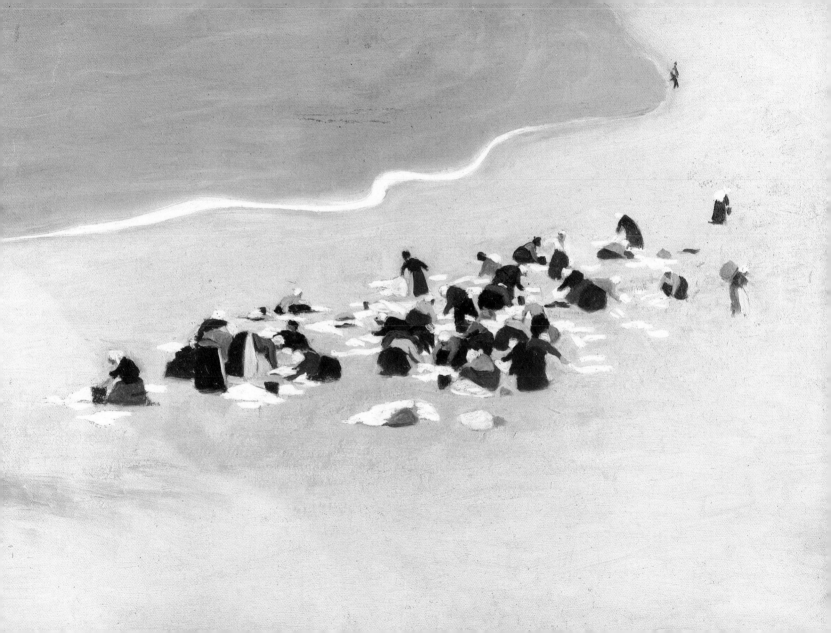

Even virtue is fairer when it appears
in a beautiful person.

Virgil

Olympia, 1863
Edouard Manet
Musée d'Orsay, Paris

1 2 3 4 **5** 6 7 8 9 10 11 12 13 14 15 16 17 18 19 20 21 22 23 24 25 26 27 28 29 30 31

MAY

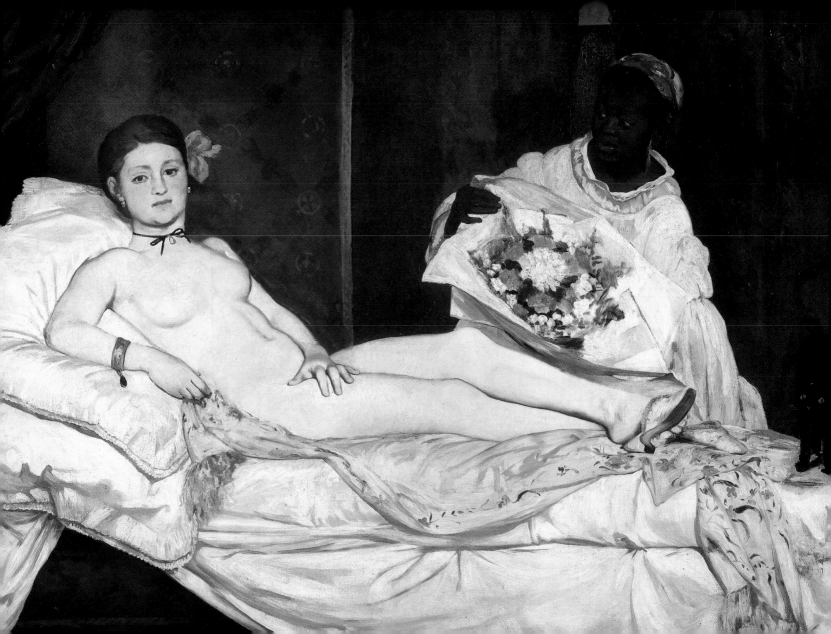

Nature teaches more than she preaches.

John Borroughs

Fishing Monk, c. 1863
Carl Spitzweg
Private Collection

1 2 3 4 5 **6** 7 8 9 10 11 12 13 14 15 16 17 18 19 20 21 22 23 24 25 26 27 28 29 30 31

MAY

Next to virtue, the fun in this world is what we can least spare.

Agnes Strickland

Fête in a Tavern, 1676
Jan Steen
Musée du Louvre, Paris

1 2 3 4 5 6 **7** 8 9 10 11 12 13 14 15 16 17 18 19 20 21 22 23 24 25 26 27 28 29 30 31

May

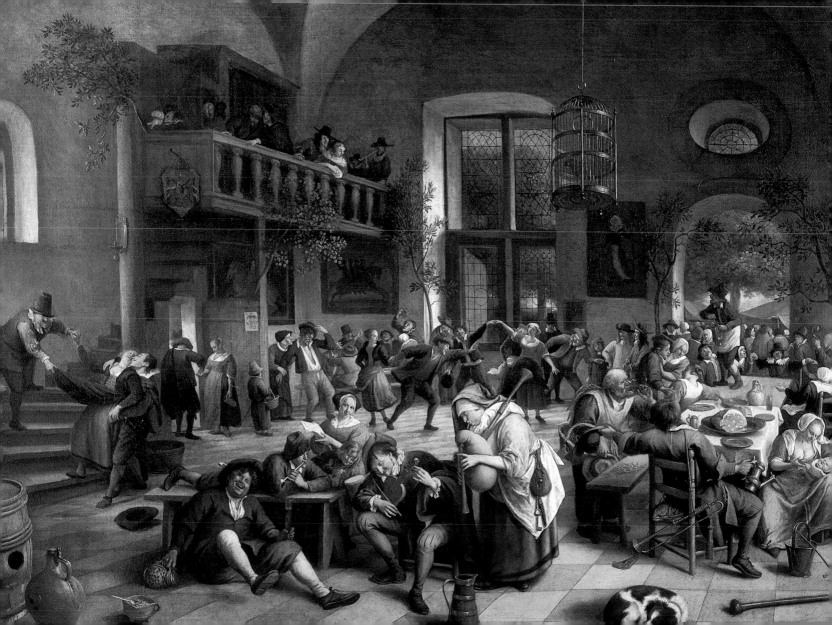

*For the nature of a women
is closely allied to art.*

Mrs. Ernest Major, 1902–03
Joseph DeCamp
The Procter & Gamble Company, Cincinnati

1 2 3 4 5 6 7 **8** 9 10 11 12 13 14 15 16 17 18 19 20 21 22 23 24 25 26 27 28 29 30 31

MAY

Live in the sunshine, swim the sea, drink the wild air …

RALPH WALDO EMERSON

Lake Chiem Landscape, 19th century
Peter von Hess
Nymphenburg Palace, Munich

1 2 3 4 5 6 7 8 **9** 10 11 12 13 14 15 16 17 18 19 20 21 22 23 24 25 26 27 28 29 30 31

MAY

Raising himself a little way and holding his arms out to the woods, he asks, "Has anyone ever loved more cruelly than I?"

OVID

Narcissus at the Fountain, late 16th or early 17th century
Francesco Curradi
Palazzo Pitti, Florence

1 2 3 4 5 6 7 8 9 **10** 11 12 13 14 15 16 17 18 19 20 21 22 23 24 25 26 27 28 29 30 31

MAY

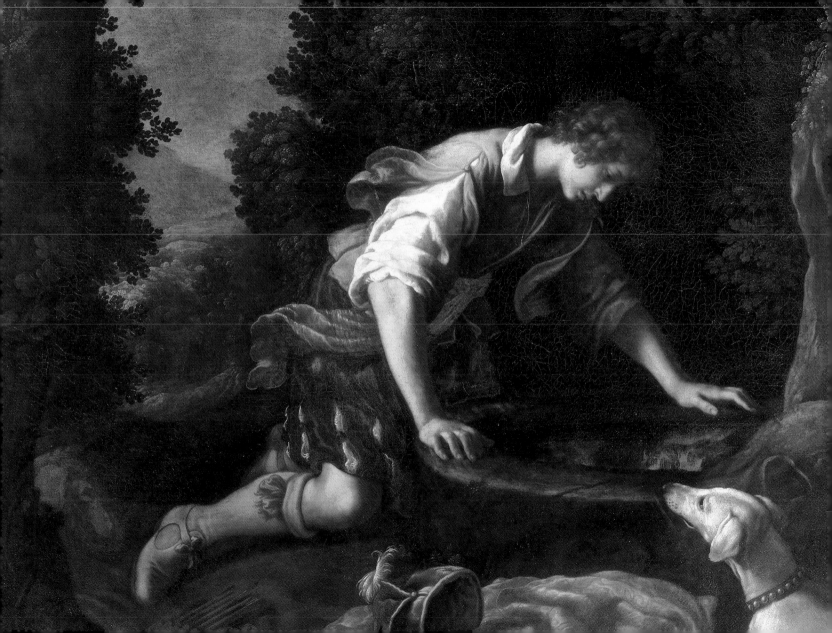

Everything painted directly and on the spot
has a strength, vigor, and vivacity of touch
that can never be attained in the studio.
Three brush strokes from nature are worth
more than two days studio work at the easel.

EUGÈNE BOUDIN

On the Beach at Trouville, 1865
Eugène Boudin
Musée d'Orsay, Paris

1 2 3 4 5 6 7 8 9 10 **11** 12 13 14 15 16 17 18 19 20 21 22 23 24 25 26 27 28 29 30 31

MAY

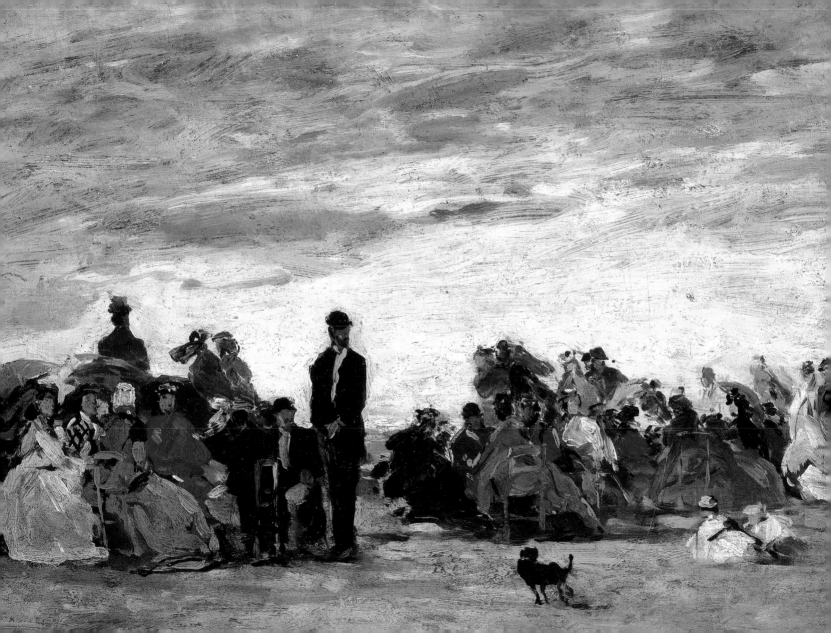

*Beauty is the radiance of truth
and the fragrance of goodness.*

VINCENT MCNABB

Portrait of Ginevra d' Este, 15th century
Pisanello (Antonio di Puccio)
Musée du Louvre, Paris

1 2 3 4 5 6 7 8 9 10 11 **12** 13 14 15 16 17 18 19 20 21 22 23 24 25 26 27 28 29 30 31

MAY

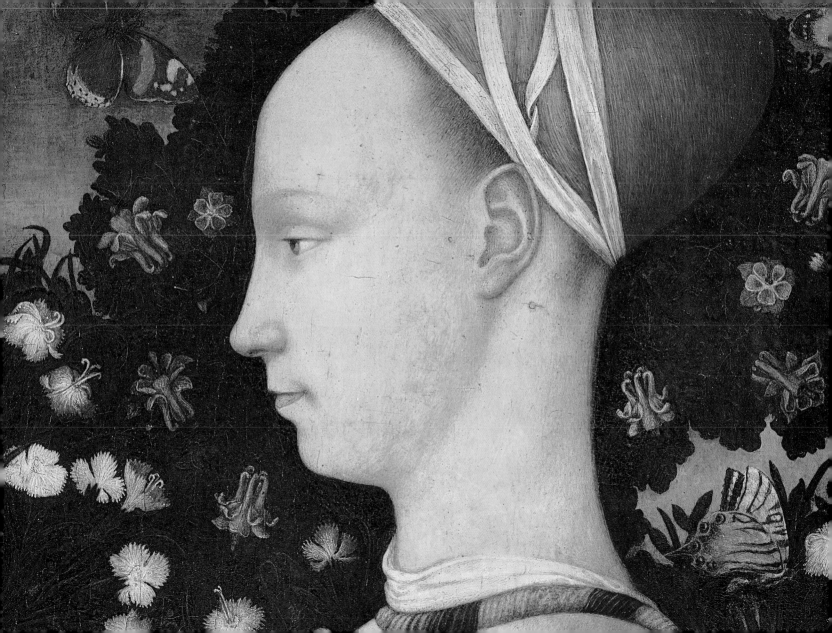

I met the sun's bravado,
And saw below me, fold on fold,
Grey to pearl and pearl to gold,
This London like a land of old ...

HENRY HOWARTH BASHFORD

View of London with the Thames, 1746–47
Canaletto
National Gallery, Prague

1 2 3 4 5 6 7 8 9 10 11 12 **13** 14 15 16 17 18 19 20 21 22 23 24 25 26 27 28 29 30 31

MAY

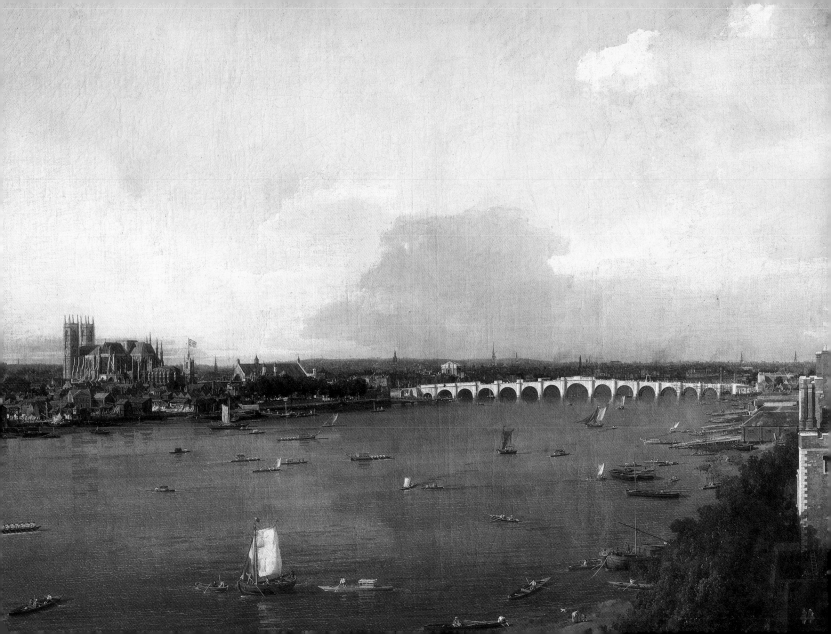

The whole world is one family.

SUN YAT-SEN

Dante's Vision of Rachel and Leah, 1855
Dante Gabriel Rossetti
Tate Gallery, London

1 2 3 4 5 6 7 8 9 10 11 12 13 **14** 15 16 17 18 19 20 21 22 23 24 25 26 27 28 29 30 31

MAY

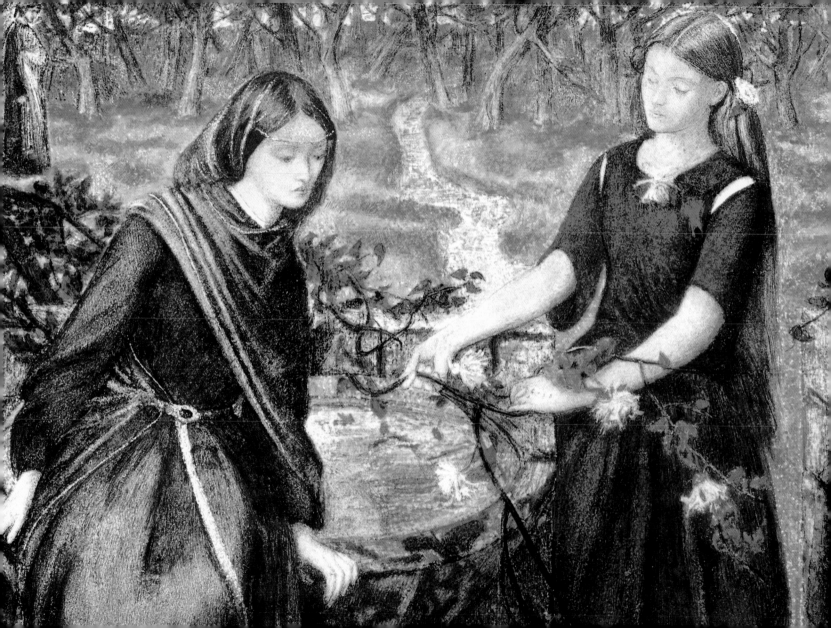

Painting is the aesthetic side of the object but it has never been original, has never been its own goal.

KAZIMIR MALEVICH

Four-Corner and Three-Corner, *c.* 1920
Kazimir Malevich
Private Collection

1 2 3 4 5 6 7 8 9 10 11 12 13 14 **15** 16 17 18 19 20 21 22 23 24 25 26 27 28 29 30 31

MAY

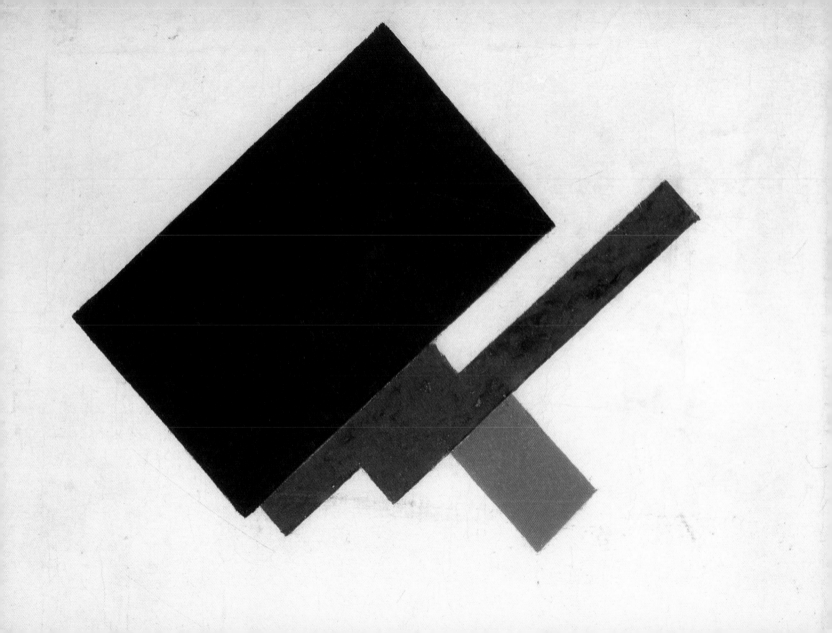

He that will make a good use of any part of his life must allow a large portion of it to recreation.

John Locke

Children on the Water, 1914
August Macke
Private Collection

1 2 3 4 5 6 7 8 9 10 11 12 13 14 15 **16** 17 18 19 20 21 22 23 24 25 26 27 28 29 30 31

MAY

And forget not that the earth delights to feel your bare feet and the winds long to play with your hair.

Kahlil Gibran

Landscape with Clouds, 1893
Hans Thoma
Kunsthalle, Mannheim

1 2 3 4 5 6 7 8 9 10 11 12 13 14 15 16 **17** 18 19 20 21 22 23 24 25 26 27 28 29 30 31

MAY

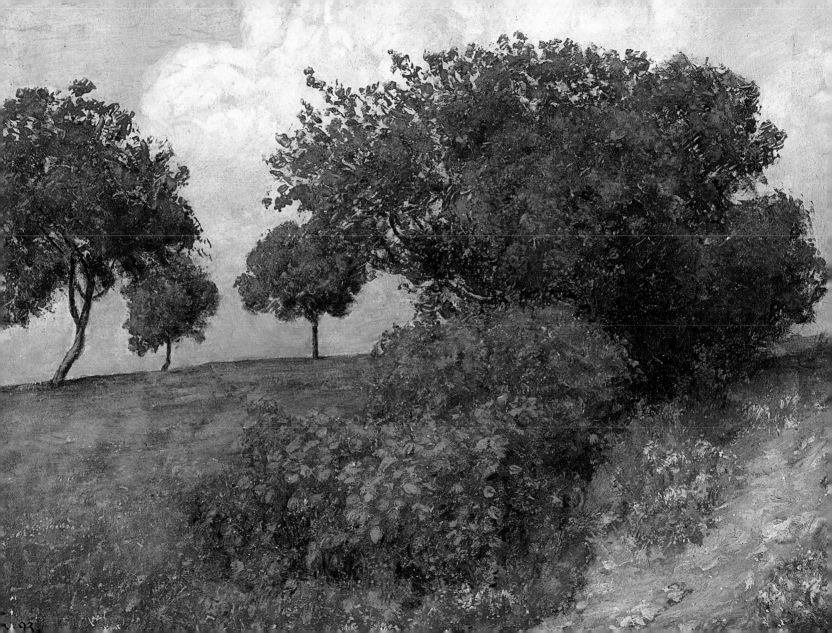

What you do yourself is well done.

<small>DANISH PROVERB</small>

Old Woman Cooking Eggs, 1618
Diego Rodríguez de Velázquez
National Gallery, Edinburgh

1 2 3 4 5 6 7 8 9 10 11 12 13 14 15 16 17 **18** 19 20 21 22 23 24 25 26 27 28 29 30 31

MAY

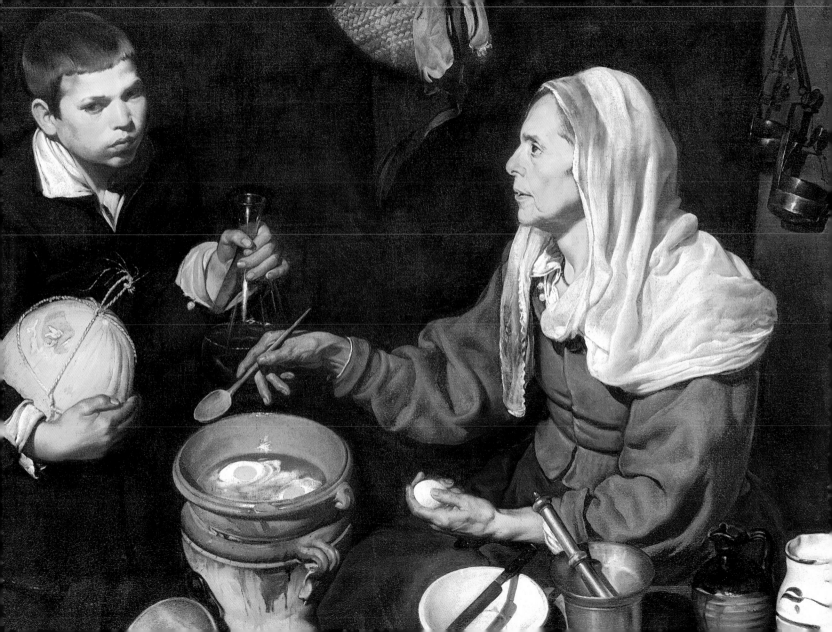

If we could see the miracle of a single flower clearly, our whole life would change.

<small>Buddha</small>

Spring Garden, 1898–1901
Victor Borisov-Musatov
Russian Museum, St. Petersburg

1 2 3 4 5 6 7 8 9 10 11 12 13 14 15 16 17 18 **19** 20 21 22 23 24 25 26 27 28 29 30 31

MAY

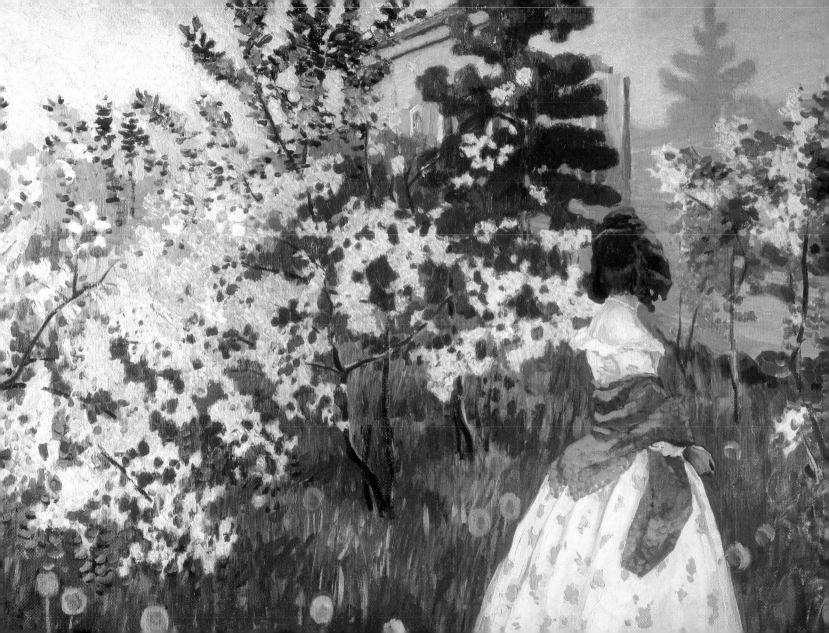

Love is blind, but sees afar.

ITALIAN PROVERB

Venus Blindfolding Cupid, 1565
Titian
The State Hermitage Museum, St. Petersburg

1 2 3 4 5 6 7 8 9 10 11 12 13 14 15 16 17 18 19 **20** 21 22 23 24 25 26 27 28 29 30 31

MAY

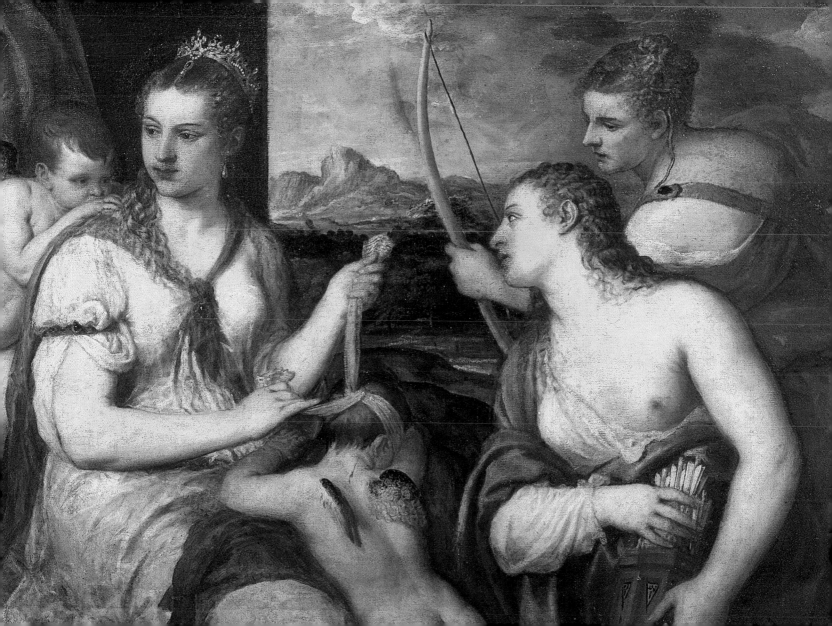

The morning steals upon the night,
Melting the darkness.

WILLIAM SHAKESPEARE

Morning by the Lake, 1858
Charles-François Daubigny
The Pushkin Museum of Fine Arts, Moscow

1 2 3 4 5 6 7 8 9 10 11 12 13 14 15 16 17 18 19 20 21 22 23 24 25 26 27 28 29 30 31

MAY

Observation more than books,
experience rather than persons,
are the prime educators.

<small>AMOS BRONSON ALCOTT</small>

The Town School, 1845
Eduard Ritter
Private Collection

1 2 3 4 5 6 7 8 9 10 11 12 13 14 15 16 17 18 19 20 21 **22** 23 24 25 26 27 28 29 30 31

MAY

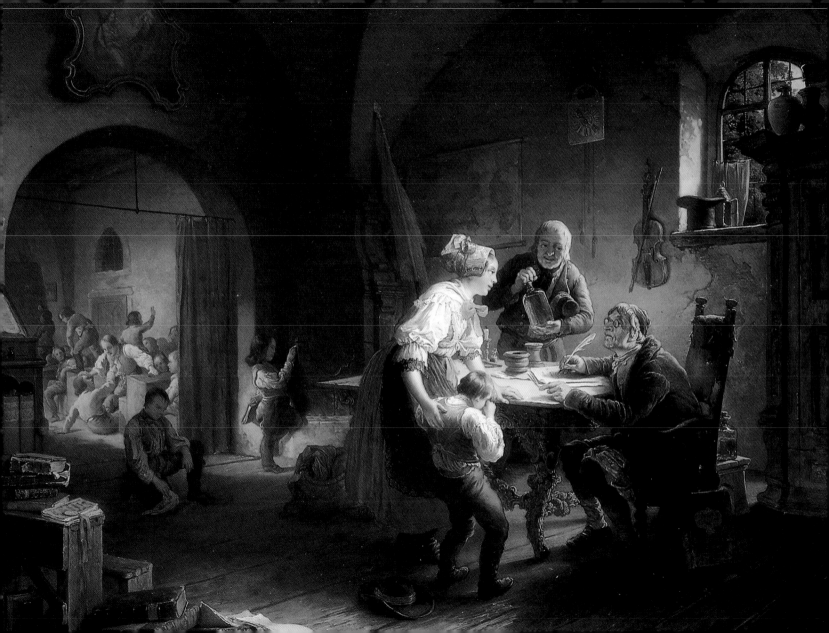

Give me the splendid silent sun
with all his beams full-dazzling.

<small>WALT WHITMAN</small>

The Meadow, 1875
Alfred Sisley
National Gallery, Washington, D.C.

1 2 3 4 5 6 7 8 9 10 11 12 13 14 15 16 17 18 19 20 21 22 **23** 24 25 26 27 28 29 30 31

MAY

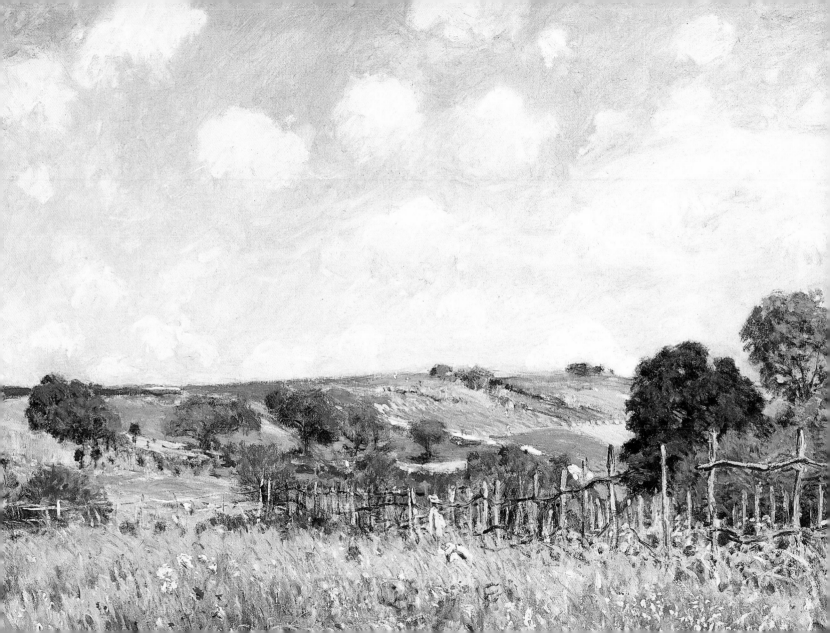

The sun does not shine
for a few trees and flowers,
but for the wide world's joy.

<small>HENRY WARD BEECHER</small>

The Great Sun, 1958
Marc Chagall
Private Collection

1 2 3 4 5 6 7 8 9 10 11 12 13 14 15 16 17 18 19 20 21 22 23 **24** 25 26 27 28 29 30 31

MAY

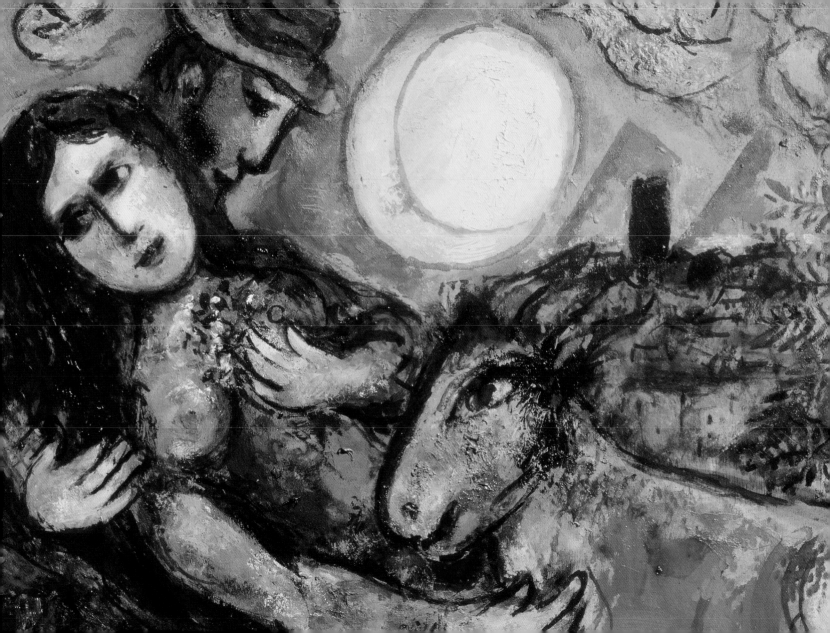

*We work not only to produce
but to give value to time.*

EUGÈNE DELACROIX

Town Landscape with Blacksmiths, 1603
Jan Brueghel the Elder
The Pushkin Museum of Fine Arts, Moscow

1 2 3 4 5 6 7 8 9 10 11 12 13 14 15 16 17 18 19 20 21 22 23 24 **25** 26 27 28 29 30 31

MAY

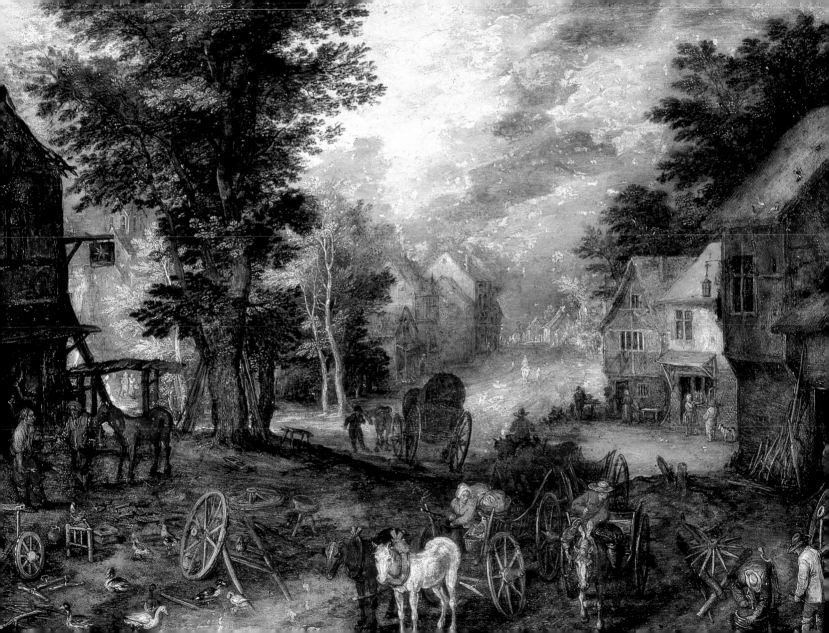

*The golden moments in the stream of life
rush past us and we see nothing but sand.
The angels come to visit us, and we only
know them when they are gone.*

<small>GEORGE ELIOT</small>

At the Beach, 1873
Edouard Manet
Musée d'Orsay, Paris

1 2 3 4 5 6 7 8 9 10 11 12 13 14 15 16 17 18 19 20 21 22 23 24 25 **26** 27 28 29 30 31

MAY

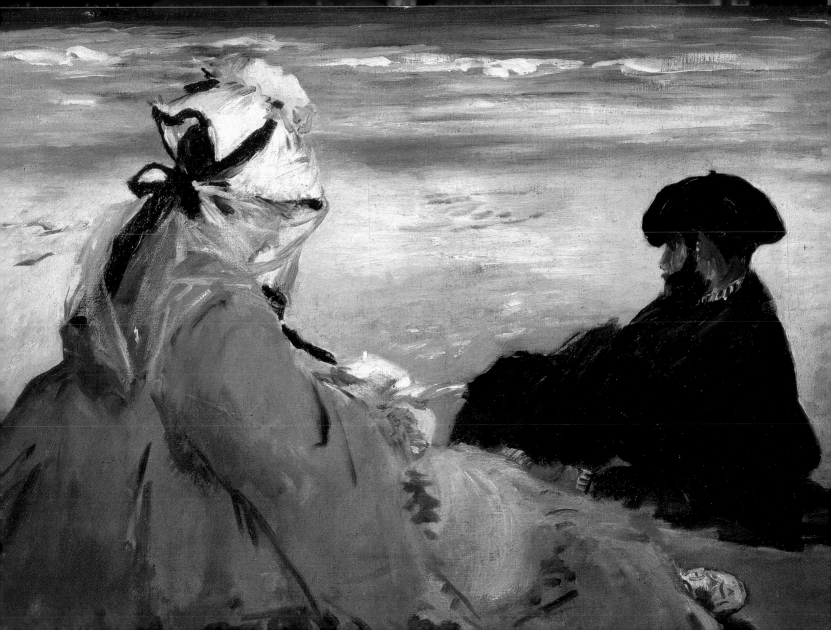

The Awakening of Adonis, 1899
John William Waterhouse
Christie's, London

Eden revives in the first kiss of love.

<small>Lord Byron</small>

1 2 3 4 5 6 7 8 9 10 11 12 13 14 15 16 17 18 19 20 21 22 23 24 25 26 **27** 28 29 30 31

May

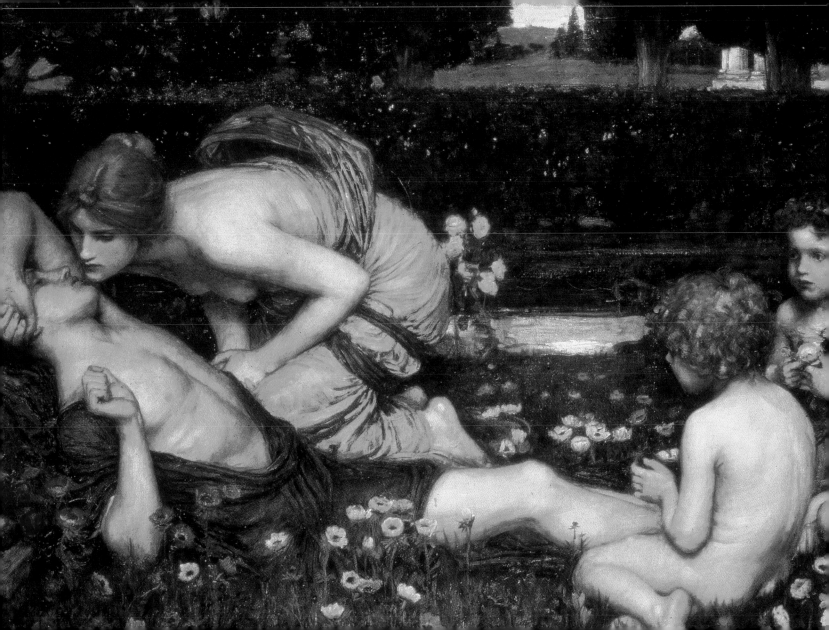

I could paint for a hundred years,
a thousand years without stopping
and I would still feel as though
I knew nothing.

PAUL CÉZANNE

House in Aix-en-Provence, 1885–87
Paul Cézanne
National Gallery, Prague

1 2 3 4 5 6 7 8 9 10 11 12 13 14 15 16 17 18 19 20 21 22 23 24 25 26 27 **28** 29 30 31

MAY

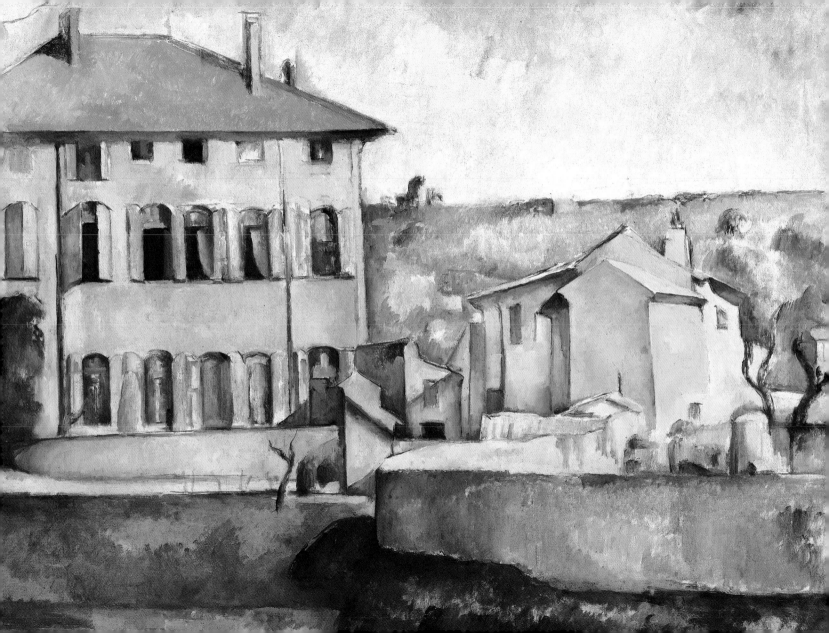

You should examine yourself daily.
If you find faults, you should correct them.
When you find none, you should try
even harder.

Xɪ Zʜɪ

I Lock the Door upon Myself, 1891
Fernand Khnopff
Neue Pinakothek, Munich

1 2 3 4 5 6 7 8 9 10 11 12 13 14 15 16 17 18 19 20 21 22 23 24 25 26 27 28 **29** 30 31

MAY

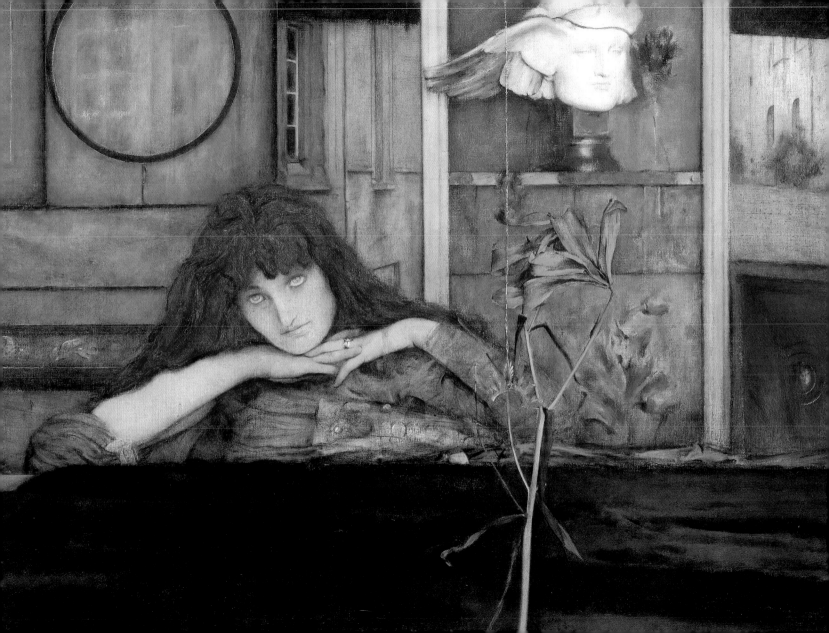

I've caught this magical landscape and it's the enchantment of it that I'm so keen to render. Of course, lots of people will protest that it's quite unreal, but that's just too bad.

<small>CLAUDE MONET</small>

Garden at Sainte-Adresse, 1867
Claude Monet
The Metropolitan Museum of Art, New York

1 2 3 4 5 6 7 8 9 10 11 12 13 14 15 16 17 18 19 20 21 22 23 24 25 26 27 28 29 **30** 31

MAY

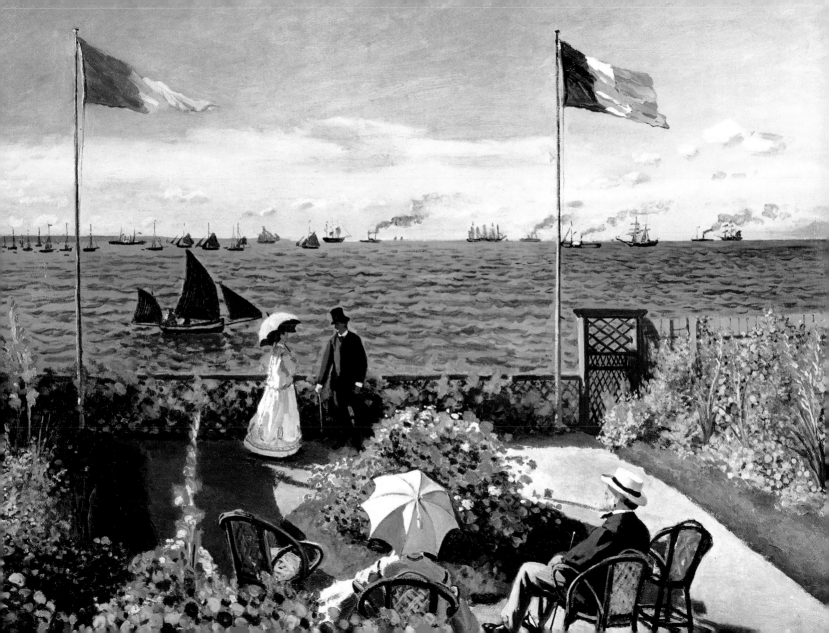

He who sees his heir in his own child,
carries his eye over hopes and possessions
lying far beyond his gravestone …

<small>EDWARD GEORGE BULWER-LYTTON</small>

Heneage Lloyd and His Sister, 1750
Thomas Gainsborough
Fitzwilliams Museum, Cambridge

1 2 3 4 5 6 7 8 9 10 11 12 13 14 15 16 17 18 19 20 21 22 23 24 25 26 27 28 29 30 **31**

MAY

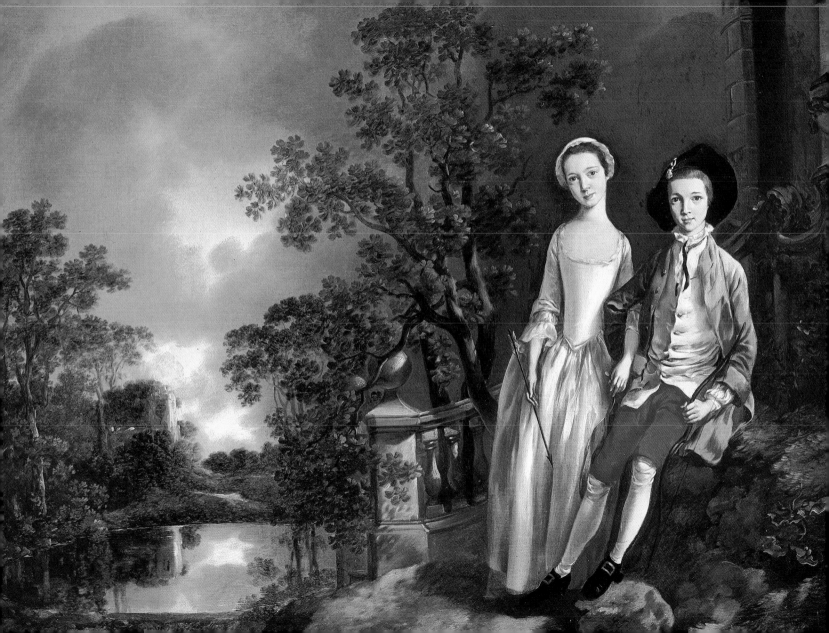

Tobias said, "I will not eat nor drink here this day, unless thou first grant me my petition, and promise to give me Sarah thy daughter."

THE BOOK OF TOBIT, 7:10

Sarah Awaits Tobias on the Wedding Night, 1644
Rembrandt van Rijn
National Gallery, Edinburgh

1 2 3 4 5 6 7 8 9 10 11 12 13 14 15 16 17 18 19 20 21 22 23 24 25 26 27 28 29 30

JUNE

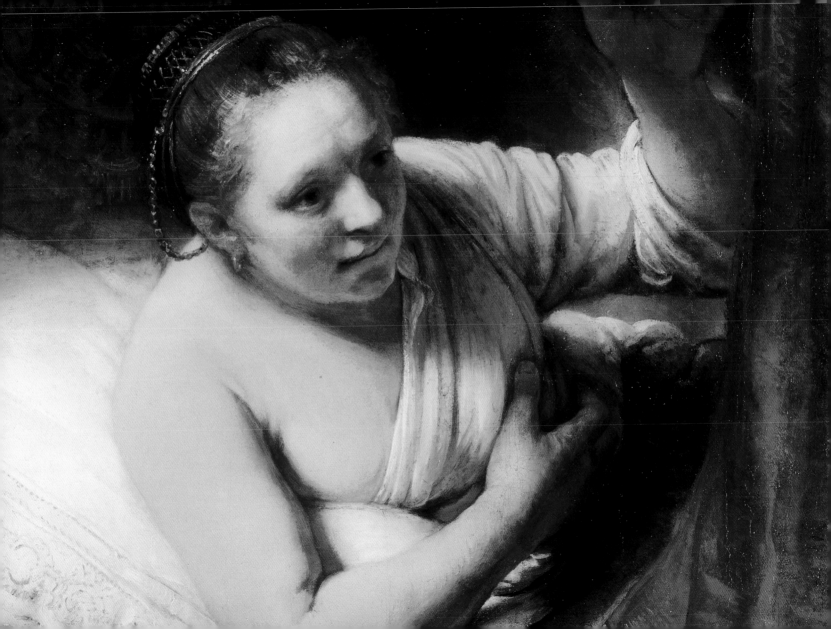

Everything existing in the universe is the fruit of chance and necessity.

<small>DEMOCRITUS</small>

The Lottery: the Reading of the Numbers, 1861–66
John Phillip
City of Aberdeen Art Gallery and Museum Collections

1 **2** 3 4 5 6 7 8 9 10 11 12 13 14 15 16 17 18 19 20 21 22 23 24 25 26 27 28 29 30

JUNE

Veni, vidi, vici.
(I came, I saw, I conquered.)

GAIUS JULIUS CAESAR

Shepherd Boy on a Hill, 19th century
Franz von Lenbach
Lenbachhaus, Munich

1 2 **3** 4 5 6 7 8 9 10 11 12 13 14 15 16 17 18 19 20 21 22 23 24 25 26 27 28 29 30

JUNE

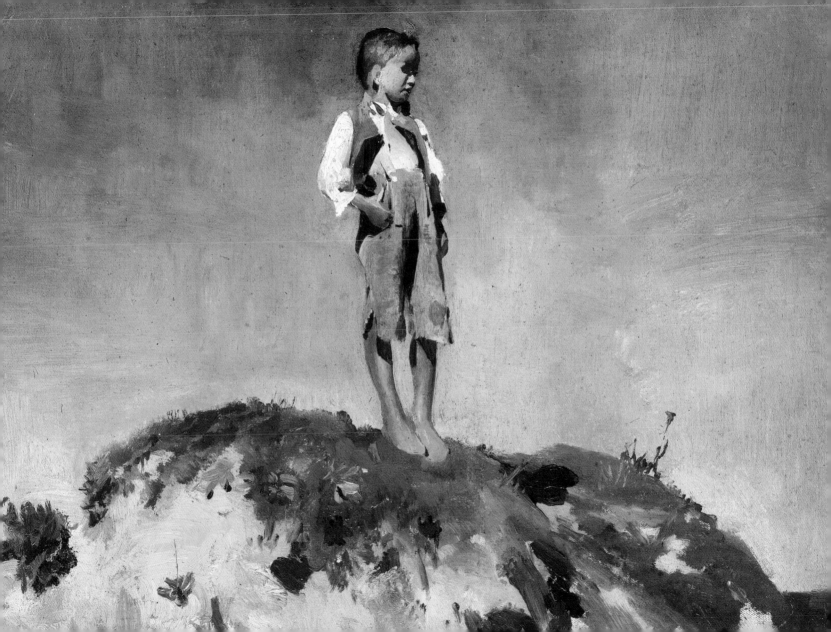

I am a landmark. Others will come.

Paul Cézanne

Blue Landscape, *c.* 1903
Paul Cézanne
The State Hermitage Museum, St. Petersburg

1 2 3 **4** 5 6 7 8 9 10 11 12 13 14 15 16 17 18 19 20 21 22 23 24 25 26 27 28 29 30

JUNE

Away, away, from men and towns,
To the wild wood and the downs,
To the silent wilderness.

PERCY BYSSHE SHELLEY

Apparition in the Woods, *c.* 1858
Moritz von Schwind
Schack Gallery, Munich

1 2 3 4 **5** 6 7 8 9 10 11 12 13 14 15 16 17 18 19 20 21 22 23 24 25 26 27 28 29 30

JUNE

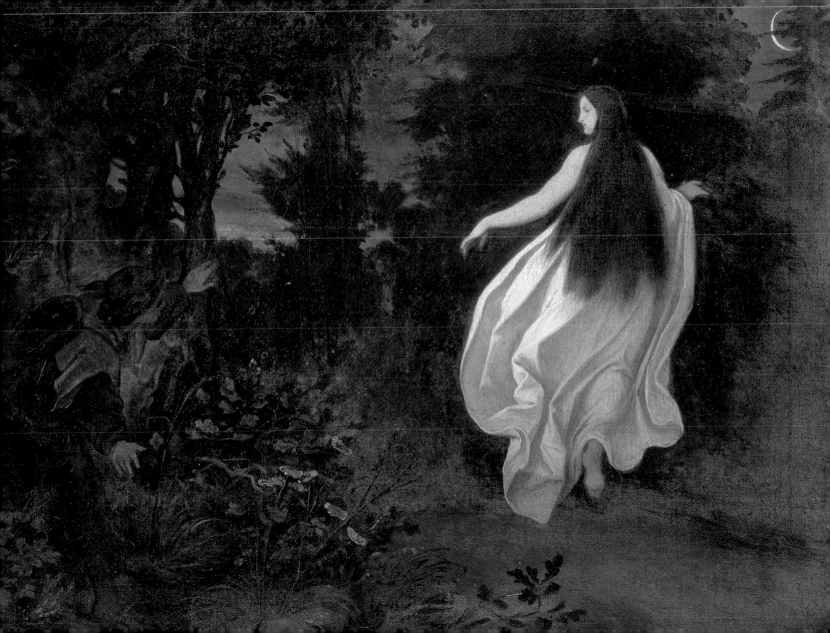

Beauty's choicest mirror is an admiring eye.

JAMES LENDALL BASFORD

The Turkish Bath, 1863
Jean-Auguste-Dominique Ingres
Musée du Louvre, Paris

1 2 3 4 5 **6** 7 8 9 10 11 12 13 14 15 16 17 18 19 20 21 22 23 24 25 26 27 28 29 30

JUNE

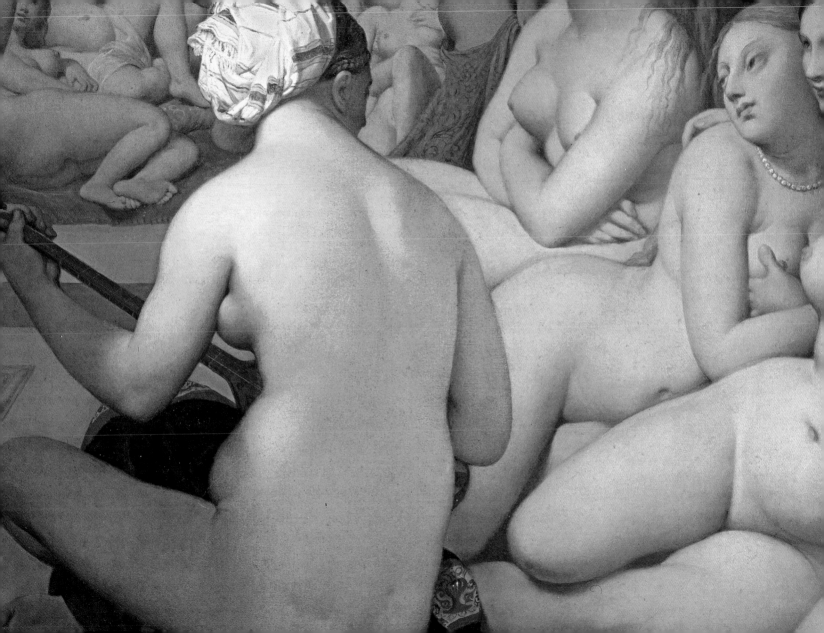

Human subtelty will never devise an invention more beautiful, more simple or more direct than does nature, because in her inventions, nothing is lacking and nothing is superfluous.

LEONARDO DA VINCI

Mona Lisa, *c.* 1503
Leonardo da Vinci
Musée du Louvre, Paris

1 2 3 4 5 6 **7** 8 9 10 11 12 13 14 15 16 17 18 19 20 21 22 23 24 25 26 27 28 29 30

JUNE

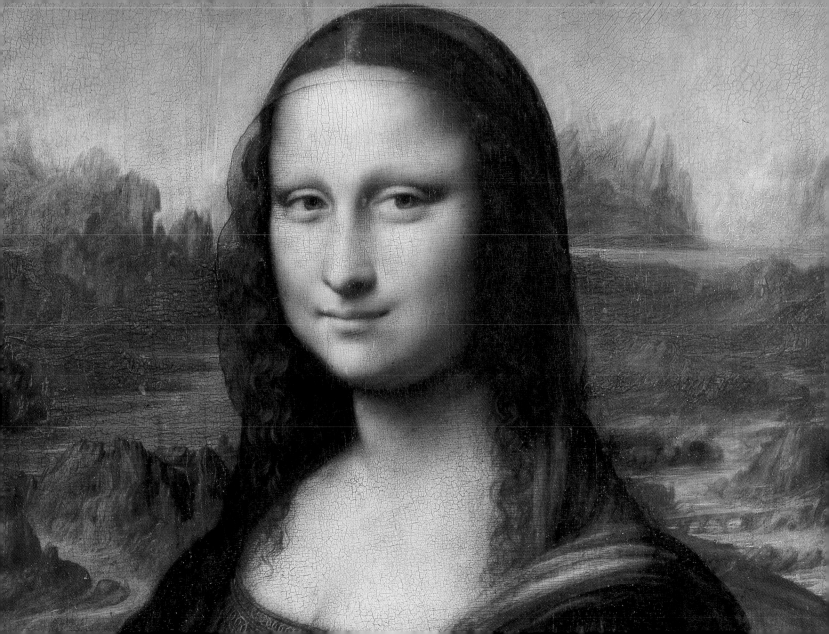

See the rivers, how they run,
Changeless to the changeless sea.

CHARLES KINGSLEY

Arai, from "Fifty-three Stations of the Tokaido," *c.* 1833–34
Utagawa Hiroshige

1 2 3 4 5 6 7 8 9 10 11 12 13 14 15 16 17 18 19 20 21 22 23 24 25 26 27 28 29 30

JUNE

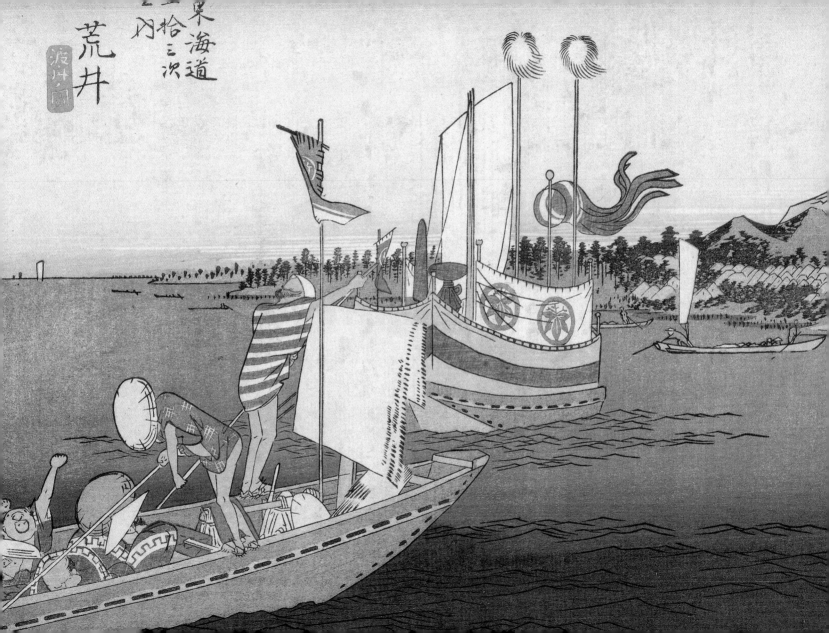

In shape and feature Beauty's queen,
In pastoral array.

ANON.

Diana Leaves Her Bath, 1742
François Boucher
Musée du Louvre, Paris

1 2 3 4 5 6 7 8 **9** 10 11 12 13 14 15 16 17 18 19 20 21 22 23 24 25 26 27 28 29 30

JUNE

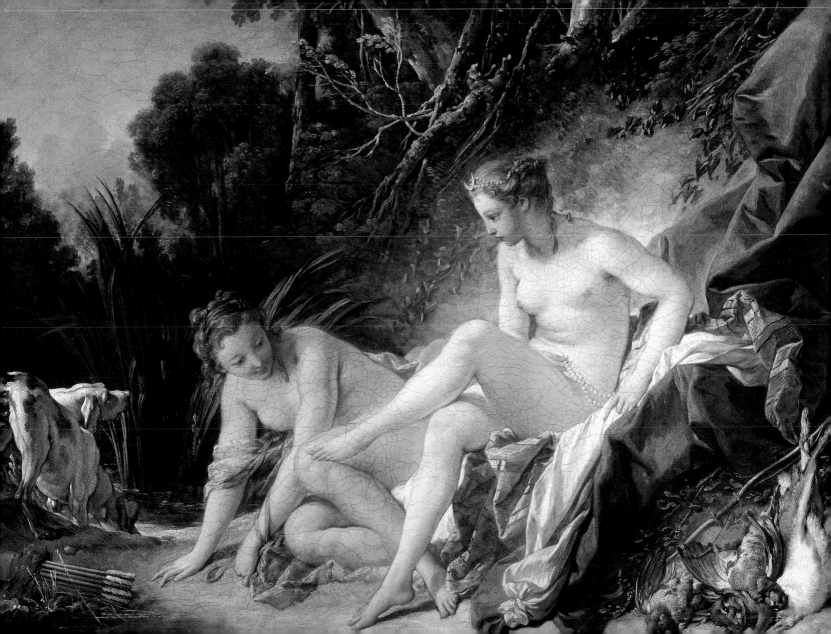

*The goal of life is living
in agreement with nature.*

Zeno

Salem Cove, 1916
Maurice Prendergast
National Gallery of Art, Washington, D.C.

1 2 3 4 5 6 7 8 9 **10** 11 12 13 14 15 16 17 18 19 20 21 22 23 24 25 26 27 28 29 30

JUNE

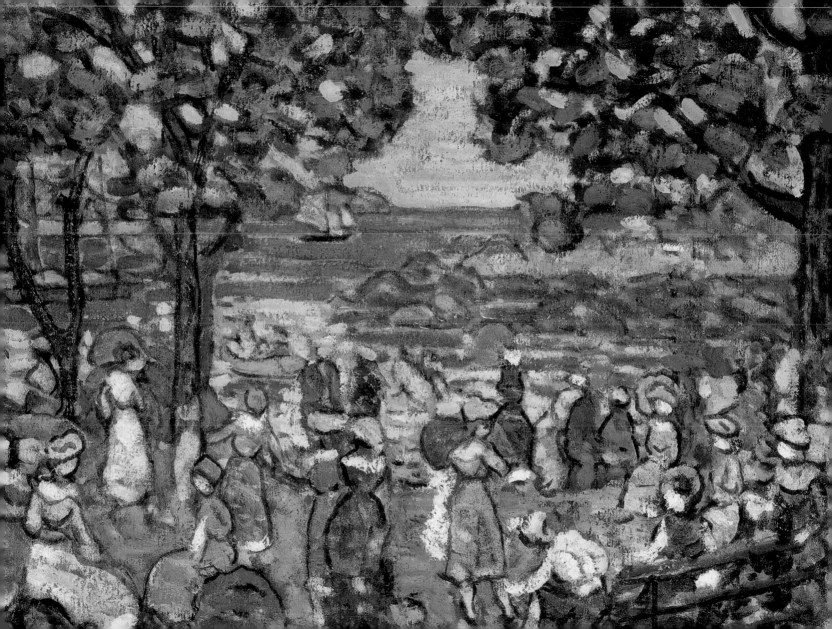

*What a desolate place would be a world
without a flower! It would be a face
without a smile...
Are not flowers the stars of the earth,
and are not our stars the flowers of heaven?*

CLARA LUCAS BALFOUR

The Garden of Leibl in Aibling, c. 1880
Johann Sperl
Lenbachhaus, Munich

1 2 3 4 5 6 7 8 9 10 **11** 12 13 14 15 16 17 18 19 20 21 22 23 24 25 26 27 28 29 30

JUNE

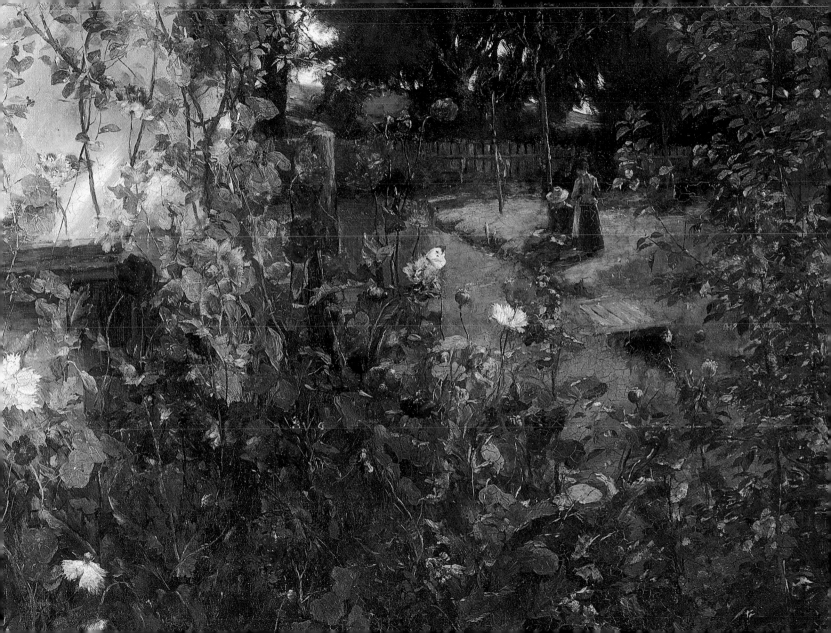

Whenever you are sincerely pleased you are nourished.

Ralph Waldo Emerson

Satyr and Maiden with a Basket of Fruit, early 17th century
Peter Paul Rubens
Residenzgalerie, Salzburg

12

1 2 3 4 5 6 7 8 9 10 11 **12** 13 14 15 16 17 18 19 20 21 22 23 24 25 26 27 28 29 30

June

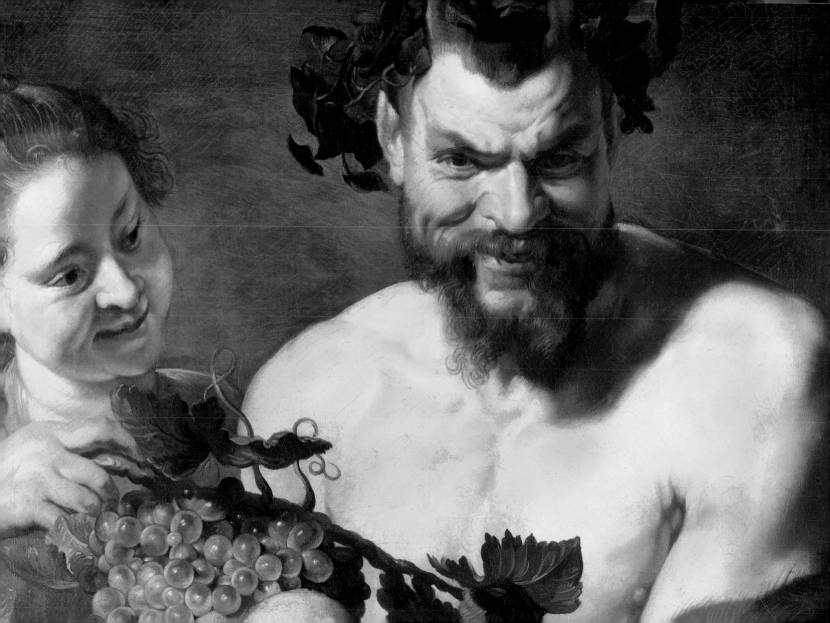

Home is where the heart is.

<small>KARL KRAUS</small>

Portrait of a Ten-Person Family, 1647–50
Frans Hals
National Gallery, London

1 2 3 4 5 6 7 8 9 10 11 12 **13** 14 15 16 17 18 19 20 21 22 23 24 25 26 27 28 29 30

JUNE

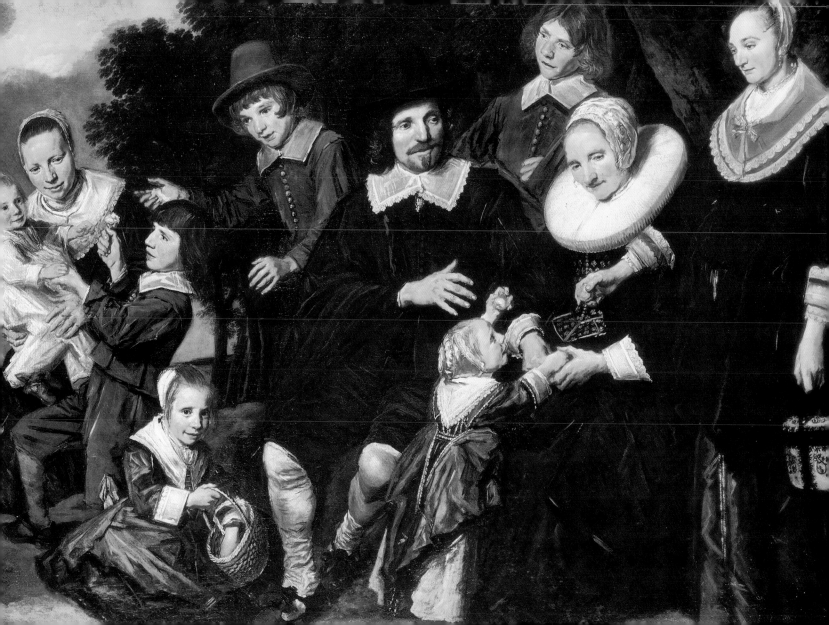

The sun, center and sire of light,
The keystone of the world-built arch of heaven.

<small>PHILIP JAMES BAILEY</small>

Sun over the Ocean, 1829
Carl Blechen
National Gallery, Berlin

1 2 3 4 5 6 7 8 9 10 11 12 13 **14** 15 16 17 18 19 20 21 22 23 24 25 26 27 28 29 30

JUNE

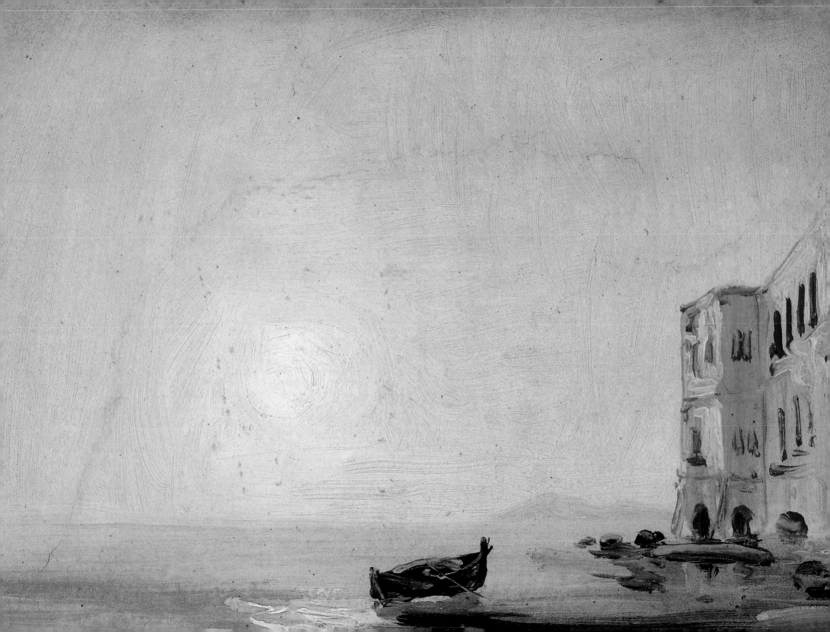

What know we of the blest above
But that they sing, and that they love?

WILLIAM WORDSWORTH

Mary with Child and Angels, 1517
Rosso Fiorentino
The State Hermitage Museum, St. Petersburg

1 2 3 4 5 6 7 8 9 10 11 12 13 14 **15** 16 17 18 19 20 21 22 23 24 25 26 27 28 29 30

JUNE

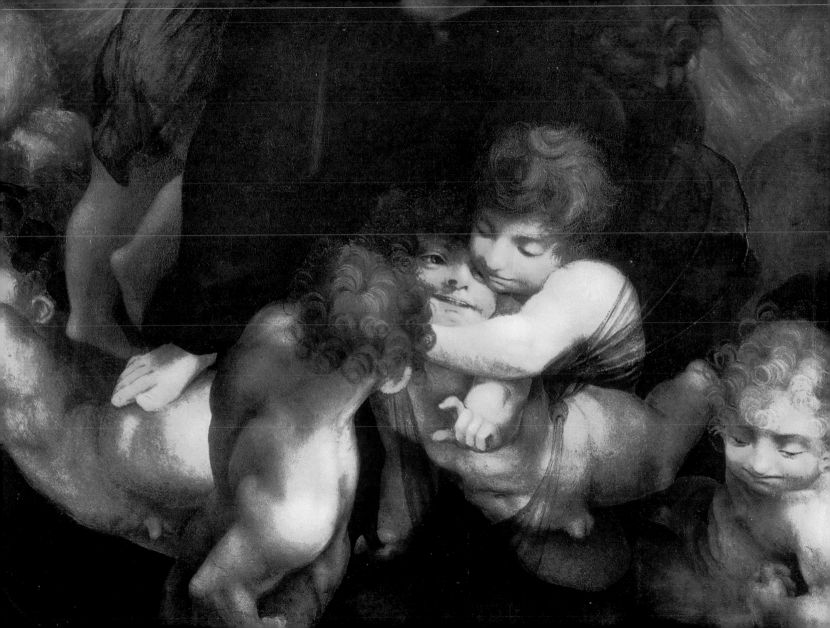

Haven't we learned in the last thousand years that the more we confront objects with the reflection of their appearance, the more silent they become?

Franz Marc

Playing Forms, 1914
Franz Marc
Private Collection

1 2 3 4 5 6 7 8 9 10 11 12 13 14 15 **16** 17 18 19 20 21 22 23 24 25 26 27 28 29 30

JUNE

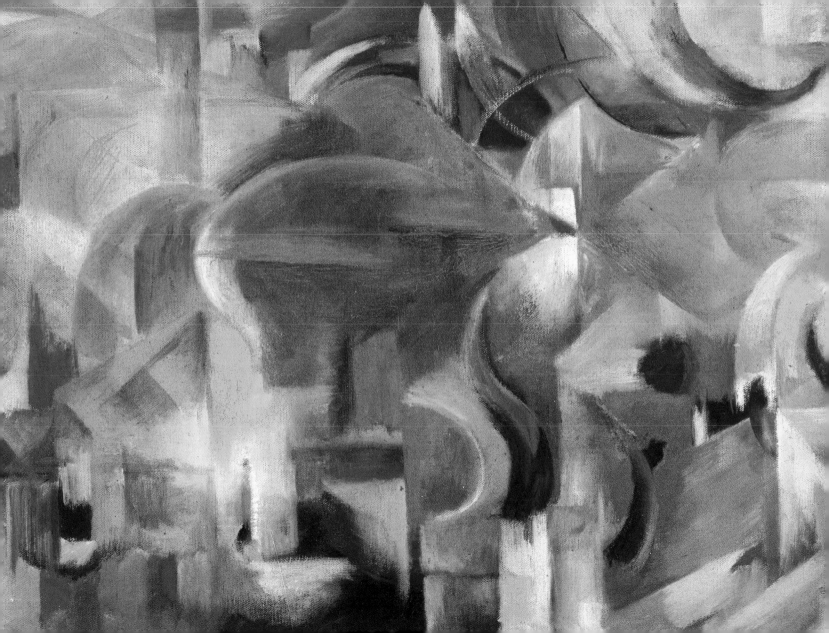

*Nothing so much convinces me
of the boundlessness of the human mind
as its operations in dreaming.*

WILLIAM BENTON CLULOW

The Nightmare, 1810–20
Johann Heinrich Füssli
Private Collection

1 2 3 4 5 6 7 8 9 10 11 12 13 14 15 16 **17** 18 19 20 21 22 23 24 25 26 27 28 29 30

JUNE

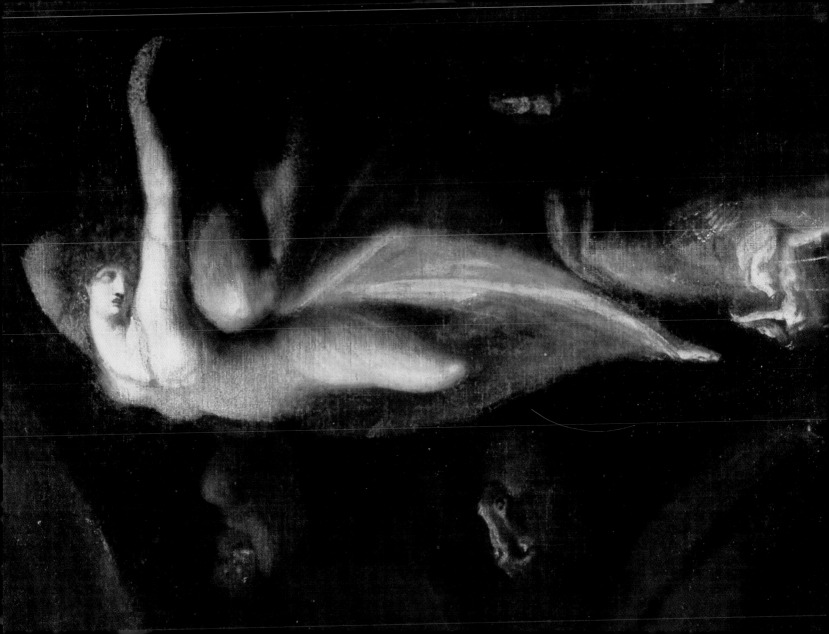

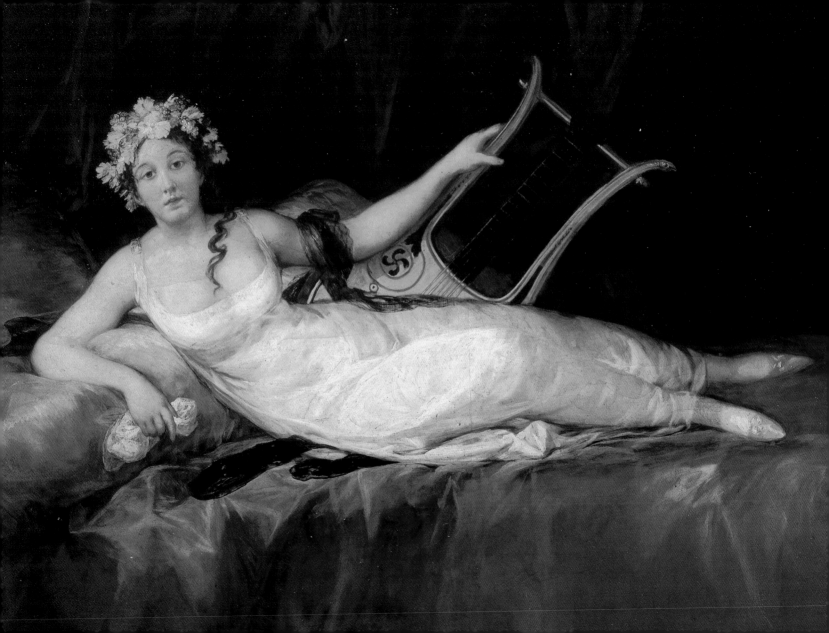

The golden age has not passed.
It lies in the future.

Antibes: The Pink Cloud, 1916
Paul Signac
Private Collection

1 2 3 4 5 6 7 8 9 10 11 12 13 14 15 16 17 18 19 20 21 22 23 24 25 26 27 28 **29** 30

June

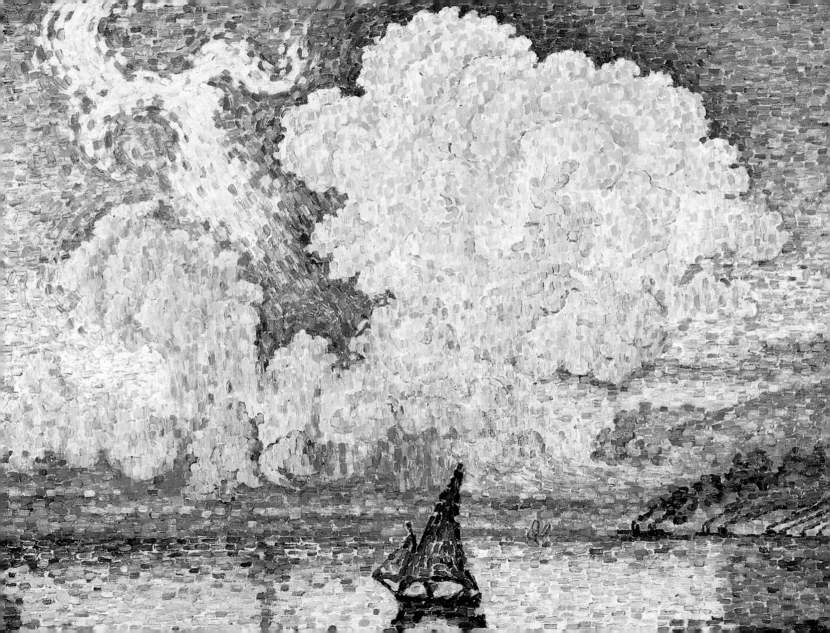

... the glorious sun
Stays in his course and plays the alchemist,
Turning with splendor of his precious eye
The meager cloddy earth to glittering gold ...

WILLIAM SHAKESPEARE

The Alchemist, 19th century
Carl Spitzweg
Staatsgalerie, Stuttgart

1 2 3 4 5 6 7 8 9 10 11 12 13 14 15 16 17 18 19 20 21 22 23 24 25 26 27 28 29 30

JUNE

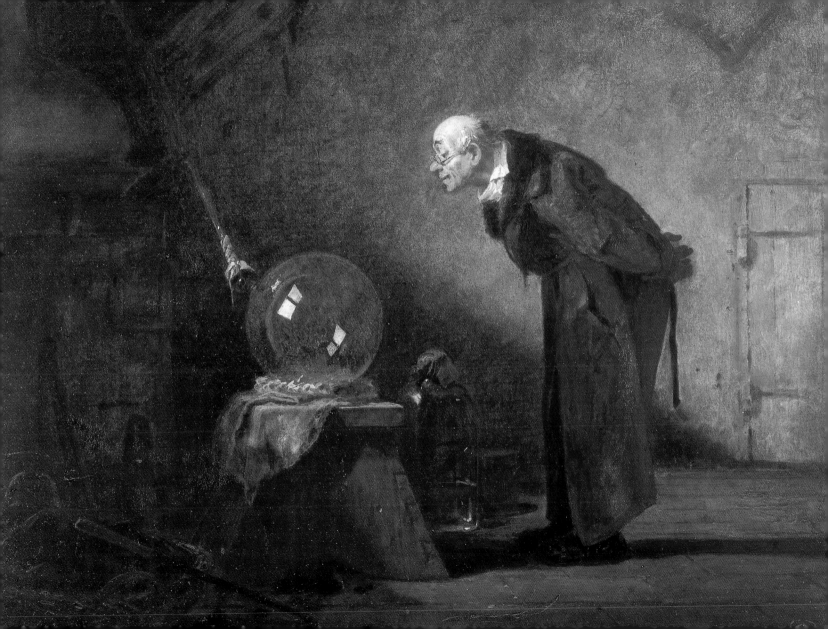

For my part, I travel not to go anywhere,
but to go. I travel for travel's sake.

<small>Robert Louis Stevenson</small>

The Embarcation to Kythera, 1717
Jean-Antoine Watteau
Musée du Louvre, Paris

1 2 3 4 5 6 7 8 9 10 11 12 13 14 15 16 17 18 19 20 21 22 23 24 25 26 27 28 29 30 31

JULY

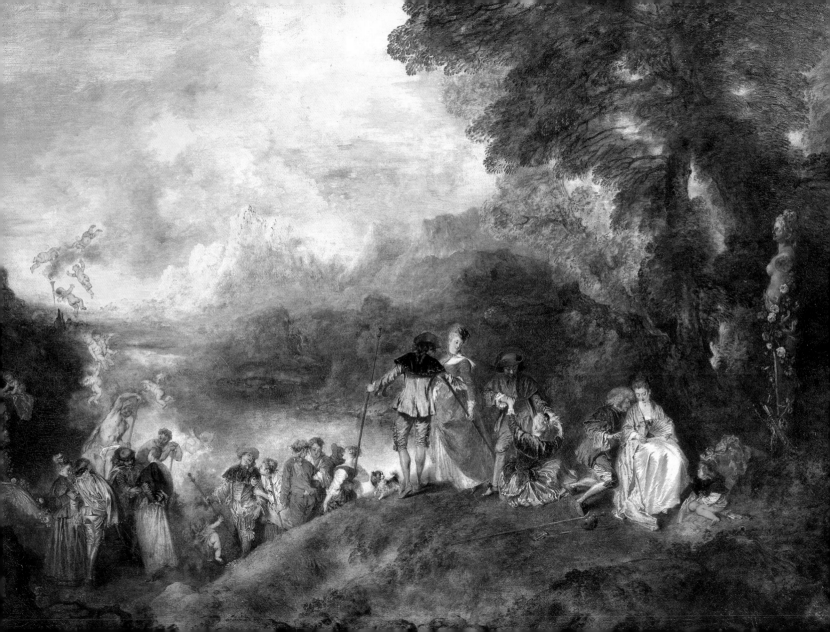

I never saw an ugly thing in my life.

JOHN CONSTABLE

View of the Highgate from Hampstead Heath, 1830s
John Constable
The Pushkin Museum of Fine Arts, Moscow

1 **2** 3 4 5 6 7 8 9 10 11 12 13 14 15 16 17 18 19 20 21 22 23 24 25 26 27 28 29 30 31

JULY

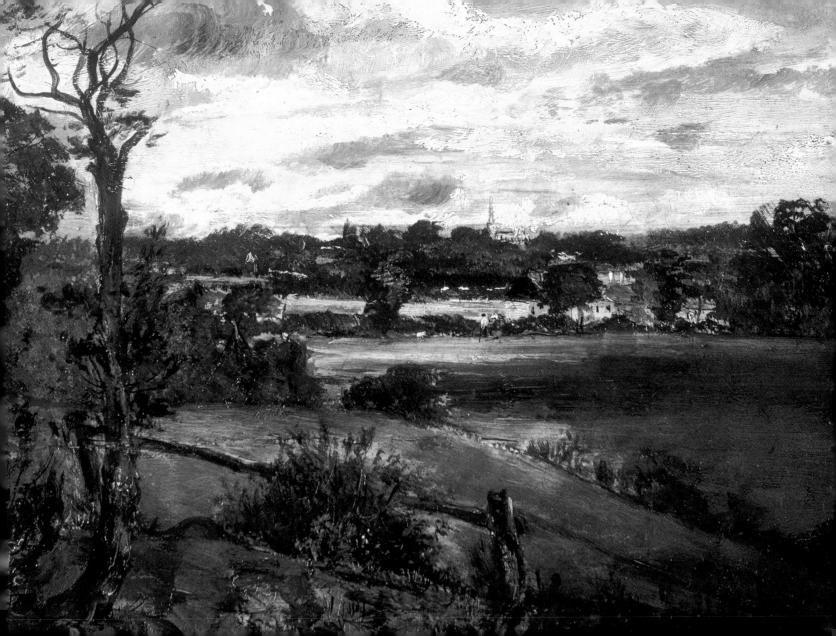

You were made for enjoyment, and the world
was filled with things which you will enjoy…

The Balloon, 1899
Félix Vallotton
Musée d'Orsay, Paris

1 2 **3** 4 5 6 7 8 9 10 11 12 13 14 15 16 17 18 19 20 21 22 23 24 25 26 27 28 29 30 31

JULY

*We hold these truths to be self-evident,
that all men are created equal, that they are
endowed by their Creator with certain
unalienable Rights, that among these are
Life, Liberty and the pursuit of Happiness.*

THOMAS JEFFERSON (AMERICAN DECLARATION OF INDEPENDENCE)

The Declaration of Independence, 1786–97
John Trumbull
Yale University Art Gallery, New Haven

1 2 3 4 5 6 7 8 9 10 11 12 13 14 15 16 17 18 19 20 21 22 23 24 25 26 27 28 29 30 31

JULY

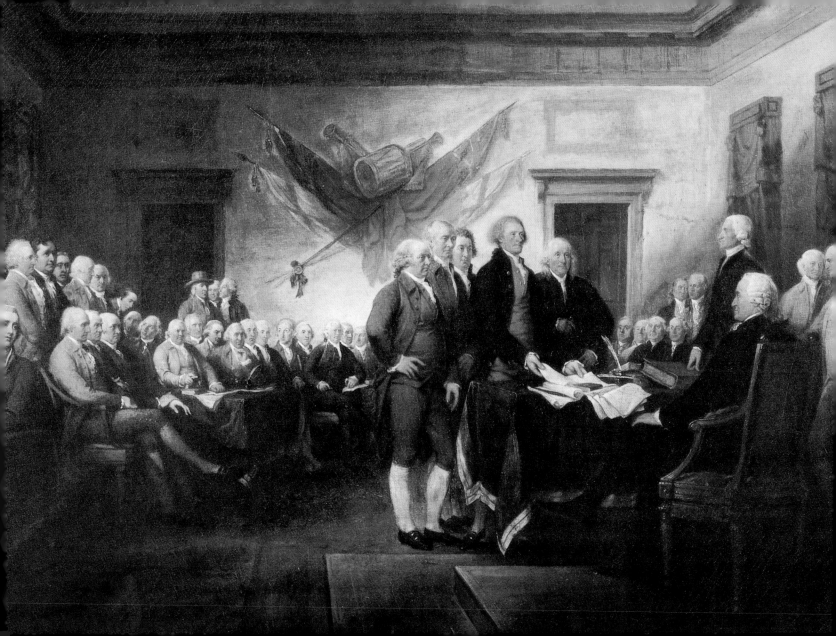

In dreams we are true poets.

Ralph Waldo Emerson

The Dream, 1912
Franz Marc
Private Collection

1 2 3 4 **5** 6 7 8 9 10 11 12 13 14 15 16 17 18 19 20 21 22 23 24 25 26 27 28 29 30 31

July

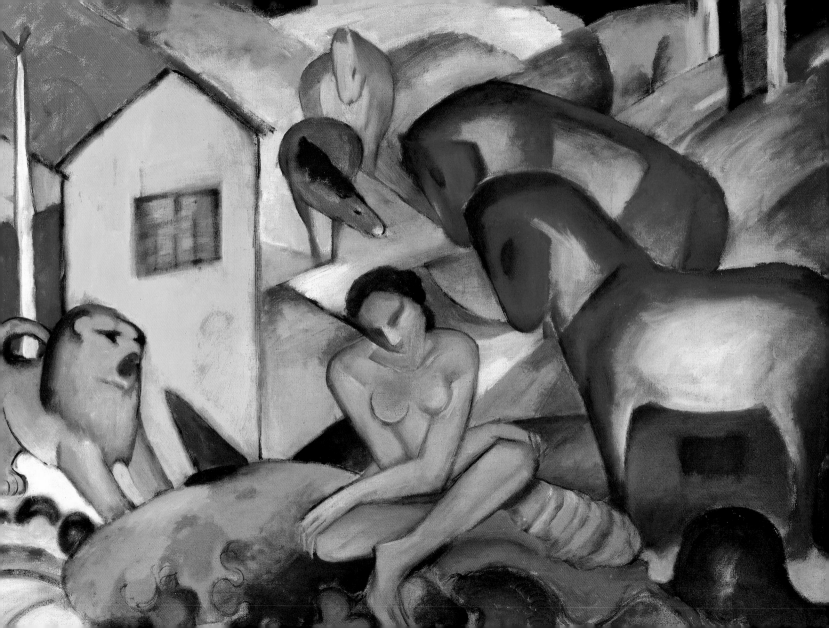

*All really great pictures exhibit the general
habits of nature, manifested in some peculiar,
rare, and beautiful way.*

JOHN RUSKIN

Sundown over a Lake, 1840
Joseph Mallord William Turner
Tate Gallery, London

1 2 3 4 5 **6** 7 8 9 10 11 12 13 14 15 16 17 18 19 20 21 22 23 24 25 26 27 28 29 30 31

JULY

Whoever you are, motion and reflection are especially for you, The divine ship sails the divine sea for you.

<small>WALT WHITMAN</small>

Harbor, 1901
Félix Vallotton
The Pushkin Museum of Fine Arts, Moscow

7

1 2 3 4 5 6 7 8 9 10 11 12 13 14 15 16 17 18 19 20 21 22 23 24 25 26 27 28 29 30 31

JULY

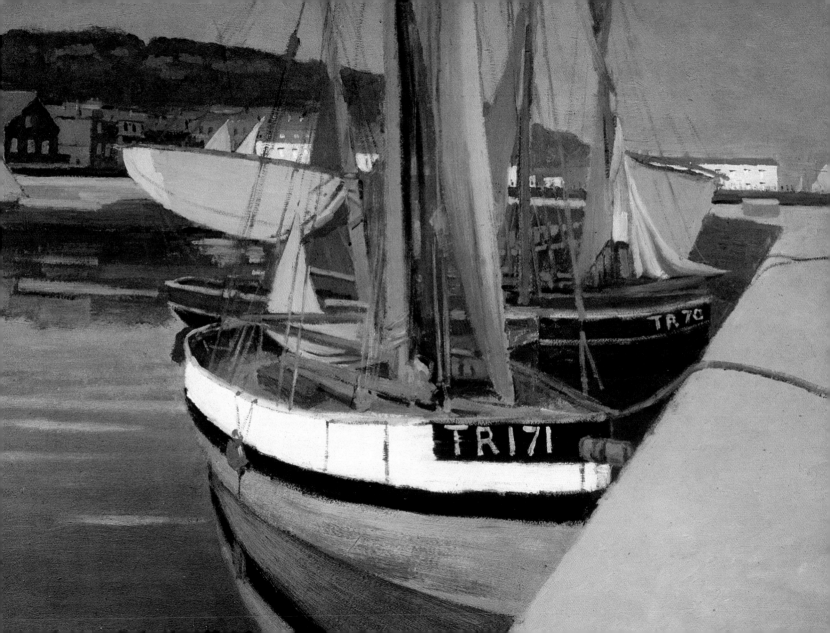

*Novelty is seldom the essential ...
make a subject better from its
intrinsic nature.*

Henri de Toulouse-Lautrec

In the Moulin Rouge, 1892
Henri de Toulouse-Lautrec
National Gallery, Prague

1 2 3 4 5 6 7 **8** 9 10 11 12 13 14 15 16 17 18 19 20 21 22 23 24 25 26 27 28 29 30 31

JULY

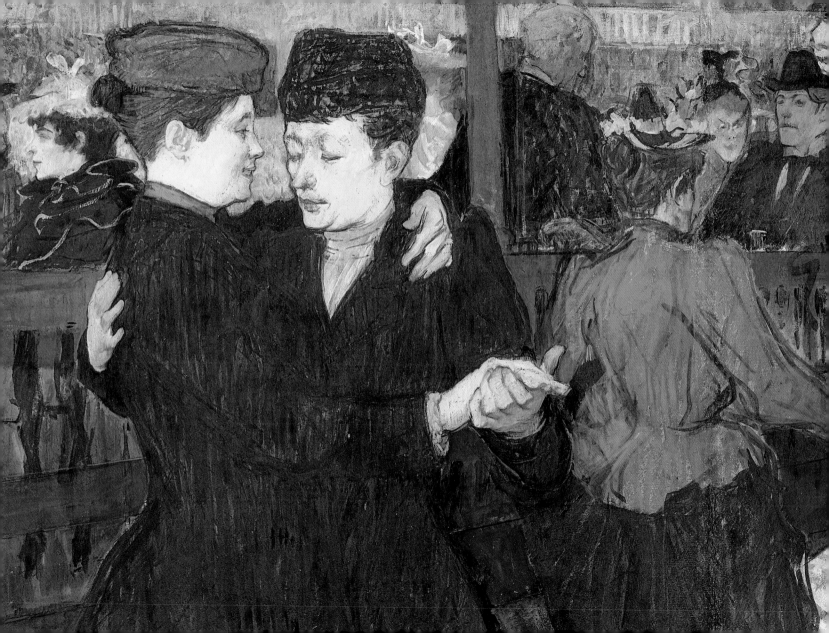

*The anarchist painter is not the one
who will create anarchist pictures,
but the one who will fight with all his
individuality against official conventions.*

PAUL SIGNAC

The Papal Palace in Avignon, 1900
Paul Signac
Musée d'Orsay, Paris

1 2 3 4 5 6 7 8 **9** 10 11 12 13 14 15 16 17 18 19 20 21 22 23 24 25 26 27 28 29 30 31

JULY

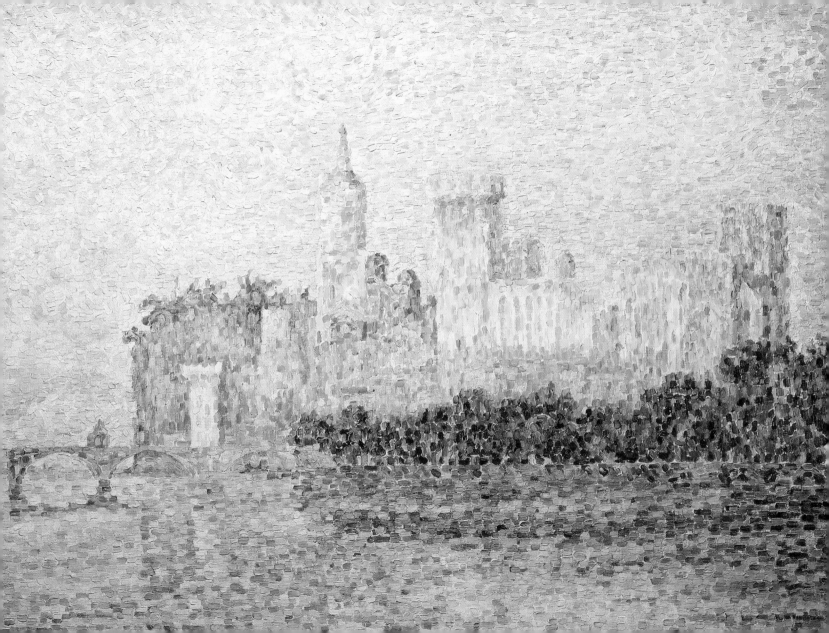

Art is not the application of a canon of beauty but what the instinct and the brain can conceive beyond any canon. When we love a woman we don't start measuring her limbs.

PABLO PICASSO

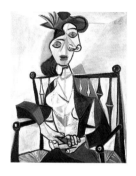

Sitting Woman (Dora Maar), 1941
Pablo Picasso
Pinakothek der Moderne, Munich

1 2 3 4 5 6 7 8 9 **10** 11 12 13 14 15 16 17 18 19 20 21 22 23 24 25 26 27 28 29 30 31

JULY

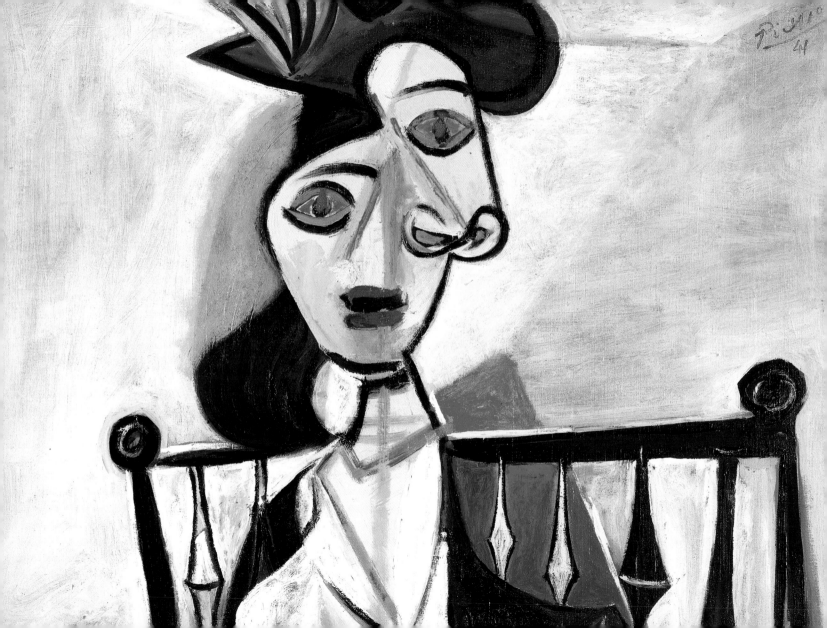

There are no lines in nature,
only areas of color, one against another.

EDOUARD MANET

Horse Race in Longchamps, 1864
Edouard Manet
The Art Institute of Chicago

1 2 3 4 5 6 7 8 9 10 **11** 12 13 14 15 16 17 18 19 20 21 22 23 24 25 26 27 28 29 30 31

JULY

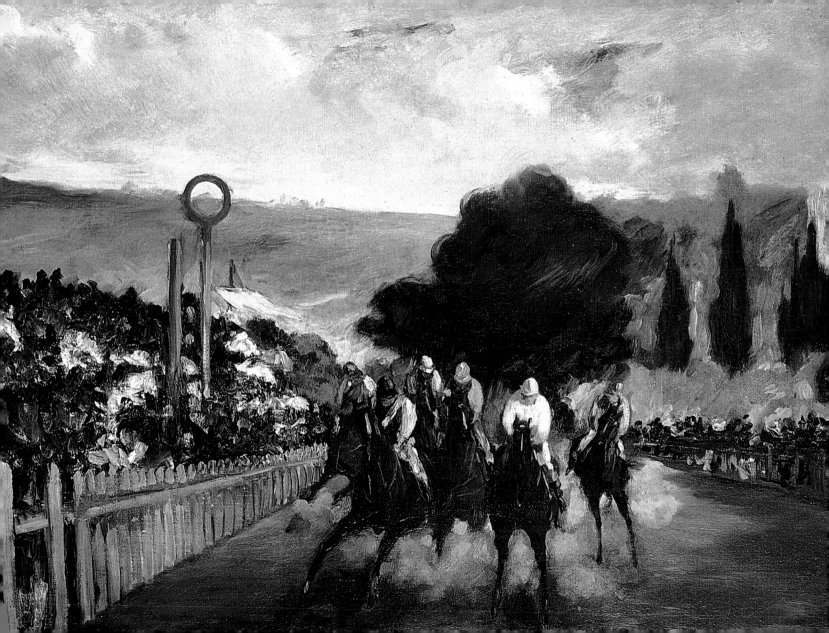

I am lord of myself, accountable to none.

<small>BENJAMIN FRANKLIN</small>

Young Woman Standing on the Rocks, 1888
Winslow Homer
Christie's, New York

1 2 3 4 5 6 7 8 9 10 11 **12** 13 14 15 16 17 18 19 20 21 22 23 24 25 26 27 28 29 30 31

JULY

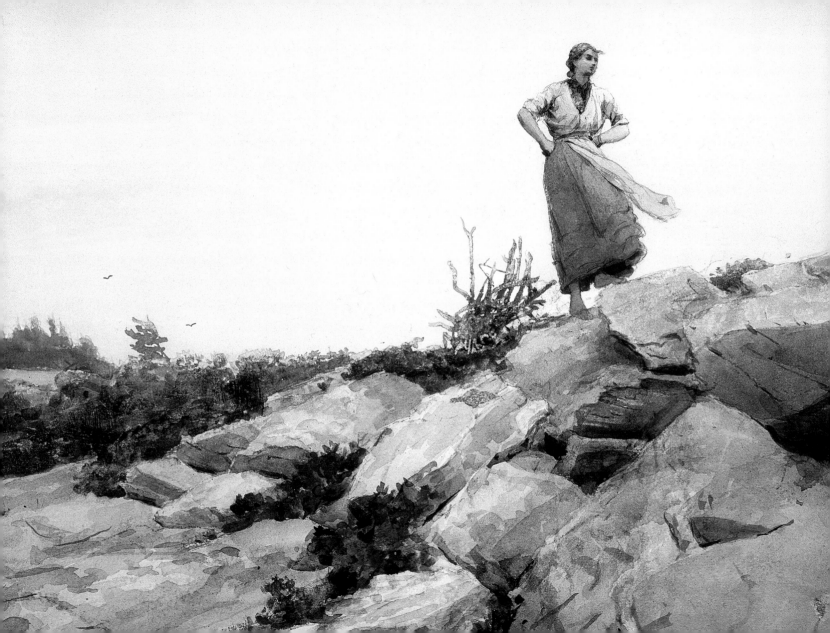

Everything in nature contains
all the power of nature.
Everything is made of one hidden stuff.

RALPH WALDO EMERSON

Capo di Noli, 1898
Paul Signac
Corboud Collection

1 2 3 4 5 6 7 8 9 10 11 12 **13** 14 15 16 17 18 19 20 21 22 23 24 25 26 27 28 29 30 31

JULY

Oh! let me live forever on those lips!
The nectar of the gods to these is tasteless.

John Dryden

Hercules and Omphale, c. 1730
François Boucher
The Pushkin Museum of Fine Arts, Moscow

1 2 3 4 5 6 7 8 9 10 11 12 13 **14** 15 16 17 18 19 20 21 22 23 24 25 26 27 28 29 30 31

JULY

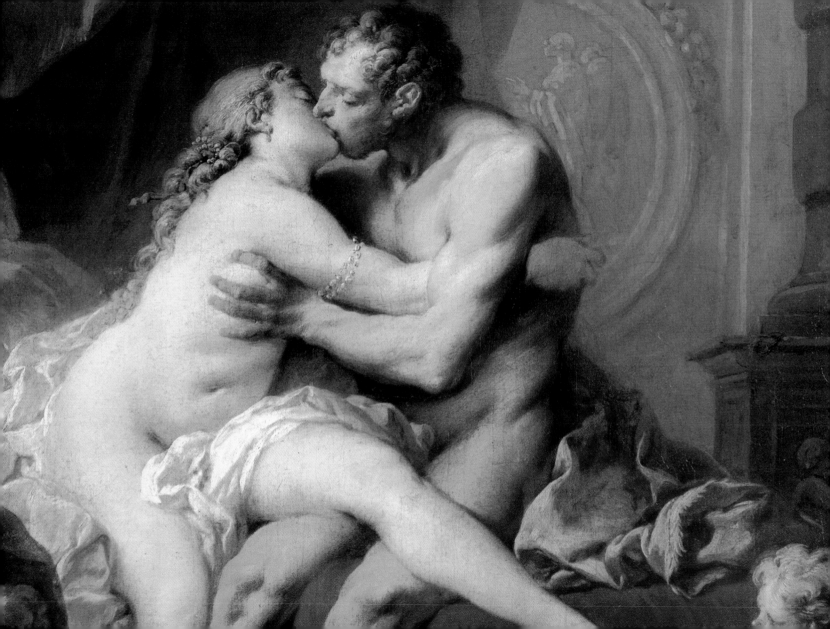

To a young heart everything is fun.

CHARLES DICKENS

Greek Maiden Playing with a Ball, c. 1889
Frederic Lord Leighton
The Dick Institute, Klimarnock

1 2 3 4 5 6 7 8 9 10 11 12 13 14 **15** 16 17 18 19 20 21 22 23 24 25 26 27 28 29 30 31

JULY

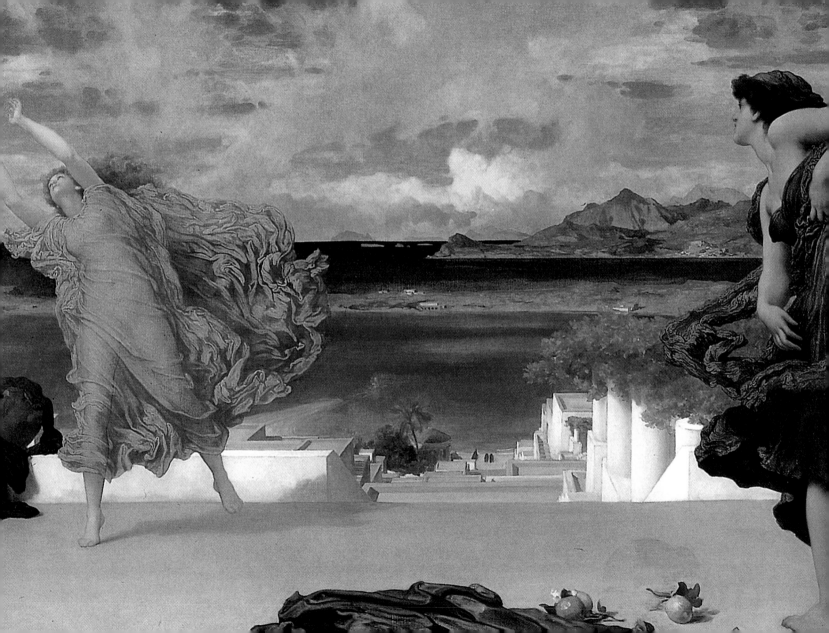

What causes fights and quarrels among you? Don't they come from your desires that battle within you?

THE EPISTLE OF JAMES, 4:1

The Battle of Issus, 333 B.C., 1529
Albrecht Altdorfer
Alte Pinakothek, Munich

1 2 3 4 5 6 7 8 9 10 11 12 13 14 15 **16** 17 18 19 20 21 22 23 24 25 26 27 28 29 30 31

JULY

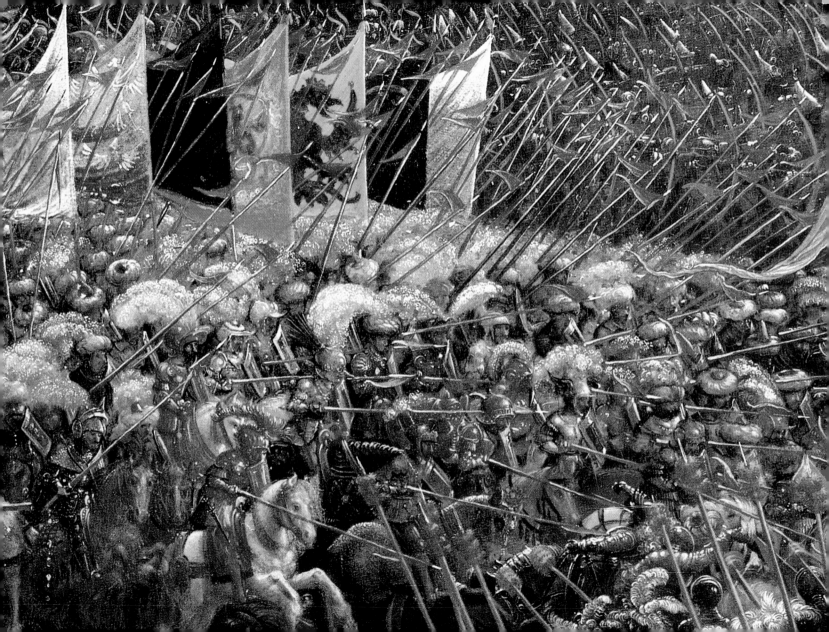

Beyond my heart
I need not reach
When all is summer there.

<small>JOHN VANCE CHENEY</small>

A Bathing Place near Asnieres, 1883–84
Georges Seurat
National Gallery, London

1 2 3 4 5 6 7 8 9 10 11 12 13 14 15 16 **17** 18 19 20 21 22 23 24 25 26 27 28 29 30 31

JULY

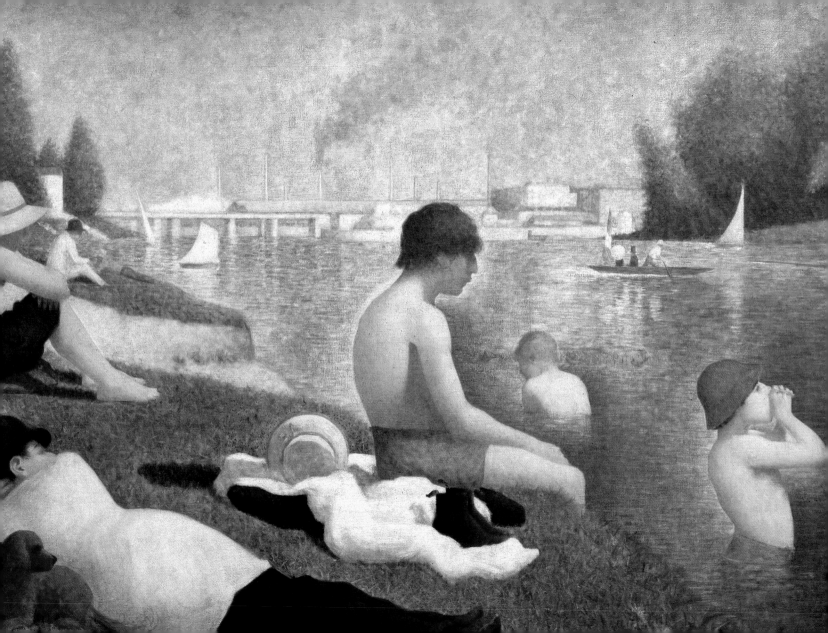

They are idols of hearts and of households;
They are angels of God in disguise;
His sunlight still sleeps in their tresses,
His glory still gleams in their eyes…

<small>CHARLES MONROE DICKENSON</small>

The Sleepers, 1831
Josef Danhauser
Private Collection

1 2 3 4 5 6 7 8 9 10 11 12 13 14 15 16 17 **18** 19 20 21 22 23 24 25 26 27 28 29 30 31

JULY

The Hot Air Balloon Launch, 1784
Francesco Guardi
Gemäldegalerie, Berlin

The sky is the daily bread of the eyes.

RALPH WALDO EMERSON

1 2 3 4 5 6 7 8 9 10 11 12 13 14 15 16 17 18 **19** 20 21 22 23 24 25 26 27 28 29 30 31

JULY

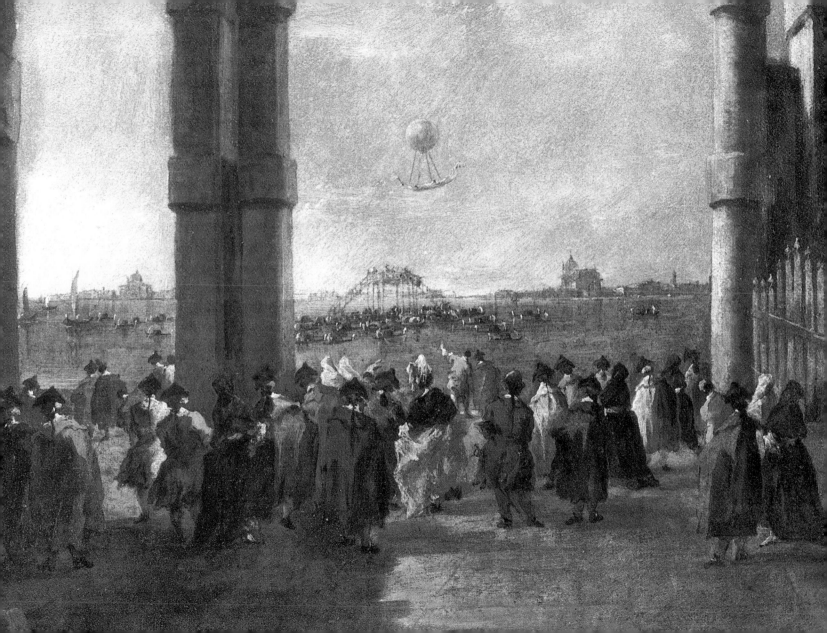

What sweet delight a quiet life affords.

WILLIAM DRUMMOND

Two Women under a Cork Oak, 1902
Henri Edmond Cross
Private Collection

1 2 3 4 5 6 7 8 9 10 11 12 13 14 15 16 17 18 19 **20** 21 22 23 24 25 26 27 28 29 30 31

JULY

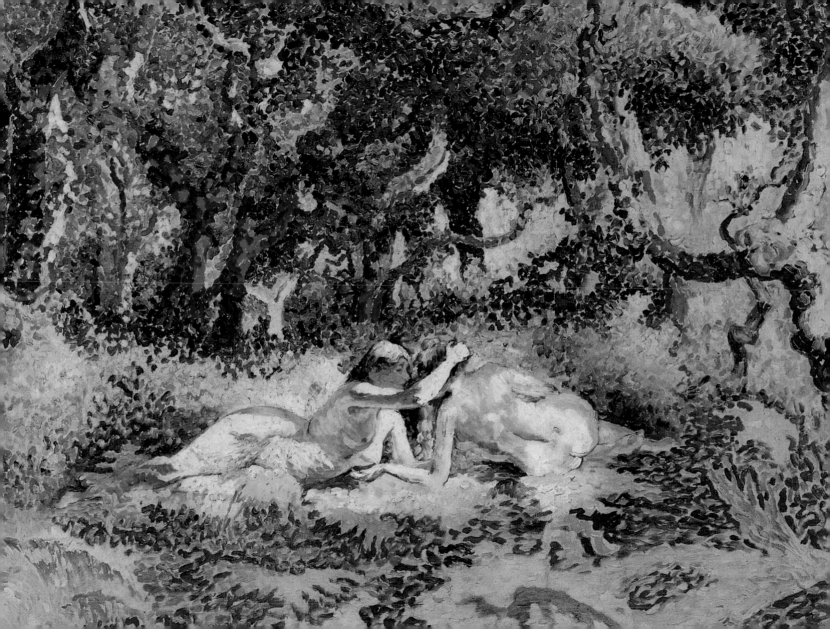

*After Jesus was born in Bethlehem in Judea,
during the time of King Herod, Magi from the
east came to Jerusalem and asked, "Where is
the one who has been born King of the Jews?"*

THE GOSPEL OF ST. MATTHEW, 2:1-2

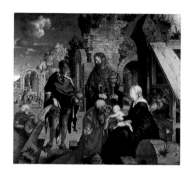

The Adoration of the Magi, 1504
Albrecht Dürer
Uffizi Gallery, Florence

1 2 3 4 5 6 7 8 9 10 11 12 13 14 15 16 17 18 19 20 **21** 22 23 24 25 26 27 28 29 30 31

JULY

Who has not found the heaven below
Will fail of it above.
God's residence is next to mine,
His furniture is love.

<small>EMILY DICKINSON</small>

View of Volterra from the Plains of Pisa, 1892
Sir William Blake Richmond
Private Collection

1 2 3 4 5 6 7 8 9 10 11 12 13 14 15 16 17 18 19 20 21 **22** 23 24 25 26 27 28 29 30 31

JULY

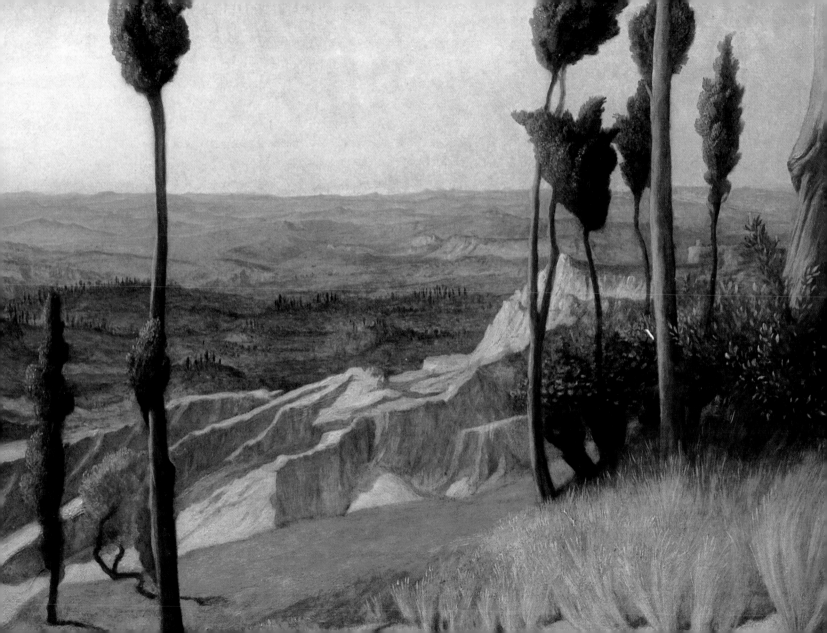

Although a dream is a very strange phenomenon and an inexplicable mystery, far more inexplicable is the mystery and aspect our minds confer on certain objects and aspects of life.

GIORGIO DE CHIRICO

The Enigma of the Hour, 1910–11
Giorgio de Chirico
Private Collection

1 2 3 4 5 6 7 8 9 10 11 12 13 14 15 16 17 18 19 20 21 22 **23** 24 25 26 27 28 29 30 31

JULY

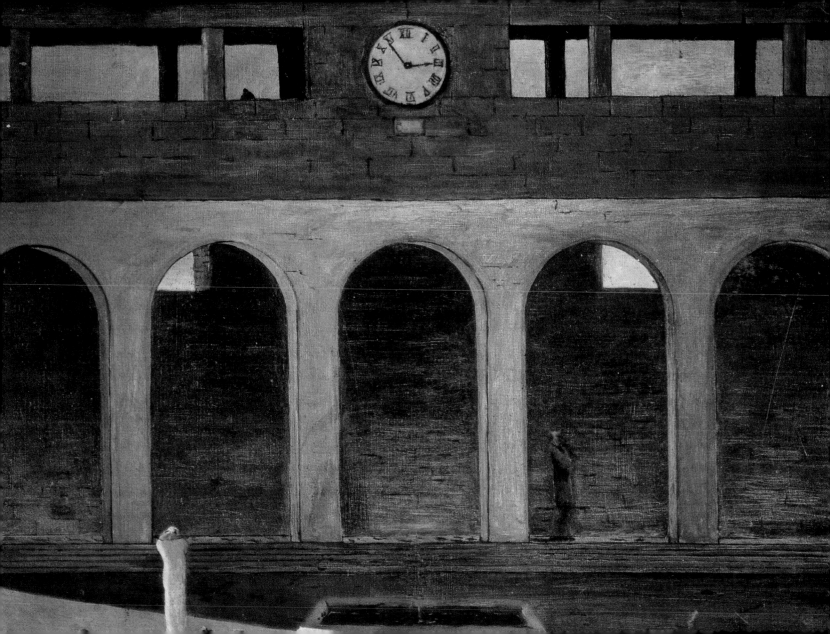

Quackery is a thing universal,
and universally successful.

Henry David Thoreau

The Visit to the Quack Doctor,
from "Marriage à la mode," early 18th century
William Hogarth
National Gallery, London

1 2 3 4 5 6 7 8 9 10 11 12 13 14 15 16 17 18 19 20 21 22 23 **24** 25 26 27 28 29 30 31

July

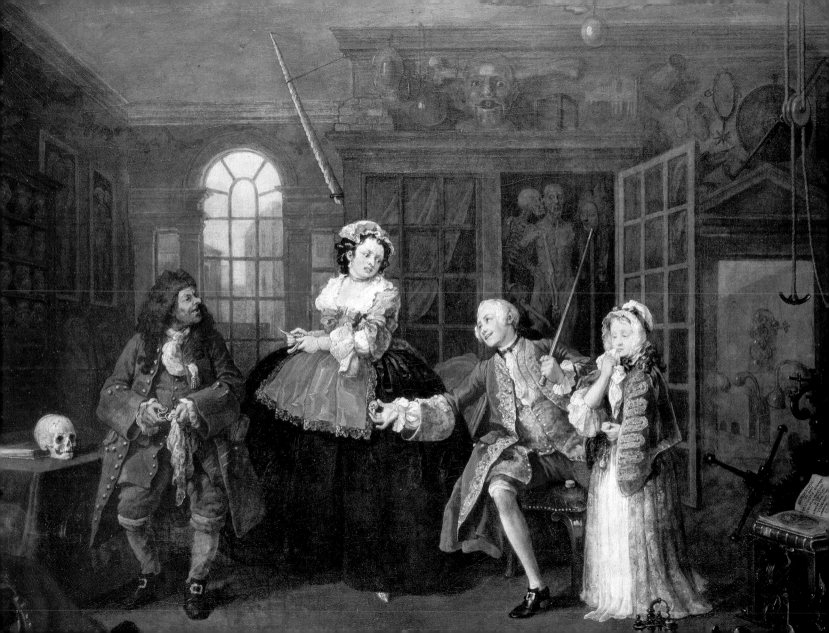

Most glorious night!
Thou wert not sent for slumber!

LORD BYRON

At the Moulin Rouge, 1892–93
Henri de Toulouse-Lautrec
The Art Institute of Chicago

1 2 3 4 5 6 7 8 9 10 11 12 13 14 15 16 17 18 19 20 21 22 23 24 **25** 26 27 28 29 30 31

JULY

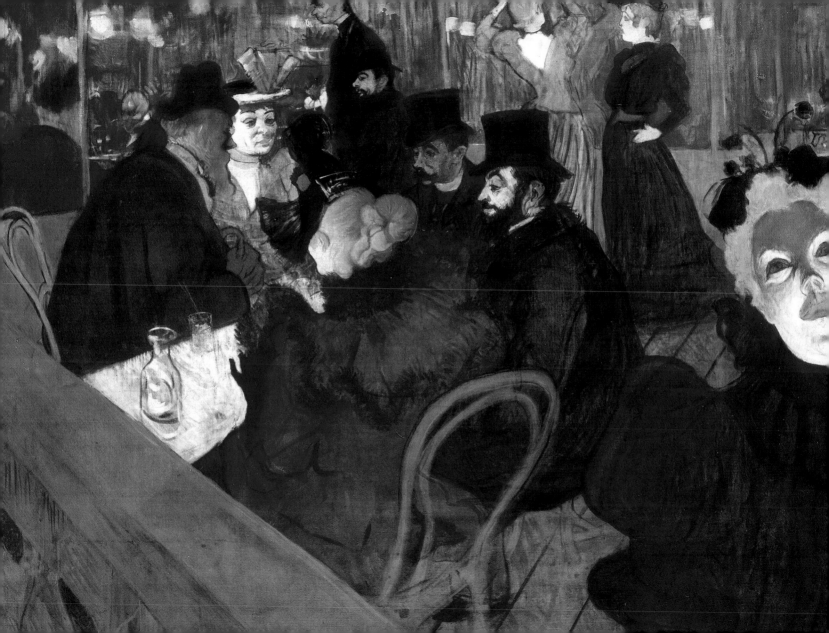

Nature, like a kind and smiling mother, lends herself to our dreams and cherishes our fancies.

<small>VICTOR HUGO</small>

The Heath of Saint-Guinolé near Pont-Aven, 1900
Henry Moret
Corboud Collection

1 2 3 4 5 6 7 8 9 10 11 12 13 14 15 16 17 18 19 20 21 22 23 24 25 **26** 27 28 29 30 31

JULY

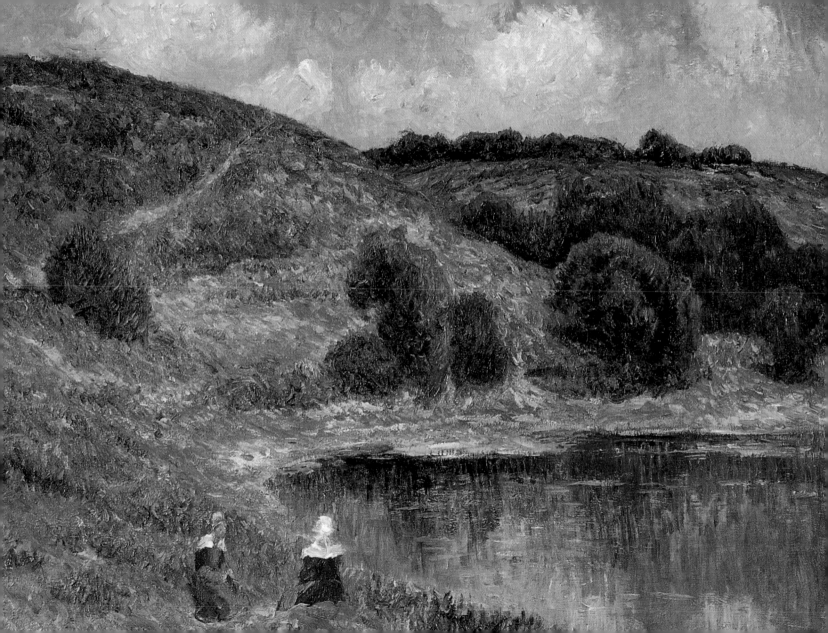

Now, Susanna was a very delicate woman, and beauteous to behold.

THE BOOK OF DANIEL, 13:31

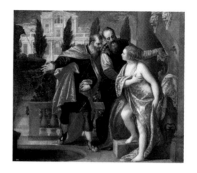

Susanna and the Elders, 16th century
Paolo Veronese
Museo Nacional del Prado, Madrid

1 2 3 4 5 6 7 8 9 10 11 12 13 14 15 16 17 18 19 20 21 22 23 24 25 26 27 28 29 30 31

JULY

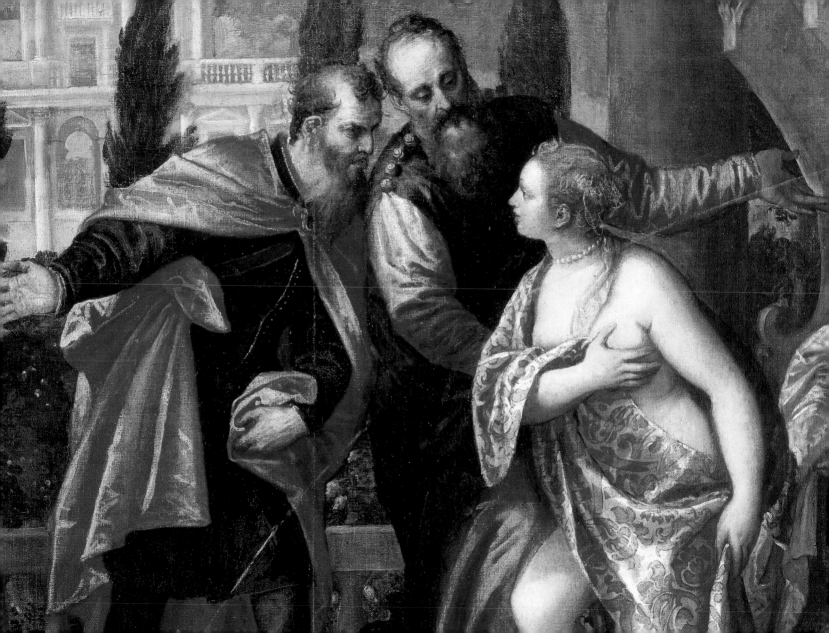

*Nature's peace will flow into you
as sunshine flows into trees.*

The Goose Girl, 1893
Camille Pissarro
Private Collection

1 2 3 4 5 6 7 8 9 10 11 12 13 14 15 16 17 18 19 20 21 22 23 24 25 26 27 **28** 29 30 31

JULY

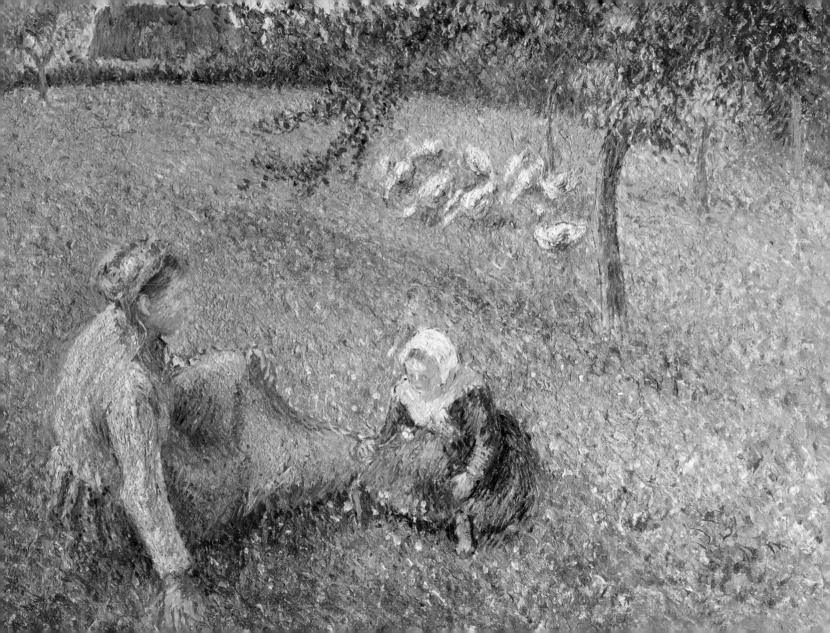

Music is a higher revelation than philosophy.

LUDWIG VON BEETHOVEN

The Guitar Player, 1908
Joseph DeCamp
The Hayden Collection

1 2 3 4 5 6 7 8 9 10 11 12 13 14 15 16 17 18 19 20 21 22 23 24 25 26 27 28 **29** 30 31

JULY

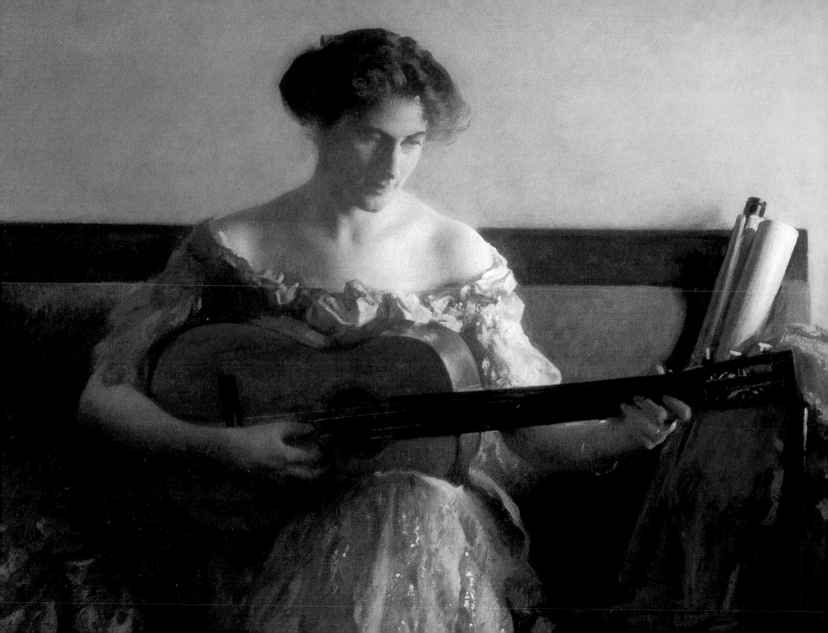

Instead of saying that man is the creature of circumstance, it would be nearer the mark to say that man is the architect of circumstance.

THOMAS CARLYLE

**The Last Judgment
(Detail from the Wall of the Sistine Chapel),** 1535–41

Michelangelo
Vatican Museum, Vatican City

1 2 3 4 5 6 7 8 9 10 11 12 13 14 15 16 17 18 19 20 21 22 23 24 25 26 27 28 29 **30** 31

JULY

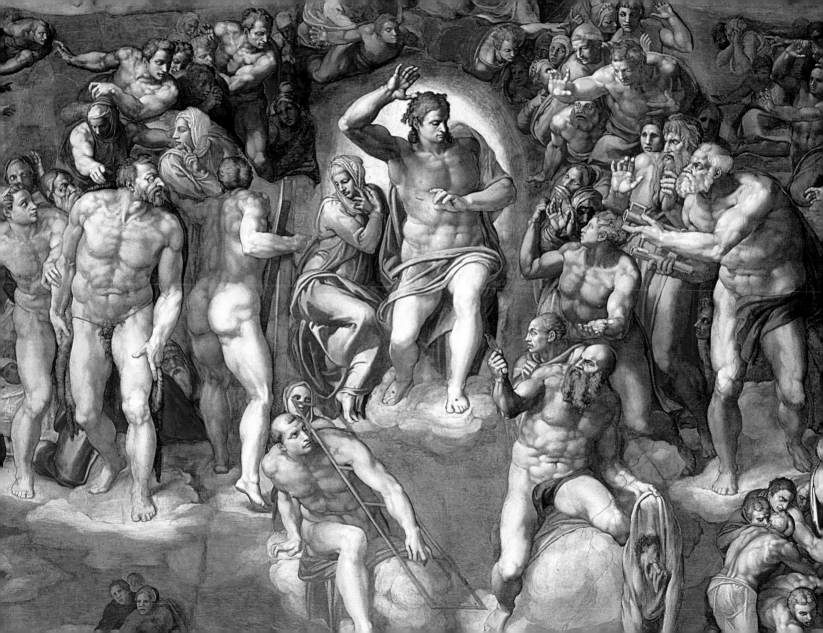

*If you tickle the earth with a hoe
she laughs with a harvest.*

DOUGLAS WILLIAM JERROLD

The Plains near Auvers, 1890
Vincent van Gogh
Belvedere, Vienna

1 2 3 4 5 6 7 8 9 10 11 12 13 14 15 16 17 18 19 20 21 22 23 24 25 26 27 28 29 30 31

JULY

Houses are like the human beings that inhabit them.

VICTOR HUGO

Villa on the Sea, 1865
Arnold Böcklin
Schack Gallery, Munich

1 2 3 4 5 6 7 8 9 10 11 12 13 14 15 16 17 18 19 20 21 22 23 24 25 26 27 28 29 30 31

AUGUST

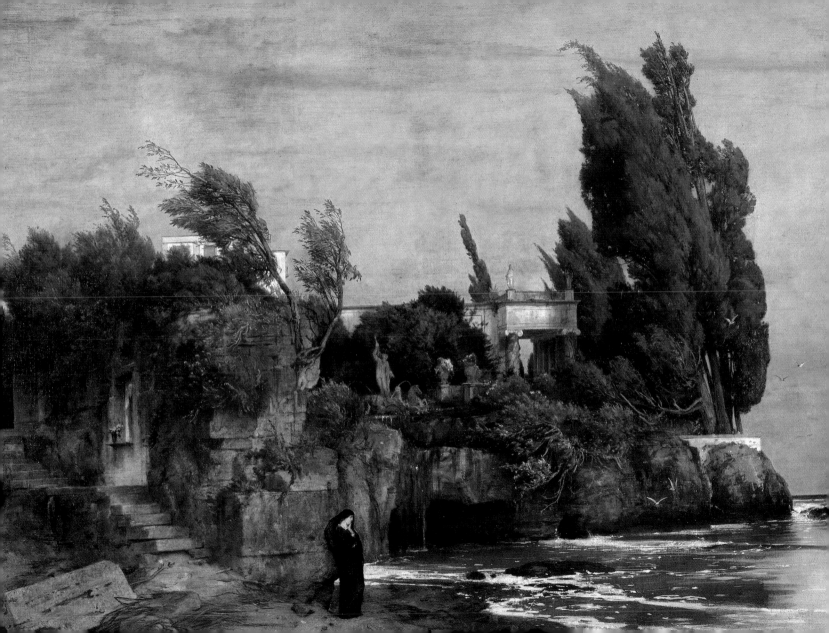

The direct relation of music is not to ideas,
but emotions.

Henry Giles

The Concert, 1510
Titian
Galleria Palatina, Florence

2

1 2 3 4 5 6 7 8 9 10 11 12 13 14 15 16 17 18 19 20 21 22 23 24 25 26 27 28 29 30 31

AUGUST

A horse! A horse! My kingdom for a horse!

WILLIAM SHAKESPEARE

Horse Groom with Lord Grosvenor's Arabian Horse, 18th century
George Stubbs
Kimbell Art Museum

1 2 **3** 4 5 6 7 8 9 10 11 12 13 14 15 16 17 18 19 20 21 22 23 24 25 26 27 28 29 30 31

AUGUST

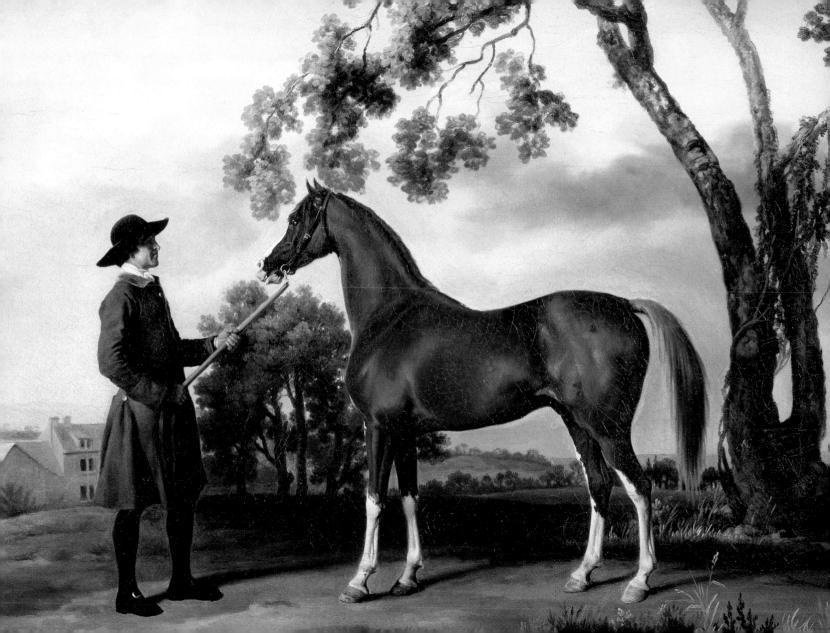

Genius is the ability to renew one's emotions in daily experience.

Paul Cézanne

End Station, Oak Park, Illinois, 1893
Childe Hassam
Private Collection

1 2 3 **4** 5 6 7 8 9 10 11 12 13 14 15 16 17 18 19 20 21 22 23 24 25 26 27 28 29 30 31

AUGUST

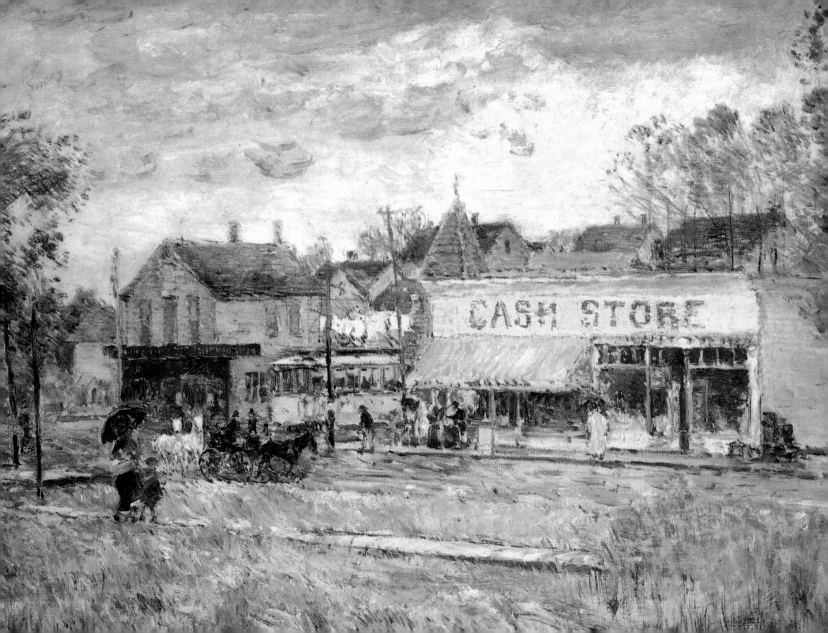

He enjoys true leisure
who has time to improve his soul's estate.

HENRY DAVID THOREAU

The Hammock, *c.* 1895
Joseph DeCamp
Adelson Galleries Inc., New York

1 2 3 4 **5** 6 7 8 9 10 11 12 13 14 15 16 17 18 19 20 21 22 23 24 25 26 27 28 29 30 31

AUGUST

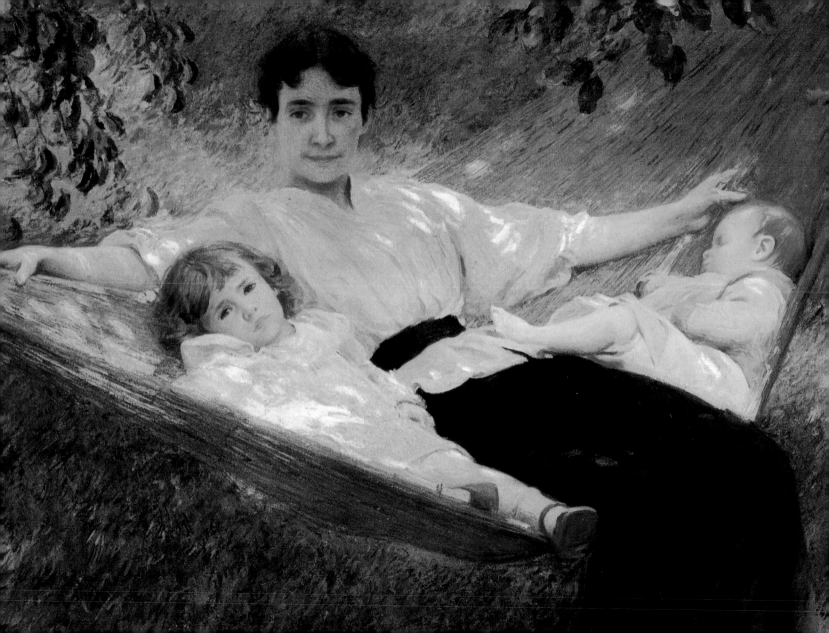

While our hearts are pure,
Our lives are happy and our peace is sure.

<small>WILLIAM WINTER</small>

Women Bathing in Dieppe II, c. 1857
Carl Spitzweg
Landesmuseum, Hanover

1 2 3 4 5 **6** 7 8 9 10 11 12 13 14 15 16 17 18 19 20 21 22 23 24 25 26 27 28 29 30 31

AUGUST

*A contented mind is the greatest blessing
a man can enjoy in this world ...*

Joseph Addison

Pedestrian in the Glow of a Street Lantern, c. 1895
Félix Vallotton
Private Collection

1 2 3 4 5 6 **7** 8 9 10 11 12 13 14 15 16 17 18 19 20 21 22 23 24 25 26 27 28 29 30 31

AUGUST

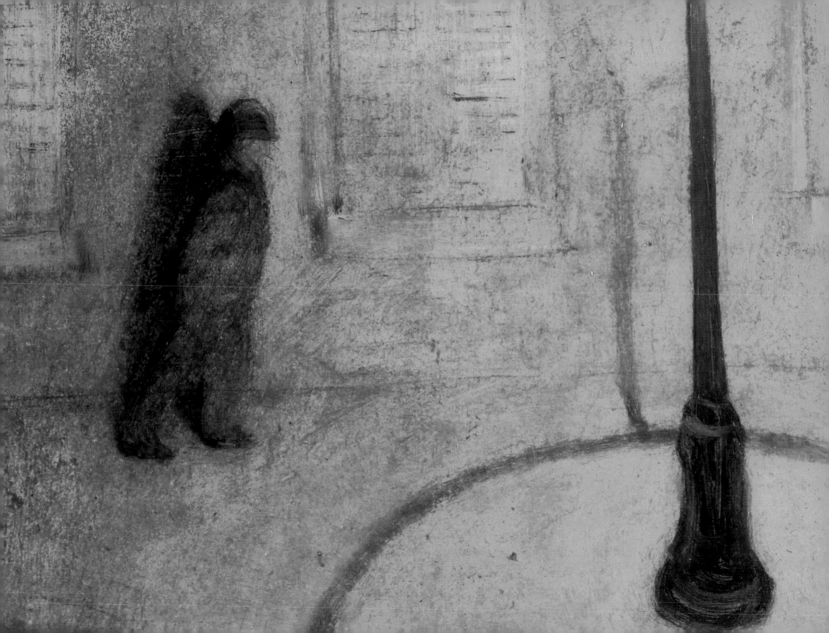

All action is of the mind and the mirror of the mind is the face, its index the eyes.

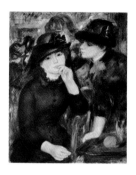

Young Ladies in Black, *c.* 1881
Pierre-Auguste Renoir
The Pushkin Museum of Fine Arts, Moscow

1 2 3 4 5 6 7 **8** 9 10 11 12 13 14 15 16 17 18 19 20 21 22 23 24 25 26 27 28 29 30 31

AUGUST

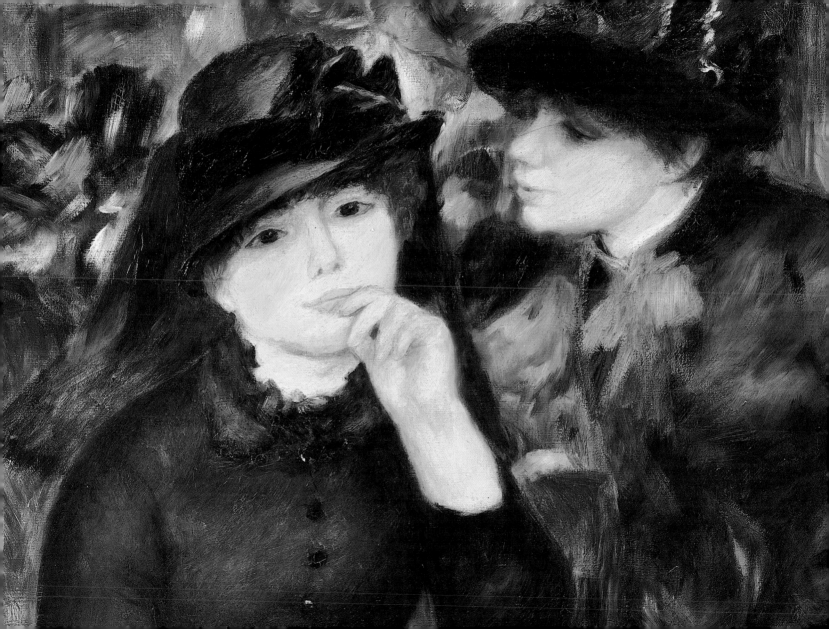

The grandest operations, both in nature and grace, are the most silent and imperceptible.

The Marketplace in Hoorn, 1784
Isaak Ouwater
Schleissheim Palace, Munich

1 2 3 4 5 6 7 8 **9** 10 11 12 13 14 15 16 17 18 19 20 21 22 23 24 25 26 27 28 29 30 31

AUGUST

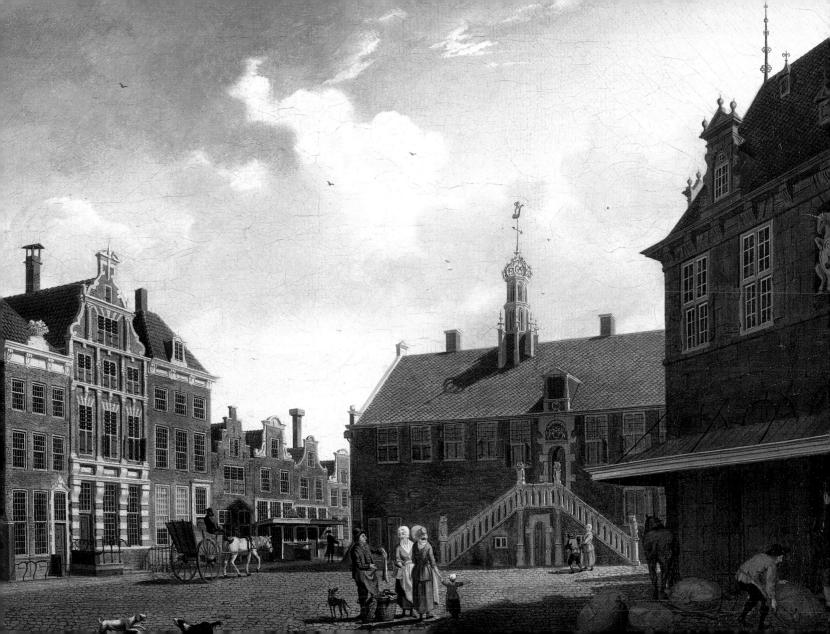

So cloudless, clear, and purely beautiful,
That God alone was to be seen in heaven.

LORD BYRON

Shepherd Boy, 1860
Franz von Lenbach
Schack Gallery, Munich

1 2 3 4 5 6 7 8 9 **10** 11 12 13 14 15 16 17 18 19 20 21 22 23 24 25 26 27 28 29 30 31

AUGUST

The most wonderful fairy tale is life itself.

HANS CHRISTIAN ANDERSEN

Miranda in a Storm, 1916
John William Waterhouse
Christie's, London

1 2 3 4 5 6 7 8 9 10 **11** 12 13 14 15 16 17 18 19 20 21 22 23 24 25 26 27 28 29 30 31

AUGUST

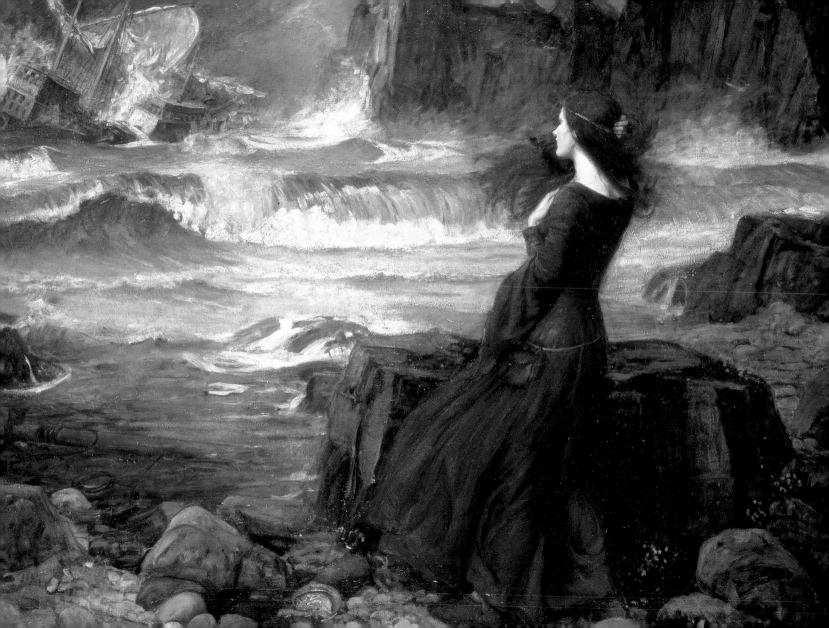

It is absurd to look for perfection.

Camille Pissarro

Double Portrait of an Elderly Married Couple, *c. 1600*
Lucas I van Valckenborch (?) and Georg Flegel
National Museum, Stockholm

1 2 3 4 5 6 7 8 9 10 11 **12** 13 14 15 16 17 18 19 20 21 22 23 24 25 26 27 28 29 30 31

AUGUST

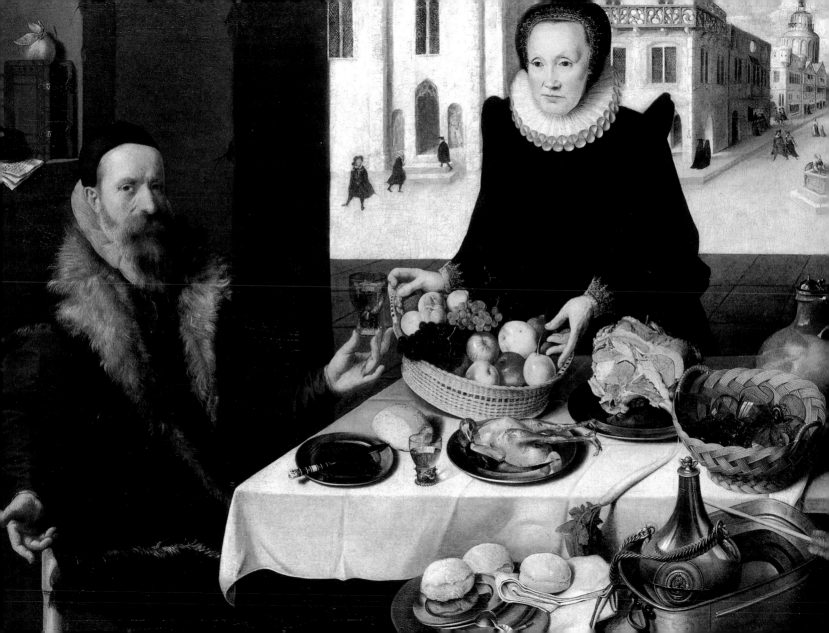

Summer afternoon, summer afternoon ...
the two most beautiful words in the
English language.

Henry James

Summer, late 19th or early 20th century
Guglielmo Ciardi
Galleria Internazionale d'Arte Moderna di Ca' Pesaro

1 2 3 4 5 6 7 8 9 10 11 12 **13** 14 15 16 17 18 19 20 21 22 23 24 25 26 27 28 29 30 31

AUGUST

Man is not born to solve the problem of the universe, but to find out what he has to do; and to restrain himself within the limits of his comprehension.

JOHANN WOLFGANG VON GOETHE

Goethe in the Campagna, 1786
Johann Heinrich Wilhelm Tischbein
Städel Museum, Frankfurt

1 2 3 4 5 6 7 8 9 10 11 12 13 **14** 15 16 17 18 19 20 21 22 23 24 25 26 27 28 29 30 31

AUGUST

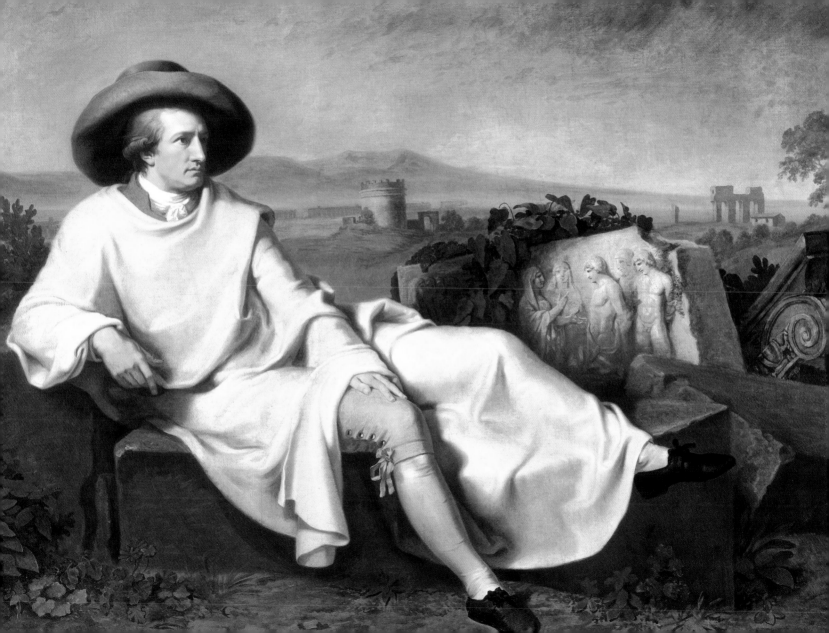

This likeness is enchantingly lovely,
As no eye has ever beheld!

Emanuel Schikaneder

Madonna in the Rose Bower, c. 1450
Stephan Lochner
Wallraf Richartz Museum, Cologne

1 2 3 4 5 6 7 8 9 10 11 12 13 14 **15** 16 17 18 19 20 21 22 23 24 25 26 27 28 29 30 31

AUGUST

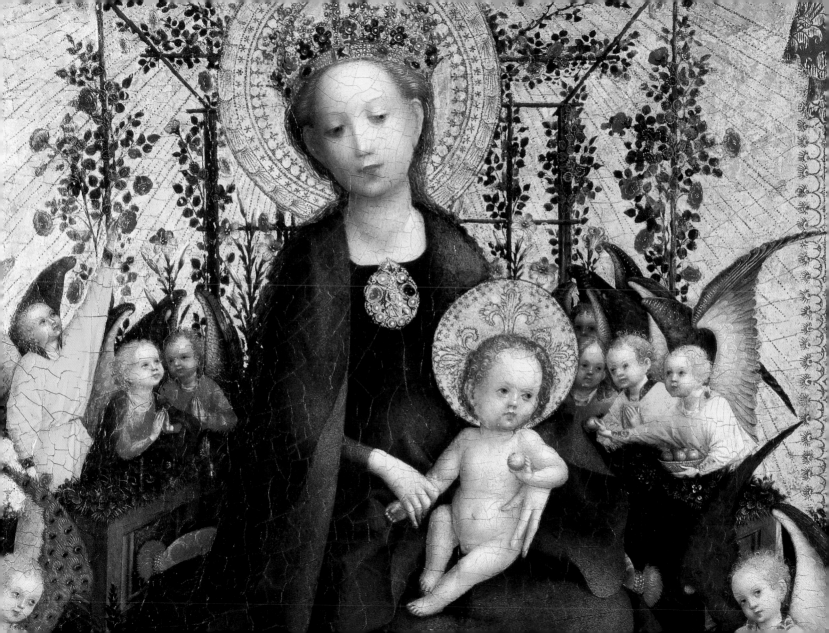

Nature gives to every time and season
some beauties of its own,
and from morning to night ...

CHARLES DICKENS

Cypresses at Cagnes, 1908
Henri Edmond Cross
Musée d'Orsay, Paris

1 2 3 4 5 6 7 8 9 10 11 12 13 14 15 **16** 17 18 19 20 21 22 23 24 25 26 27 28 29 30 31

AUGUST

*Cleanliness may be defined
to be the emblem of purity of mind.*

JOSEPH ADDISON

After Bathing, 1906
Lovis Corinth
Hamburger Kunsthalle

1 2 3 4 5 6 7 8 9 10 11 12 13 14 15 16 **17** 18 19 20 21 22 23 24 25 26 27 28 29 30 31

AUGUST

The only paradise is the lost paradise.

<small>MARCEL PROUST</small>

Paradise Landscape with Noah's Ark, late 16th or early 17th century
Jan Brueghel the Elder
Szépmüvészeti Múzeum, Budapest

1 2 3 4 5 6 7 8 9 10 11 12 13 14 15 16 17 **18** 19 20 21 22 23 24 25 26 27 28 29 30 31

AUGUST

The family is the country of the heart.

G<small>IUSEPPE</small> M<small>AZZINI</small>

Portrait of the Palumbo-Fossati Family, 19th century
Michelangelo Grigoletti
Palumbo-Fossati Collection, Venice

1 2 3 4 5 6 7 8 9 10 11 12 13 14 15 16 17 18 **19** 20 21 22 23 24 25 26 27 28 29 30 31

AUGUST

*Dance light, for my heart it lies
under your feet.*

<small>JOHN FRANCIS WALLER</small>

The Dancer Camargot, 1730
Nicolas Lancret
The State Hermitage Museum, St. Petersburg

1 2 3 4 5 6 7 8 9 10 11 12 13 14 15 16 17 18 19 **20** 21 22 23 24 25 26 27 28 29 30 31

AUGUST

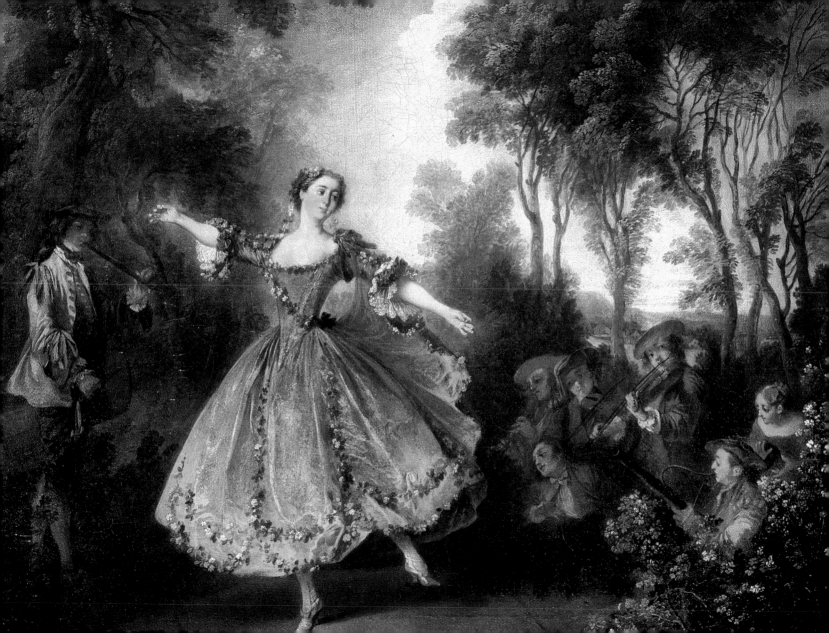

An angel of the Lord appeared to Joseph in a dream. "Get up," he said, "take the child and his mother and escape to Egypt. Stay there until I tell you, for Herod is going to search for the child to kill him."

THE GOSPEL OF ST. MATTHEW, 2:13

The Flight to Egypt, c. 1525–30
Wolf Huber
Gemäldegalerie, Berlin

1 2 3 4 5 6 7 8 9 10 11 12 13 14 15 16 17 18 19 20 **21** 22 23 24 25 26 27 28 29 30 31

AUGUST

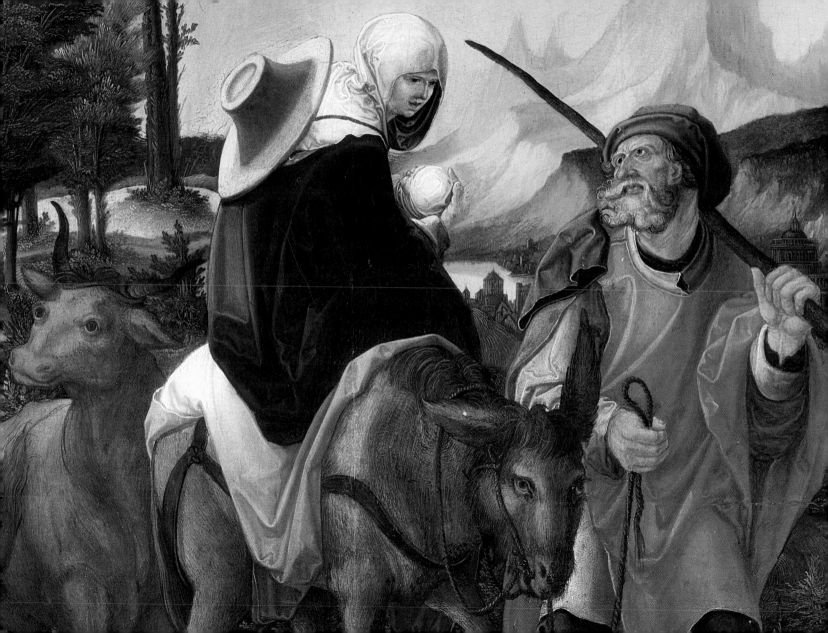

If all the ships I have at sea
Should come a-sailing home to me,
Ah, well! the harbor would not hold
So many ships as there would be
If all my ships came home from sea.

<small>ELLA WHEELER WILCOX</small>

Boys on the Seashore, 1875
Winslow Homer
Forbes Collection, New York

1 2 3 4 5 6 7 8 9 10 11 12 13 14 15 16 17 18 19 20 21 **22** 23 24 25 26 27 28 29 30 31

AUGUST

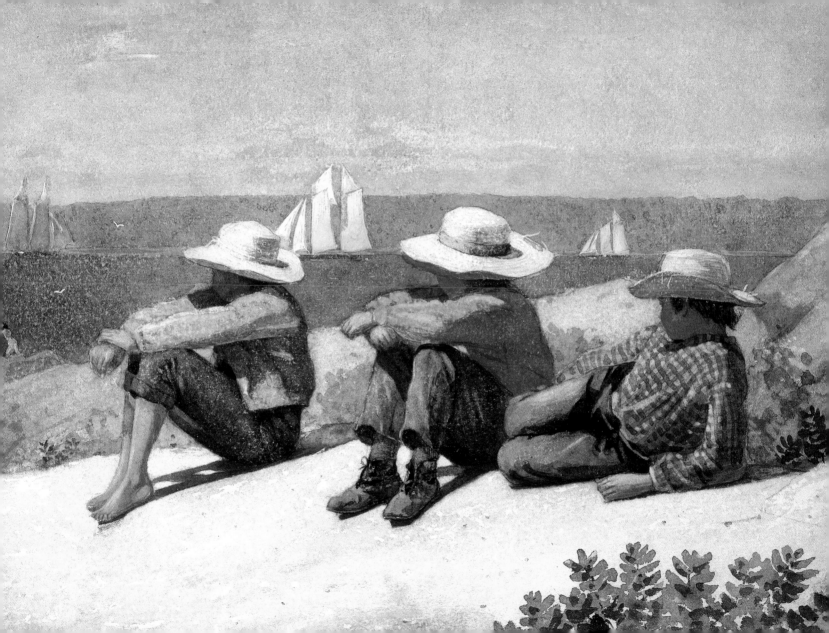

Green calm below, blue quietness above.

JOHN GREENLEAF WHITTIER

Summer Day in the Hamme Marsh with a View of Weyerberg,
c. 1900
Fritz Overbeck
Worpsweder Kunsthalle

1 2 3 4 5 6 7 8 9 10 11 12 13 14 15 16 17 18 19 20 21 22 **23** 24 25 26 27 28 29 30 31

AUGUST

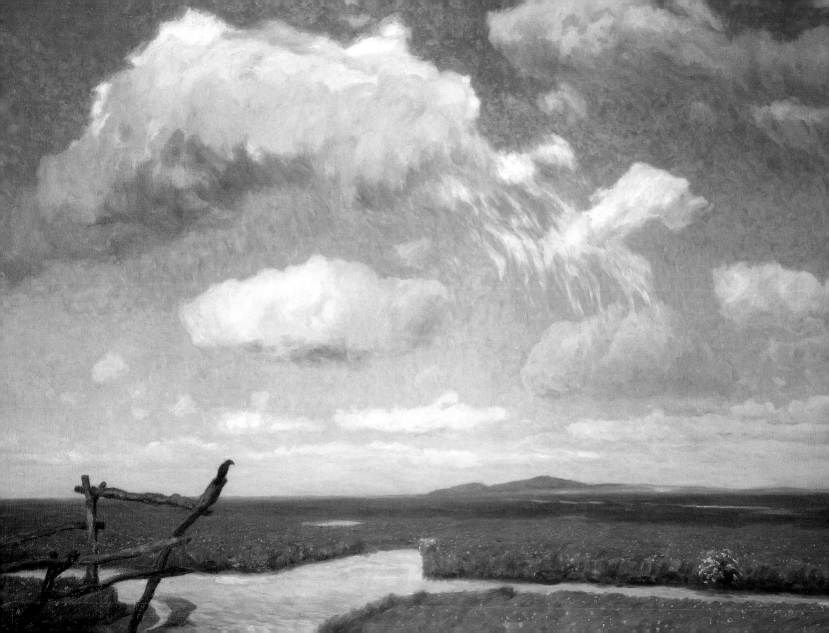

Present fears are less than horrible imaginings.

WILLIAM SHAKESPEARE

The Witch, 17th century
David Ryckaert III
Kunsthistorisches Museum, Vienna

1 2 3 4 5 6 7 8 9 10 11 12 13 14 15 16 17 18 19 20 21 22 23 **24** 25 26 27 28 29 30 31

AUGUST

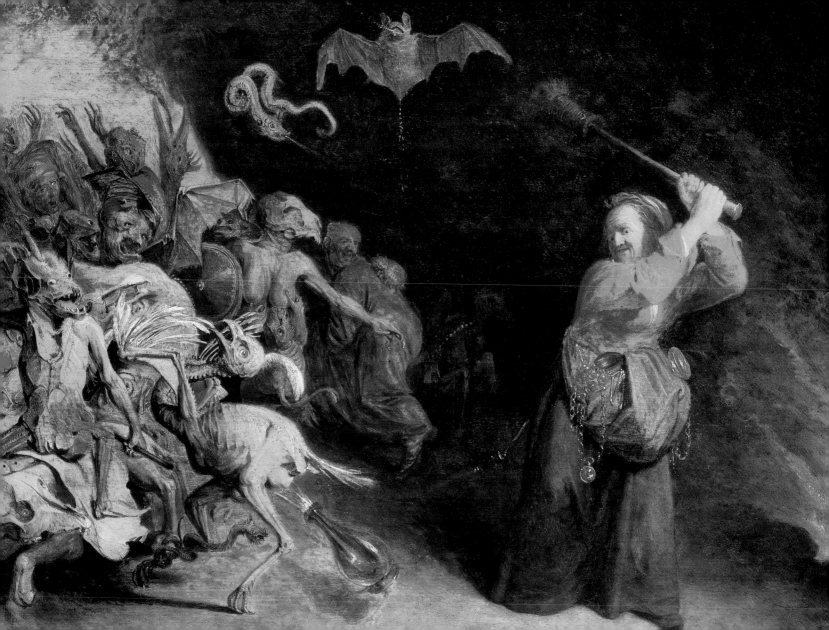

By faithful study of the nobler arts,
our nature's softened, and more gentle grows.

<small>OVID</small>

Melancholy II, 17th century
Isaac de Jouderville
Kunstmuseum, Serpuchov

1 2 3 4 5 6 7 8 9 10 11 12 13 14 15 16 17 18 19 20 21 22 23 24 **25** 26 27 28 29 30 31

AUGUST

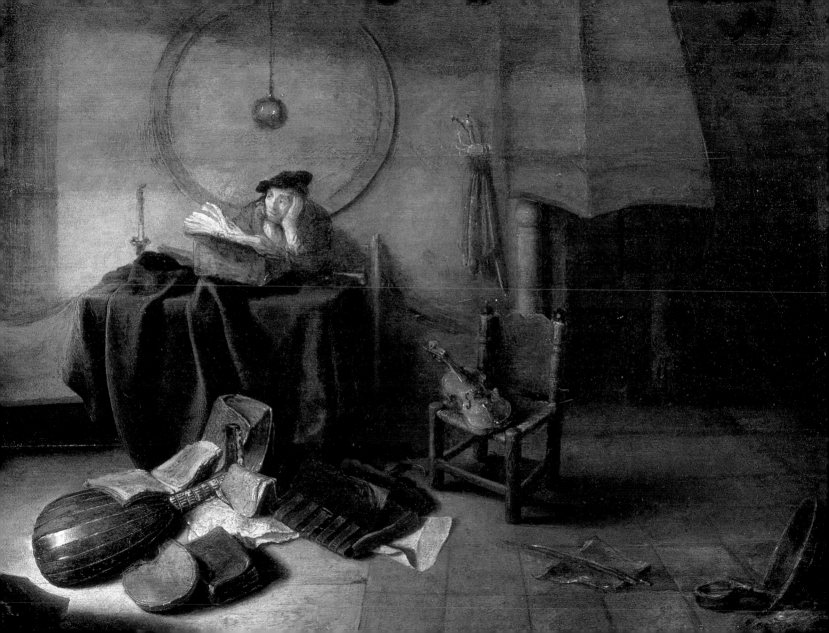

Why, one day in the country
Is worth a month in town.

CHRISTINA GEORGINA ROSSETTI

Haystack in a Summer Landscape at Giverny, 1886
Claude Monet
The State Hermitage Museum, St. Petersburg

1 2 3 4 5 6 7 8 9 10 11 12 13 14 15 16 17 18 19 20 21 22 23 24 25 **26** 27 28 29 30 31

AUGUST

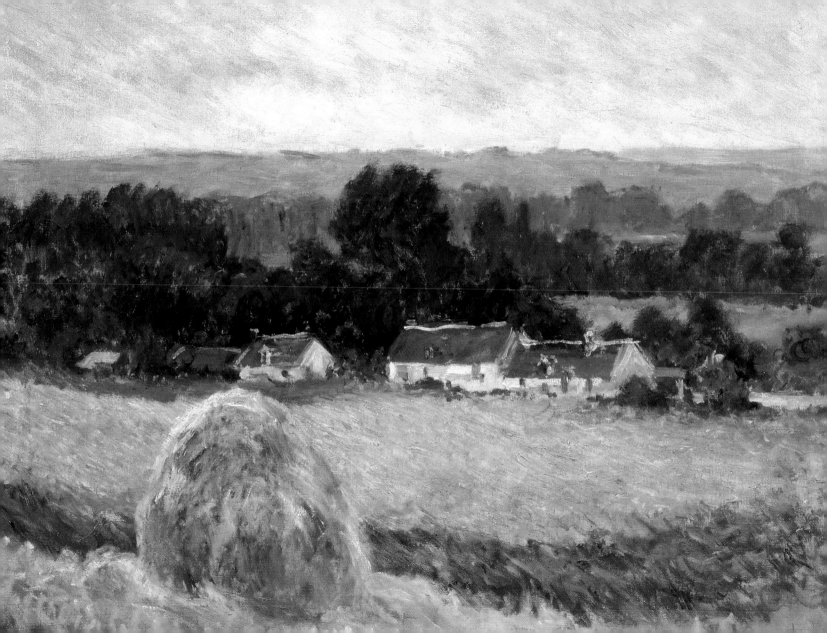

*The true way to render ourselves happy
is to love our work and find in it our pleasure.*

Francoise de Motteville

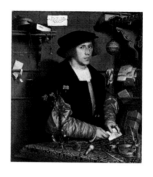

Portrait of the Merchant Georg Gisze, 1532
Hans Holbein the Younger
Gemäldegalerie, Berlin

1 2 3 4 5 6 7 8 9 10 11 12 13 14 15 16 17 18 19 20 21 22 23 24 25 26 **27** 28 29 30 31

AUGUST

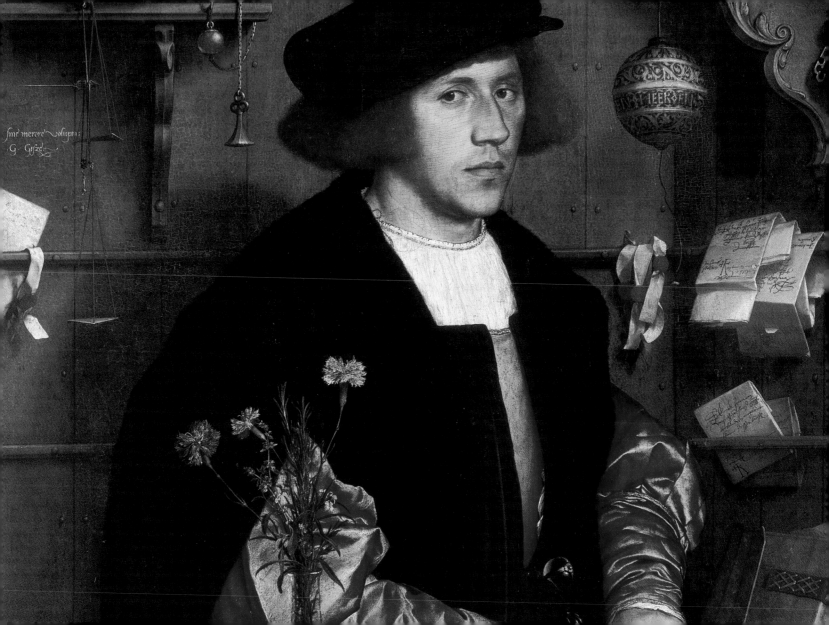

Blue is the male principle, stern and spiritual. Yellow the female principle, gentle, cheerful, and sensual. Red is matter, brutal and heavy and always the color which must be fought and vanquished by the other two.

FRANZ MARC

Bluish-black Fox, 1911
Franz Marc
Von der Heydt-Museum, Wuppertal

1 2 3 4 5 6 7 8 9 10 11 12 13 14 15 16 17 18 19 20 21 22 23 24 25 26 27 **28** 29 30 31

AUGUST

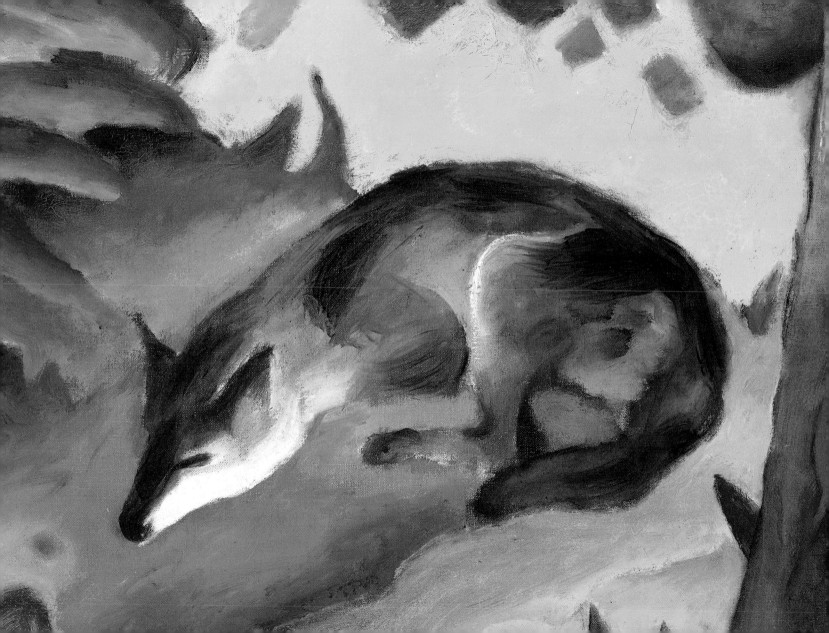

*You could see the lightning
in the goddess's eyes, the sky and
the elements laughing about her.*

POLIZIANO

The Birth of Venus, c. 1485–86
Sandro Botticelli
Uffizi Gallery, Florence

1 2 3 4 5 6 7 8 9 10 11 12 13 14 15 16 17 18 19 20 21 22 23 24 25 26 27 28 **29** 30 31

AUGUST

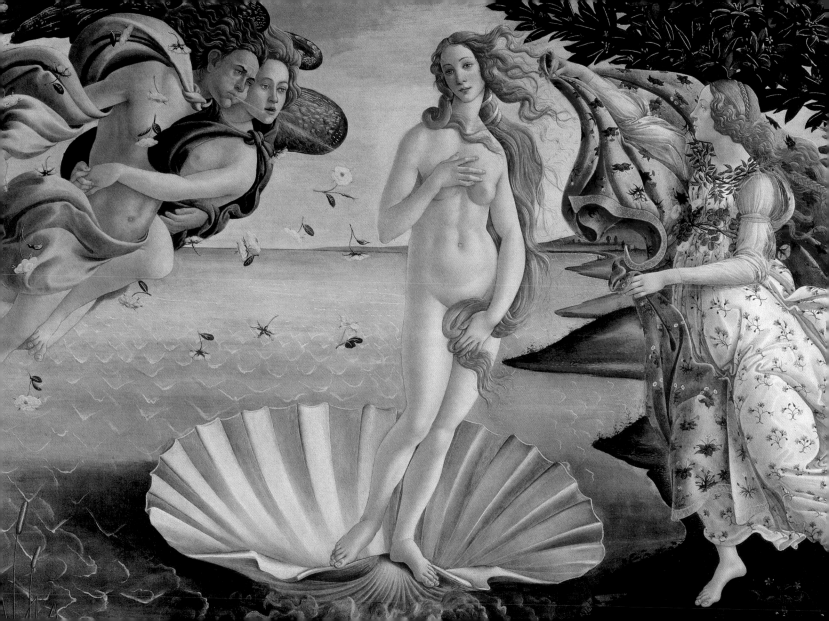

Love is a canvas furnished by nature and embroidered by imagination.

VOLTAIRE

Olive Grove, *c.* 1870
Charles-François Daubigny
The Pushkin Museum of Fine Arts, Moscow

1 2 3 4 5 6 7 8 9 10 11 12 13 14 15 16 17 18 19 20 21 22 23 24 25 26 27 28 29 30 31

AUGUST

Don't waste life in doubts and fears.
Spend yourself on the work before you,
well assured that the right performance of
this hour's duties will be the best preparation
for the hours and ages that will follow it.

RALPH WALDO EMERSON

The Washers, *c.* 1779
Francisco José de Goya
Oskar Reinhart Collection, Winterthur

1 2 3 4 5 6 7 8 9 10 11 12 13 14 15 16 17 18 19 20 21 22 23 24 25 26 27 28 29 30 31

AUGUST

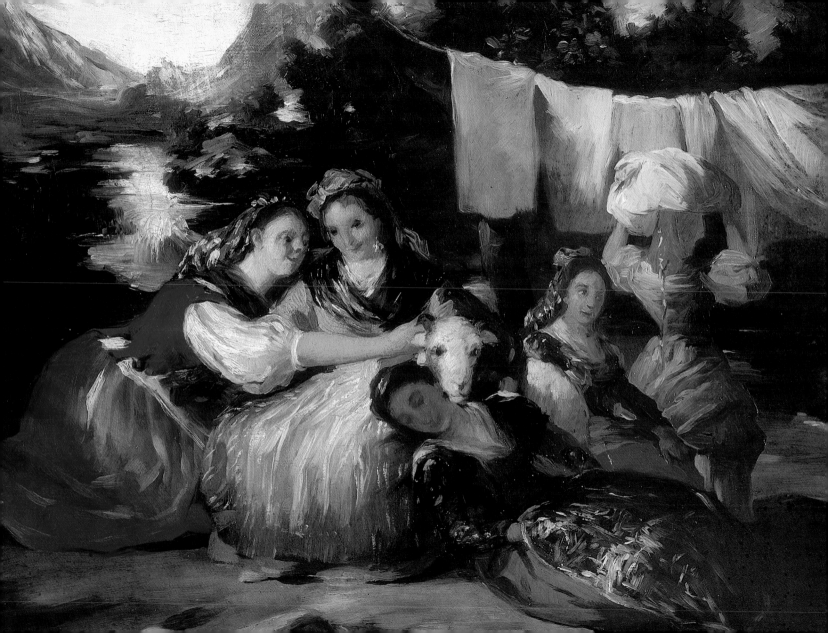

There is only one thing in the world worse than being talked about, and that is not being talked about.

Oscar Wilde

Parisian Restaurant, early 20th century
Albert Weisgerber
Lenbachhaus, Munich

1 2 3 4 5 6 7 8 9 10 11 12 13 14 15 16 17 18 19 20 21 22 23 24 25 26 27 28 29 30

SEPTEMBER

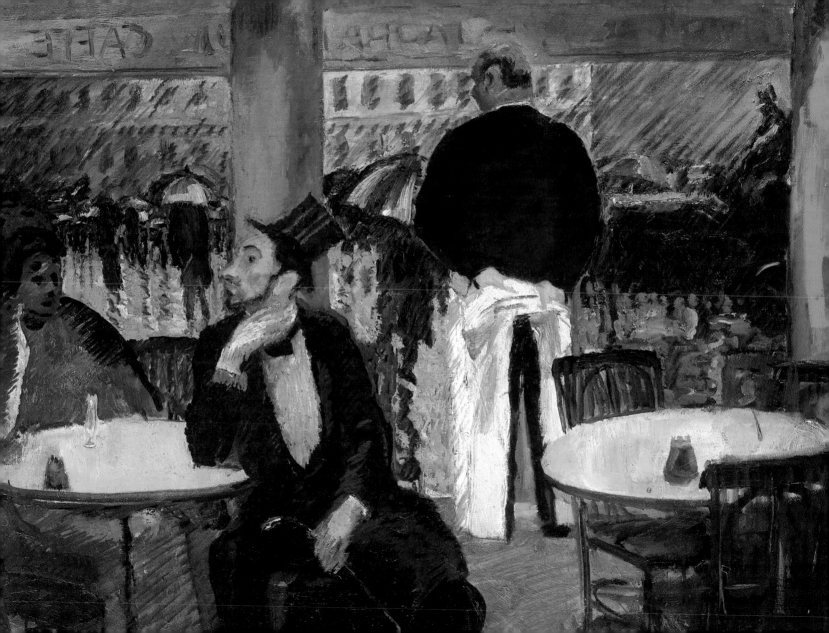

Art is truly a battle.

Edgar Degas

Racehorses Training, 1894
Edgar Degas
Thyssen-Bornemisza Collection, Lugano

1 2 3 4 5 6 7 8 9 10 11 12 13 14 15 16 17 18 19 20 21 22 23 24 25 26 27 28 29 30

SEPTEMBER

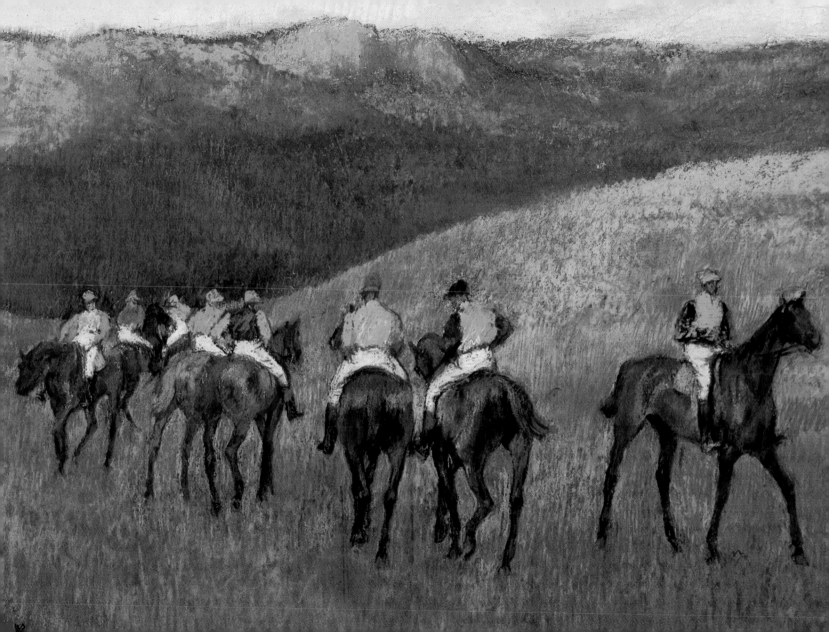

Stop and smell the roses.

Rosenduft-Erinnerung, c. 1845–46
Carl Spitzweg
Kunstmuseum, Bern

1 2 **3** 4 5 6 7 8 9 10 11 12 13 14 15 16 17 18 19 20 21 22 23 24 25 26 27 28 29 30

SEPTEMBER

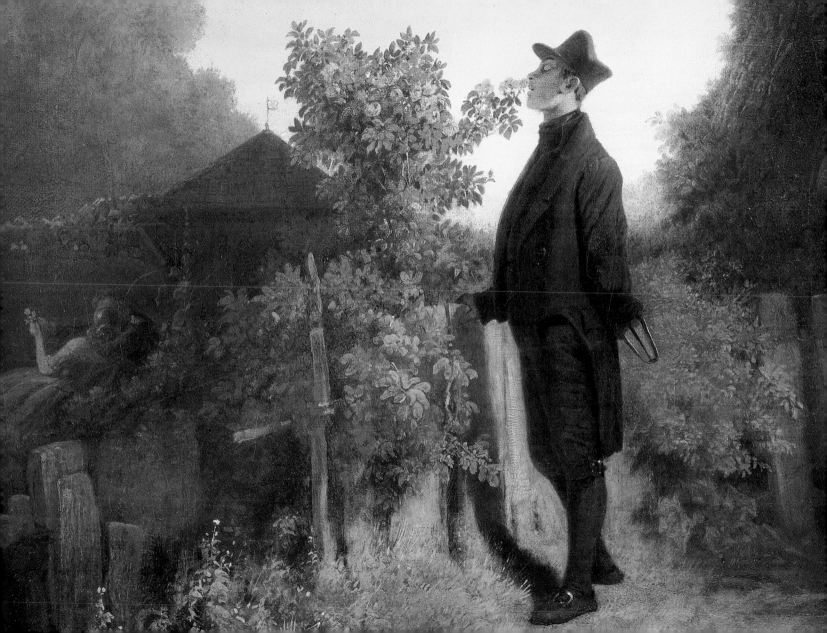

A silence, the brief Sabbath of an hour,
Reigns o'er the fields ...

<small>WILLIAM CULLEN BRYANT</small>

Landscape at Noon, 1661
Claude Lorrain
The State Hermitage Museum, St. Petersburg

1 2 3 **4** 5 6 7 8 9 10 11 12 13 14 15 16 17 18 19 20 21 22 23 24 25 26 27 28 29 30

SEPTEMBER

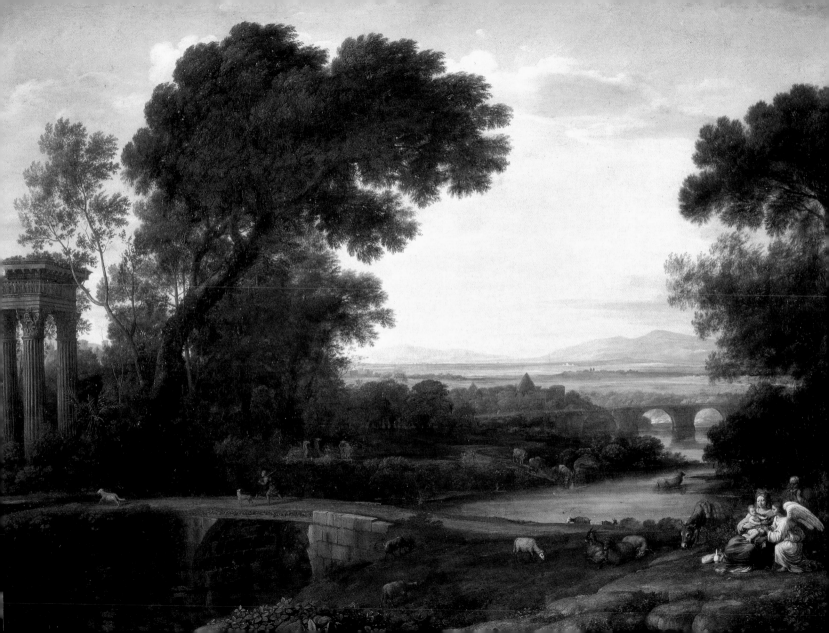

*All colors are the friends of their neighbors
and the lovers of their opposites.*

Marc Chagall

The Cutter, 1928–30
Marc Chagall
National Gallery, Prague

1 2 3 4 **5** 6 7 8 9 10 11 12 13 14 15 16 17 18 19 20 21 22 23 24 25 26 27 28 29 30

SEPTEMBER

Sweet and smiling are thy ways,
Beauteous, golden autumn days.

WILLIAM CARLETON

The Harvest, 16th century
Pieter Brueghel the Elder
National Gallery, Prague

1 2 3 4 5 **6** 7 8 9 10 11 12 13 14 15 16 17 18 19 20 21 22 23 24 25 26 27 28 29 30

SEPTEMBER

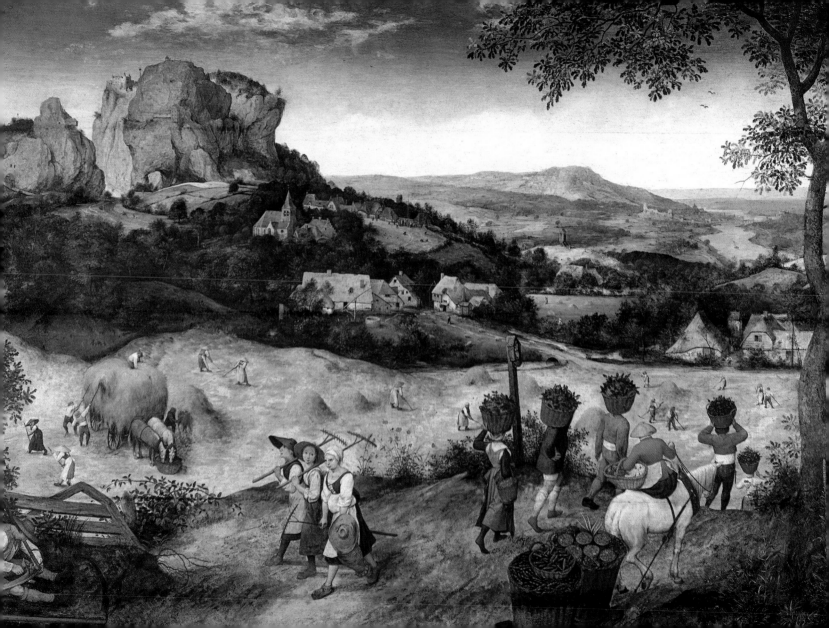

This cup is the new covenant in my blood, which is poured out for you. But the hand of him who is going to betray me is with mine on the table.

THE GOSPEL OF ST. LUKE, 22:20-21

The Last Supper, 1495–97
Leonardo da Vinci
S. Maria delle Grazie, Milan

1 2 3 4 5 6 **7** 8 9 10 11 12 13 14 15 16 17 18 19 20 21 22 23 24 25 26 27 28 29 30

SEPTEMBER

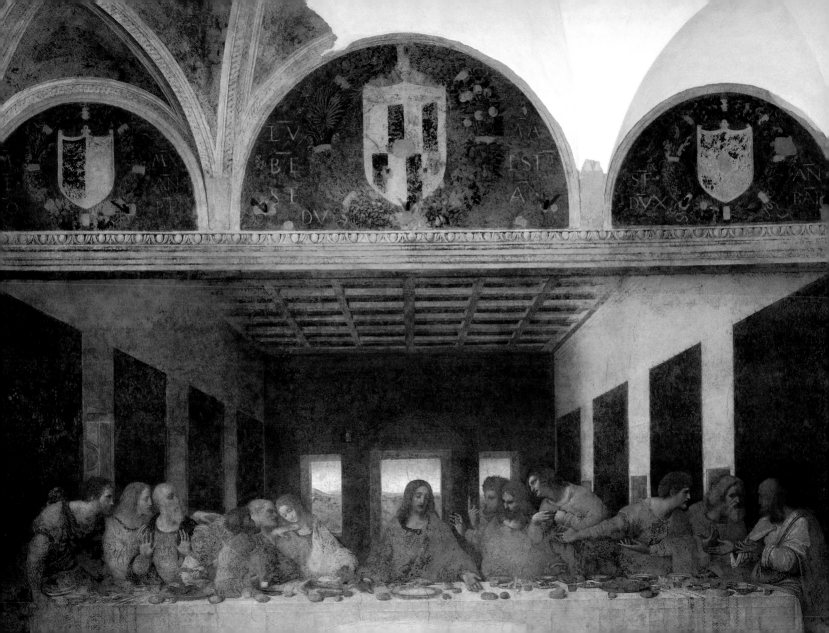

Music is not a science any more than poetry is. It is a sublime instinct, like genius of all kinds.

The Flute Player, 17th century
Cecco del Caravaggio
Ashmolean Museum, Oxford

8
1 2 3 4 5 6 7 8 9 10 11 12 13 14 15 16 17 18 19 20 21 22 23 24 25 26 27 28 29 30

SEPTEMBER

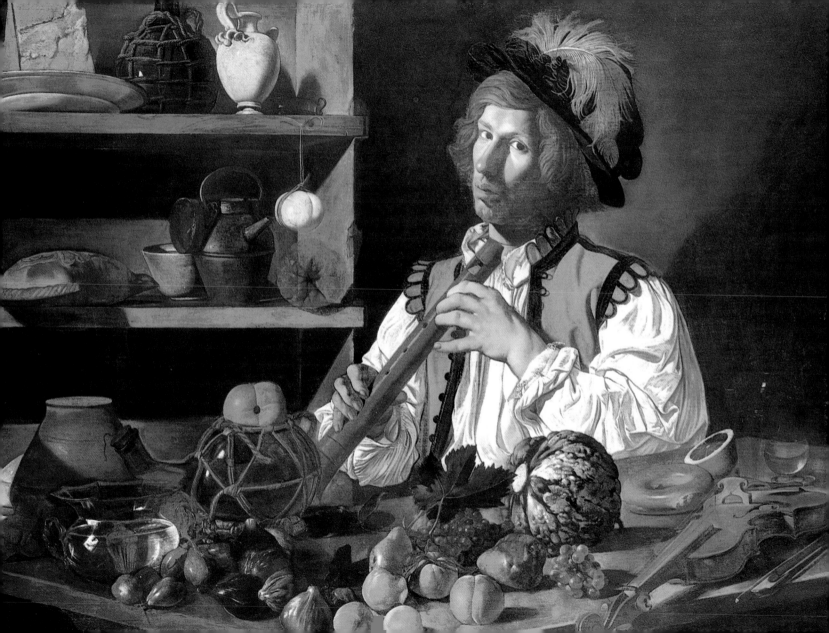

How beautiful yellow is!

Vincent van Gogh

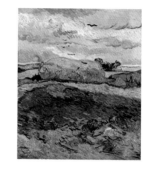

Haystack on a Rainy Day, Auvers-sur-Oise, 1890
Vincent van Gogh
Museum Kröller-Müller, Otterlo

1 2 3 4 5 6 7 8 **9** 10 11 12 13 14 15 16 17 18 19 20 21 22 23 24 25 26 27 28 29 30

SEPTEMBER

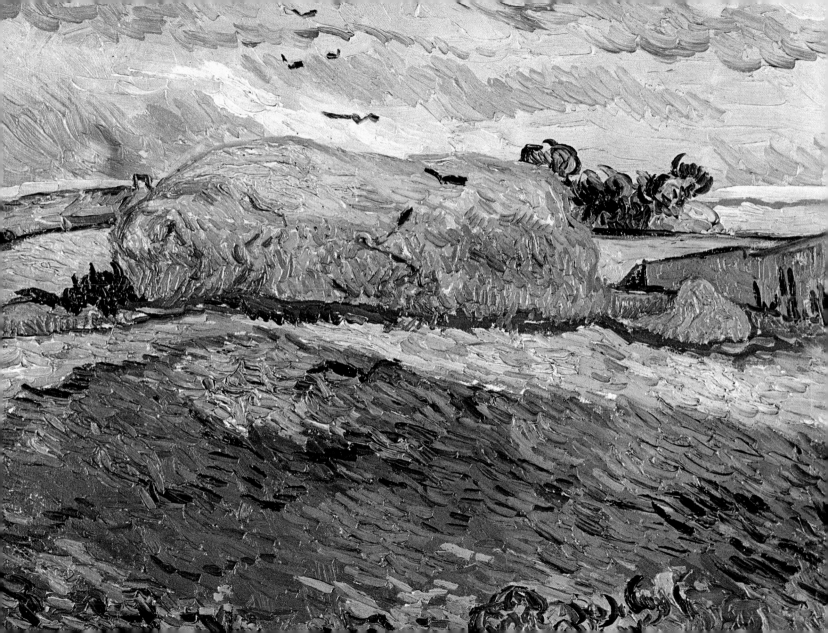

Things that are holy are revealed only to men who are holy.

Hippocrates

Saint John the Evangelist and Saint Francis, late 16th century
El Greco
Uffizi Gallery, Florence

1 2 3 4 5 6 7 8 9 **10** 11 12 13 14 15 16 17 18 19 20 21 22 23 24 25 26 27 28 29 30

SEPTEMBER

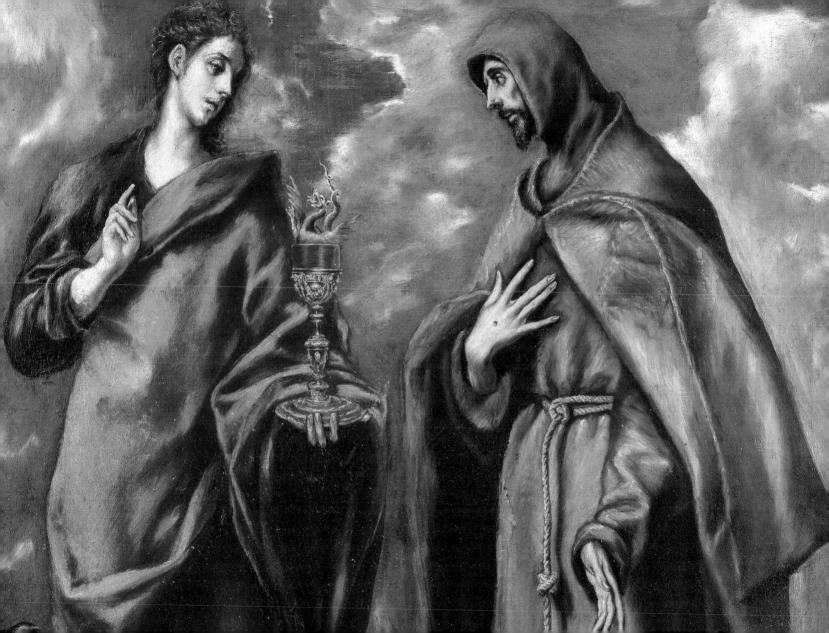

*Not what we have, but what we enjoy,
constitutes our abundance.*

Jean-Antoine Petit-Senn

Dates, late 17th or early 18th century
Bartolomeo Bimbi
Palazzo Pitti, Florence

1 2 3 4 5 6 7 8 9 10 **11** 12 13 14 15 16 17 18 19 20 21 22 23 24 25 26 27 28 29 30

SEPTEMBER

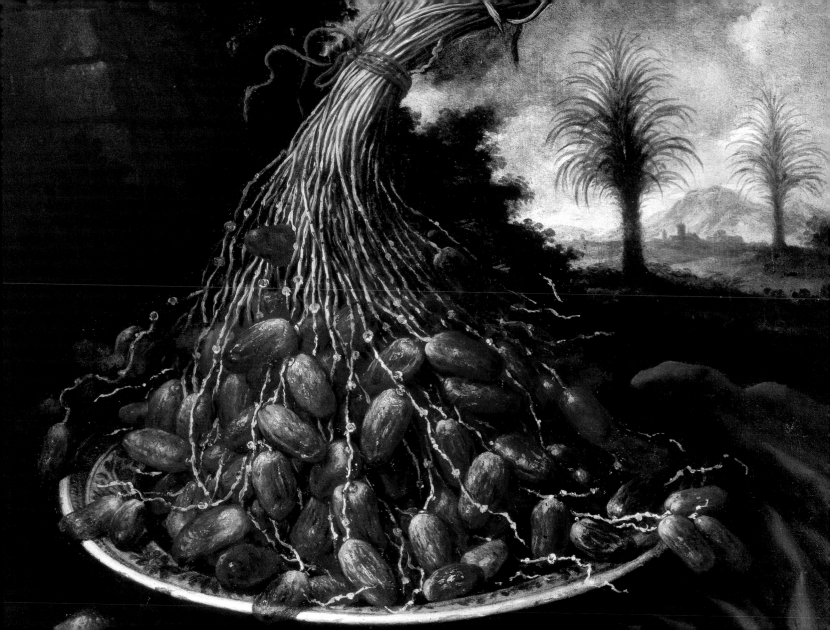

Let children walk with nature, let them see the beautiful blendings and communions of death and life, their joyous inseparable unity, as taught in woods and meadows, plains and mountains and streams of our blessed star...

<small>John Muir</small>

Indians on Horses, 1911
August Macke
Lenbachhaus, Munich

1 2 3 4 5 6 7 8 9 10 11 **12** 13 14 15 16 17 18 19 20 21 22 23 24 25 26 27 28 29 30

SEPTEMBER

There is a feeling of eternity in youth which makes us amends for everything.

WILLIAM HAZLITT

Grape and Melon Eaters, 1645–46
Bartolomé Estéban Murillo
Alte Pinakothek, Munich

1 2 3 4 5 6 7 8 9 10 11 12 **13** 14 15 16 17 18 19 20 21 22 23 24 25 26 27 28 29 30

SEPTEMBER

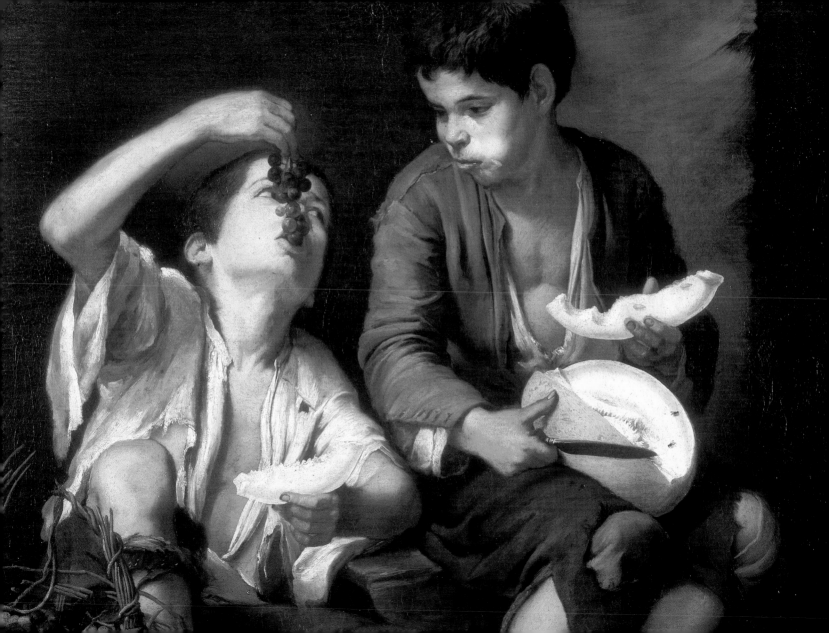

Do not quench your inspiration
and your imagination.
Do not become the slave of your model.

VINCENT VAN GOGH

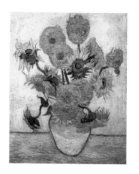

Fourteen Sunflowers in a Vase, 1889
Vincent van Gogh
Yasuda Insurance, Tokyo

1 2 3 4 5 6 7 8 9 10 11 12 13 **14** 15 16 17 18 19 20 21 22 23 24 25 26 27 28 29 30

SEPTEMBER

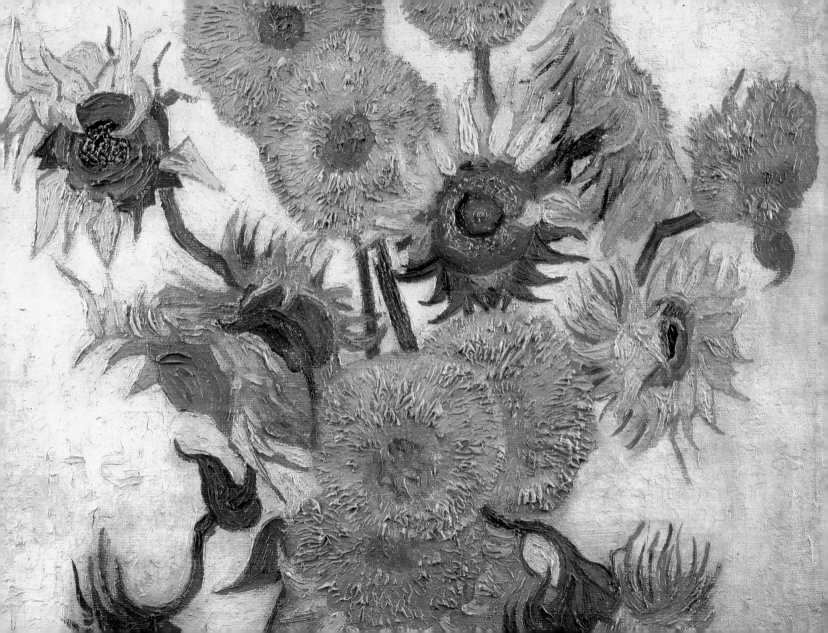

Merrily, merrily whirled the wheels
of the dizzying dances
Under the orchard-trees and down the path
to the meadows.

Henry Wadsworth Longfellow

The Wedding Dance, 1566
Pieter Brueghel the Elder
The Detroit Institute of Arts

1 2 3 4 5 6 7 8 9 10 11 12 13 14 **15** 16 17 18 19 20 21 22 23 24 25 26 27 28 29 30

SEPTEMBER

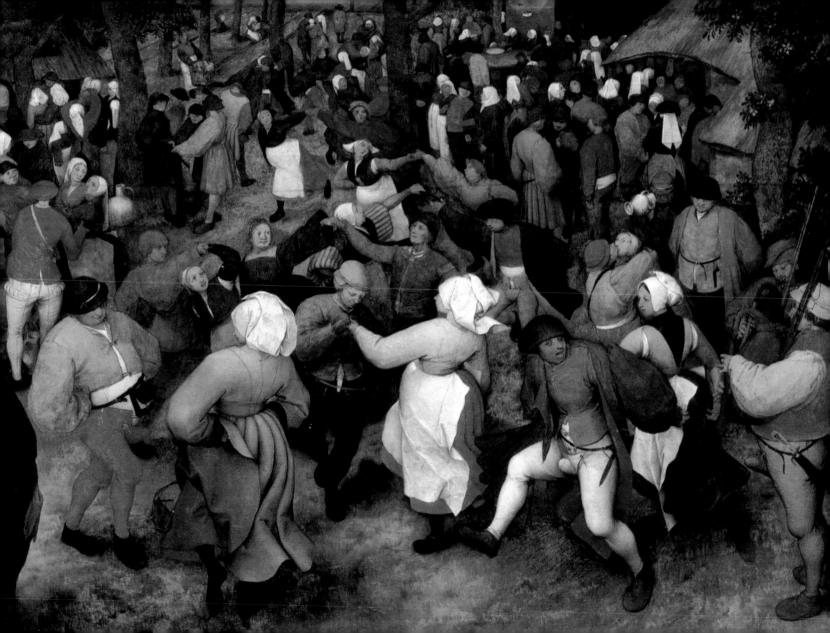

There is a harmony
In autumn, and a lustre in its sky …

<small>PERCY BYSSHE SHELLEY</small>

Sunny Autumn Day, *c.* 1898
Otto Modersohn
Private Collection

1 2 3 4 5 6 7 8 9 10 11 12 13 14 15 **16** 17 18 19 20 21 22 23 24 25 26 27 28 29 30

SEPTEMBER

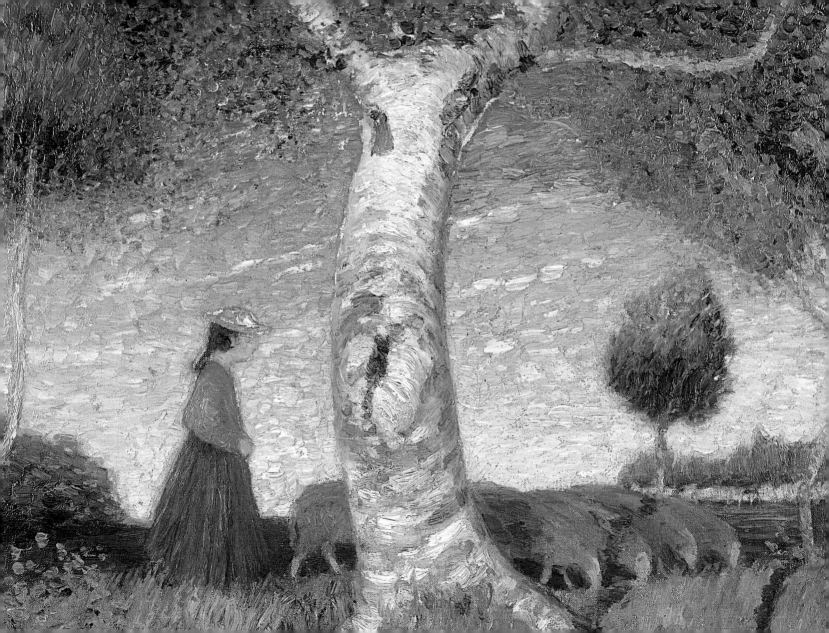

For the bow cannot possibly stand always bent, nor can human nature or human frailty subsist without some lawful recreation.

MIGUEL DE CERVANTES

On the Thames, 1876
James Tissot
Wakefield Museums, Galleries and Castles

1 2 3 4 5 6 7 8 9 10 11 12 13 14 15 16 **17** 18 19 20 21 22 23 24 25 26 27 28 29 30

SEPTEMBER

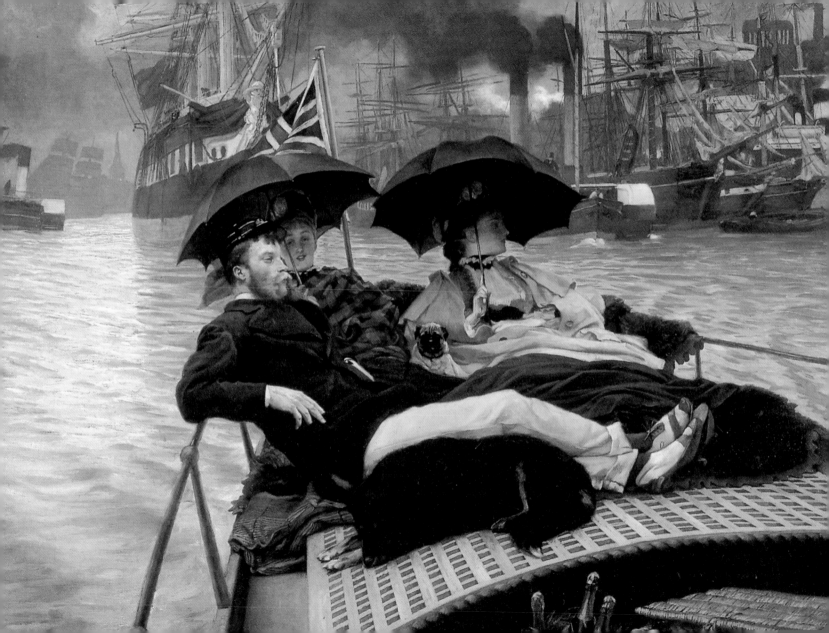

I believe ... that such abnormal moments can be found in everyone, and it is all the more fortunate when they occur in individuals with creative talent or with clairvoyant powers.

GIORGIO DE CHIRICO

The Enigma of the Day, 1914
Giorgio de Chirico
Museum of Contemporary Art of the University of São Paolo

1 2 3 4 5 6 7 8 9 10 11 12 13 14 15 16 17 **18** 19 20 21 22 23 24 25 26 27 28 29 30

SEPTEMBER

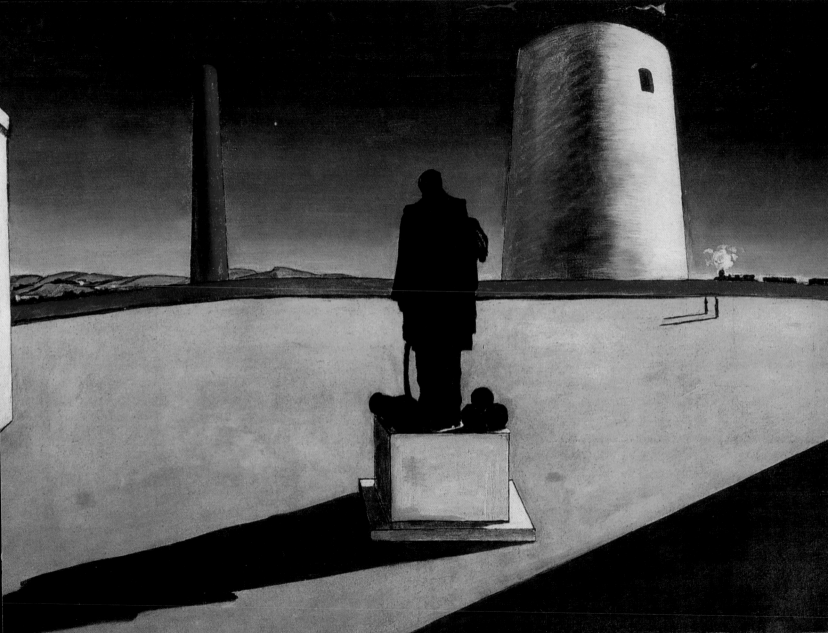

And frame your mind to mirth and merriment,
Which bars a thousand harms and lengthens life.

WILLIAM SHAKESPEARE

Wine, Woman, and Song, 1839
Josef Danhauser
Belvedere, Vienna

1 2 3 4 5 6 7 8 9 10 11 12 13 14 15 16 17 18 **19** 20 21 22 23 24 25 26 27 28 29 30

SEPTEMBER

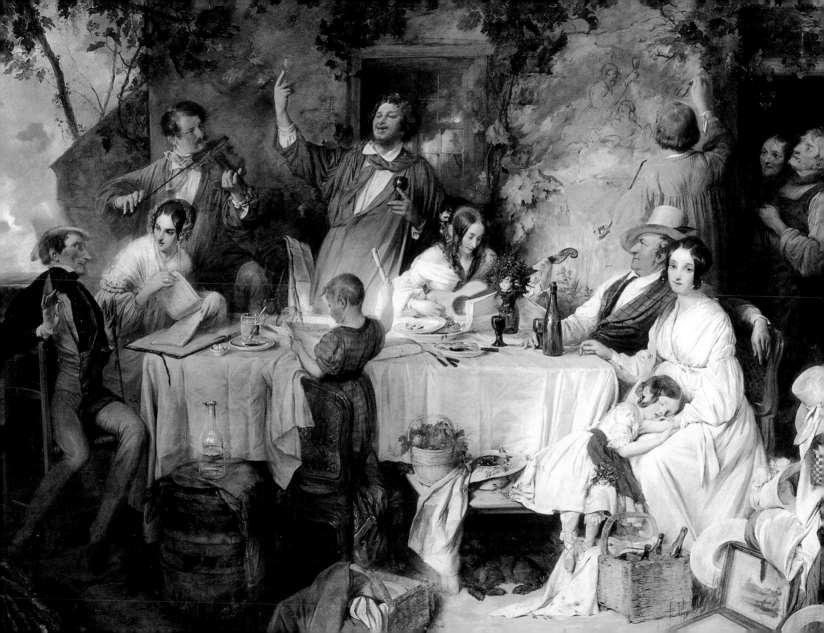

It's on the strength of observation and reflection that one finds a way. So we must dig and delve unceasingly.

Claude Monet

Town Road in Normandy, *c.* 1867
Claude Monet
Kunsthalle, Mannheim

1 2 3 4 5 6 7 8 9 10 11 12 13 14 15 16 17 18 19 **20** 21 22 23 24 25 26 27 28 29 30

SEPTEMBER

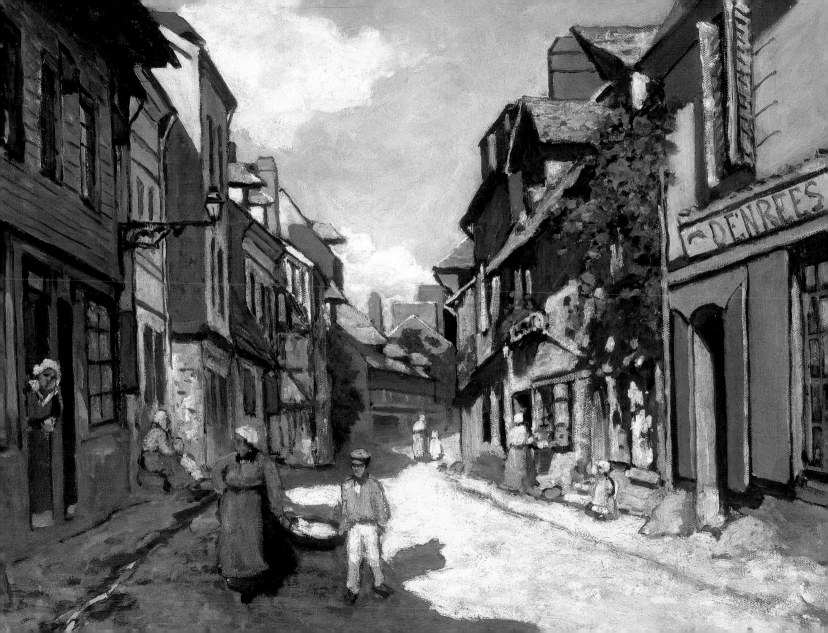

And when my lips meet thine
Thy very soul is wedded unto mine.

HJALMAR HJORTH BOYESEN

The Kiss, 1907–08
Gustav Klimt
Belvedere, Vienna

1 2 3 4 5 6 7 8 9 10 11 12 13 14 15 16 17 18 19 20 **21** 22 23 24 25 26 27 28 29 30

SEPTEMBER

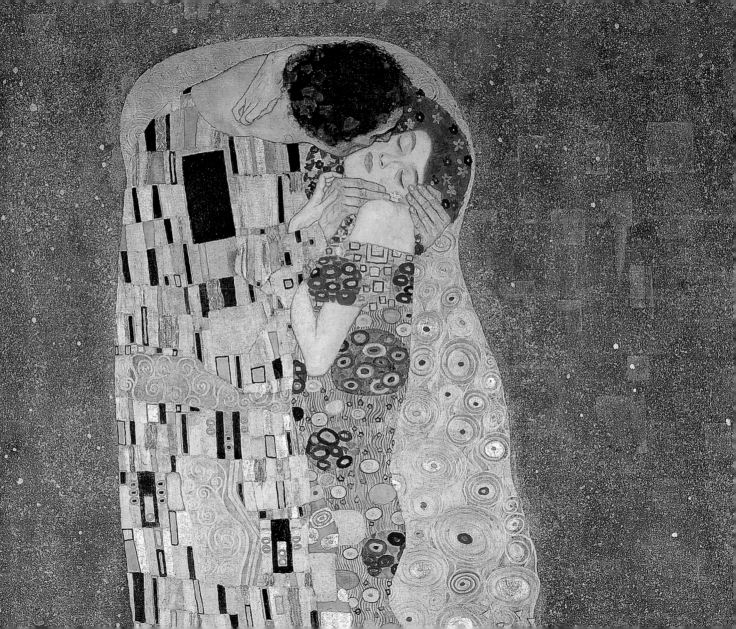

Play up, play up, and play the game.

Henry John Newboldt

Snap the Whip, 1872
Winslow Homer
John H. Sherwood Collection (USA)

1 2 3 4 5 6 7 8 9 10 11 12 13 14 15 16 17 18 19 20 21 **22** 23 24 25 26 27 28 29 30

September

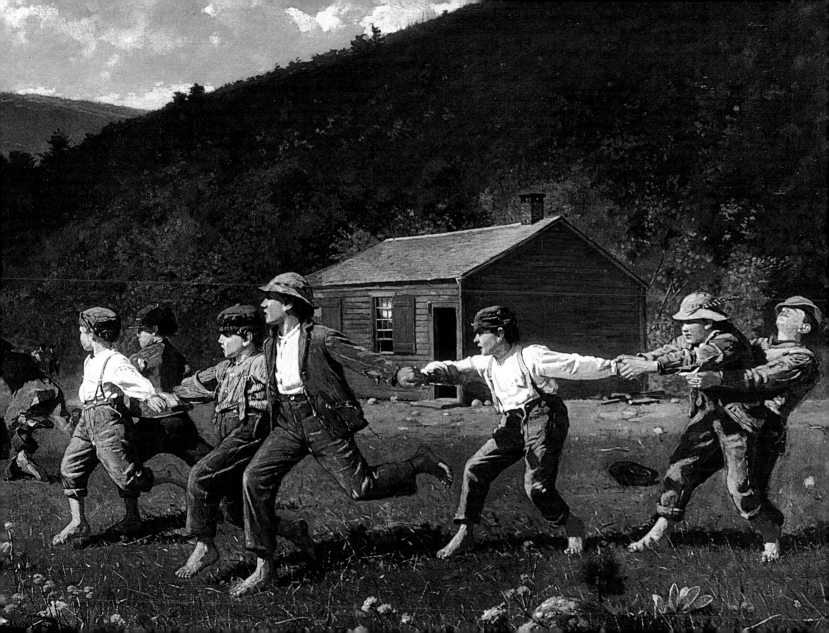

I always pet a dog with my left hand because if he bit me I'd still have my right hand to paint with.

Juan Gris

Pierrot, 1922
Juan Gris
Von der Heydt-Museum, Wuppertal

1 2 3 4 5 6 7 8 9 10 11 12 13 14 15 16 17 18 19 20 21 22 **23** 24 25 26 27 28 29 30

SEPTEMBER

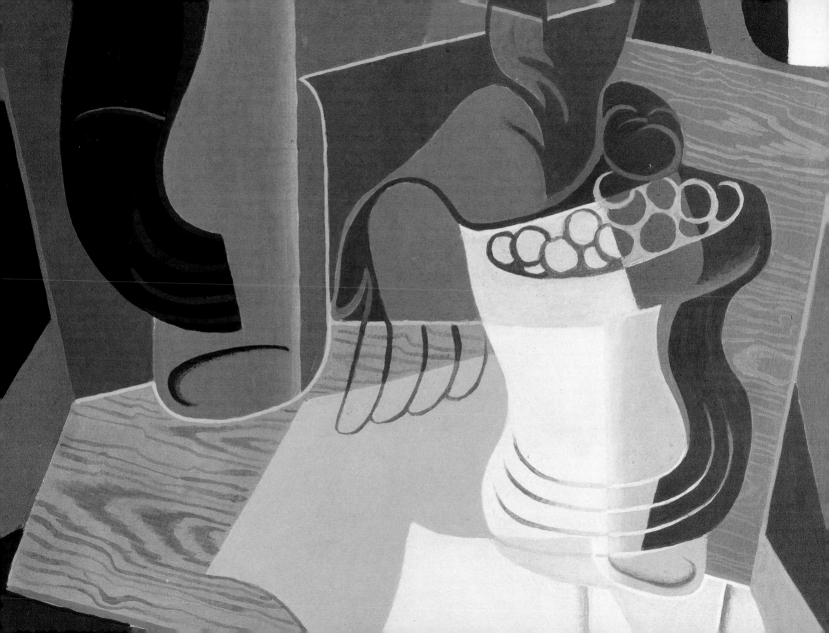

The modern majesty consists in work.
What a man can do is his greatest ornament,
and he always consults his dignity
by doing it.

Thomas Carlyle

The Gleaners, 1857
Jean-François Millet
Musée d'Orsay, Paris

1 2 3 4 5 6 7 8 9 10 11 12 13 14 15 16 17 18 19 20 21 22 23 **24** 25 26 27 28 29 30

SEPTEMBER

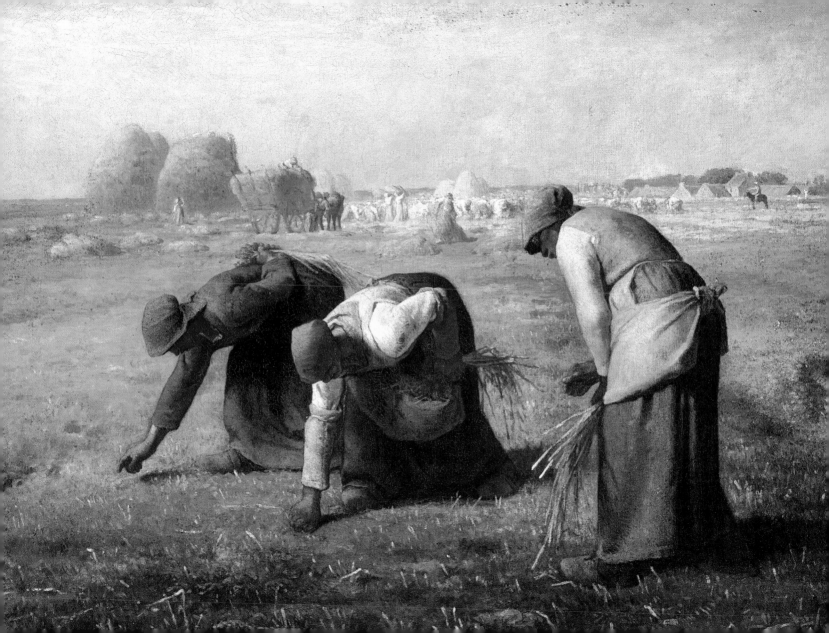

Life is very short ... but I would like to live four times and if I could, I would set out to do no other things than I am seeking now to do.

<small>WILLIAM MERRITT CHASE</small>

Season's End, 1884
William Merritt Chase
Mount Holyoke College Art Museum, South Hadley

1 2 3 4 5 6 7 8 9 10 11 12 13 14 15 16 17 18 19 20 21 22 23 24 **25** 26 27 28 29 30

SEPTEMBER

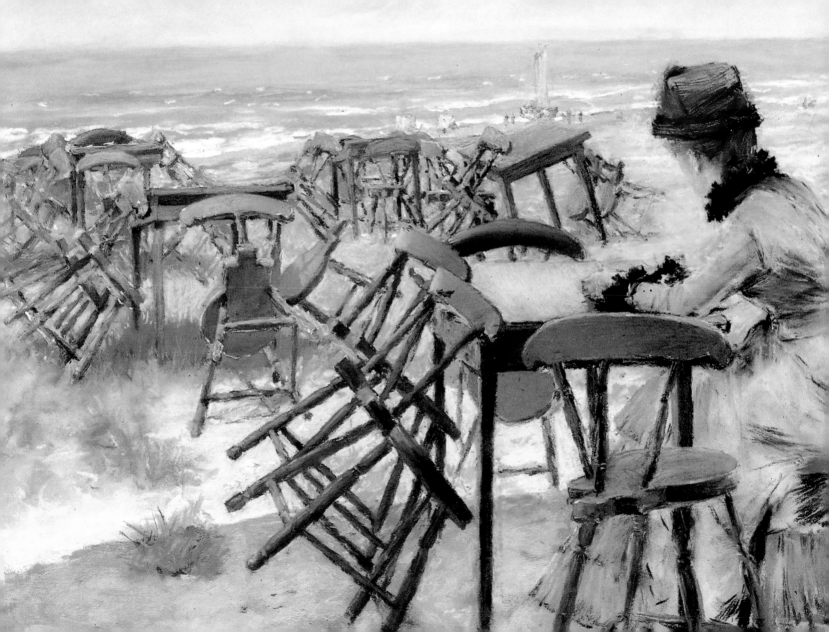

*The picture must radiate light,
the bodies have their own light
which they consume to live.
They burn, they are not lit from outside.*

EGON SCHIELE

People on the Blue Sea, 1913
August Macke
Staatliche Kunsthalle, Karlsruhe

1 2 3 4 5 6 7 8 9 10 11 12 13 14 15 16 17 18 19 20 21 22 23 24 25 **26** 27 28 29 30

SEPTEMBER

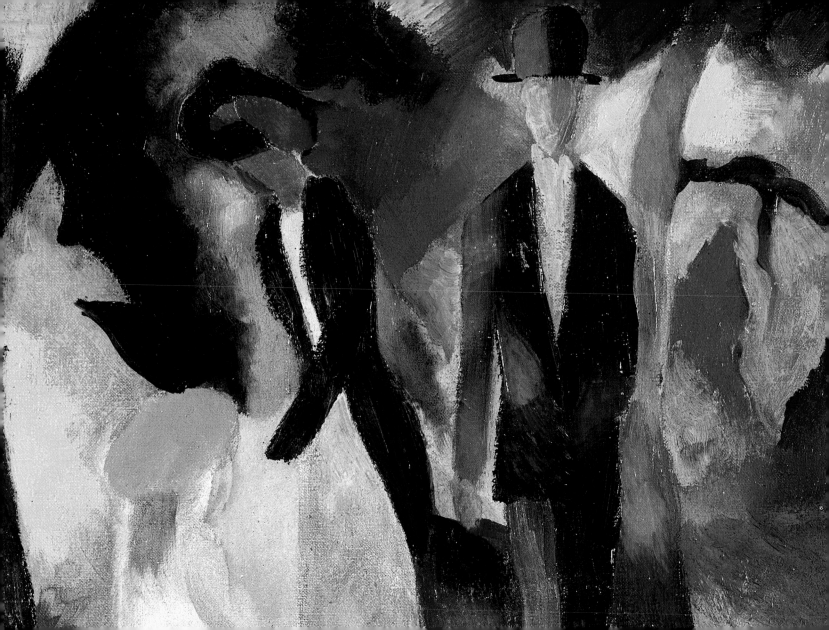

Let other lands, exulting, glean
The apple from the pine,
The orange from its glossy green,
The cluster from the vine.

JOHN GREENLEAF WHITTIER

Fruit Basket, c. 1593–94
Caravaggio
Pinacoteca Ambrosiana, Milan

1 2 3 4 5 6 7 8 9 10 11 12 13 14 15 16 17 18 19 20 21 22 23 24 25 26 **27** 28 29 30

SEPTEMBER

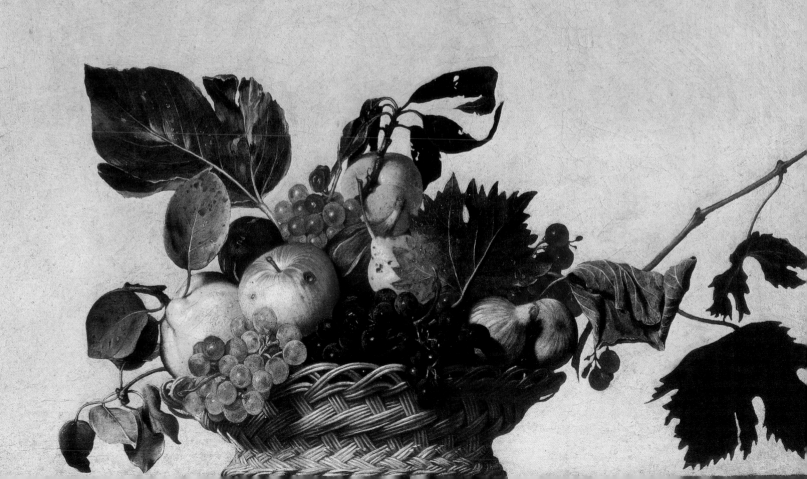

The winds grow high;
Impending tempests charge the sky ...

Matthew Prior

The Black Sea before the Storm, 1881
Ivan Konstantinovich Aivasovsky
The State Tretyakov Gallery, Moscow

1 2 3 4 5 6 7 8 9 10 11 12 13 14 15 16 17 18 19 20 21 22 23 24 25 26 27 **28** 29 30

SEPTEMBER

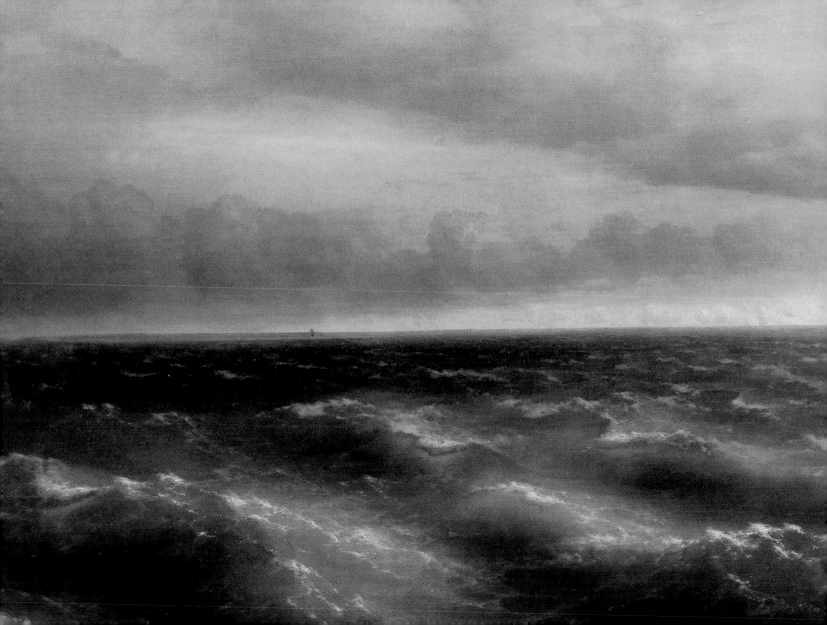

Some women's faces are,
in their brightness, a prophecy;
and some, in their sadness, a history.

<small>CHARLES DICKENS</small>

The Unkown, 1883
Ivan Nikolaevich Kramskoy
The State Tretyakov Gallery, Moscow

1 2 3 4 5 6 7 8 9 10 11 12 13 14 15 16 17 18 19 20 21 22 23 24 25 26 27 28 **29** 30

SEPTEMBER

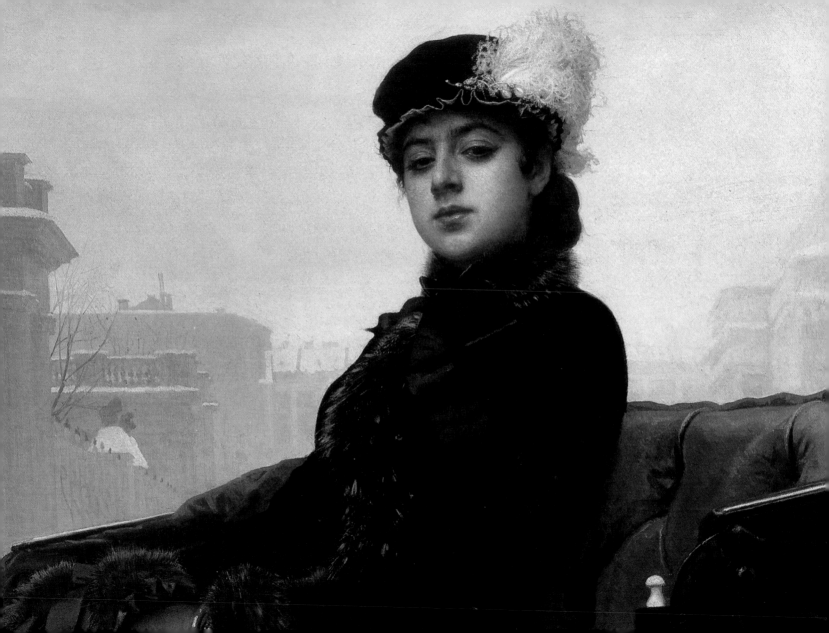

Don't be an art critic. Paint.
There lies salvation.

Paul Cézanne

Apples, 1877–78
Paul Cézanne
Fitzwilliam Museum, Cambridge

1 2 3 4 5 6 7 8 9 10 11 12 13 14 15 16 17 18 19 20 21 22 23 24 25 26 27 28 29 30

SEPTEMBER

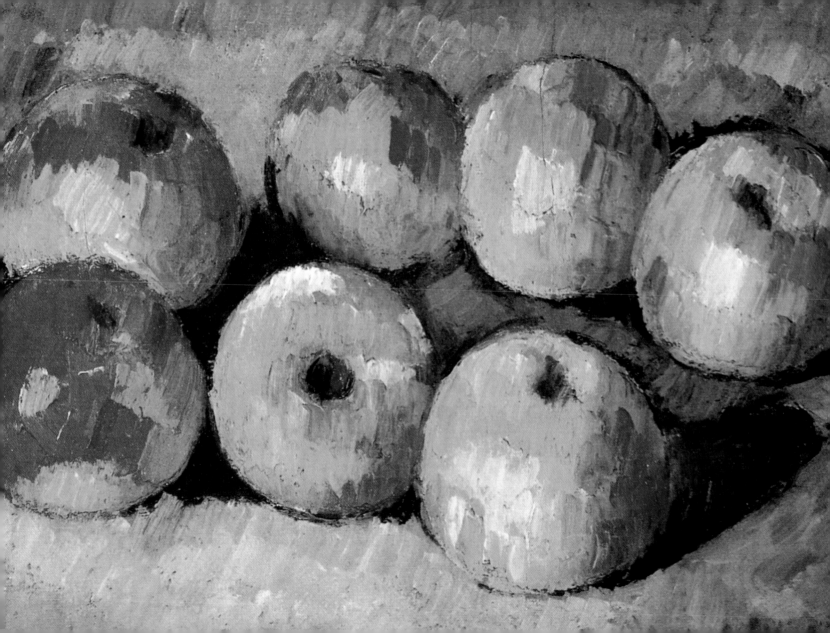

Come, evening, once again, season of peace;
Return, sweet evening, and continue long!

WILLIAM COWPER

The Return of the Herd, 1565
Pieter Brueghel the Elder
Kunsthistorisches Museum, Vienna

1 2 3 4 5 6 7 8 9 10 11 12 13 14 15 16 17 18 19 20 21 22 23 24 25 26 27 28 29 30 31

OCTOBER

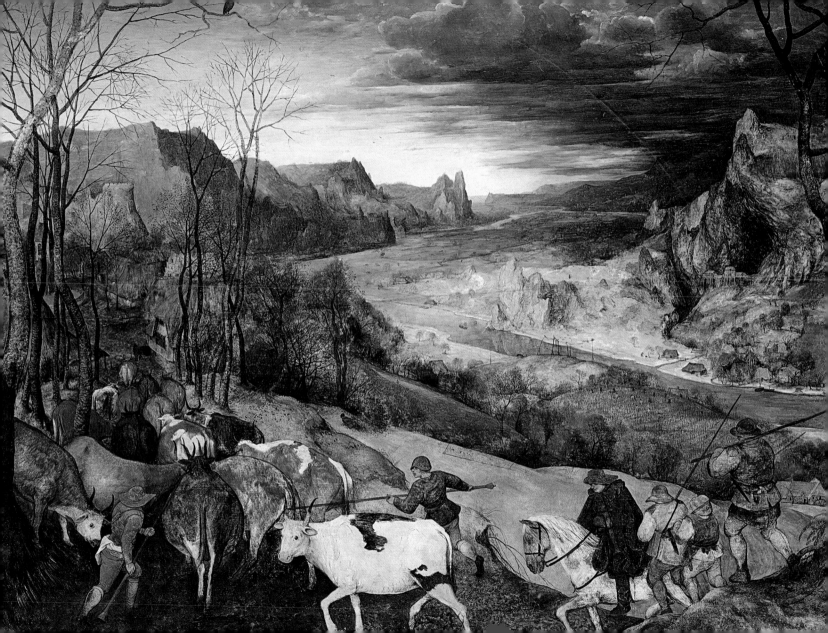

Music! Soft charm of heav'n and earth ...

Edmund Neale Smith

Angels with Sheet Music (Detail from the Enthroned Madonna with Child and Saints), late 15th or early 16th century

Leonardo Malatesta
Pinacotheca, Volterra

1 2 3 4 5 6 7 8 9 10 11 12 13 14 15 16 17 18 19 20 21 22 23 24 25 26 27 28 29 30 31

OCTOBER

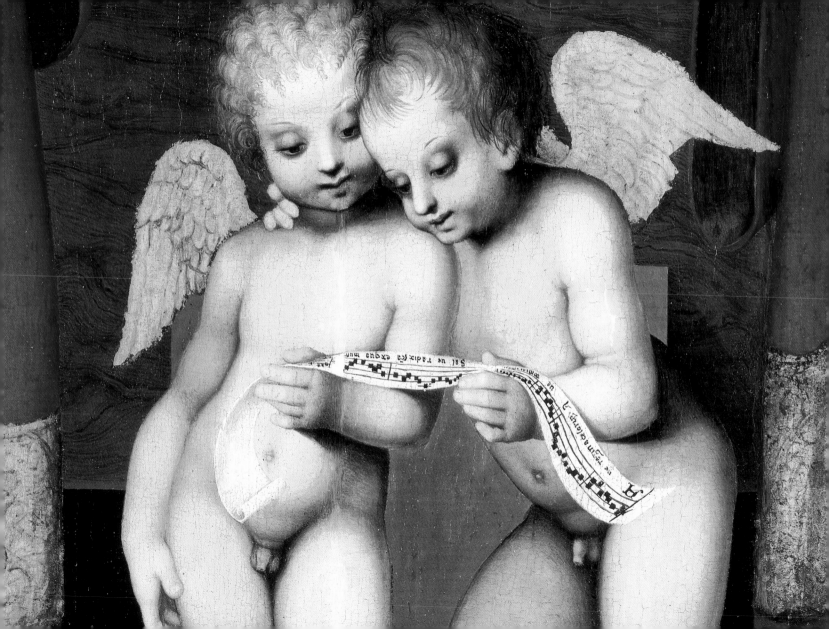

To restrict the artist is a crime.

EGON SCHIELE

The Mill, 1916
Egon Schiele
Niederösterreichisches Landesmuseum, Vienna

1 2 **3** 4 5 6 7 8 9 10 11 12 13 14 15 16 17 18 19 20 21 22 23 24 25 26 27 28 29 30 31

OCTOBER

Dreams are like portraits.

Geoge Crabbe

The Nobleman's Dream, 17th century
Antonio de Pereda
Academia de San Fernando, Madrid

1 2 3 **4** 5 6 7 8 9 10 11 12 13 14 15 16 17 18 19 20 21 22 23 24 25 26 27 28 29 30 31

OCTOBER

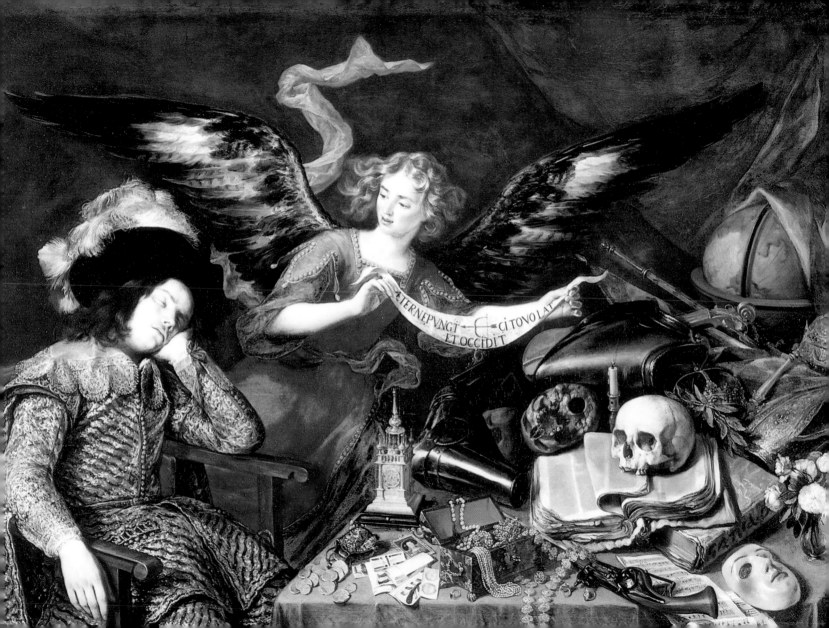

The salesman knows nothing of what he is selling save that he is charging a great deal too much for it.

Oscar Wilde

Solicitors in a Tavern, 1783
Karl Kaspar Pitz
Alte Pinakothek, Munich

1 2 3 4 **5** 6 7 8 9 10 11 12 13 14 15 16 17 18 19 20 21 22 23 24 25 26 27 28 29 30 31

OCTOBER

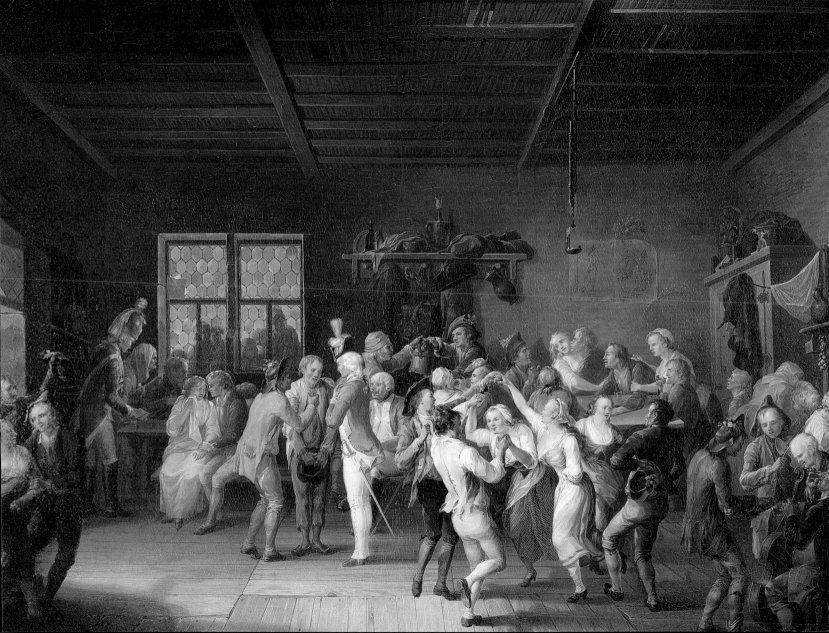

For my part I know nothing with any certainty, but the sight of the stars makes me dream.

Vincent van Gogh

The Starry Night, 1889
Vincent van Gogh
The Museum of Modern Art, New York

1 2 3 4 5 **6** 7 8 9 10 11 12 13 14 15 16 17 18 19 20 21 22 23 24 25 26 27 28 29 30 31

OCTOBER

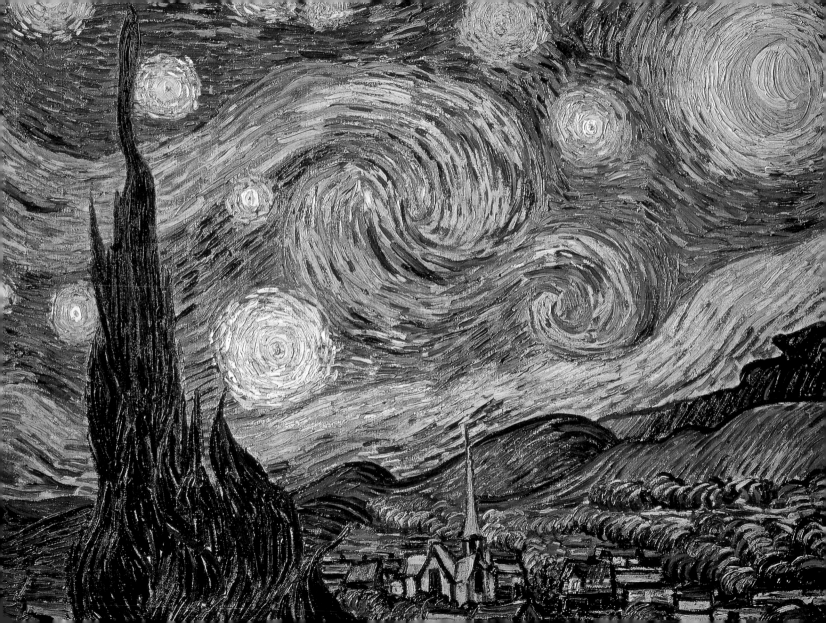

If a woman's soul is without cultivation, without taste, without refinement, without the sweetness of a happy mind, not all the mysteries of art can ever make her face beautiful.

LOLA MONTEZ

Portrait of Lola Montez, 1847
Joseph Karl Stieler
Nymphenburg Palace, Munich

1 2 3 4 5 6 **7** 8 9 10 11 12 13 14 15 16 17 18 19 20 21 22 23 24 25 26 27 28 29 30 31

OCTOBER

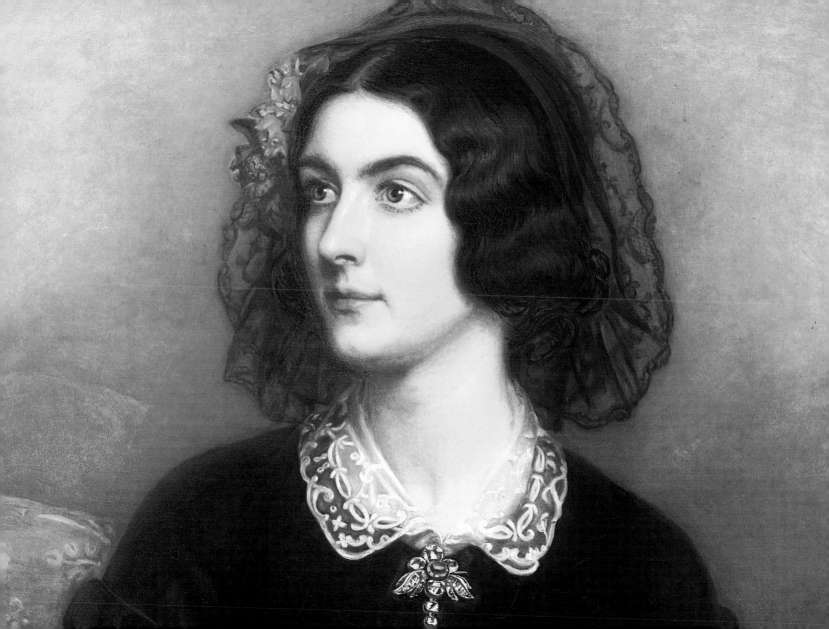

An oath! Why, it is the traffic of the soul,
the law within a man, the seal of faith,
and the bond of every conscience.

THOMAS DEKKER

The Oath of the Horatii, 1784
Jacques-Louis David
Musée du Louvre, Paris

1 2 3 4 5 6 7 **8** 9 10 11 12 13 14 15 16 17 18 19 20 21 22 23 24 25 26 27 28 29 30 31

OCTOBER

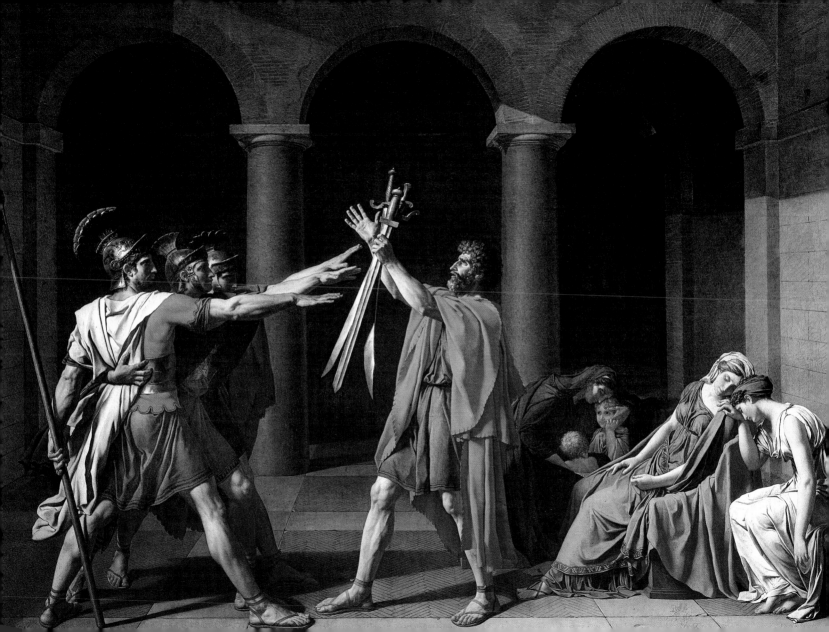

*I feel the need of attaining the maximum
of intensity with the minimum of means.
It is this which has led me to give my painting
a character of even greater bareness.*

JOAN MIRÓ

Landscape, 1927
Joan Miró
Private Collection

1 2 3 4 5 6 7 8 **9** 10 11 12 13 14 15 16 17 18 19 20 21 22 23 24 25 26 27 28 29 30 31

OCTOBER

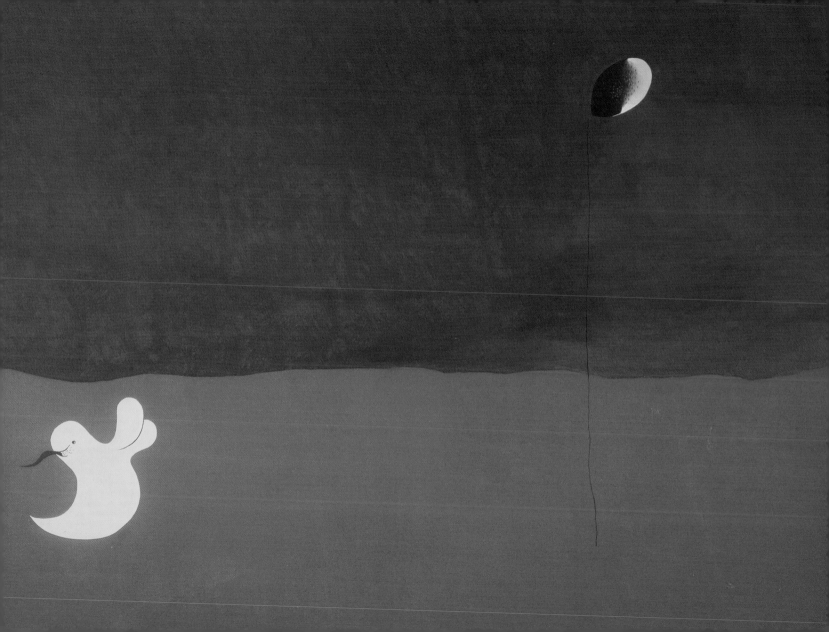

God never made anything else
so beautiful as man.

Henry Ward Beecher

Figure Study, 1855
Hippolyte Flandrin
Musée d'Orsay, Paris

1 2 3 4 5 6 7 8 9 **10** 11 12 13 14 15 16 17 18 19 20 21 22 23 24 25 26 27 28 29 30 31

OCTOBER

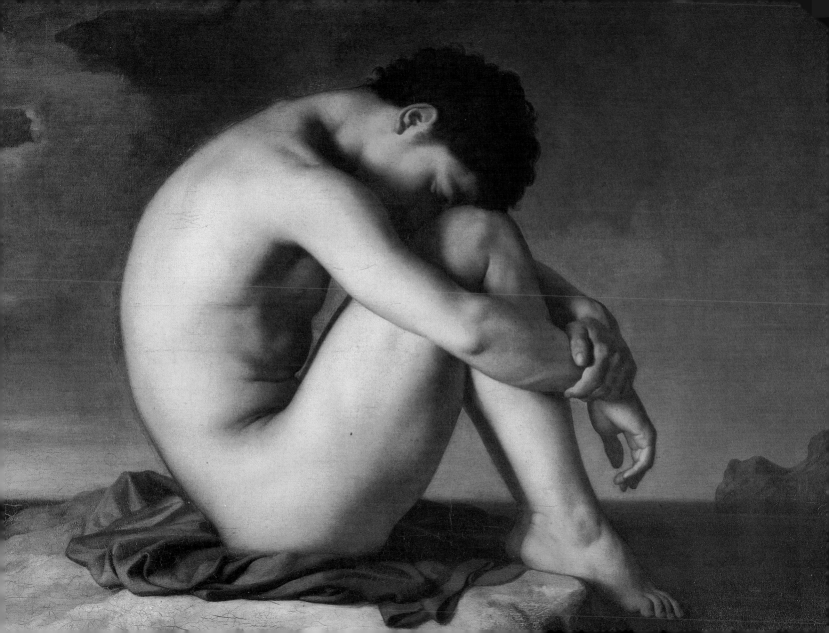

How like a queen comes forth the lonely moon
From the slow opening curtains of the clouds
Walking in beauty to her midnight throne!

<small>GEORGE CROLY</small>

The Piazzetta in Moonlight, 1842
Friedrich Nerly
Landesmuseum Mainz, loan from a private collection

1 2 3 4 5 6 7 8 9 10 **11** 12 13 14 15 16 17 18 19 20 21 22 23 24 25 26 27 28 29 30 31

OCTOBER

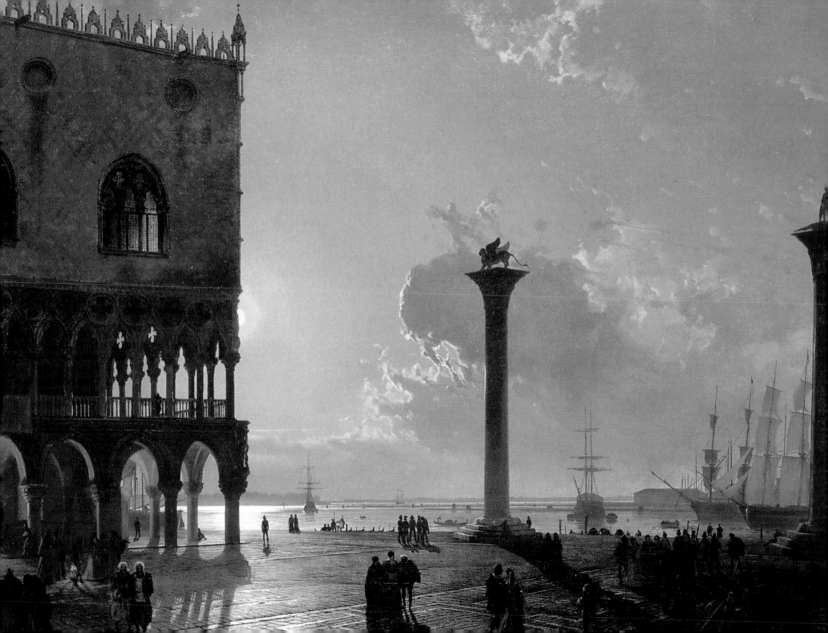

I think I could turn and live with animals,
They are so placid and self-contain'd,
I stand and look at them long and long.

WALT WHITMAN

Zoo I, 1912
August Macke
Lenbachhaus, Munich

1 2 3 4 5 6 7 8 9 10 11 **12** 13 14 15 16 17 18 19 20 21 22 23 24 25 26 27 28 29 30 31

OCTOBER

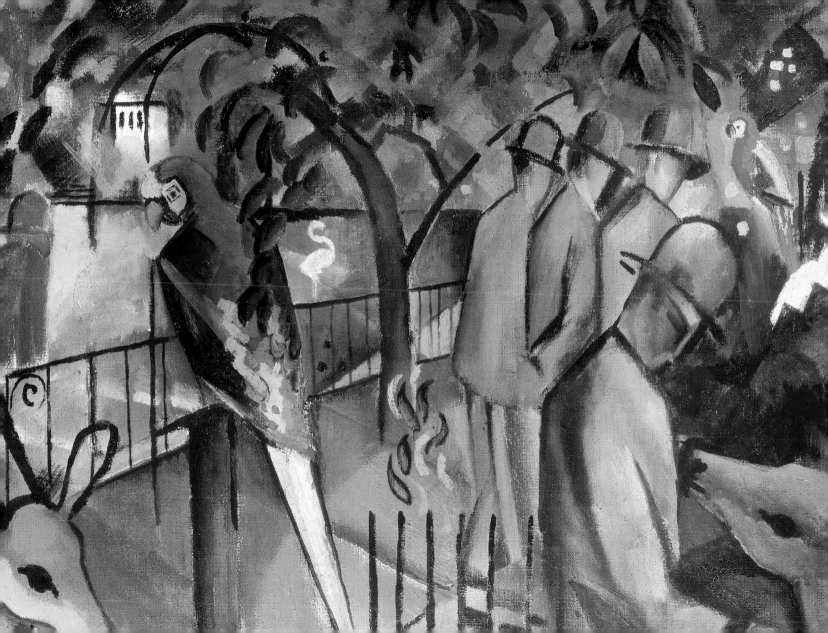

Childhood, whose very happiness is love.

Elizabeth Letitia Landon

Girl with Racket and Shuttlecock, 18th century
Jean-Baptiste Siméon Chardin
Uffizi Gallery, Florence

1 2 3 4 5 6 7 8 9 10 11 12 **13** 14 15 16 17 18 19 20 21 22 23 24 25 26 27 28 29 30 31

OCTOBER

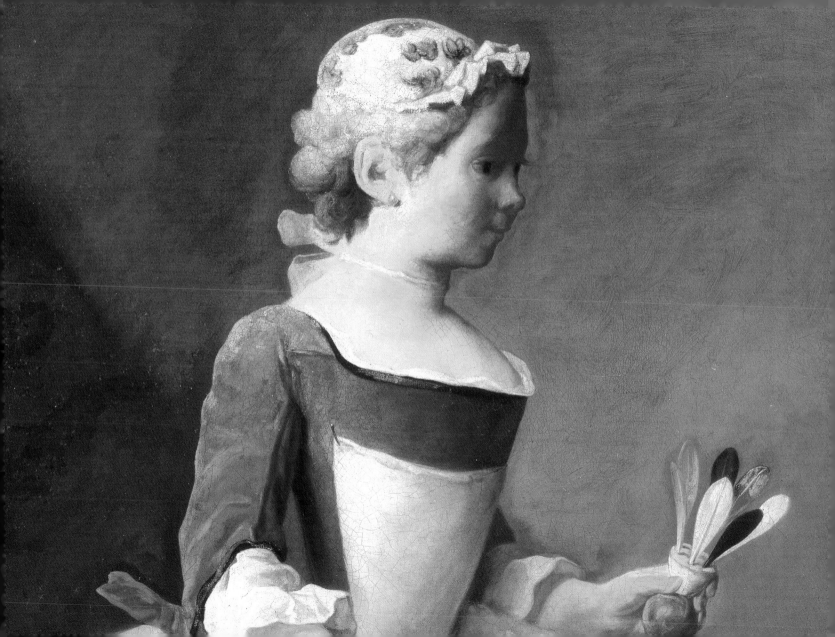

I know that to paint the sea really well,
you need to look at it every hour of every day
in the same place so that you can understand
its way in that particular spot.

CLAUDE MONET

Port de Mer (Le Havre), 1874
Claude Monet
E. G. Hermann Collection, Los Angeles

1 2 3 4 5 6 7 8 9 10 11 12 13 **14** 15 16 17 18 19 20 21 22 23 24 25 26 27 28 29 30 31

OCTOBER

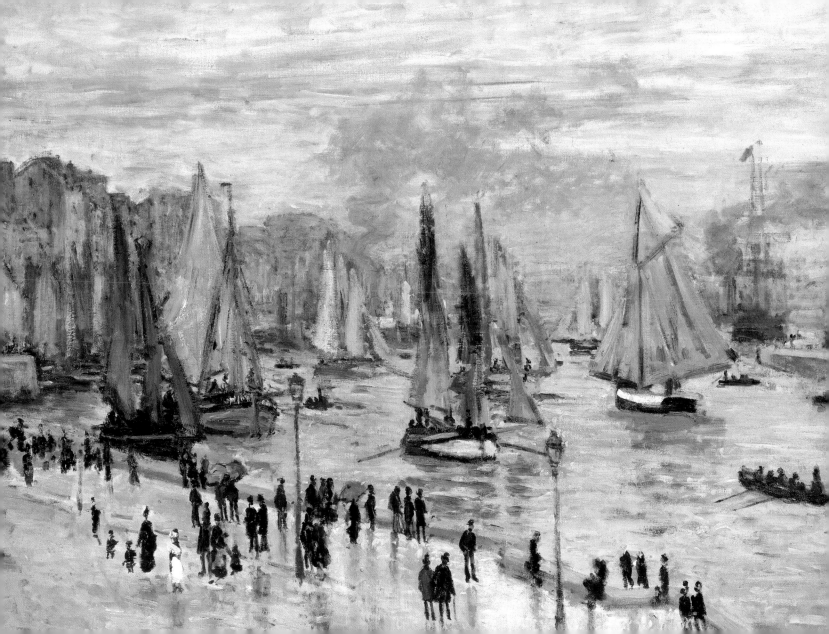

Oh, sleep! Sweet sleep!
Whatever form thou takest, thou art fair ...

Henry Wadsworth Longfellow

Women on the Shore of the Seine, 1856–57
Gustave Courbet
Musée du Petit Palais, Paris

1 2 3 4 5 6 7 8 9 10 11 12 13 14 **15** 16 17 18 19 20 21 22 23 24 25 26 27 28 29 30 31

OCTOBER

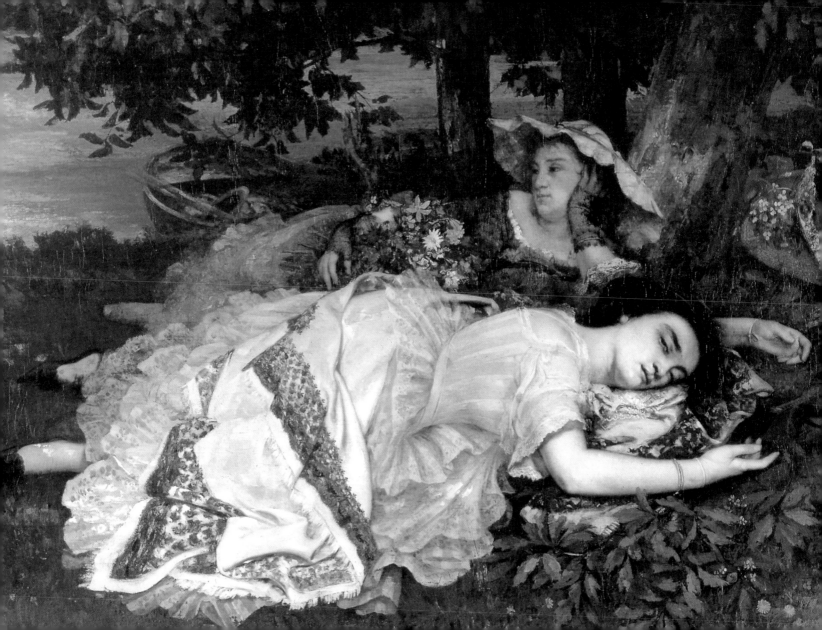

There is music in all things, if men had ears.

<small>LORD BYRON</small>

A Gust of Wind, 1864–73
Jean-Baptiste Camille Corot
The Pushkin Museum of Fine Arts, Moscow

1 2 3 4 5 6 7 8 9 10 11 12 13 14 15 **16** 17 18 19 20 21 22 23 24 25 26 27 28 29 30 31

OCTOBER

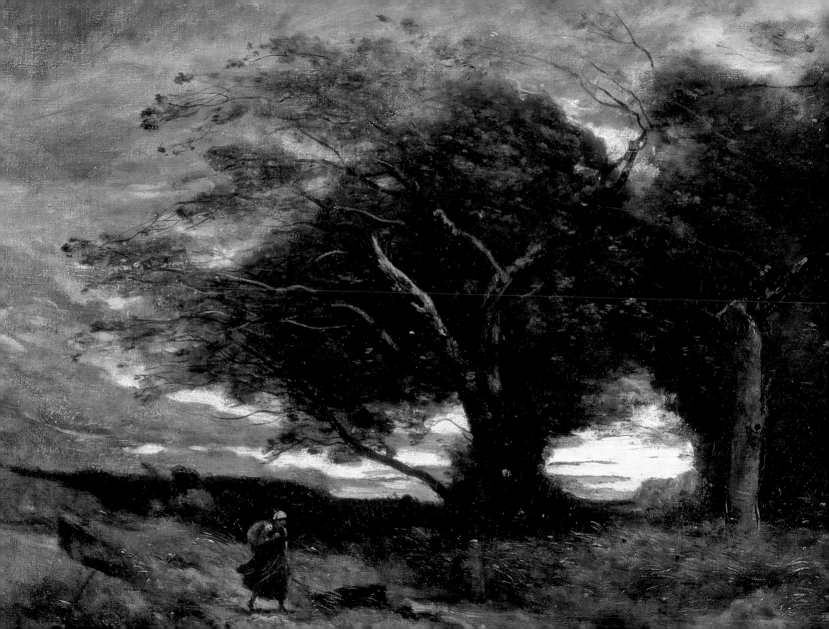

The wise are above books.

Samuel Daniel

Portrait of Robert Chaseman with Hunting Falcon, 1533
Hans Holbein the Younger
Mauritshuis, The Hague

1 2 3 4 5 6 7 8 9 10 11 12 13 14 15 16 **17** 18 19 20 21 22 23 24 25 26 27 28 29 30 31

OCTOBER

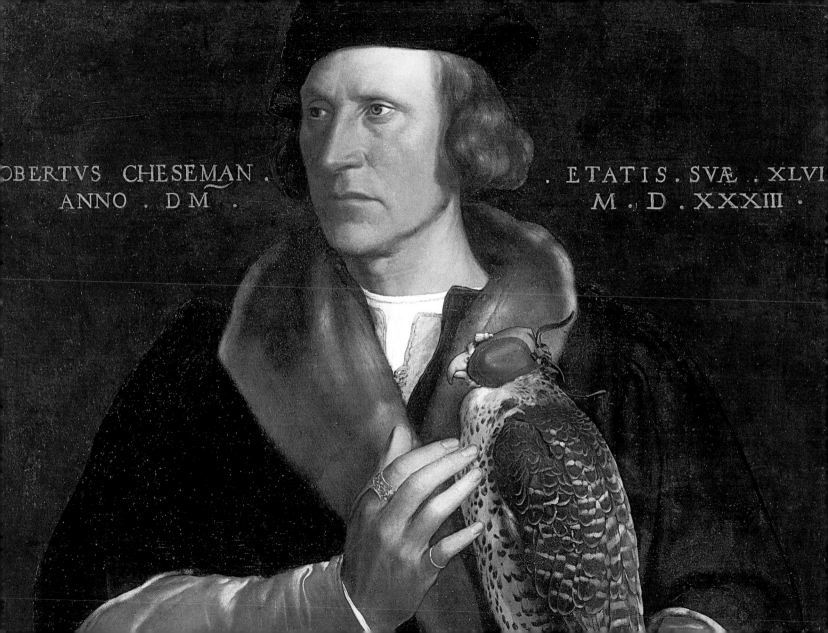

OBERTVS CHESEMAN .

ANNO . DM̃ .

. ETATIS . SVÆ . XLVI

M . D . XXXIII .

Prosperities can only be enjoyed by those who fear not at all to lose them.

Jeremy Taylor

Still Life with Fruit and Nautilus Shell, 17th century
Jan Davidsz de Heem
Uffizi Gallery, Florence

1 2 3 4 5 6 7 8 9 10 11 12 13 14 15 16 17 **18** 19 20 21 22 23 24 25 26 27 28 29 30 31

OCTOBER

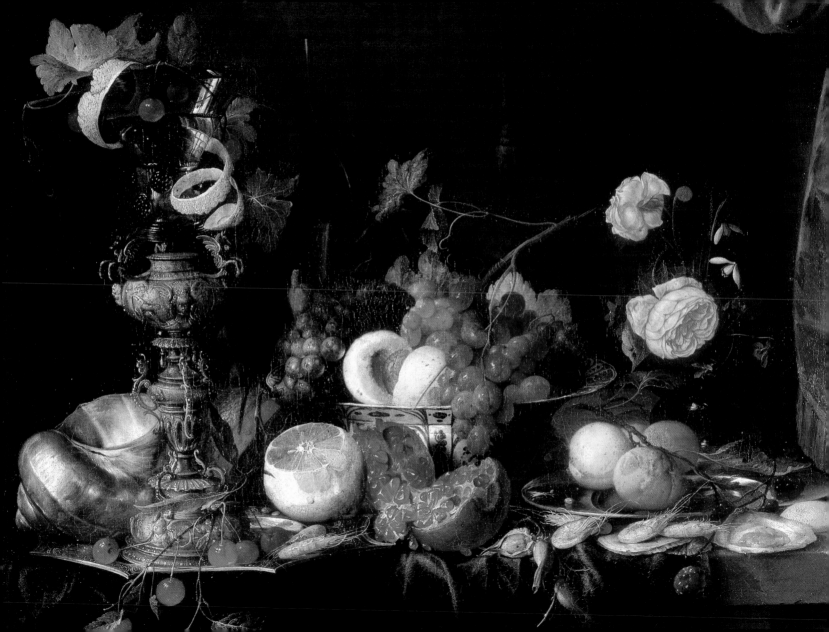

But the Lord provided a great fish
to swallow Jonah, and Jonah was inside
the fish three days and three nights.

THE BOOK OF JONAH, 1:17

Jonah and the Whale, c. 1596
Jan Brueghel the Elder
Alte Pinakothek, Munich

1 2 3 4 5 6 7 8 9 10 11 12 13 14 15 16 17 18 **19** 20 21 22 23 24 25 26 27 28 29 30 31

OCTOBER

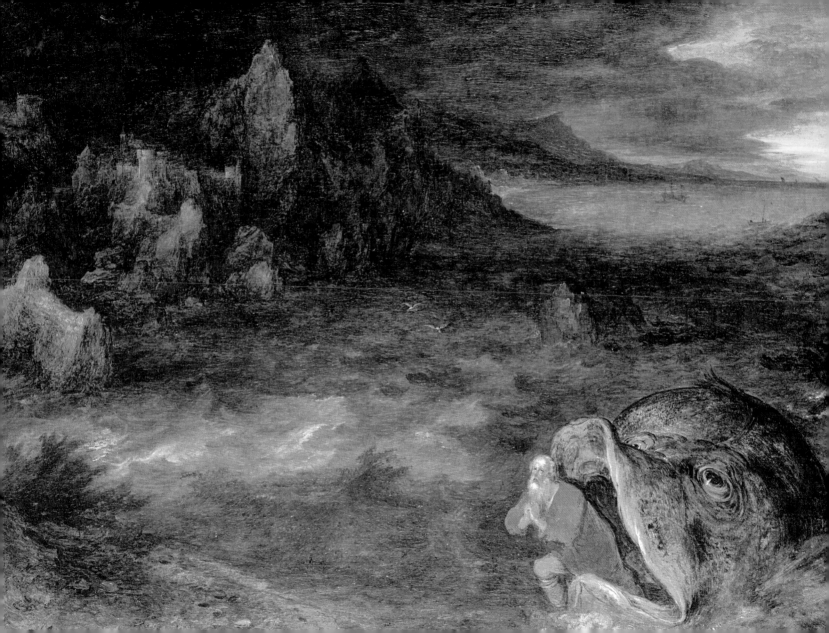

And the angel said to him:
I will conduct him thither,
and bring him back to thee.

THE BOOK OF TOBIT, 5:15

Landscape with Tobias and the Angel, 1610–15
Abraham Bloemaert
The State Hermitage Museum, St. Petersburg

1 2 3 4 5 6 7 8 9 10 11 12 13 14 15 16 17 18 19 **20** 21 22 23 24 25 26 27 28 29 30 31

OCTOBER

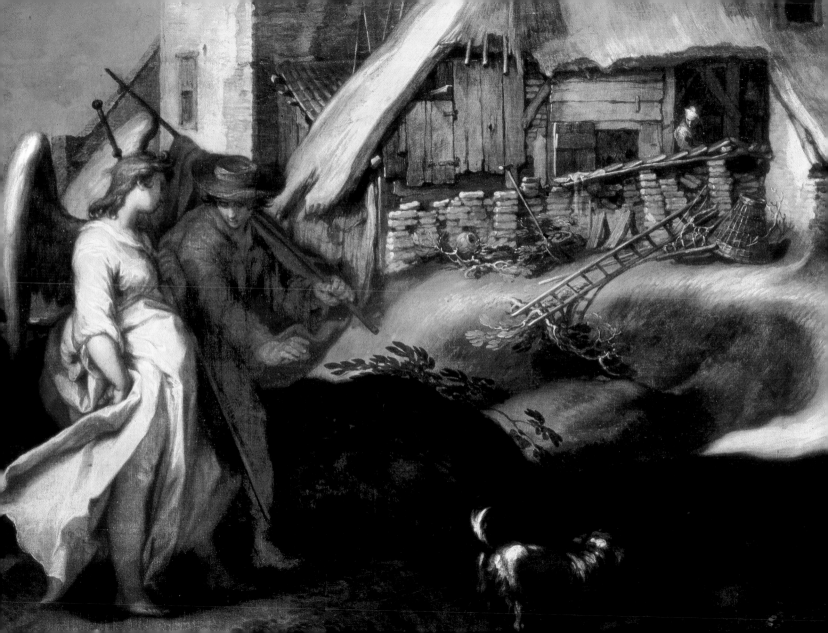

As I grew older, I realized that it was much better to insist on the genuine forms of nature, for simplicity is the greatest adornment of art.

ALBRECHT DÜRER

Self-Portrait in a Fur-Trimmed Robe, 1500
Albrecht Dürer
Alte Pinakothek, Munich

1 2 3 4 5 6 7 8 9 10 11 12 13 14 15 16 17 18 19 20 **21** 22 23 24 25 26 27 28 29 30 31

OCTOBER

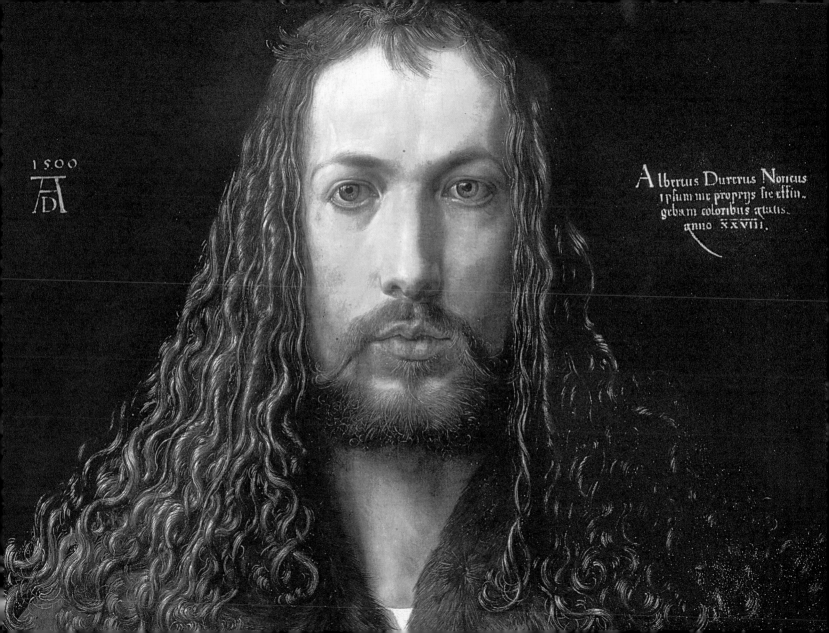

1500

AD

Albertus Durerus Noricus
ipsum me proprijs sic effin.
gebam coloribus ætatis.
anno XXVIII.

The purpose of life is life itself.

JOHANN WOLFGANG VON GOETHE

The Colorful Life, 1907
Wassily Kandinsky
Lenbachhaus, Munich

1 2 3 4 5 6 7 8 9 10 11 12 13 14 15 16 17 18 19 20 21 **22** 23 24 25 26 27 28 29 30 31

OCTOBER

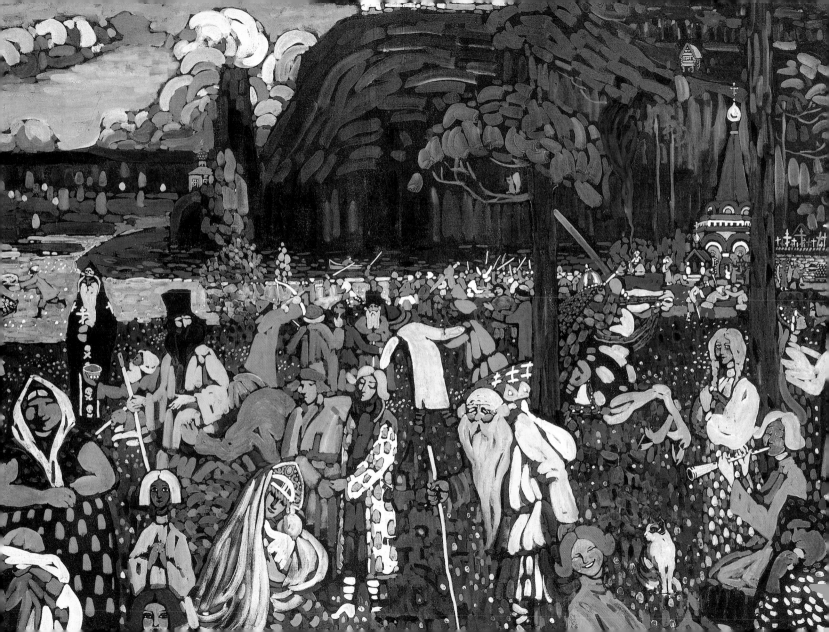

First come, first served.

The Pancake Seller, 17th century
Gerrit Dou
Uffizi Gallery, Florence

1 2 3 4 5 6 7 8 9 10 11 12 13 14 15 16 17 18 19 20 21 22 **23** 24 25 26 27 28 29 30 31

OCTOBER

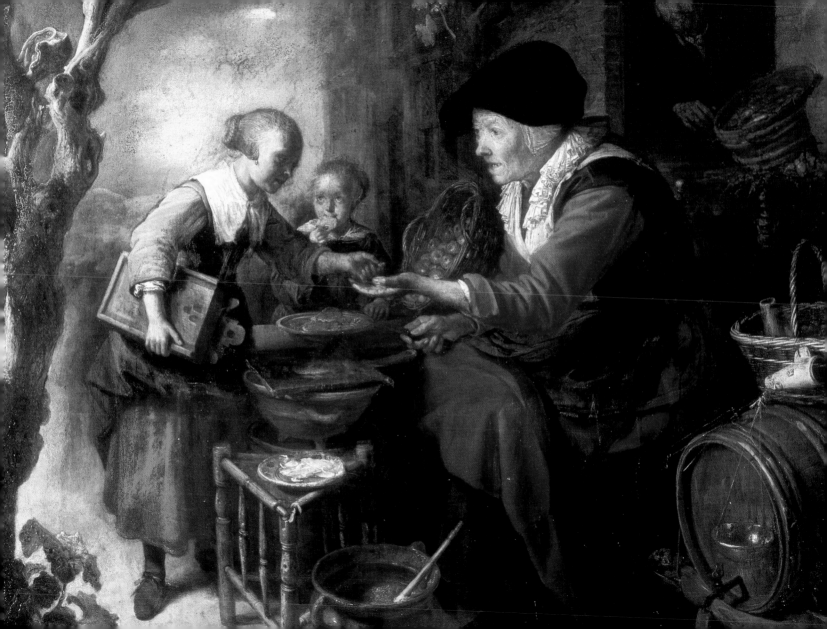

*Grace is the beauty of form
under the influence of freedom.*

FRIEDRICH SCHILLER

Dancer at the Photographer's, 1875
Edgar Degas
The Pushkin Museum of Fine Arts, Moscow

1 2 3 4 5 6 7 8 9 10 11 12 13 14 15 16 17 18 19 20 21 22 23 **24** 25 26 27 28 29 30 31

OCTOBER

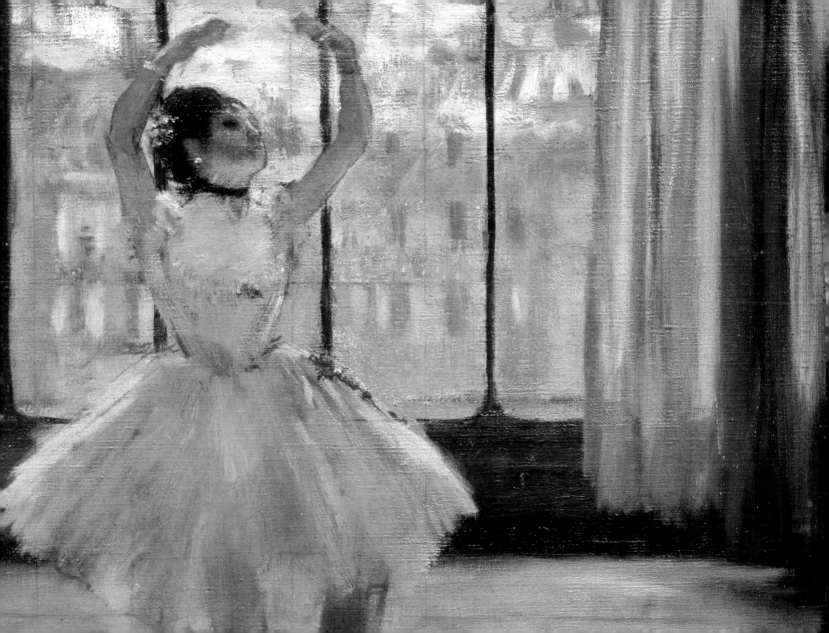

The beautiful is in nature ...
Once it is found it belongs to art,
or rather to the artist who discovers it.

Gustave Courbet

Ploughed Field, *c.* 1830–35
Caspar David Friedrich
Hamburger Kunsthalle

1 2 3 4 5 6 7 8 9 10 11 12 13 14 15 16 17 18 19 20 21 22 23 24 **25** 26 27 28 29 30 31

OCTOBER

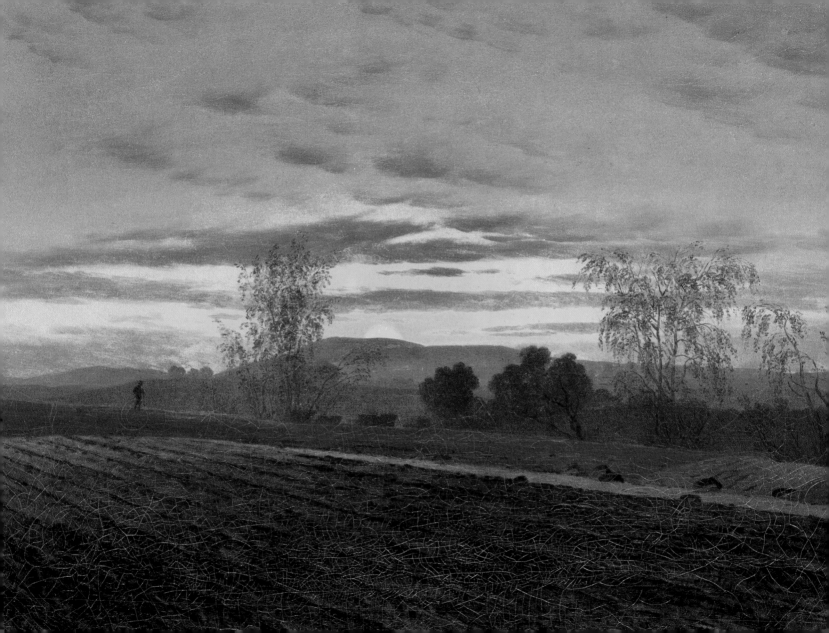

Certain thoughts are prayers.
There are moments when, whatever be the
attitude of the body, the soul is on its knees.

VICTOR HUGO

Magdalene in a Flickering Light, early 17th century
Georges de La Tour
Musée du Louvre, Paris

1 2 3 4 5 6 7 8 9 10 11 12 13 14 15 16 17 18 19 20 21 22 23 24 25 **26** 27 28 29 30 31

OCTOBER

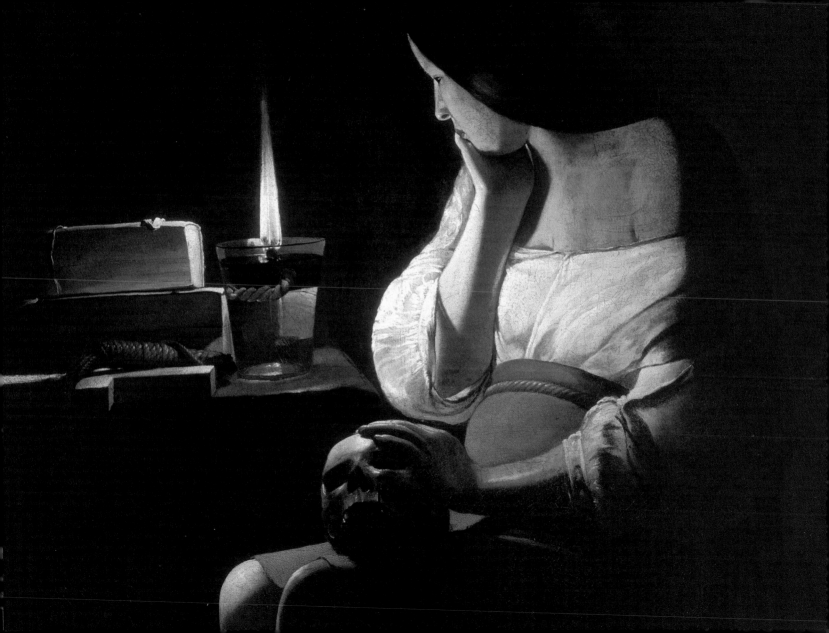

The Château of La Roche-Guillon, 1909
Georges Braque
The Pushkin Museum of Fine Arts, Moscow

Art is made to disturb, science reassures.

GEORGES BRAQUE

1 2 3 4 5 6 7 8 9 10 11 12 13 14 15 16 17 18 19 20 21 22 23 24 25 26 **27** 28 29 30 31

OCTOBER

Man is the measure of all things.

Protagoras

The School of Athens, 1509–10
Raphael
Stanza della Segnatura, Vatican City

1 2 3 4 5 6 7 8 9 10 11 12 13 14 15 16 17 18 19 20 21 22 23 24 25 26 27 **28** 29 30 31

OCTOBER

Never did sun more beautifully steep
In his first splendor, valley, rock, or hill;
Ne'er saw I, never felt, a calm so deep!

WILLIAM WORDSWORTH

Autumn Evening, 1852
Louis Cabat
Musée d'Orsay, Paris

1 2 3 4 5 6 7 8 9 10 11 12 13 14 15 16 17 18 19 20 21 22 23 24 25 26 27 28 **29** 30 31

OCTOBER

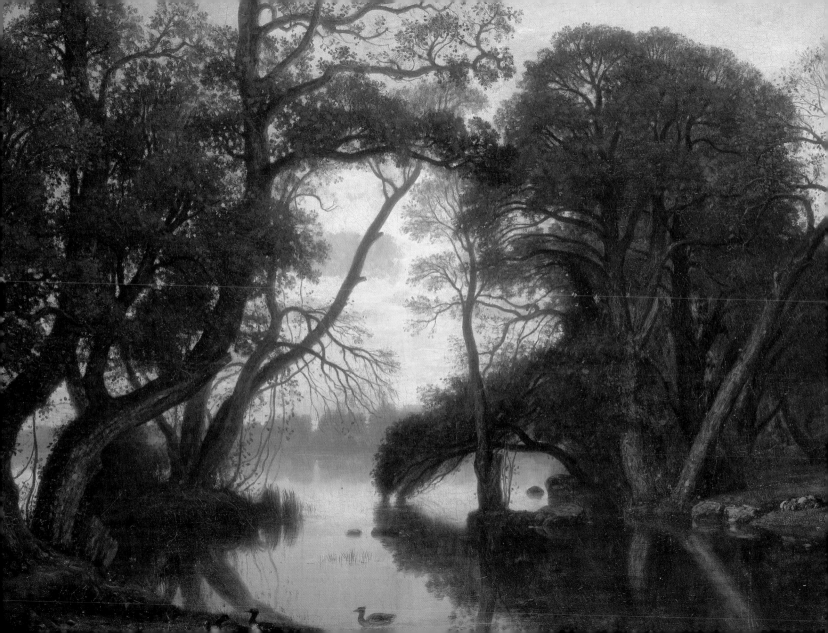

All that I am, my mother made me.

<small>JOHN QUINCY ADAMS</small>

Mother and Child, late 19th or early 20th century
Mary Cassatt
The Pushkin Museum of Fine Arts, Moscow

1 2 3 4 5 6 7 8 9 10 11 12 13 14 15 16 17 18 19 20 21 22 23 24 25 26 27 28 29 **30** 31

OCTOBER

Keep thy shop, and thy shop will keep thee.

GEORGE CHAPMAN

Grocer in front of a Farmhouse, 1839
Johann Fischbach
Residenzgalerie, Salzburg

1 2 3 4 5 6 7 8 9 10 11 12 13 14 15 16 17 18 19 20 21 22 23 24 25 26 27 28 29 30 31

OCTOBER

*Nothing great in the world has ever
been accomplished without passion.*

CHRISTIAN FRIEDRICH HEBBEL

The Bolt, before 1784
Jean-Honoré Fragonard
Musée du Louvre, Paris

1 2 3 4 5 6 7 8 9 10 11 12 13 14 15 16 17 18 19 20 21 22 23 24 25 26 27 28 29 30

NOVEMBER

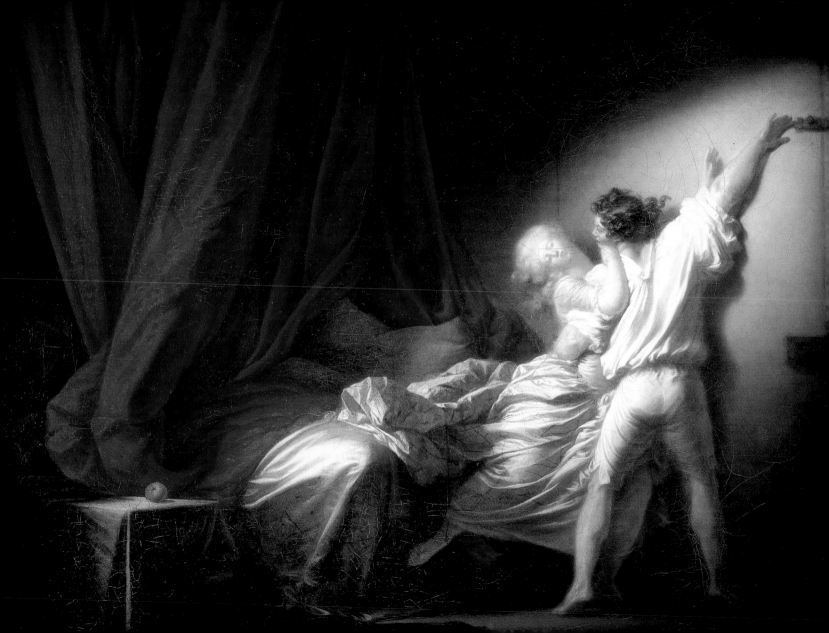

*What appears spectral today
will be natural tomorrow.*

Franz Marc

The Red Horses, 1911
Franz Marc
Private Collection

1 2 3 4 5 6 7 8 9 10 11 12 13 14 15 16 17 18 19 20 21 22 23 24 25 26 27 28 29 30

NOVEMBER

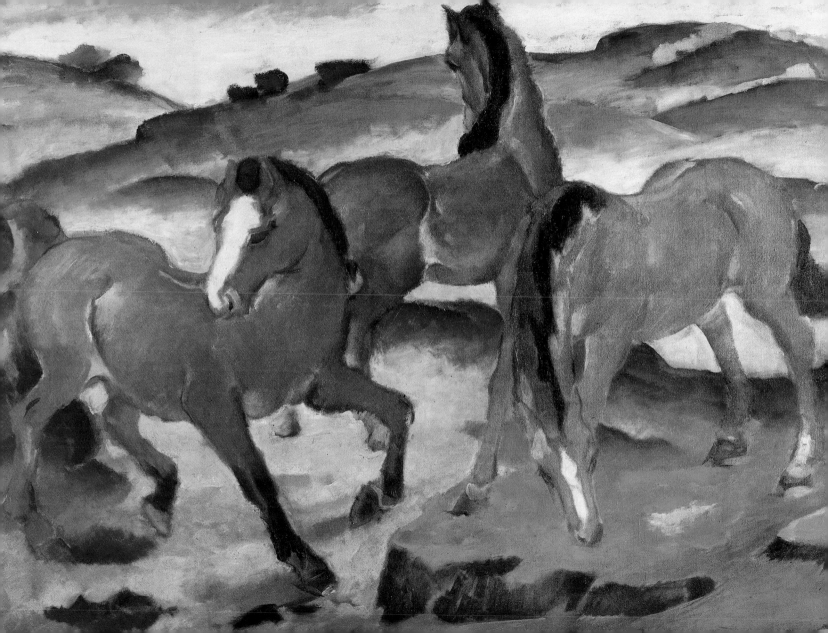

To err is human, but contrition felt for the crime distinguishes the virtuous from the wicked.

Vittorio Alfieri

The Seven Sacraments: Penance, 17th century
Nicolas Poussin
National Gallery, Edinburgh

1 2 **3** 4 5 6 7 8 9 10 11 12 13 14 15 16 17 18 19 20 21 22 23 24 25 26 27 28 29 30

NOVEMBER

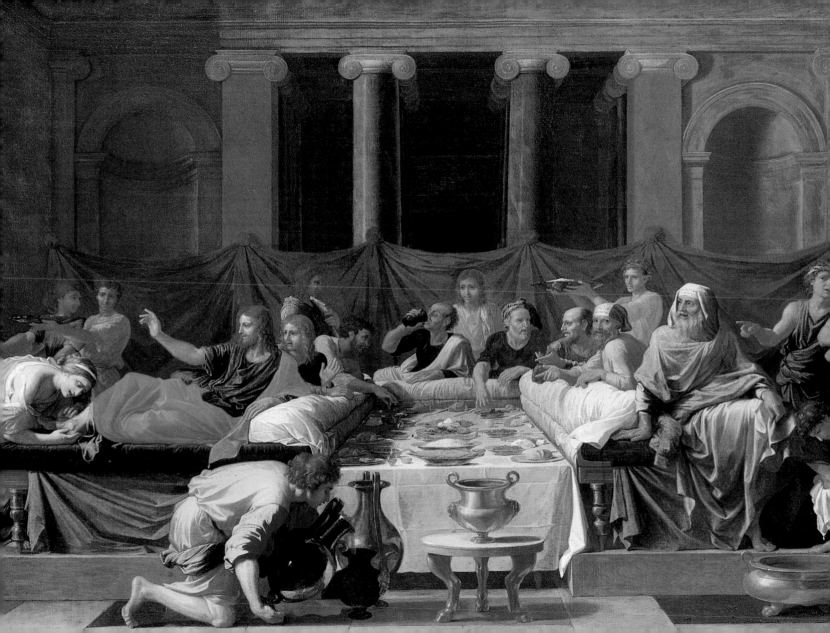

Good books are true friends.

<small>Francis Bacon</small>

The Reader, *c.* 1880–90
Jean-Jacques Henner
Musée d'Orsay, Paris

1 2 3 **4** 5 6 7 8 9 10 11 12 13 14 15 16 17 18 19 20 21 22 23 24 25 26 27 28 29 30

NOVEMBER

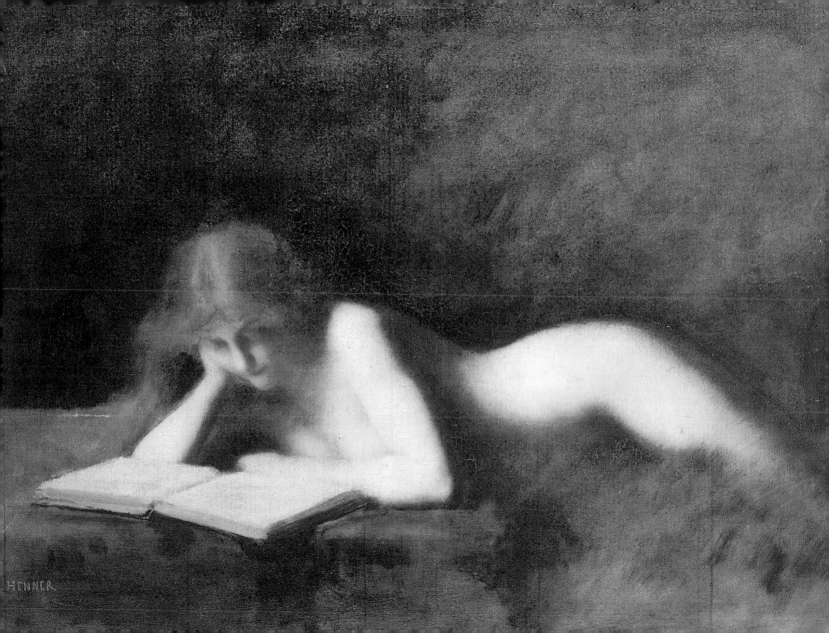

HENNER

His home, the spot of earth supremely blest,
A dearer, sweeter spot than all the rest.

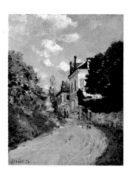

View of the Rue de Moubuisson in Louveciennes, 1874
Alfred Sisley
Staatliche Kunsthalle, Karlsruhe

1 2 3 4 **5** 6 7 8 9 10 11 12 13 14 15 16 17 18 19 20 21 22 23 24 25 26 27 28 29 30

NOVEMBER

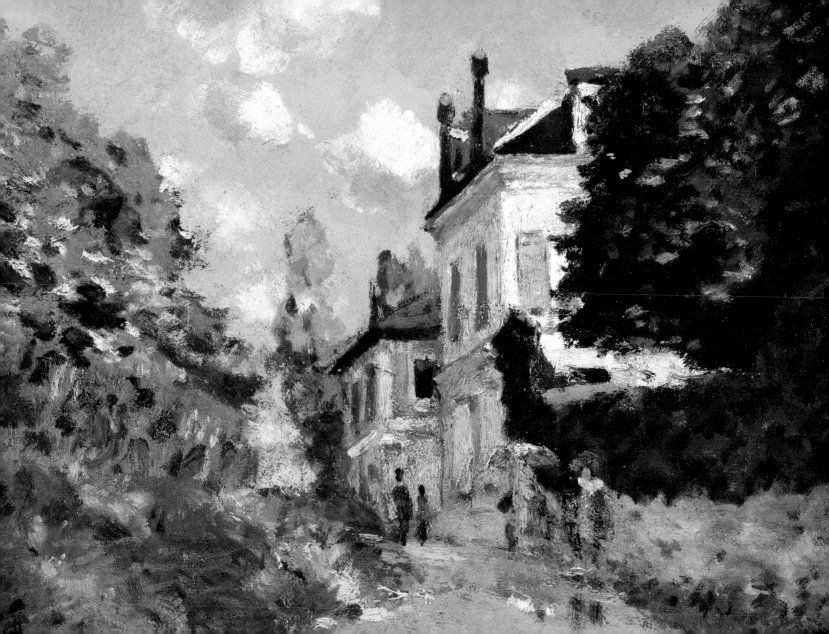

It is the common wonder of all men,
how among so many millions of faces
there should be none alike.

SIR THOMAS BROWNE

Last (?) Self Portrait, 1669
Rembrandt van Rijn
Mauritshuis, The Hague

1 2 3 4 5 **6** 7 8 9 10 11 12 13 14 15 16 17 18 19 20 21 22 23 24 25 26 27 28 29 30

NOVEMBER

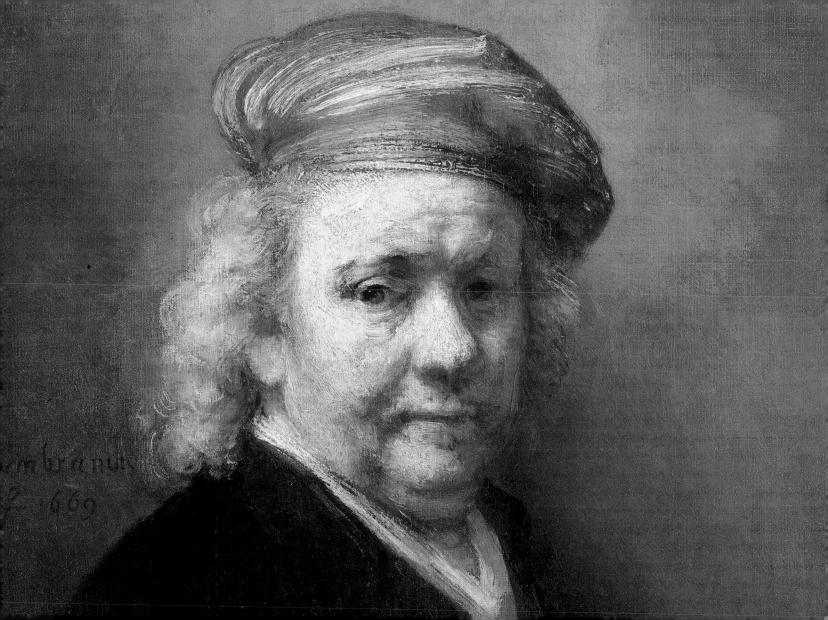

Virtue is not knowing but doing.

Sakanoshita, from "Fifty-three Stations of the Tokaido,"
c. 1833–34
Utagawa Hiroshige

Japanese Proverb

1 2 3 4 5 6 **7** 8 9 10 11 12 13 14 15 16 17 18 19 20 21 22 23 24 25 26 27 28 29 30

November

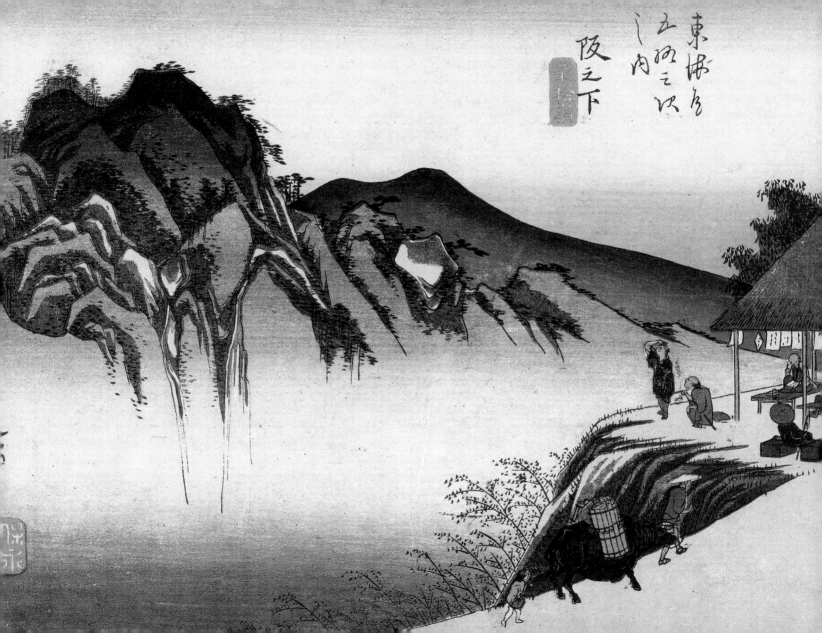

And ne'er did Grecian chisel trace
A Nymph, a Naiad, or a Grace,
Of finer form, or lovelier face!

SIR WALTER SCOTT

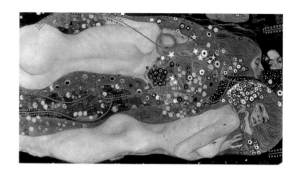

Water Snakes II, 1904–07
Gustav Klimt
Private Collection

1 2 3 4 5 6 7 **8** 9 10 11 12 13 14 15 16 17 18 19 20 21 22 23 24 25 26 27 28 29 30

NOVEMBER

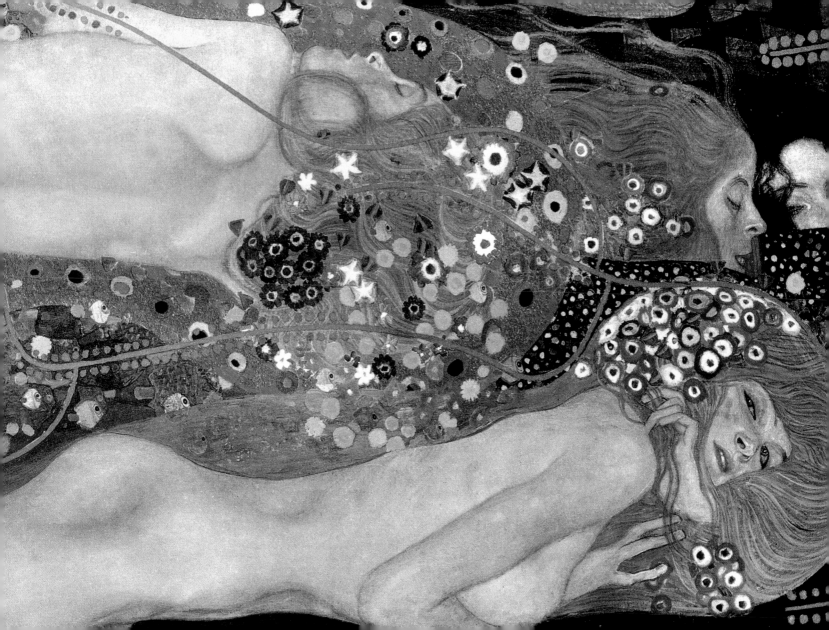

Queen and huntress, chaste and fair,
Now the sun is laid to sleep ...
Hesperus entreats thy light
Goddess, excellently bright!

BEN JONSON

Diana the Huntress, c. 1550
School of Fontainebleau
Musée du Louvre, Paris

1 2 3 4 5 6 7 8 **9** 10 11 12 13 14 15 16 17 18 19 20 21 22 23 24 25 26 27 28 29 30

NOVEMBER

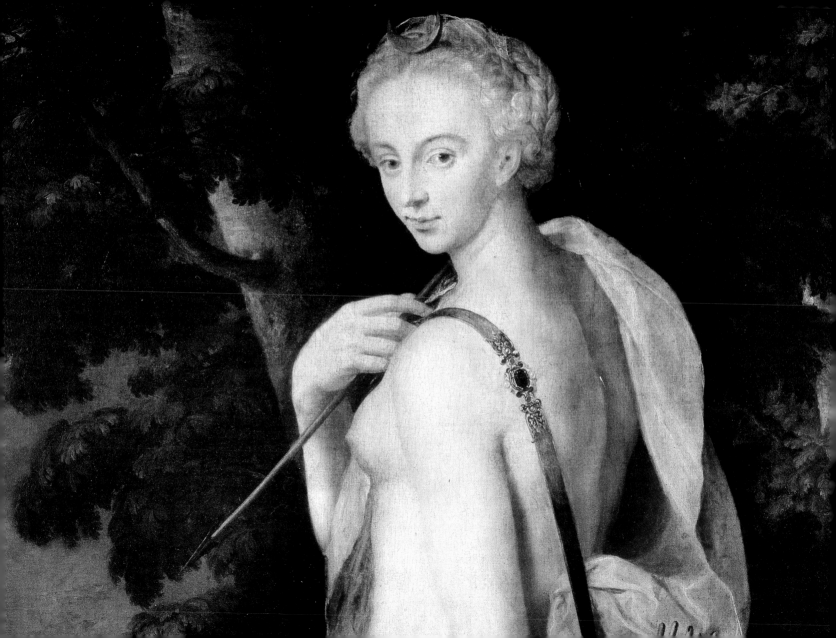

My talent is such that no undertaking, however vast in size ... has ever surpassed my courage.

PETER PAUL RUBENS

Rape of the Daughters of Leukippos, c. 1618
Peter Paul Rubens
Alte Pinakothek, Munich

1 2 3 4 5 6 7 8 9 **10** 11 12 13 14 15 16 17 18 19 20 21 22 23 24 25 26 27 28 29 30

NOVEMBER

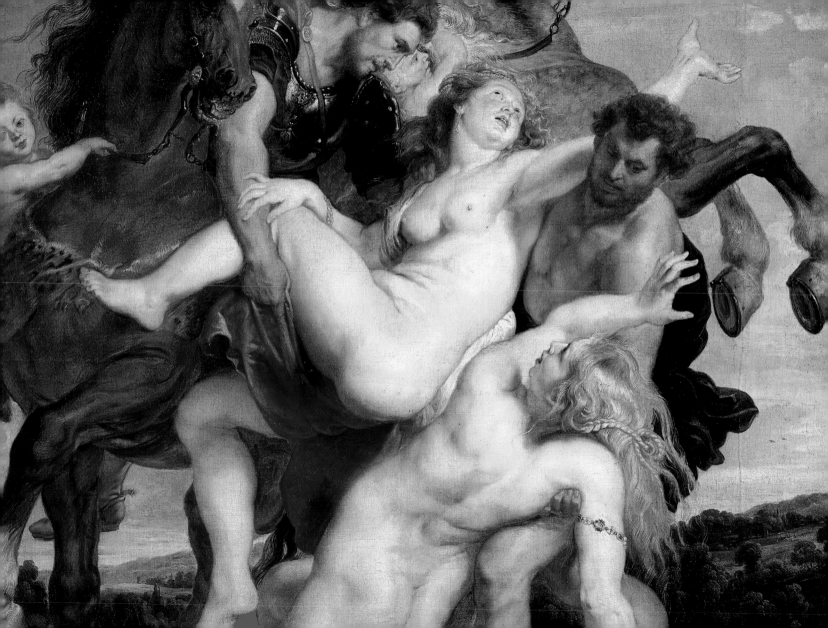

The artist must train not only his eye but also his soul.

WASSILY KANDINSKY

Movement, 1935
Wassily Kandinsky
The State Tretyakov Gallery, Moscow

1 2 3 4 5 6 7 8 9 10 **11** 12 13 14 15 16 17 18 19 20 21 22 23 24 25 26 27 28 29 30

NOVEMBER

Abandon hope, all ye who enter here.

<small>DANTE</small>

Dante and Virgil in Hell, 1822
Eugène Delacroix
Musée du Louvre, Paris

1 2 3 4 5 6 7 8 9 10 11 **12** 13 14 15 16 17 18 19 20 21 22 23 24 25 26 27 28 29 30

NOVEMBER

White swan of cities slumbering in thy nest ...
White phantom city, whose untrodden streets
Are rivers, and whose pavements are the shifting
Shadows of the places and strips of sky.

HENRY WADSWORTH LONGFELLOW

Venice, Dogana, and San Giorgio Maggiore, 1834
Joseph Mallord William Turner
National Gallery, Washington, D.C.

1 2 3 4 5 6 7 8 9 10 11 12 **13** 14 15 16 17 18 19 20 21 22 23 24 25 26 27 28 29 30

NOVEMBER

Art requires philosophy,
just as philosophy requires art.
Otherwise, what would become of beauty?

PAUL GAUGUIN

Bonjour, Monsieur Gauguin, 1889
Paul Gauguin
National Gallery, Prague

1 2 3 4 5 6 7 8 9 10 11 12 13 **14** 15 16 17 18 19 20 21 22 23 24 25 26 27 28 29 30

NOVEMBER

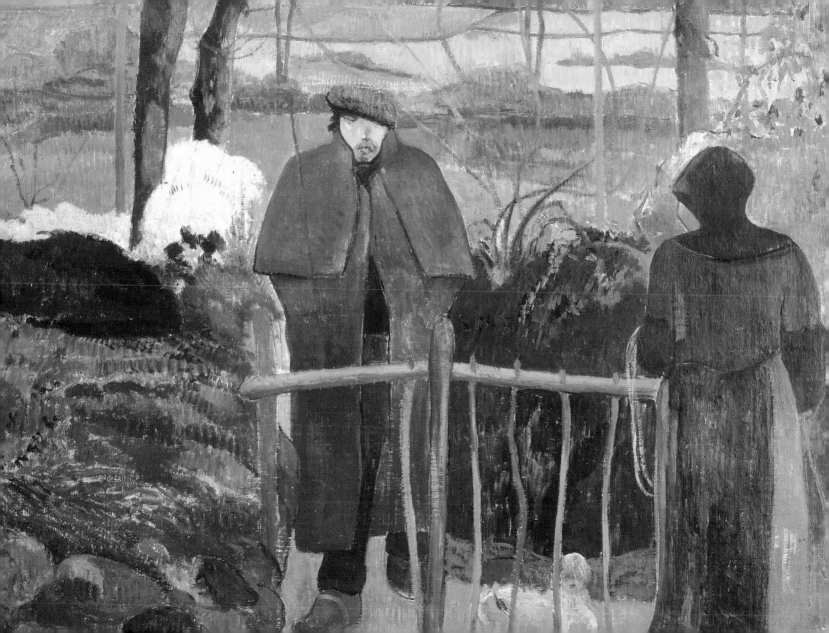

Life is a short affair.
We should try to make it smooth,
and free from strife.

EURIPIDES

The Battle of Zama, early 16th century
Giulio Romano
Musée du Louvre, Paris

1 2 3 4 5 6 7 8 9 10 11 12 13 14 **15** 16 17 18 19 20 21 22 23 24 25 26 27 28 29 30

NOVEMBER

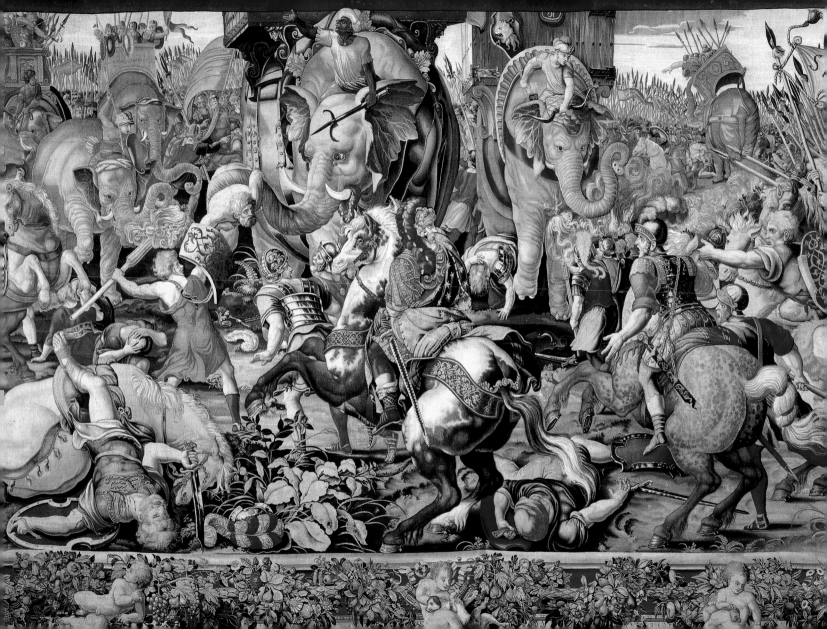

Softly the evening came.
The sun from the western horizon
Like a magician extended his golden wand
o'er the landscape.

HENRY WADSWORTH LONGFELLOW

Moorgate in the Evening Sunshine, 1899
Otto Modersohn
Museum der bildenden Künste, Leipzig

1 2 3 4 5 6 7 8 9 10 11 12 13 14 15 **16** 17 18 19 20 21 22 23 24 25 26 27 28 29 30

NOVEMBER

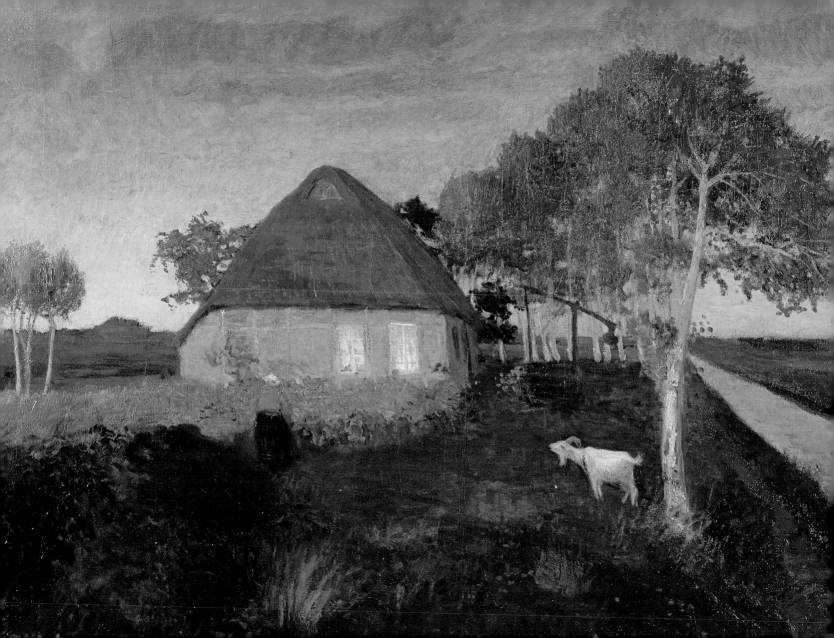

*The motto of chivalry is also the motto
of wisdom: to serve all, but love only one.*

HONORÉ DE BALZAC

A Lady and a Knight, 17th century
Gabriel Metsu
Uffizi Gallery, Florence

1 2 3 4 5 6 7 8 9 10 11 12 13 14 15 16 **17** 18 19 20 21 22 23 24 25 26 27 28 29 30

NOVEMBER

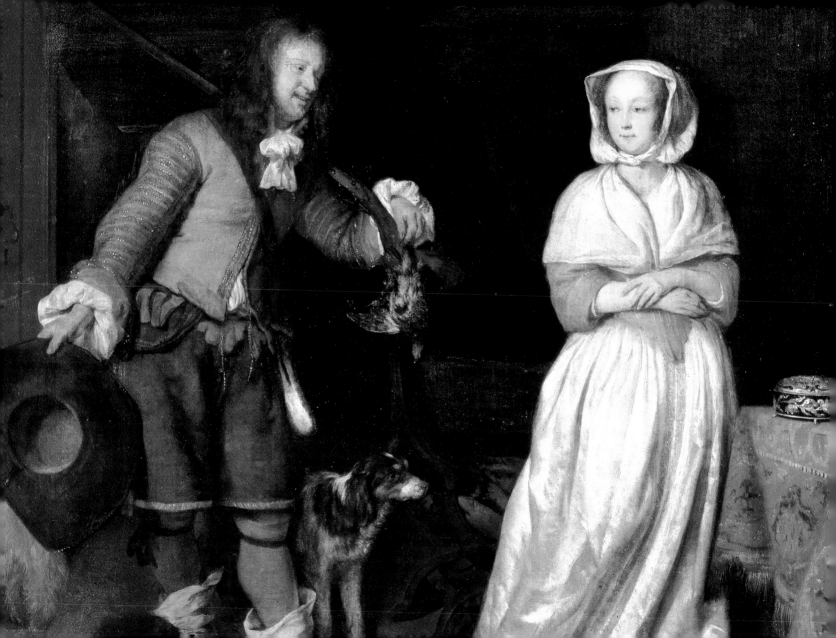

Art is not an end in itself,
but a means of addressing humanity.

<small>Modest Petrovich Mussorgsky</small>

Gathering of Art Lovers, early 17th century
Louis Le Nain
Musée du Louvre, Paris

1 2 3 4 5 6 7 8 9 10 11 12 13 14 15 16 17 **18** 19 20 21 22 23 24 25 26 27 28 29 30

November

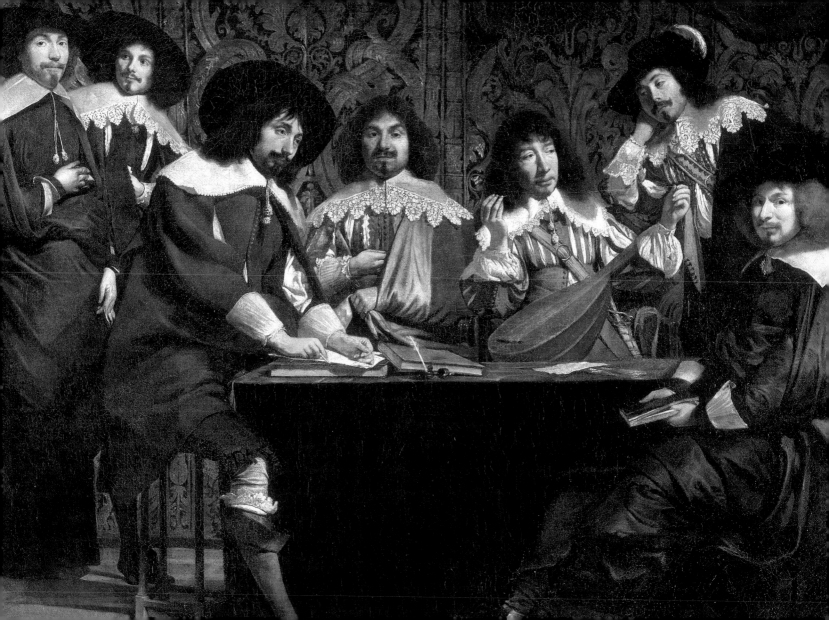

The man who fights too long against dragons becomes a dragon himself.

FRIEDRICH NIETZSCHE

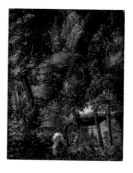

St. George and the Dragon, 1510

Albrecht Altdorfer

Alte Pinakothek, Munich

1 2 3 4 5 6 7 8 9 10 11 12 13 14 15 16 17 18 **19** 20 21 22 23 24 25 26 27 28 29 30

NOVEMBER

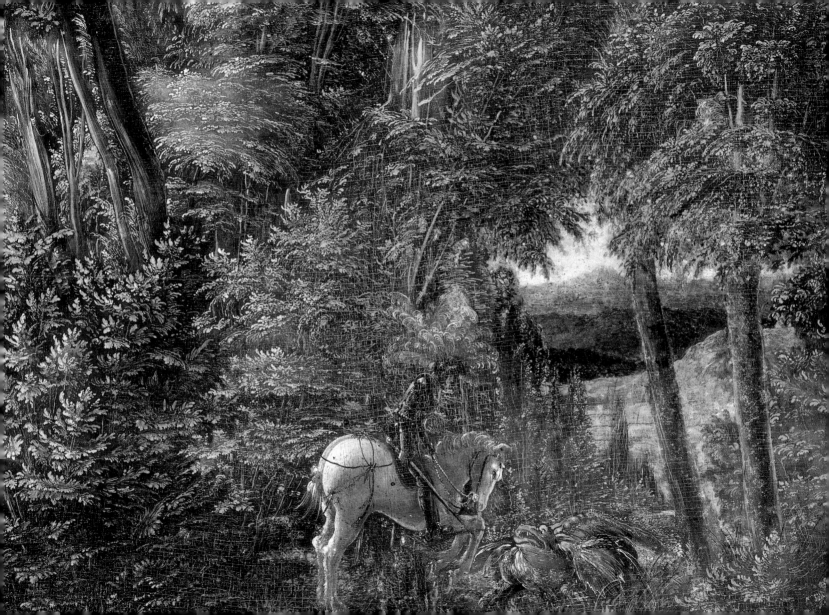

The job of the artist is to deepen the mystery.

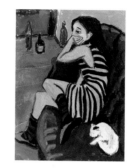

The Artist, 1910
Ernst Ludwig Kirchner
Brücke-Museum, Berlin

1 2 3 4 5 6 7 8 9 10 11 12 13 14 15 16 17 18 19 **20** 21 22 23 24 25 26 27 28 29 30

November

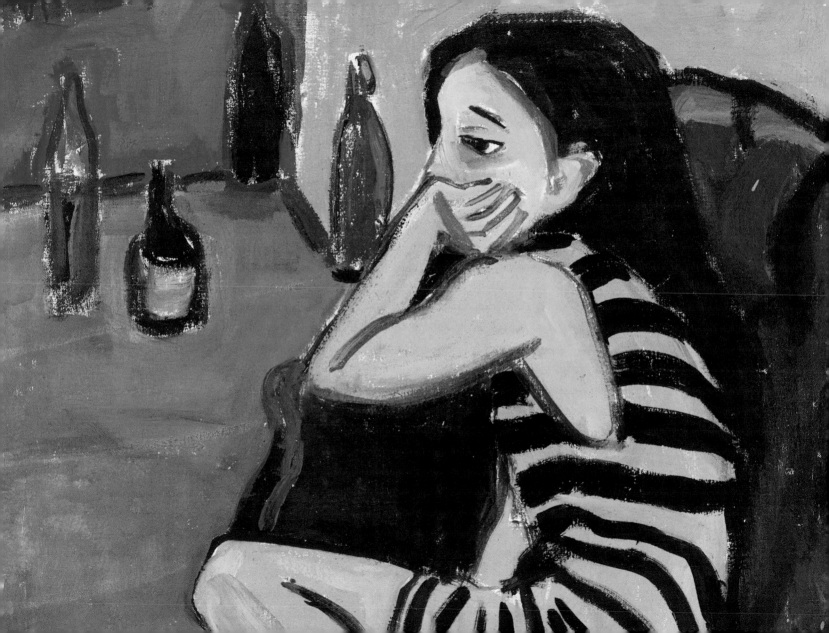

... covetous of the goodly apple,
she did step aside and snatched up
the rolling fruit of gold. With that
Hippomenes caught her.

<small>OVID</small>

Atalanta and Hippomenes, late 16th or early 17th century
Guido Reni
Museo Nacional del Prado, Madrid

1 2 3 4 5 6 7 8 9 10 11 12 13 14 15 16 17 18 19 20 **21** 22 23 24 25 26 27 28 29 30

NOVEMBER

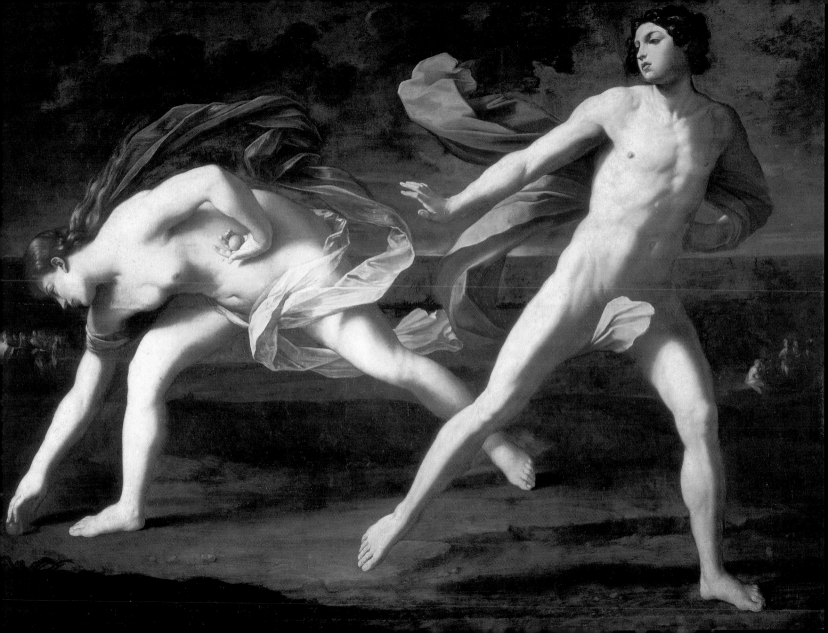

Wild is the music of autumnal winds amongst the faded woods.

WILLIAM WORDSWORTH

Shore of the Seine in Autumn, 1876
Alfred Sisley
Städel Museum, Frankfurt

1 2 3 4 5 6 7 8 9 10 11 12 13 14 15 16 17 18 19 20 21 **22** 23 24 25 26 27 28 29 30

NOVEMBER

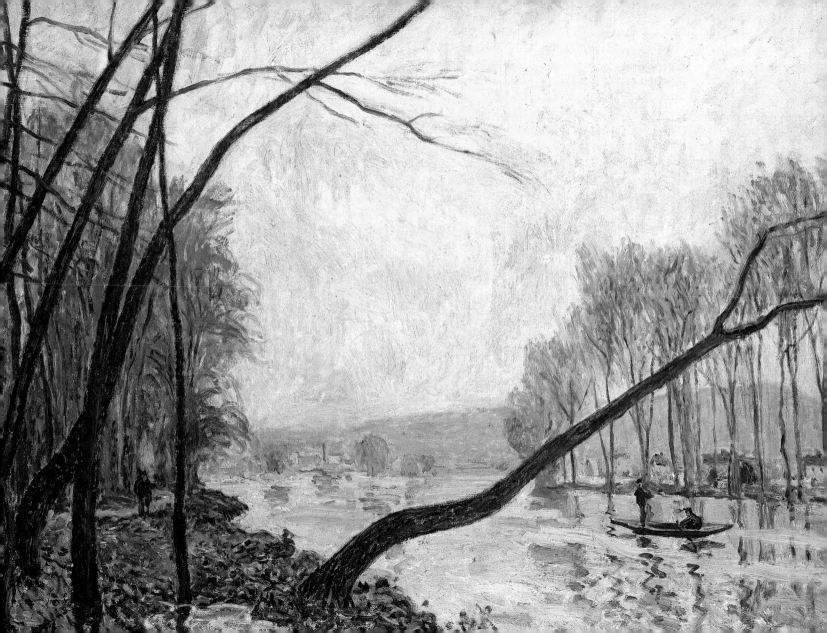

The Sunshine spread a carpet,
And everything was grand,
Miss Weather led the dancing,
Professor Wind the band.

<small>GEORGE COOPER</small>

Peasant Wedding, c. 1630
Peter Paul Rubens
Musée du Louvre, Paris

1 2 3 4 5 6 7 8 9 10 11 12 13 14 15 16 17 18 19 20 21 22 **23** 24 25 26 27 28 29 30

NOVEMBER

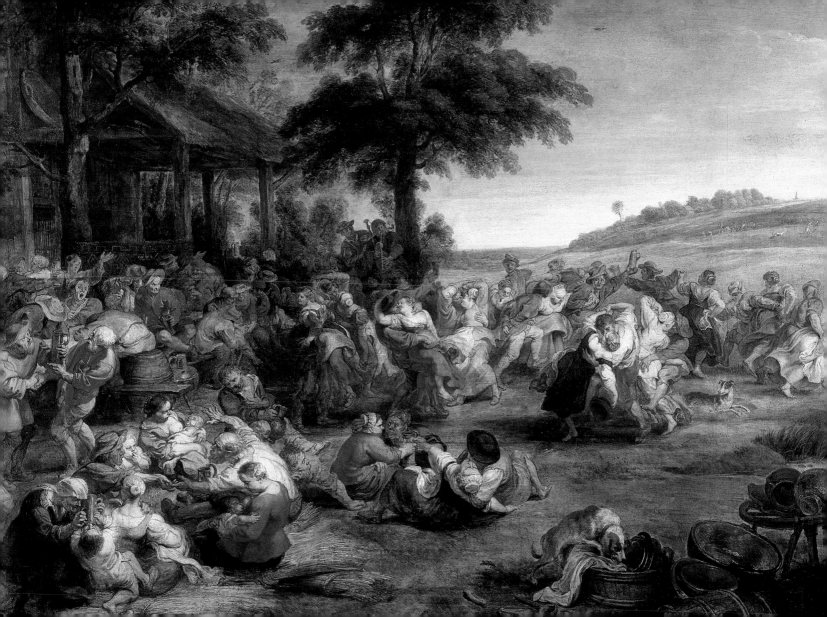

There is only one true thing:
instantly paint what you see.
When you've got it, you've got it.
When you haven't, you begin again.

EDOUARD MANET

Breakfast in Atelier, 1868
Edouard Manet
Neue Pinakothek, Munich

1 2 3 4 5 6 7 8 9 10 11 12 13 14 15 16 17 18 19 20 21 22 23 **24** 25 26 27 28 29 30

NOVEMBER

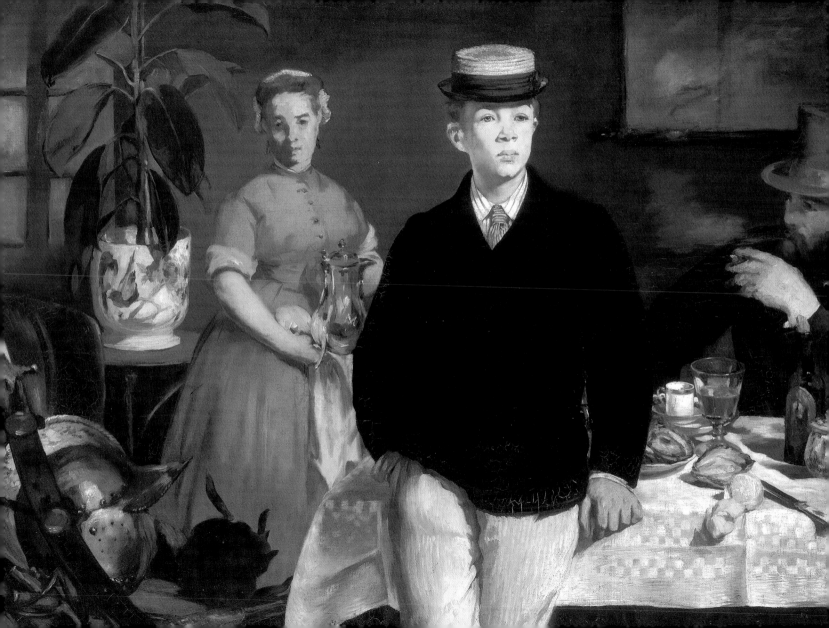

Medicine for the soul.

ANON. (INSCRIPTION OVER THE DOOR OF THE LIBRARY AT THEBES)

The Bookworm, c. 1850
Carl Spitzweg
Georg Schäfer Collection

1 2 3 4 5 6 7 8 9 10 11 12 13 14 15 16 17 18 19 20 21 22 23 24 **25** 26 27 28 29 30

NOVEMBER

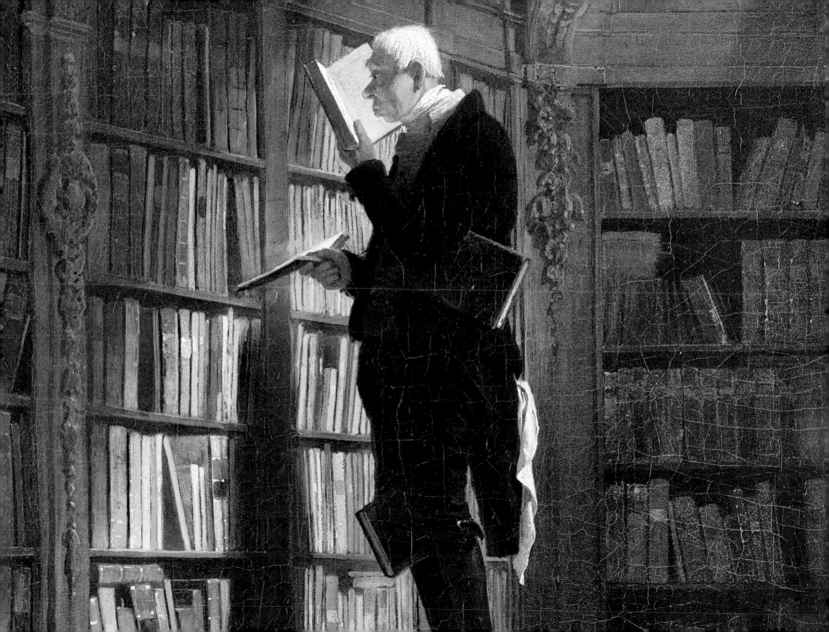

The great artist is the slave of his ideal.

Imaginary View of the Grande Galerie in the Louvre, 1796
Hubert Robert
Musée du Louvre, Paris

1 2 3 4 5 6 7 8 9 10 11 12 13 14 15 16 17 18 19 20 21 22 23 24 25 **26** 27 28 29 30

NOVEMBER

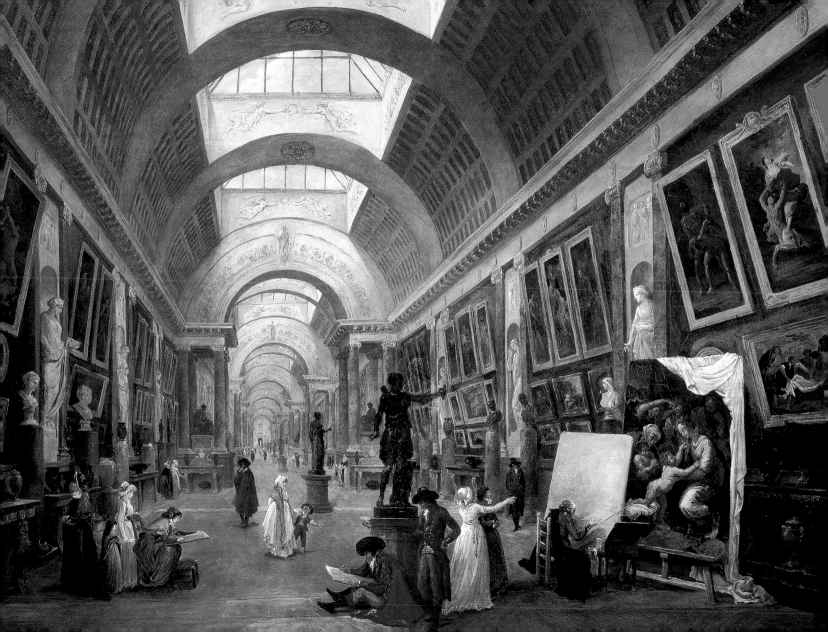

As to the pure mind all things are pure,
so to the poetic mind all things are poetical.

Henry Wadsworth Longfellow

In the Apodyterium at the Baths in Rome, 1886
Sir Lawrence Alma-Tadema
Christie's, New York

1 2 3 4 5 6 7 8 9 10 11 12 13 14 15 16 17 18 19 20 21 22 23 24 25 26 **27** 28 29 30

NOVEMBER

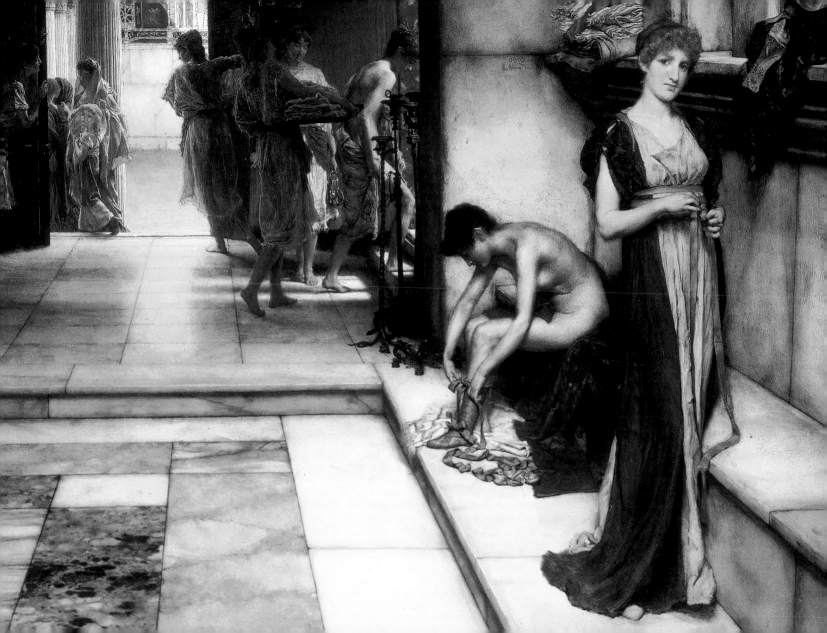

There the sea I found
Calm as a cradled child in dreamless slumber bound.

Percy Bysshe Shelley

Calm Sea, 1885
Ivan Konstantinovich Aivazovsky
Russian Museum, St. Petersburg

1 2 3 4 5 6 7 8 9 10 11 12 13 14 15 16 17 18 19 20 21 22 23 24 25 26 27 **28** 29 30

NOVEMBER

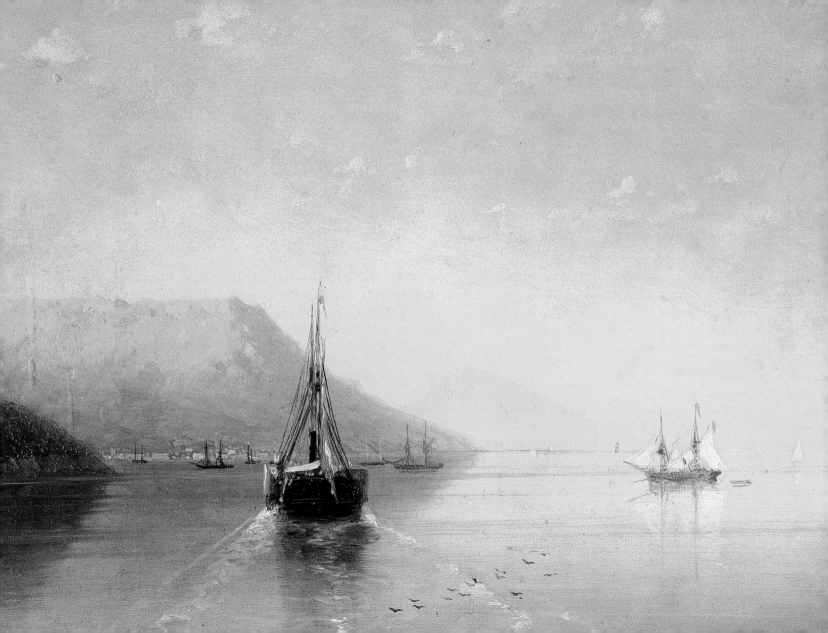

If you would know and not be known,
live in a city.

Charles Caleb Colton

The Street, 1913
Ernst Ludwig Kirchner
The Museum of Modern Art, New York

1 2 3 4 5 6 7 8 9 10 11 12 13 14 15 16 17 18 19 20 21 22 23 24 25 26 27 28 **29** 30

November

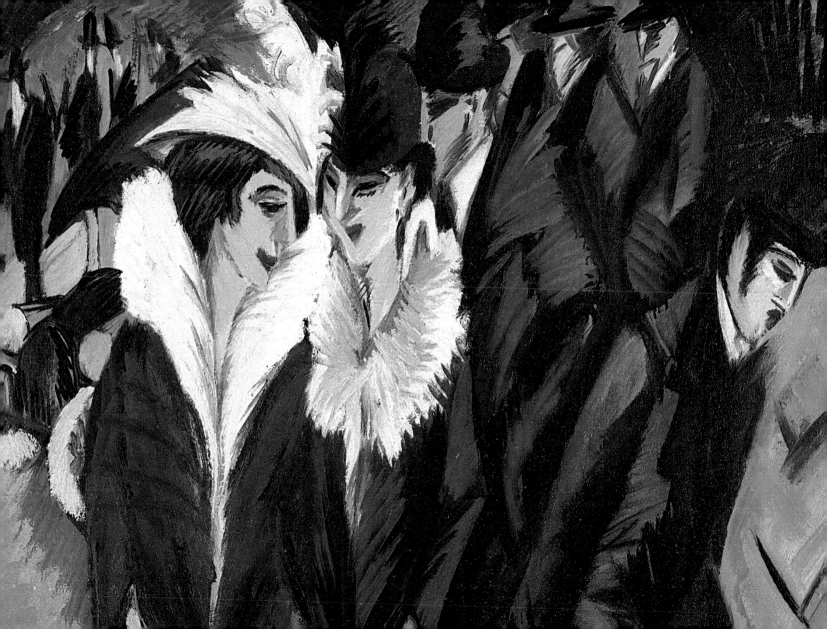

... Dresden on the Elbe,
that handsome city,
Where straw hats, verses,
and cigars are made ...

HEINRICH HEINE

The Old Marketplace in Dresden, 1751
Bernardo Bellotto
The Pushkin Museum of Fine Arts, Moscow

1 2 3 4 5 6 7 8 9 10 11 12 13 14 15 16 17 18 19 20 21 22 23 24 25 26 27 28 29 **30**

NOVEMBER

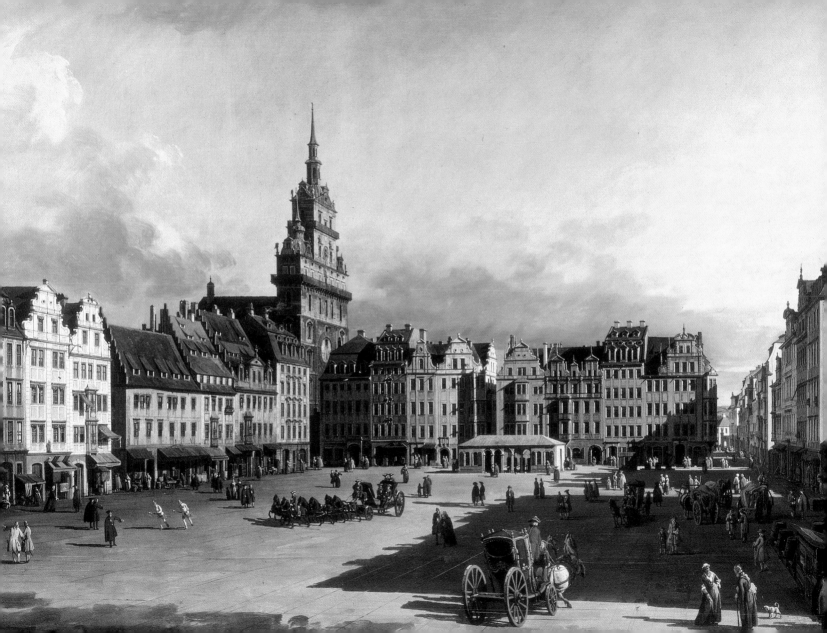

*Secret, and self-contained,
and solitary as an oyster.*

<small>Charles Dickens</small>

The Oyster Eater, *c.* 1661–62
Jan Steen
Mauritshuis, The Hague

1 2 3 4 5 6 7 8 9 10 11 12 13 14 15 16 17 18 19 20 21 22 23 24 25 26 27 28 29 30 31

DECEMBER

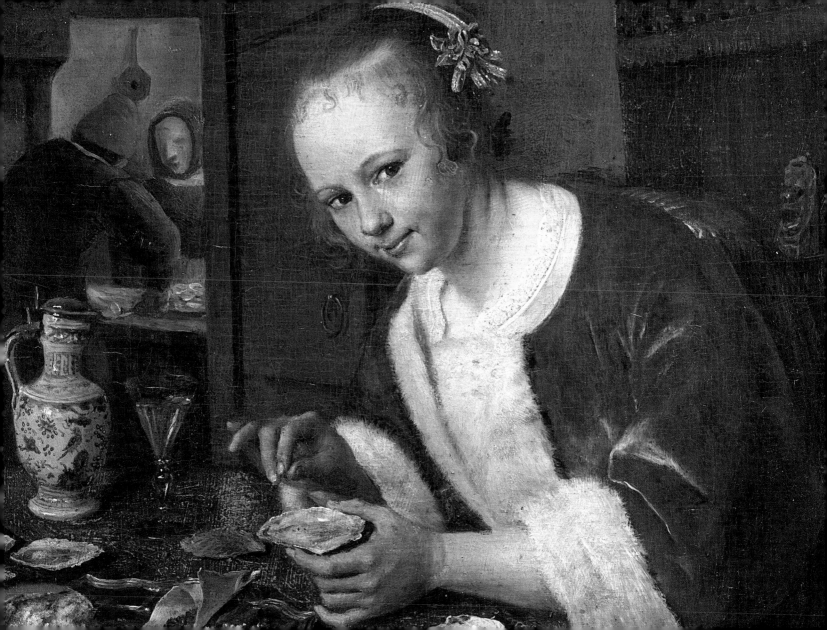

Architecture in general is frozen music.

F. W. J. Schelling

Interior of the New Church in Haarlem, 1652
Pieter Saenredam
Frans Hals Museum, Haarlem

1 2 3 4 5 6 7 8 9 10 11 12 13 14 15 16 17 18 19 20 21 22 23 24 25 26 27 28 29 30 31

DECEMBER

To be capable of respect is almost as rare as to be worthy of it.

JOSEPH JOUBERT

Madonna of the Chancellor Rolin, c. 1435
Jan van Eyck
Musée du Louvre, Paris

1 2 **3** 4 5 6 7 8 9 10 11 12 13 14 15 16 17 18 19 20 21 22 23 24 25 26 27 28 29 30 31

DECEMBER

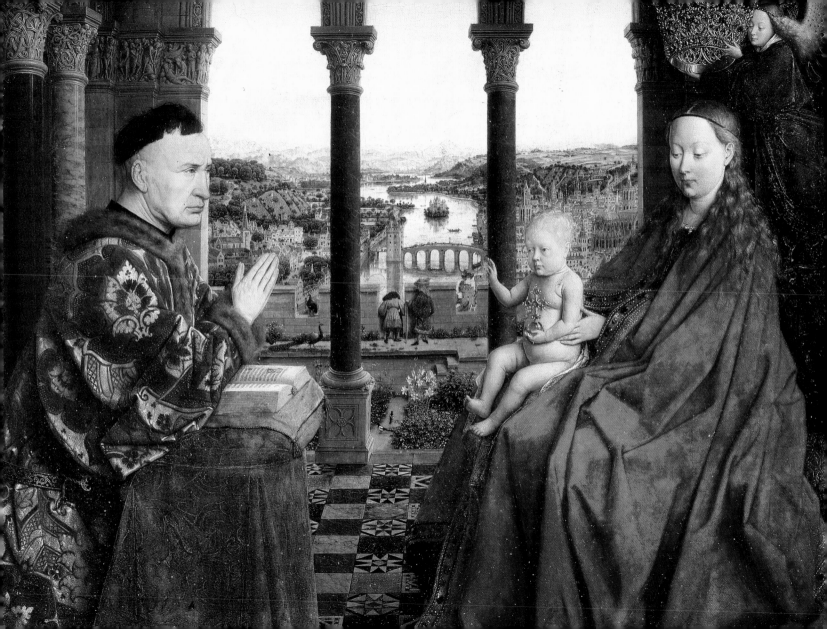

The palaces of nature, whose vast walls
Have pinnacled in clouds their snowy scalps …

LORD BYRON

Eiger, Mönch, and Jungfrau in the Sunlight, 1908
Ferdinand Hodler
Private Collection

1 2 3 **4** 5 6 7 8 9 10 11 12 13 14 15 16 17 18 19 20 21 22 23 24 25 26 27 28 29 30 31

DECEMBER

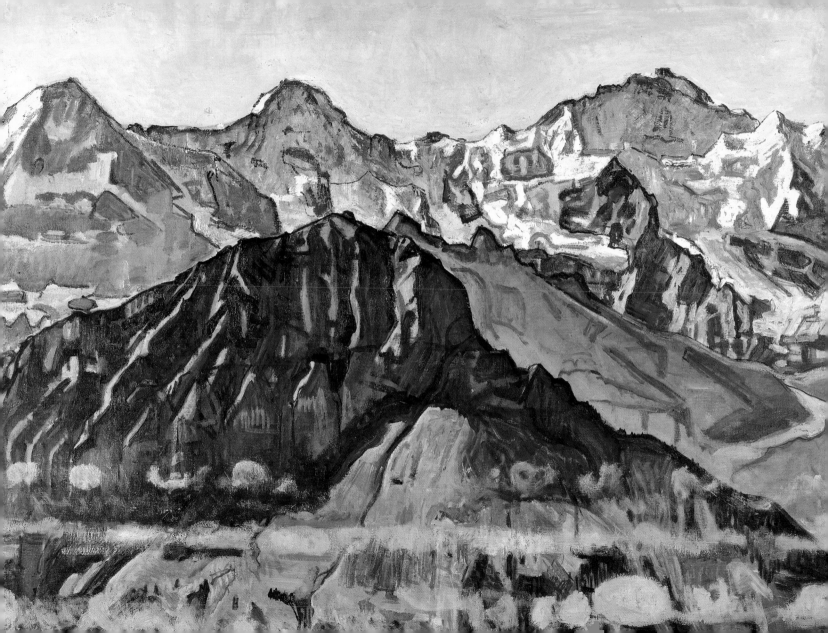

After a good dinner one can forgive anybody,
even one's own relations.

OSCAR WILDE

A Family at Meal Time, 17th century
Jan Steen
Musée du Louvre, Paris

1 2 3 4 **5** 6 7 8 9 10 11 12 13 14 15 16 17 18 19 20 21 22 23 24 25 26 27 28 29 30 31

DECEMBER

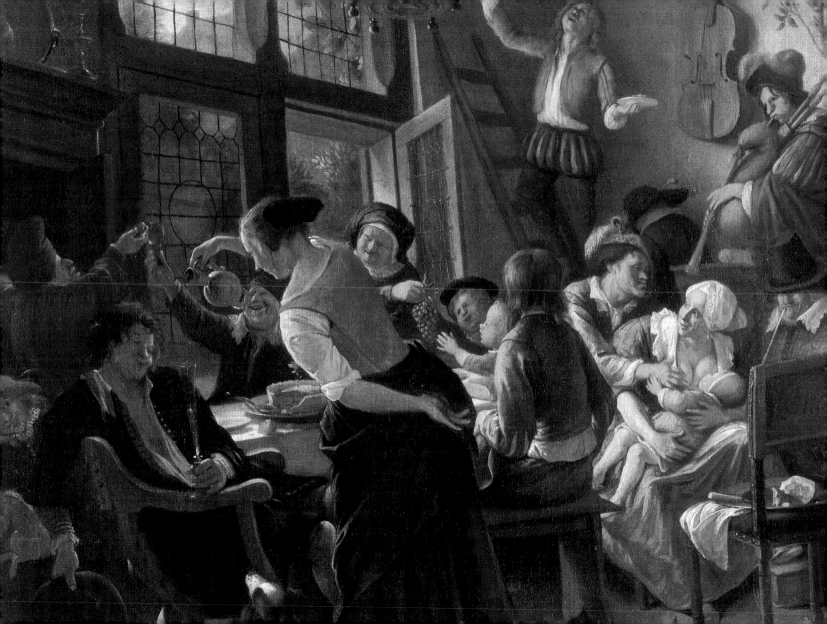

All below is strength, and all above is grace.

The Evening (Hagar and Ismael), 17th century
Claude Lorrain
The State Hermitage Museum, St. Petersburg

1 2 3 4 5 **6** 7 8 9 10 11 12 13 14 15 16 17 18 19 20 21 22 23 24 25 26 27 28 29 30 31

DECEMBER

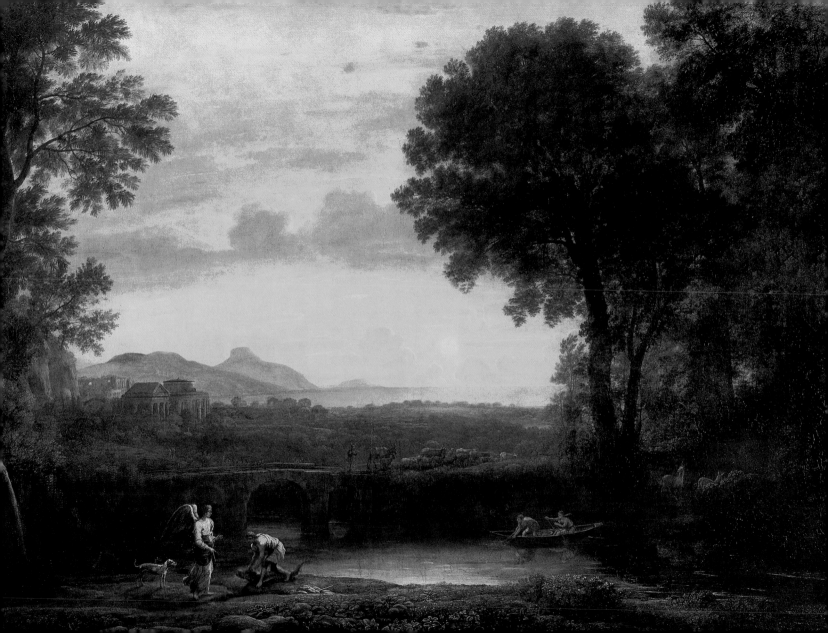

There is always some madness in love.
But there is also always some reason
in madness.

FRIEDRICH NIETZSCHE

Amor and Psyche, 1863
François-Pascal-Simon Gérard
Musée du Louvre, Paris

1 2 3 4 5 6 **7** 8 9 10 11 12 13 14 15 16 17 18 19 20 21 22 23 24 25 26 27 28 29 30 31

DECEMBER

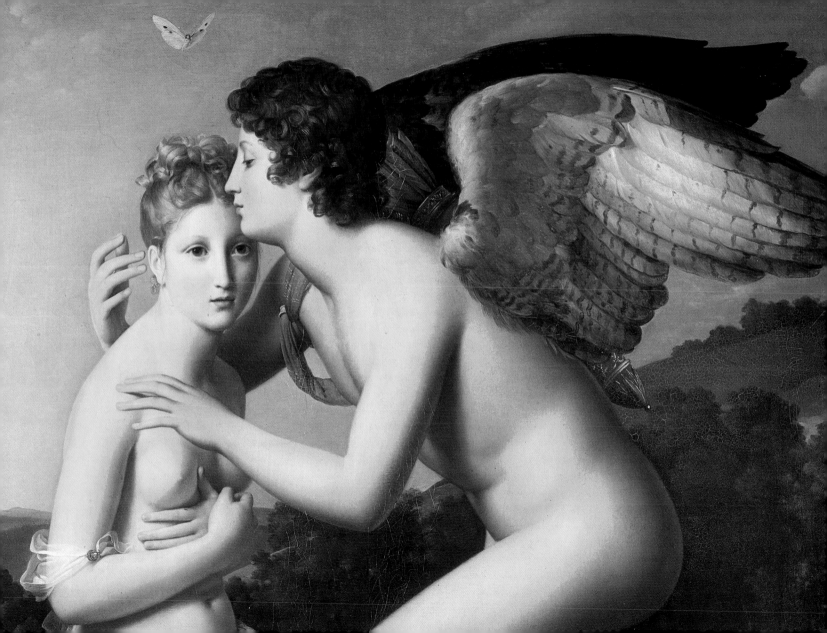

It is not necessary for the public to know whether I am joking or whether I am serious, just as it is not necessary for me to know it myself.

SALVADOR DALÍ

Moment of Transition, 1934
Salvador Dalí
Private Collection

1 2 3 4 5 6 7 **8** 9 10 11 12 13 14 15 16 17 18 19 20 21 22 23 24 25 26 27 28 29 30 31

DECEMBER

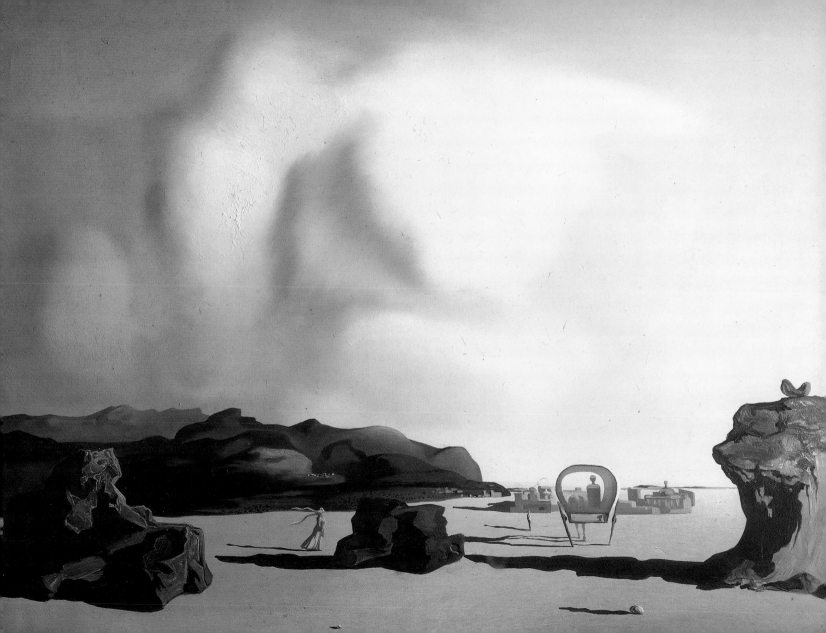

People, not buildings, make the city.

View of Marienplatz in Munich, c. 1750

Joseph Stephan
Stadtmuseum, Munich

1 2 3 4 5 6 7 8 **9** 10 11 12 13 14 15 16 17 18 19 20 21 22 23 24 25 26 27 28 29 30 31

December

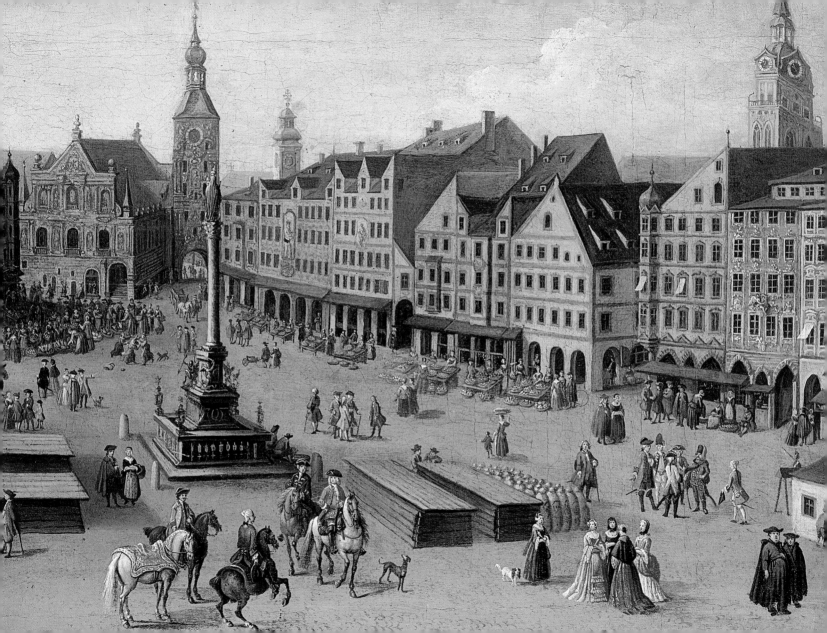

Tiger, tiger, burning bright
In the forests of the night,
What immortal hand or eye,
Could frame thy fearful symmetry?

WILLIAM BLAKE

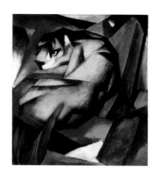

The Tiger, 1912
Franz Marc
Lenbachhaus, Munich

1 2 3 4 5 6 7 8 9 **10** 11 12 13 14 15 16 17 18 19 20 21 22 23 24 25 26 27 28 29 30 31

DECEMBER

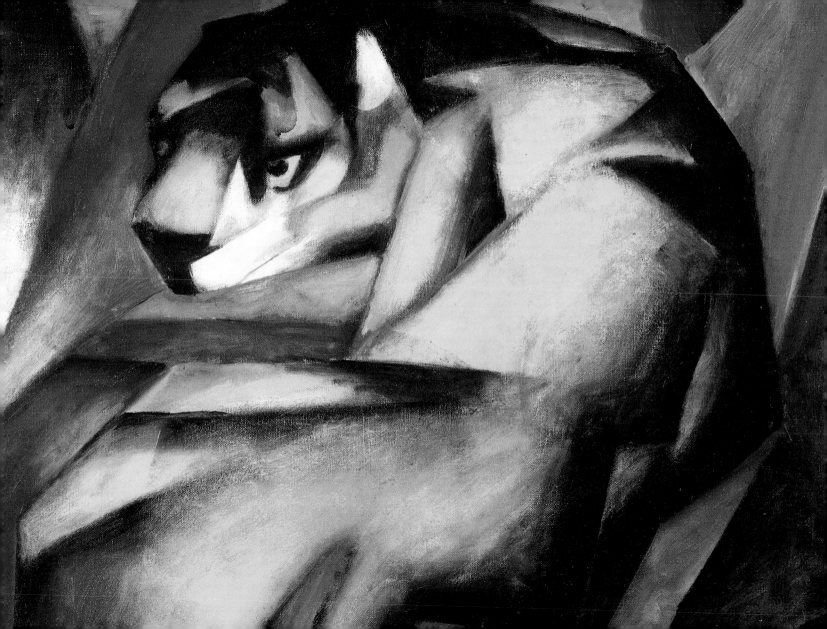

Read, mark, learn, and inwardly digest.

THE BOOK OF COMMON PRAYER

Woman Reading near an Aquarium, late 19th or early 20th century
Lovis Corinth
Belvedere, Vienna

1 2 3 4 5 6 7 8 9 10 **11** 12 13 14 15 16 17 18 19 20 21 22 23 24 25 26 27 28 29 30 31

DECEMBER

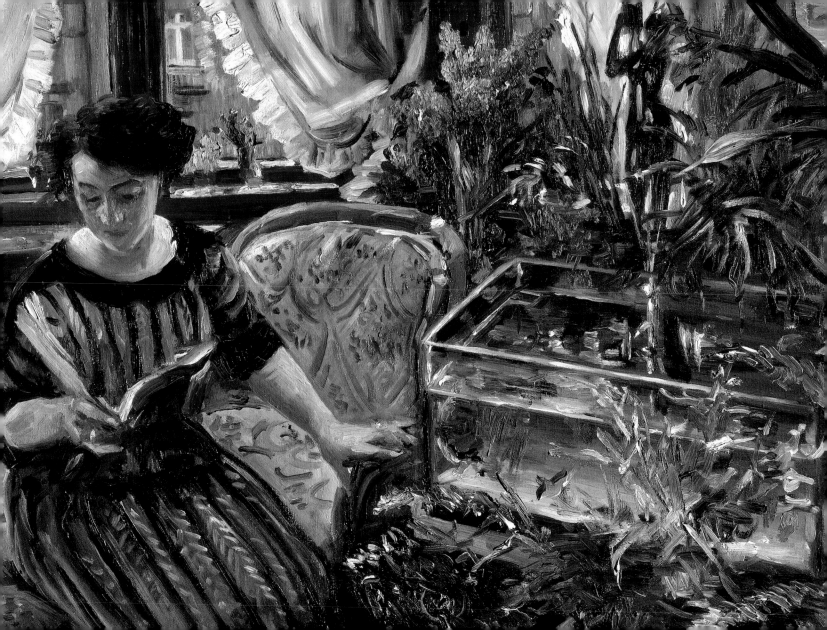

Wonder implies the desire to learn.

Aristotle

Portrait of Nikolaus Kratzer, 1528
Hans Holbein the Younger
Musée du Louvre, Paris

1 2 3 4 5 6 7 8 9 10 11 **12** 13 14 15 16 17 18 19 20 21 22 23 24 25 26 27 28 29 30 31

DECEMBER

So he said to them, "Cast the net over the right side of the boat and you will find something." So they cast it, and were not able to pull it in because of the number of fish.

THE GOSPEL OF ST. JOHN, 21:6

The Wonderful Catch of Fish, 15th century
Konrad Witz
Musée d'Art et d'Histoire, Geneva

1 2 3 4 5 6 7 8 9 10 11 12 **13** 14 15 16 17 18 19 20 21 22 23 24 25 26 27 28 29 30 31

DECEMBER

*Life does not agree with philosophy:
There is no happiness that is not idleness,
and only what is useless is pleasurable.*

ANTON CHEKHOV

Pipe Smoker, 1890–92
Paul Cézanne
The State Hermitage Museum, St. Petersburg

14

1 2 3 4 5 6 7 8 9 10 11 12 13 **14** 15 16 17 18 19 20 21 22 23 24 25 26 27 28 29 30 31

DECEMBER

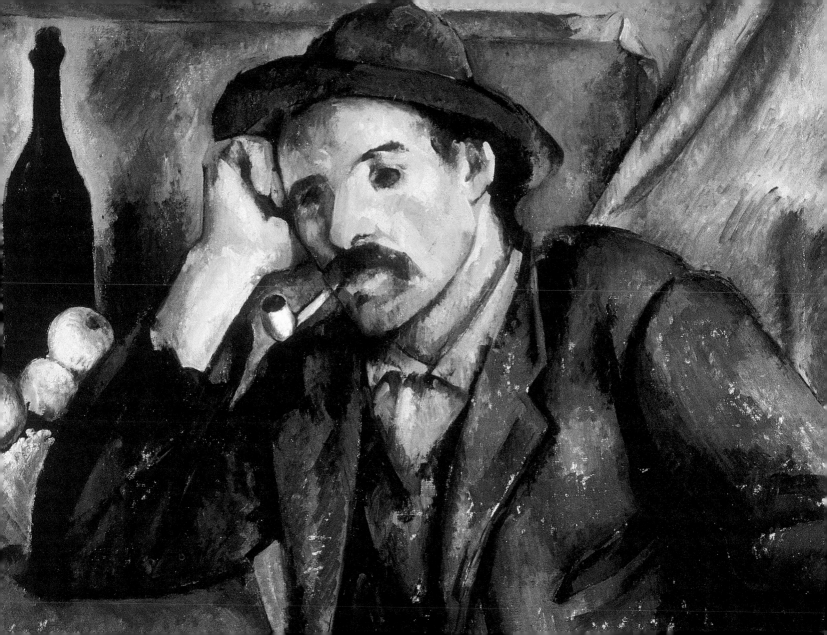

In seed time learn,
in harvest teach,
in winter enjoy.

<small>WILLIAM BLAKE</small>

Ice Skating on the City Moat in Brussels, 1649
Robert van den Hoecke
Kunsthistorisches Museum, Vienna

1 2 3 4 5 6 7 8 9 10 11 12 13 14 **15** 16 17 18 19 20 21 22 23 24 25 26 27 28 29 30 31

DECEMBER

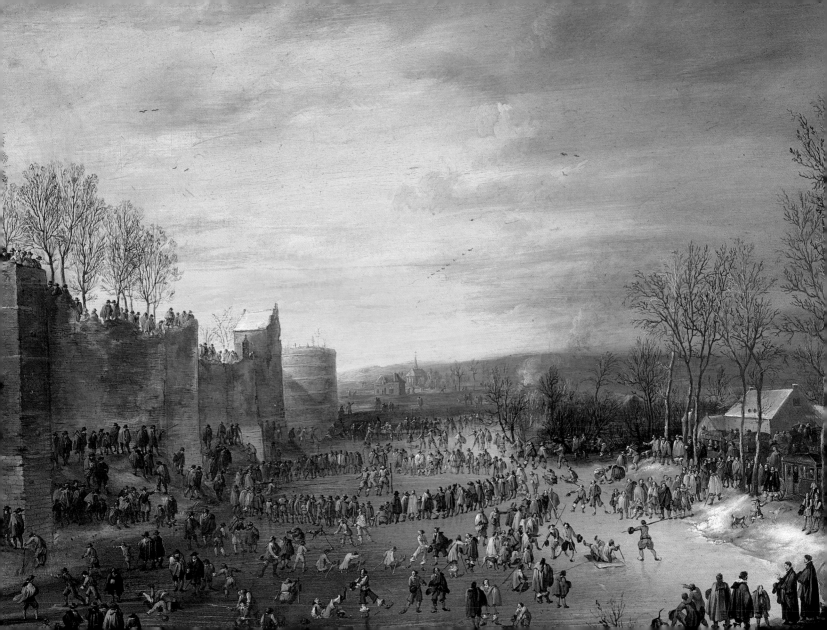

*The real sin against life is to abuse and
destroy beauty. Above all one's own,
for that has been put in our care
and we are responsible for its well-being.*

<small>PLINY THE ELDER</small>

Woman in a Bathtub Washing Leg, 1883–84
Edgar Degas
Musée d'Orsay, Paris

1 2 3 4 5 6 7 8 9 10 11 12 13 14 15 **16** 17 18 19 20 21 22 23 24 25 26 27 28 29 30 31

DECEMBER

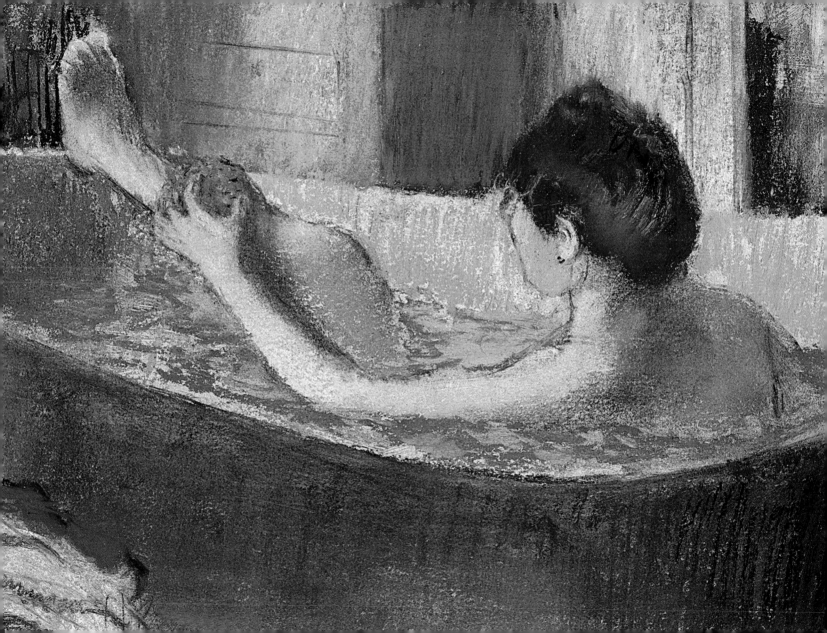

I have tried to do what is true and not ideal.

The Circus Rider in Circus Fernando, 1887–88
Henri de Toulouse-Lautrec
The Art Institute of Chicago

1 2 3 4 5 6 7 8 9 10 11 12 13 14 15 16 **17** 18 19 20 21 22 23 24 25 26 27 28 29 30 31

DECEMBER

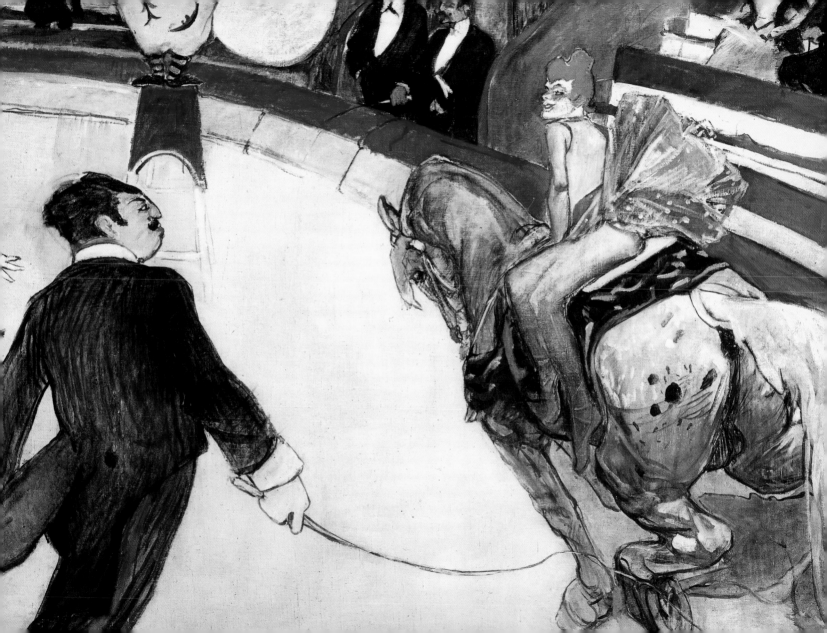

Many children, many cares;
no children, no felicity.

CHRISTIAN NESTELL BOYEE

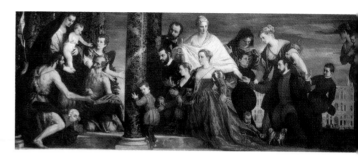

Madonna with the Cuccina Family, 1571
Paolo Veronese
Gemäldegalerie, Dresden

1 2 3 4 5 6 7 8 9 10 11 12 13 14 15 16 17 **18** 19 20 21 22 23 24 25 26 27 28 29 30 31

DECEMBER

If there is anything that will endure
The eye of God, because it still is pure,
It is the spirit of a little child.

Richard Henry Stoddard

Magdalena and Jan-Baptist de Vos, the Artist's Children, 1622
Cornelis de Vos
Gemäldegalerie, Berlin

1 2 3 4 5 6 7 8 9 10 11 12 13 14 15 16 17 18 **19** 20 21 22 23 24 25 26 27 28 29 30 31

DECEMBER

What is art? Nature concentrated.

HONORÉ DE BALZAC

Still Life with Oranges, Book and Flute,
late 17th or early 18th century
Cristoforo Munari
Uffizi Gallery, Florence

1 2 3 4 5 6 7 8 9 10 11 12 13 14 15 16 17 18 19 **20** 21 22 23 24 25 26 27 28 29 30 31

DECEMBER

*Live as you will wish to have lived
when you are dying.*

CHRISTIAN FURCHTEGOTT GELLERT

The Soothsayer, late 16th or early 17th century
Caravaggio
Musée du Louvre, Paris

1 2 3 4 5 6 7 8 9 10 11 12 13 14 15 16 17 18 19 20 **21** 22 23 24 25 26 27 28 29 30 31

DECEMBER

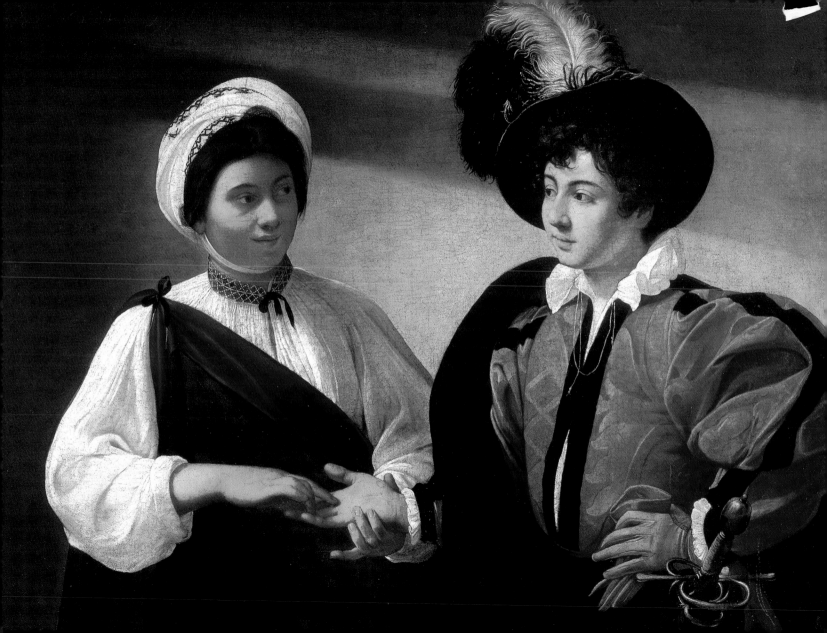

*Nothing makes me so happy as
to observe nature and to paint what I see.*

<small>HENRI ROUSSEAU</small>

Jungle with Tiger and Hunters, *c.* 1907
Henri Rousseau
Private Collection

1 2 3 4 5 6 7 8 9 10 11 12 13 14 15 16 17 18 19 20 21 **22** 23 24 25 26 27 28 29 30 31

DECEMBER

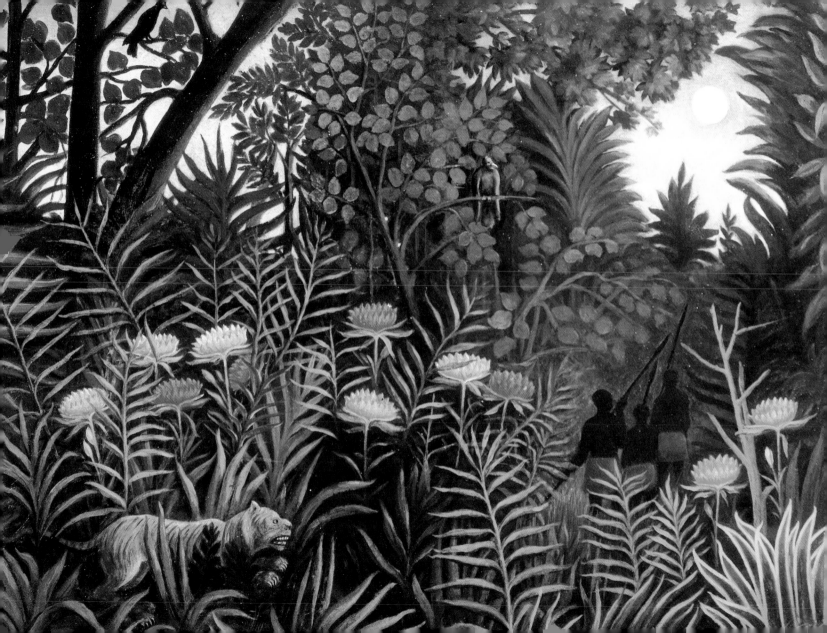

*A contented mind is the greatest blessing
a man can enjoy in this world.*

<small>JOSEPH ADDISON</small>

Idleness, 1888
Julian Alden Weir
The Metropolitan Museum of Art, New York

1 2 3 4 5 6 7 8 9 10 11 12 13 14 15 16 17 18 19 20 21 22 **23** 24 25 26 27 28 29 30 31

DECEMBER

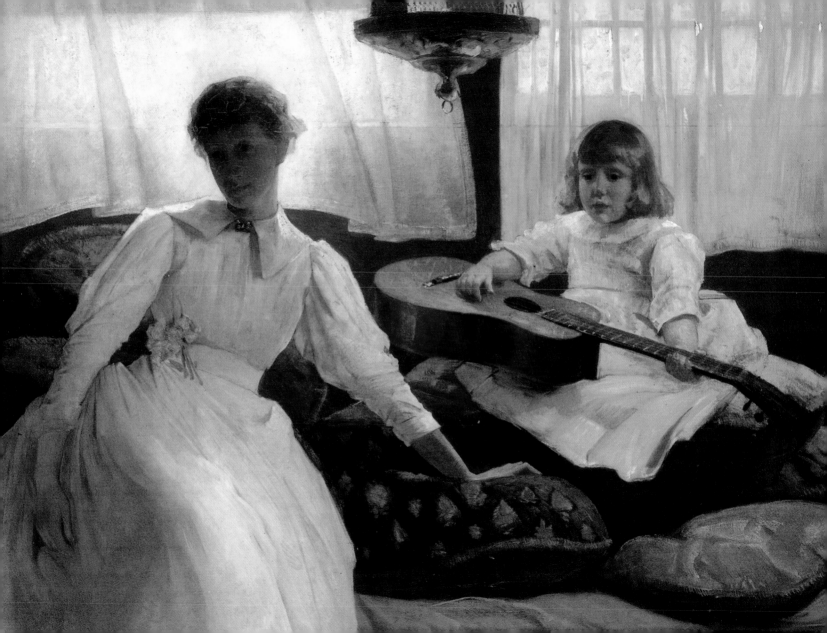

There is not one blade of grass,
there is no color in this world
that is not intended to make us rejoice.

JOHN CALVIN

The Seven Joys of Mary, 1480
Hans Memling
Alte Pinakothek, Munich

1 2 3 4 5 6 7 8 9 10 11 12 13 14 15 16 17 18 19 20 21 22 23 **24** 25 26 27 28 29 30 31

DECEMBER

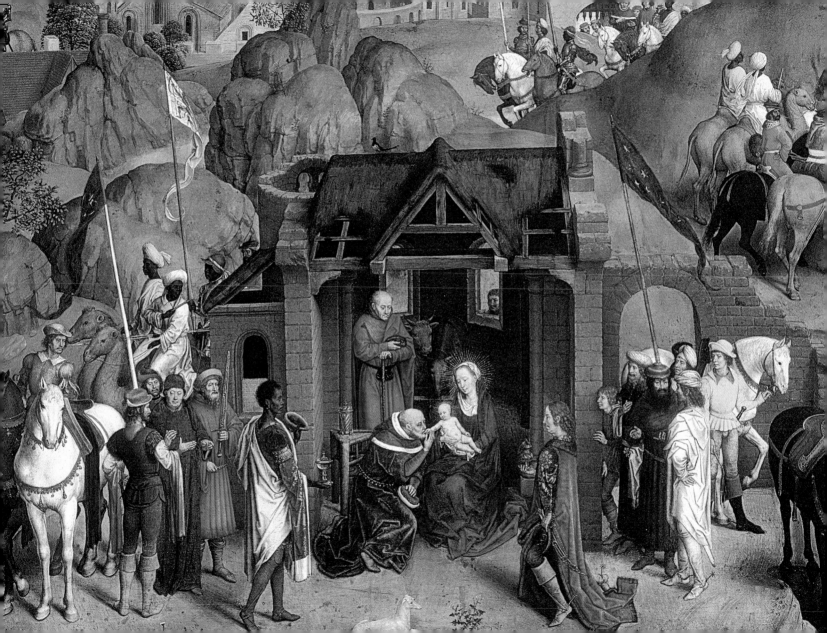

When the angels had left them and gone into heaven, the shepherds said to one another, "Let's go to Bethlehem and see this thing that has happened, which the Lord has told us about."

The Gospel of St. Luke, 2:15

Portinari-Altar, center panel: The Adoration of the Shepherds,
c. 1475–78
Hugo van der Goes
Uffizi Gallery, Florence

1 2 3 4 5 6 7 8 9 10 11 12 13 14 15 16 17 18 19 20 21 22 23 24 **25** 26 27 28 29 30 31

DECEMBER

Imagination disposes of everything.
It creates beauty, justice, and happiness,
which are everything in this world.

Couple at Dusk, 1976
Marc Chagall
Private Collection

1 2 3 4 5 6 7 8 9 10 11 12 13 14 15 16 17 18 19 20 21 22 23 24 25 **26** 27 28 29 30 31

DECEMBER

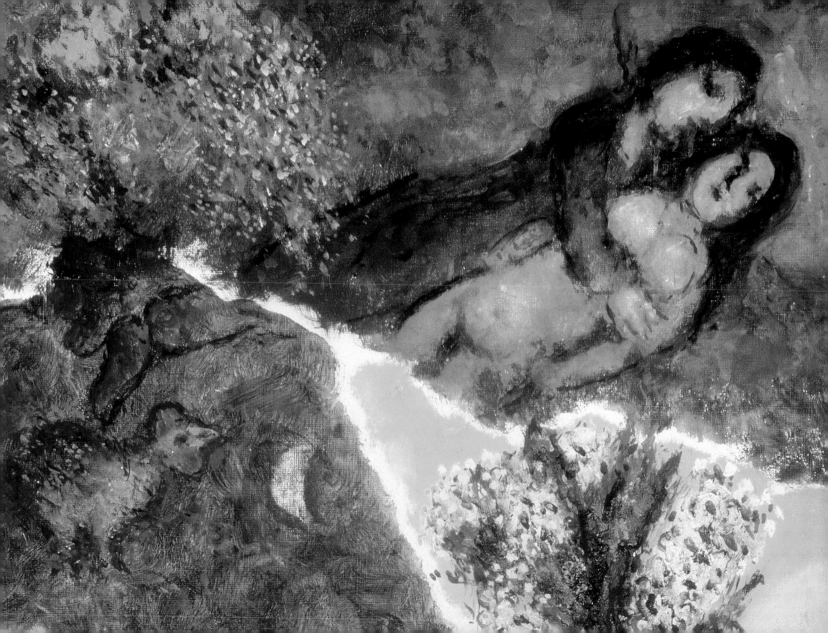

Justice is immortal, eternal, and immutable, like God Himself.

LAJOS KOSSUTH

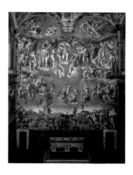

**The Last Judgment
(Detail from the Wall of the Sistine Chapel),** 1535–41
Michelangelo
Vatican Museum, Vatican City

1 2 3 4 5 6 7 8 9 10 11 12 13 14 15 16 17 18 19 20 21 22 23 24 25 26 **27** 28 29 30 31

DECEMBER

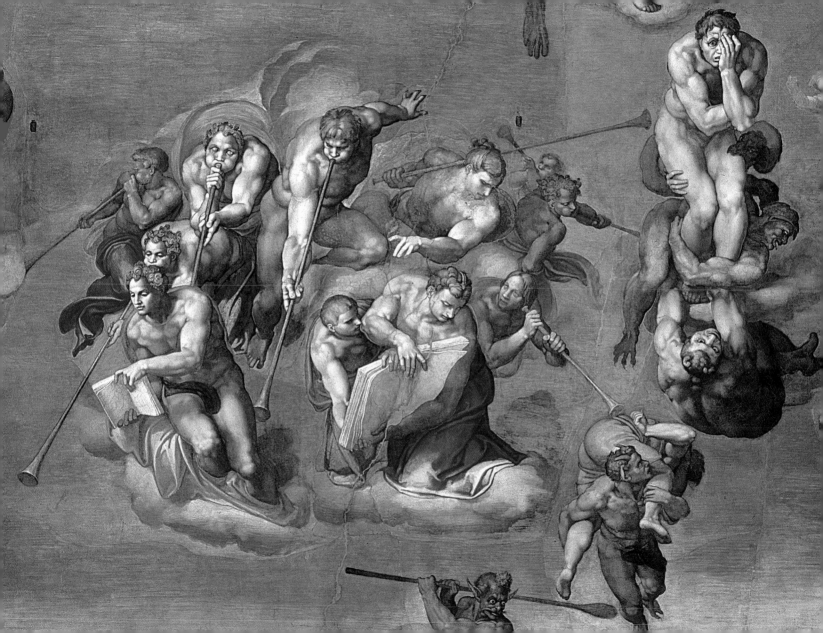

The rogue has everywhere the advantage.

Johann Wolfgang von Goethe

Little Rogue, 18th century
Sir Joshua Reynolds
The National Art Museum of Ukraine, Kiev

1 2 3 4 5 6 7 8 9 10 11 12 13 14 15 16 17 18 19 20 21 22 23 24 25 26 27 **28** 29 30 31

DECEMBER

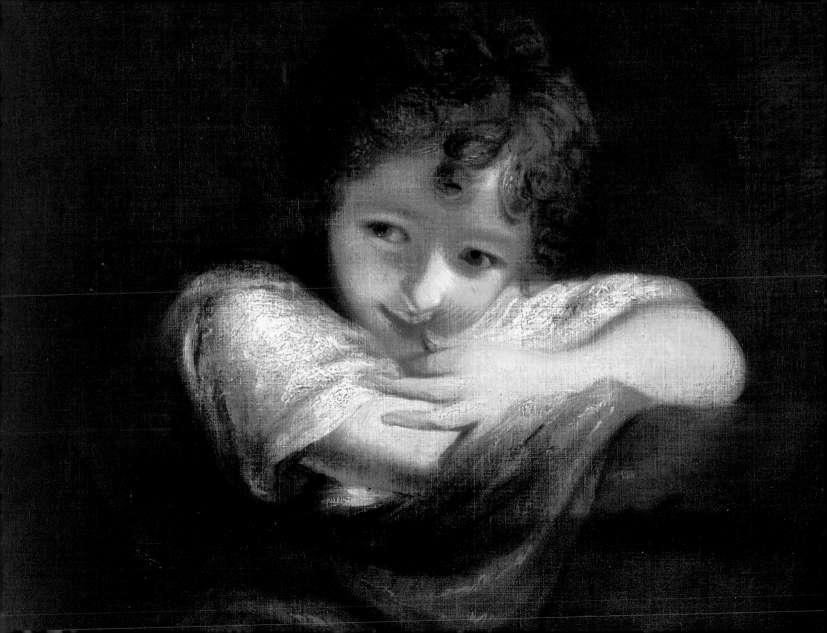

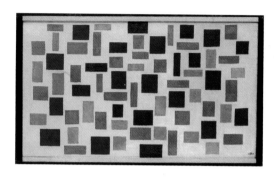

*Unity and simplicity
are the two true sources of beauty.*

JOHANN JOACHIM WINCKELMANN

Composition XI, 1918
Theo van Doesburg
Solomon R. Guggenheim Museum, New York

1 2 3 4 5 6 7 8 9 10 11 12 13 14 15 16 17 18 19 20 21 22 23 24 25 26 27 28 **29** 30 31

DECEMBER

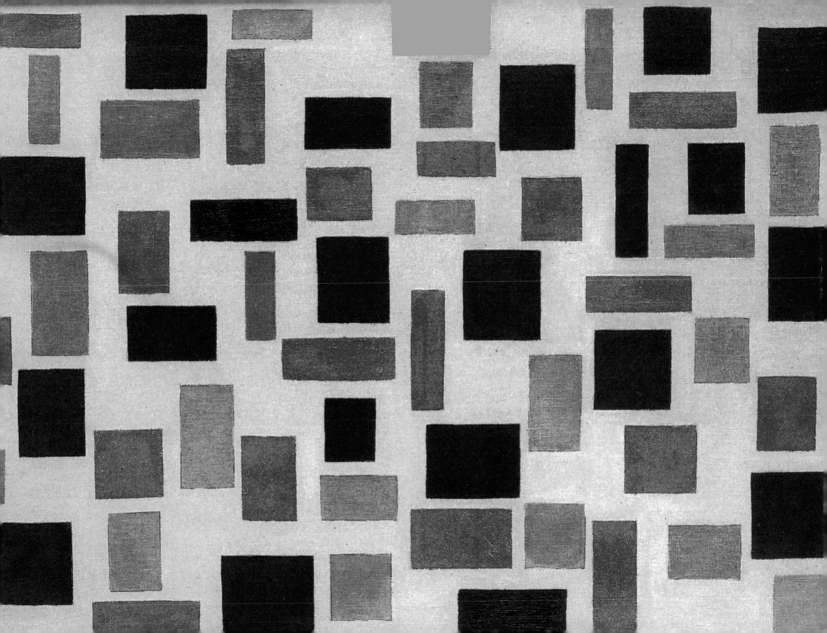

Painting is the representation
of visible forms. The essence of realism
is its negation of the ideal.

Gustave Courbet

The Wave, *c.* 1870
Gustave Courbet
The Pushkin Museum of Fine Arts, Moscow

1 2 3 4 5 6 7 8 9 10 11 12 13 14 15 16 17 18 19 20 21 22 23 24 25 26 27 28 29 **30** 31

December

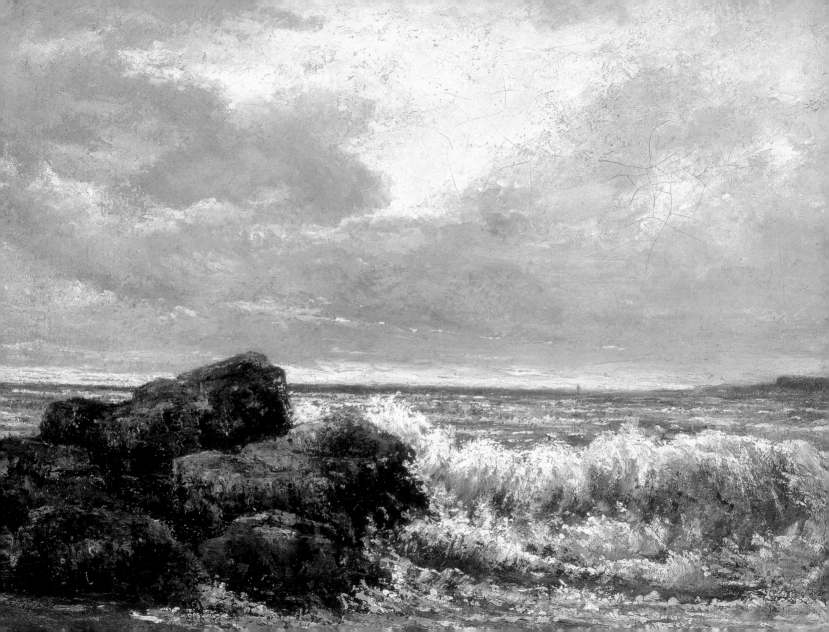

Now faith is the substance
of things hoped for, the evidence
of things not seen.

<small>THE EPISTLE TO THE HEBREWS, 11:1</small>

Mediterranean Philosopher, 1632
Rembrandt van Rijn
Musée du Louvre, Paris

1 2 3 4 5 6 7 8 9 10 11 12 13 14 15 16 17 18 19 20 21 22 23 24 25 26 27 28 29 30 **31**

DECEMBER

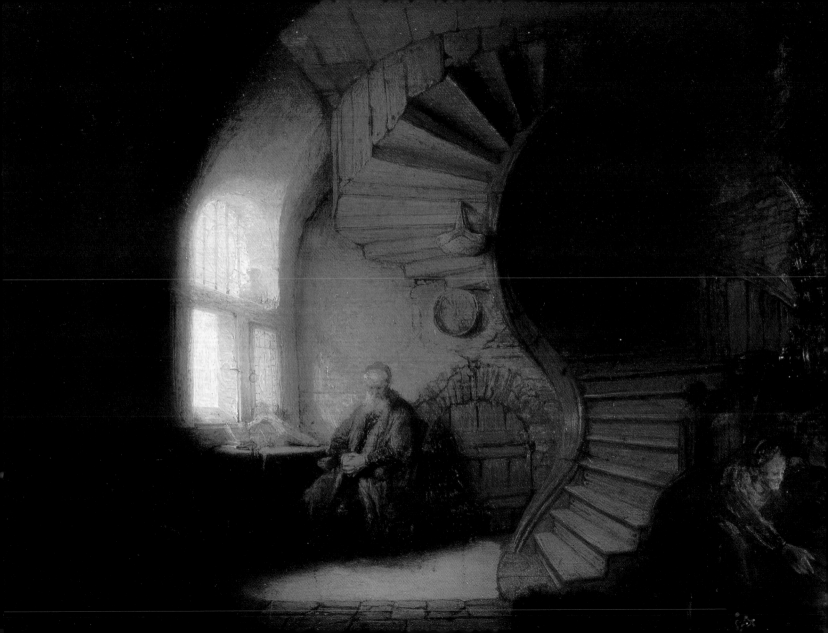

List of Artists

Aertsen, Pieter (1508–75) *June 25*
Aivasovsky, Ivan Konstantinovich (1817–1900) *September 28, November 28*
Alden Weir, Julian (1852–1919) *December 23*
Alma-Tadema, Sir Lawrence (1836–1912) *March 12, November 27*
Alsloot, Denis van (c. 1570–1628) *February 14*
Altdorfer, Albrecht (c. 1480–1538) *March 10, July 16, November 19*
Arcimboldo, Giuseppe (1527–93) *February 6*
Ast, Balthasar van der (1593–1657) *March 17*

Bellotto, Bernardo (1722–80) *November 30*
Bimbi, Bartolomeo, (c. 1648–1725) *September 11*
Blake Richmond, Sir William (1842–1921) *July 22*
Blechen, Carl (1798–1840) *February 27, June 14*
Bloemaert, Abraham (1564–1651) *October 20*
Boccioni, Umberto (1882–1916) *January 14*
Böcklin, Arnold (1827–1901) *January 10, August 1*
Borch, Gerard ter (1617–81) *January 15*
Borisov, Alexander (1866–1934) *February 7*
Borisov-Musatov, Victor (1870–1905) *May 19*
Botticelli, Sandro (1444–1510) *August 29*
Boucher, François (1703–70) *June 9, July 14*
Boudin, Eugène (1824–98) *May 11*
Bramley, Frank (1857–1915) *February 10*
Braque, Georges (1882–1963) *October 27*
Brueghel the Elder, Jan (1568–1625) *February 23, May 25, August 18, October 19*
Brueghel the Elder, Pieter (1525 or 1530–69) *March 22, April 1, September 6, September 15, October 1*
Brueghel the Younger, Pieter (1564–1638) *January 24*

Cabat, Louis (1812–93) *October 29*
Caillebotte, Gustave (1848–94) *April 28*
Canaletto (Giovanni Antonio Canal) (1697–1768) *March 3, May 13*
Caravaggio (Michelangelo Merisi da) (1571–1610) *September 27, December 21*
Caravaggio, Cecco del (Francesco Buoneri) (early 17ᵗʰ century) *September 8*
Cassatt, Mary (1845–1926) *October 30*
Ceruti, Giacomo (1698–1767) *January 31*
Cézanne, Paul (1839–1906) *May 28, June 4, September 30, December 14*
Chagall, Marc (1887–1985) *May 24, September 5, December 26*
Chardin, Jean-Baptiste Siméon (1699–1779) *April 19, October 13*
Chase, William Merritt (1849–1916) *September 25*
Chirico, Giorgio de (1888–1978) *April 15, July 23, September 18*
Ciardi, Guglielmo (1842–1917) *August 13*
Coccapani, Sigismondo (1583–1642) *January 25*
Constable, John (1776–1837) *July 2*
Corinth, Lovis (1858–1925) *February 2, August 17, December 11*
Corot, Jean-Baptiste Camille (1796–1875) *October 16*
Courbet, Gustave (1819–77) *October 15, December 30*
Crespi, Giuseppe (1600–30) *March 30*
Cross, Henri Edmond (1856–1910) *July 20, August 16*
Curradi, Francesco (1570–1661) *May 10*
Cuyp, Aelbert (1620–91) *April 8*

Dalí, Salvador (1904–89) *March 31, December 8*
Danhauser, Josef (1805–45) *July 18, September 19*
Daubigny, Charles-François (1817–78) *May 21, August 30*
David, Jacques-Louis (1748–1825) *October 8*
DeCamp, Joseph (1858–1923) *May 8, July 29, August 5*
Degas, Edgar (1834–1917) *September 2, October 24, December 16*
Delacroix, Eugène (1798–1863) *November 12*
Doesburg, Theo van (1883–1931) *January 26, December 29*
Doll, Anton (1826–87) *February 9*
Dou, Gerrit (1613–75) *October 23*
Dürer, Albrecht (1471–1528) *July 21, October 21*
Dyck, Anthonis van (1599–1641) *March 5*

Eakins, Thomas (1844–1916) *April 26, June 22*
El Greco (c. 1541–1614) *February 25, September 10*
Eyck, Jan van (c. 1390–1441) *December 3*

Fendi, Peter (1796–1842) *April 4*
Fiorentino, Rosso (1494–1540) *June 15*
Fischbach, Johann (1797–1871) *October 31*
Flandrin, Hippolyte (1809–64) *October 10*
Flegel, Georg (1566–1638) *August 12*
Fragonard, Jean-Honoré (1732–1806) *November 1*
Friedrich, Caspar David (1774–1840) *October 25*
Furini, Francesco (c. 1600–46) *April 10*
Füssli, Johann Heinrich (1741–1825) *June 17*

Gainsborough, Thomas (1727–88) *May 31*
Gauguin, Paul (1848–1903) *April 13, November 14*
Gérard, François-Pascal-Simon (1770–1837) *December 7*
Géricault, Théodore (1791–1824) *March 21*
Ghirlandaio, Domenico (1449–94) *January 13*
Giaquinto, Corrado (1699–1765) *January 16*
Giorgione (1478–1510) *March 20, April 25*
Giotto di Bondone (1266 or 1276–1337) *April 7*
Goderis, Hendrick (c. 1600–42) *April 16*
Goes, Hugo van der (1467–82) *December 25*
Gogh, Vincent van (1853–90) *April 21, June 18, July 31, September 9, September 14, October 6*
Goya, Francisco José de (1746–1828) *April 29, June 28, August 31*
Goyen, Jan van (1596–1656) *January 7*
Grigoletti, Michelangelo (1801–70) *August 19*
Gris, Juan (1887–1927) *September 23*
Guardi, Francesco (1712–1793) *July 19*

Hals, Dirck (1591–1656) *January 12*
Hals, Frans (between 1580 and 1585–1666) *June 13*
Hassam, Childe (1859–1935) *January 18, August 4*
Heem, Jan Davidsz de (1606–84) *April 12, October 18*
Henner, Jean-Jacques (1829–1905) *November 4*
Hess, Peter von (1792–1871) *May 9*
Hiroshige, Utagawa (1797–1858) *January 1, June 8, November 7*
Hodler, Ferdinand (1853–1918) *March 19, December 4*

Photo Credits

The images in this book were kindly made available by Artothek Weilheim (Artothek / Bayer & Mitko: February 22, March 6, 17; Artothek / Joachim Blauel: January 10, 11, 22, 29, 30, February 11, 16, 19, 20, 26, March 7, 13, 18, 27, 28, April 21, 30, May 3, 4, 9, 16, 17, 18, June 1, 3, 5, 11, 16, 30, July 19; August 9, 21, 27, September 1, 3, 9, 12, 13, 20, 26, October 7, 12, 14, 17, 22, 25, November 2, 3, 5, 6, 19, 20, 24, 25, December 1, 2, 10, 18, 24, 25; Artothek / Blauel / Gnamm: April 11, May 29, July 10, August 1, November 10, 22, October 21; Artothek / Christie's: January 9, March 12, May 27, July 12, August 11, September 14, November 27, Artothek / Ursula Edelmann: August 14; Artothek / Claus Hansmann: December 22; Artothek / David Hall: February 17; Artothek / Hans Hinz: January 21, February 24, March 19, May 31, July 22, 25, October 6, December 4, 13, 17; Artothek / Jochen Remmer: January 6, February 9, March 11, April 6, 12, 14, May 2, 13, 28, June 12, 21, 24, 26, July 8, August 31, September 5, 6, October 5, 31, November 14, December 28; Artothek / Paolo Tosi: January 25, 31, February 3, 28/29, March 5, 20, 25, 30, April 5, 10, 25, May 10, June 19, July 21, August 2, 29, September 10, 11, October 2, 13, 18, 23, November 17, December 20; Artothek / Joseph S. Martin: February 23, 27, March 4, 15, April 18, 29, May 14, 23, June 11, 28, July 24, 27, 30, October 28, November 13, December 8, 27; Artothek / Photobusiness: January 24, February 6, March 22, June 25, July 31, August 24, October 3, December 11, 15; Artothek / Peter Willi: January 5, 8, February 14, 21, March 16, April 3, 15, 28, May 5, 11, 12, 17, 26, June 6, 9, 23, 27, July 1, 3, 6, 9, August 8, 10, September 24, October 29, November 1, 4, 9, 12, 15, 18, 21, 23, 26, December 3, 5, 7, 21, 31; Artothek / G. Westermann: February 13, March 1, April 27; Artothek: January 3, 4, 7, 12, 14, 15, 17, 19, February 1, 4, 7, 12, 15, 18, 25, March 10, 23, 24, 26, 29, 31, April 1, 7, 8, 13, 16, 19, 20, 23, 24, May 1, 6, 19, 20, 21, 24, 25, June 4, 18, 20, July 2, 5, 7, 11, 15, 17, 19, 28, August 3, 6, 8, 15, 17, 20, 25, 26, 28, 30, September 4, 23, October 1, 9, 16, 20, 24, 27, 30, November 8, 11, 28, 29, December 6, 9, 14, 16, 19, 26, 30)
Artwork not listed here was taken from the Publisher's archive.

Images on the cover:
Front cover: see August 29
Spine: Claude Monet, Poppy Field near Argenteuil, 1873. Musée d'Orsay, Paris
Back cover (from left to right): see August 22, September 21, October 6, November 24

www.artothek.de